The Art of Satire

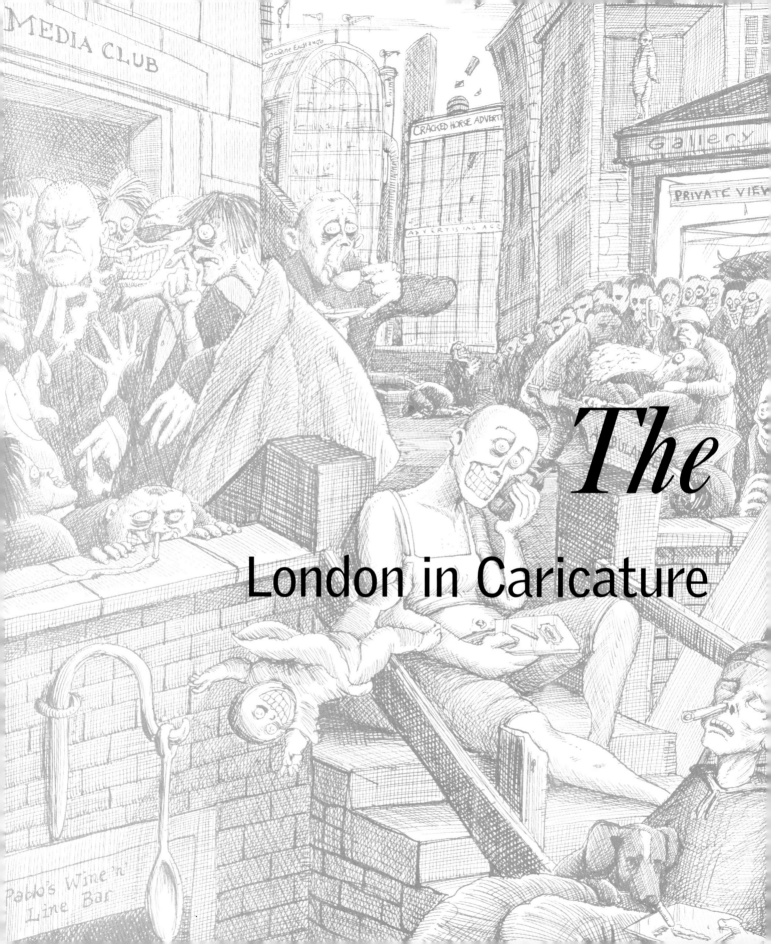

The
London in Caricature

Art of Satire

Mark Bills

MUSEUM OF LONDON

PHILIP WILSON PUBLISHERS

First published in 2006 by Philip Wilson Publishers
109 Drysdale Street, The Timber Yard
London N1 6ND

Distributed throughout the world (excluding North America) by
I. B. Tauris & Co. Ltd
6 Salem Road, London W2 4BU

Distributed in North America by Palgrave Macmillan,
a division of St Martin's Press
175 Fifth Avenue, New York NY 10010

ISBN 0 85667 627 6 (paperback)
ISBN 0 85667 613 6 (hardback)

Designed by James Campus

Printed and bound in China by Everbest Printing Co.

This book accompanies the exhibition: *Satirical London* at the
Museum of London, April – September 2006.

half-title:
John Leech, *The Image Seller*, 1843.
Wood engraving from *Punch*, 1843, p.159.

frontispiece:
Martin Rowson, *Cocaine Lane*, 2001
(detail of fig. 240).

Contents

Foreword *Ian Hislop* 7

Preface 9

1. Satirising London 10

2. The Age of Hogarth 40

3. From Drollery to Gillray 70

4. Thomas Rowlandson's London 104

5. Progress and Transition:
 Cruikshank and Regency London 136

6. Victorian Satire:
 London, Poverty and the Birth of Cartoons 168

7. Afterword:
 The Changing Faces of Satire 206

 Notes 216

 Select Bibliography 221

 Major London Printsellers of Satire 222

 Index 225

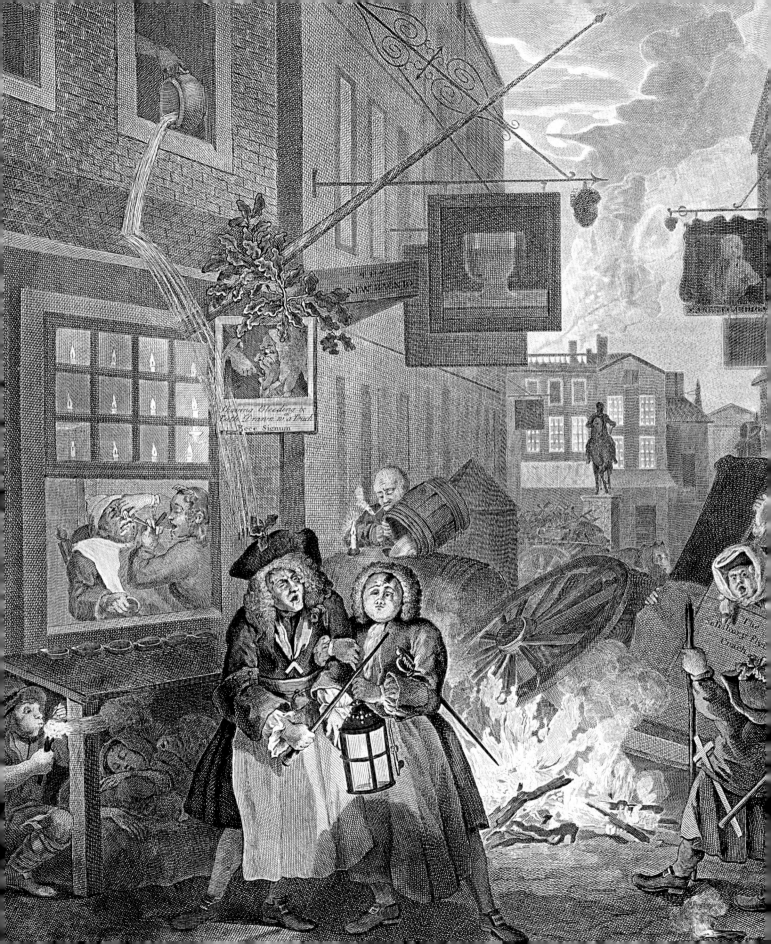

Foreword

I am indebted to Mark Bills for the information that satirical prints in London were sometimes used to decorate the inside of chamber pots. There is a pleasing symmetry in knowing that those artists who 'take the piss' had it, literally, given back to them. It is a reminder, too, that satirists should not take their work too seriously even when it is the subject of such an impressive academic study as this one. There are critics who think that satirical paintings and drawings aspire to 'high' rather than 'low' art and may well descend from the noble Italian genre of Caricatura. But there are plenty who think that they are 'nothing more than a license to distort, exaggerate and offend.' I obviously lean to the former view and would argue that some of the drawings in this collection reach a pictorial and moral truth that cannot be achieved by other art forms.

But then I would say that. For those of us still attempting to follow in the great traditions of English Satire this history is also a humbling reminder of how much of what we think of as modern and groundbreaking has actually been done before. I worked as a writer on the television programme 'Spitting Image', whose use of puppet heads and topical dialogue has been widely described in our times as extraordinarily innovative. Yet Bills reveals that there was a man called George Alexander Stephens displaying sixty papier-mâché heads on sticks and doing all the voices for them back in 1767! And as editor of the magazine *Private Eye*, I am only too aware of the long line of satirical print makers, magazine illustrators and Victorian cartoonists who have created the forms that we use today. Even the most distinctive *Private Eye* technique of sticking a speech-bubble on the head of a famous figure was done rather well by William Hogarth about 250 years ago.

I used the phrase 'English Satire' earlier but the author makes a good case here for calling it 'London Satire'. As the capital city, London was the centre of government, commerce, organised religion, fashion and the media and it was naturally the centre for all those who wanted to laugh at any of these things. London was an extraordinary city and it has an extraordinary amount of what satirists thrive on – 'Vice, Folly and Humbug'. Moreover, because of its size and its variety the city was a visual feast – all those busy streets, and pubs and offices and fairs and parks and gatherings to capture on paper. All that wealth and poverty and glamour and dirt. And this of course creates one of the ironies of so much satiric art about London. Whilst it is ostensibly criticising the failings of the Big City, it does it with a vitality and exuberance that can seem more like a celebration. Mark Bills rightly points out that generations of caricaturists and cartoonists chose the theme of the perils of prostitution not merely out of righteous anger but because they knew that their audiences liked seeing pictures of prostitutes.

Human frailty is, however, the real target of all of these artists and there was (and is) an abundance of it on display in London. I particularly like the satirical print by John Raphael Smith (1773) [fig. 3] which shows a young couple laughing at satirical prints of other people in a shop window. They are of course absurd figures themselves, a timeless reminder that in the end we are all fit targets for ridicule.

Ian Hislop

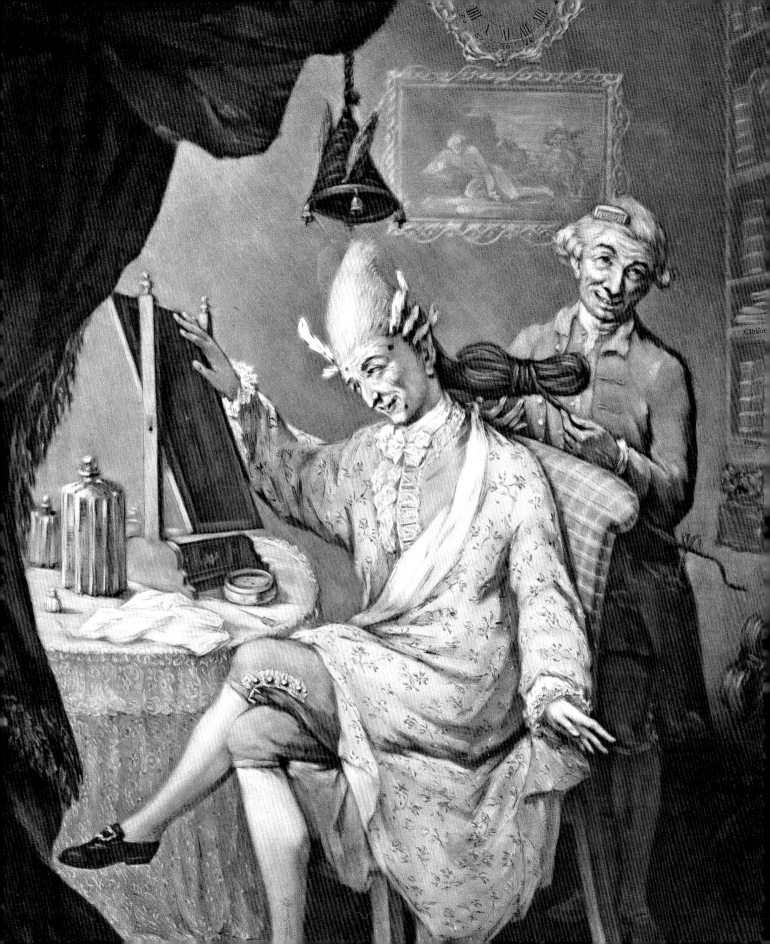

Preface

This book serves three purposes. It is an exploration of the rich satire collection held by the Museum of London, a collection that until now has been widely unknown. It also accompanies the exhibition *Satirical London*, held at the Museum between April and September 2006. Perhaps most importantly this book is a general survey of how English caricature and the print trade developed in London between 1700 and 1900, with a brief glimpse at how it has affected our own age. As a result, this book draws primarily on the large body of satire held within the Museum's own collection. I am well aware that because of the enormous number of satires produced about London the selection is necessarily going to miss many important images and several important individual satirists. What the book does do is to present a history of satirical images of London and provides a general context for these images and an entertaining introduction to the subject. It would have been impossible to write this book without Dorothy George's great catalogue of the British Museum satire collection, which still remains the cornerstone of any study of satire. I am also indebted to the scholarly work of Diana Donald, Mark Hallett and Richard Godfrey, whose books on aspects of English graphic satire are amongst the most illuminating. The work of previous curators of paintings at the Museum of London, in particular from Dr Celina Fox, John Hayes and Mireille Galinou, have left a body of publications, inspired acquisitions and information that have proved invaluable.

I would particularly like to thank David Alexander and Alex Werner for carefully reading a draft of the book and making so many useful suggestions. A great number of individuals have commented on images and shared their knowledge and enthusiasm for the subject, in particular Omek and Linda Marks, Dr Andrew Norton, Benjamin Lemer and Sean Shesgreen. The contemporary caricaturists, Roger Law, Steve Bell and Gerald Scarfe, have also been most helpful.

In researching, writing and producing the book, I would like to thank the following colleagues from the Museum of London: Jo Hall, Anna Ramsden, David Pollock, Sally Brooks, Cathy Ross, Hazel Forsyth, Tracy Wellman, Darryl McIntyre, Johan Hermans, Rose Briskman and Emma Shepley. At the Guildhall Library: John Fisher, Jeremy Smith, Lynne MacNab, Michael Melia, Gill Hemmings, Alice Powell and Hilary Ordman. Anita O'Brien at the Cartoon Art Trust, Dr Nicholas Hiley at the Centre for the Study of Cartoons, Canterbury and Sheila O'Connell at the British Museum. Also to staff at the British Library, Paul Mellon Centre Library, Political Cartoon Society and the Victoria & Albert Museum. At Philip Wilson, Anne Jackson, Cangy Venables, Norman Turpin and James Campus.

All illustrations are from the Museum of London's collection unless otherwise stated.

Mark Bills

John Dixon, *The Old Beau in Ecstasy*, 1773
(detail of fig. 91).

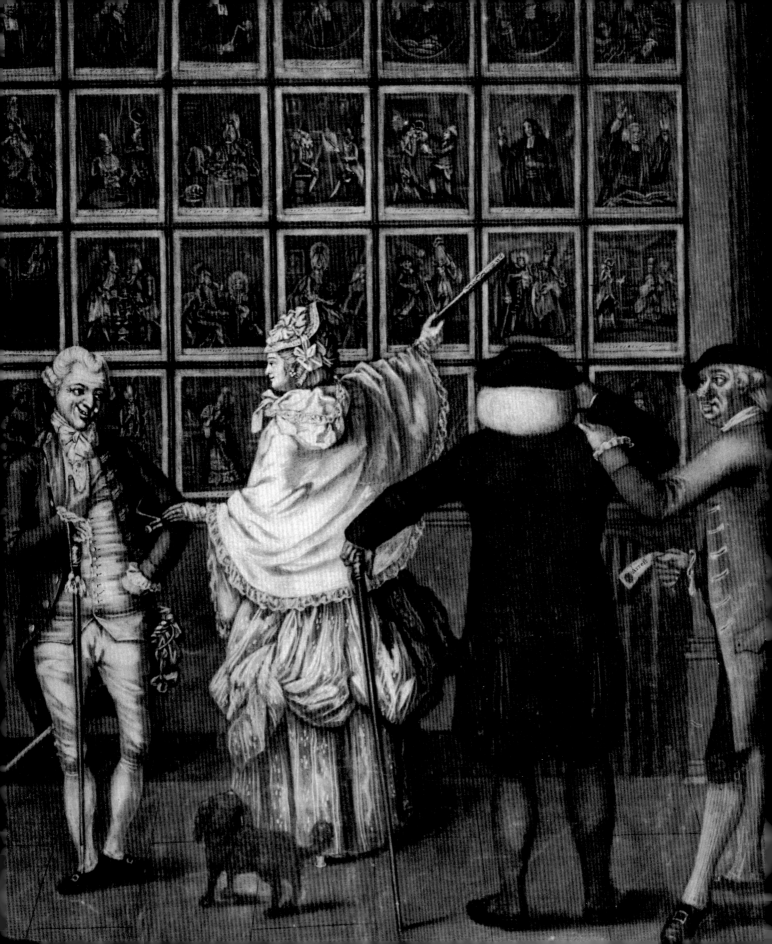

Satirising London

'The Metropolis is now before me: POUSSIN never had a
more luxuriant, variegated and interesting subject for a
landscape; nor had SIR JOSHUA REYNOLDS finer characters
for his canvas than what we have already had a sitting for
their likenesses to embellish LIFE IN LONDON.'
Pierce Egan[1]

'Contrast alone will sometimes produce a ludicrous effect...'
Francis Grose, Esq.,
Rules for Drawing Caricatures with an essay on Comic Painting,
1788[2]

1. Anonymous, *Spectators at a print shop
in St Paul's Church Yard*, c. 1770 (detail).
Mezzotint. Guildhall Library, Corporation
of London.

For over 300 years, comic images of London have amused a vast public. Thousands of social and political satires in paint, pencil, but most particularly in engraved form, have variously and humorously described London and its people. This enormous body of images ranges from the specific to the general: from caricature portraits of leading figures to the London 'types' recognised by all Londoners; from specific events and political debacles to the state of a typical London street. The array of approaches of artists, both 'high' and 'low', amateur and professional, is equally wide and ranges from light-hearted mocking to vitriolic and libellous attacks. Throughout the years of production – from the independent print publisher/seller to the editor of a comic journal – satirical images of London provide rare perspectives on the life of the city.

In focusing on the comic, on vice and folly, on strange contrasts and unsociable behaviour, these satires document the city and its people in a unique way. The outrages and exaggerations of the satirist's pen are never simply recording the events and people around them, but very consciously imbuing them with trenchant criticism, very often spiced with popular prejudice which reveal the folly, absurdity and stupidity of aspects of life in London. Topography gives us the architecture of the street and even the aspirations of the architect or planner; satire, on the other hand, offers a colourful picture of the opinions and attitudes of Londoners throughout the centuries, providing a matchless chronicle of London's history.

There is a long tradition of English caricature prints being distributed throughout Europe where they were eagerly consumed, despite their audience knowing little of the events and characters they depicted. In 1791 Frederick Wendeborn observed this phenomenon:

> Caricature prints go likewise in great quantities over to Germany, and from thence to the adjacent countries. This is the more singular and ridiculous, as very few of those who pay dearly for them, know anything of the characters and transactions which occasioned such caricatures. They laugh at them, and become merry, though they are entirely unacquainted with the persons, the manners, and the customs which are ridiculed. The wit and satire of such prints, being generally both local, are entirely lost upon them.[3]

As Wendeborn suggests, it is only by placing the images in the context of the society that produced them that we can begin to understand them. Each reaction to a new and outlandish turn in fashion, to a political outrage and to the petty foibles of a particular class of society is documented in a satirical image.

It is not within the scope of this, or indeed, any one book, to be comprehensive in its presentation of the plethora of satirical images that exist of London. The book is much more of a modest perambulation through London's streets in its consideration of a selection of important comic images that reflect London life. In doing so, its intention is to expose the language of satire and reveal the rich interpretations of London that it presents. The position of satire within art is notoriously ambiguous because of it is a hybrid of forms developing as it did from high and low cultures. It is this very freedom of its multi-referential forms and eclecticism that make it so revealing in its depictions of London. Furthermore, the development of satire was ultimately very responsive to the market in London, and its 'home' audience had a powerful effect upon the images that were produced.

The historical breadth of the book extends from the early eighteenth century to the end of the nineteenth century, considering the roots of the images in the seventeenth century and concluding with a brief consideration of how this tradition was manifest in an expansive range of forms in the twentieth century. The chronological approach allows a fuller historical account and social context for exploring the images, despite the temptation to consider recurrent themes and subjects together that are present throughout all the periods discussed. The term satire is used loosely, and encompasses caricature as it developed in London from Italy through wealthy amateurs, to Hogarth, who despised 'caricatura', and to the cartoons (first coined in its present meaning in 1843) of journals such as *Punch*. It is only within

a broad definition of satire that we can fully perceive its wide references and influences: each of these many manifestations of comic art make up the rich tradition of English satire that developed in London and the words are often used interchangeably.

Graphic satire is essentially an urban phenomena that developed in London to a greater extent than in any other city. In the eighteenth and early nineteenth century, satire flourished there and was the centre of a trade throughout Europe. Print shops sprang up in great numbers and a tradition emerged whose spirit is still felt in the cartoons of today, even after the disappearance of the Macaroni Print Shop, which specialised in 'caricatura'.

The role satire played in London beyond its obvious entertainment value was debated by contemporary commentators in each century with arguments which are still current. In this, as in many other aspects of satire, its role remained ambiguous. Caricature's supporters emphasised the

freedom of speech that satire allowed and its importance as a social control, expressed in Francis Grose's rules for caricature, written in 1788:

> In order to do justice to the art in question, it should be considered, that it is one of the elements of satirical painting, which, like poetry of the same denomination, may be most efficaciously employed in the cause of virtue and decorum, by holding up to public notice many offenders against both, who are not amenable to any other tribunal; and who, though they contemptuously defy all serious reproof, tremble at the thoughts of seeing their vices and follies attacked by the keen shafts of ridicule.[4]

Others found that the outrageous and sometimes extreme imagery went beyond the decency that some claimed it existed to protect. Certainly visitors to London in the late eighteenth century were often aghast at the freedom of the

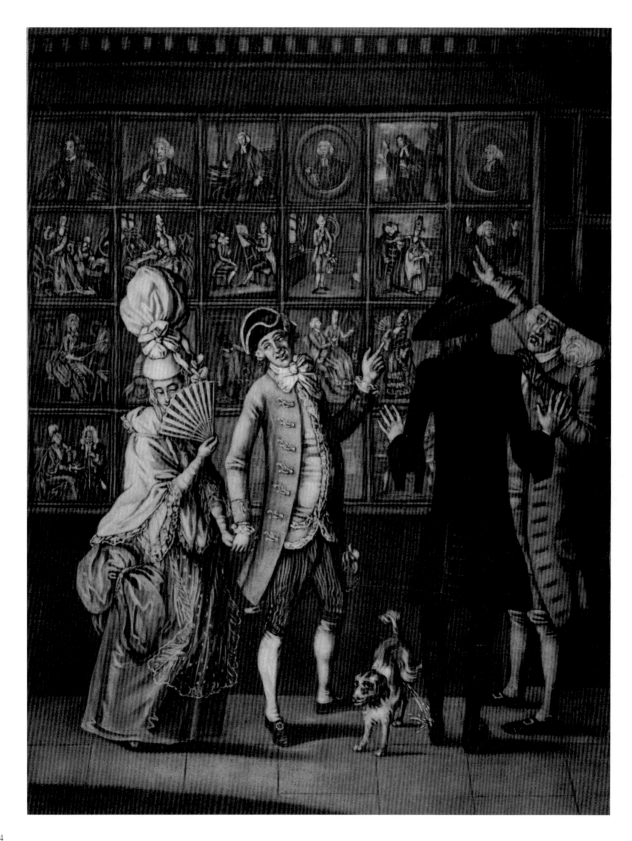

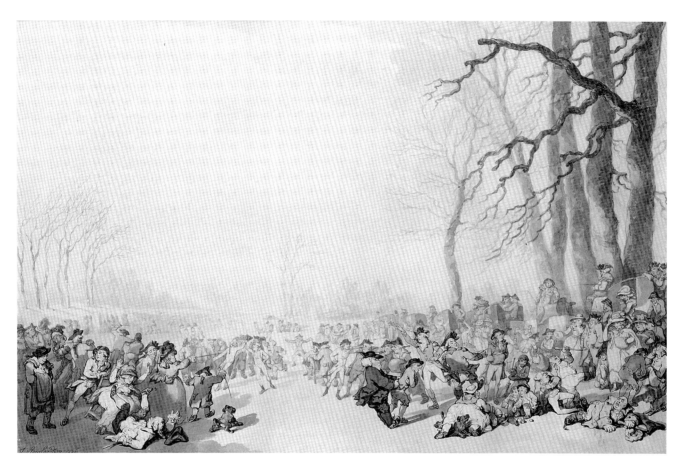

4. Thomas Rowlandson, *Skaters on the Serpentine*, c. 1786.
Pen and watercolour over pencil.

satirist's pen. Controversy also raised sales and there was suspicion about the motives of print sellers as early as 1738 when a 'True-born Englishman' reflected in his ramble through London:

> There are such contrasts in the Business of Authors, Printers and Publishers, that to the rest of Mankind it is amazing. If the Government chastises them for any Misdemeanour, it is accounted the greatest blessing that can befall them; *Punishment* being a real *Benefit and Confinement*, the boasted Liberty of the Press. A Book or Pamphlet order'd to be burnt by the Hands of the Common Hangman being the most agreeable News... I have been credibly inform'd, that if this Favour was to be purchas'd, there is not a Bookseller in London, but would give a handsome sum to have all the Books in his Shop fire'd in the same manner.[5]

Opinion continued to be divided throughout satire's history and in 1800 John Corry wrote that London print shops were 'so gratifying to the fancy of the idle and licentious,' that they 'must necessarily have a powerful influence on the morals and industry of the people.' Yet if commentators disagreed on the moral effect of satirical images they were united in their understanding of what a powerful effect satire had on its audience.

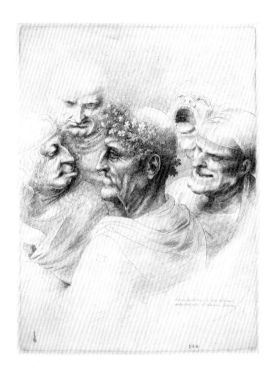

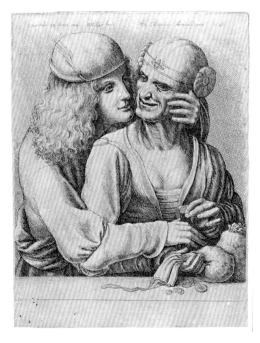

5. Wenceslaus Hollar, *Five Grotesque Old Men*, 1646. Etching.
The Metropolitan Museum of Art, Harris Brisban Dick Fund, 1926 (26.72.112). Photograph,
all rights reserved, © The Metropolitan Museum of Art, New York.

6. Wenceslaus Hollar, *A Young Man with a Hideous Old Woman*, 1646. Etching.
The Metropolitan Museum of Art, Purchase Joseph Pulitzer Bequest 1917 (17.50.18.162).
Photograph © 1994 The Metropolitan Museum of Art, New York.

7. Wenceslaus Hollar, *The world is ruled and governed by opinion*, 1641. Etching.
© The British Museum, London.

8. Thomas Patch, *Tommaso Patch Autore*, c. 1771. Etching. National Art Library, London.

The Language of Satire and Caricature

> The art of drawing Caricatura is generally considered as a dangerous acquisition, tending rather to make the possessor feared than esteemed; but it is certainly an unfair mode of reasoning, to urge the abuse to which any art is liable, as an argument against the art itself.
>
> *Francis Grose*, 1788 [6]

Humorous images of visual distortion and marked contrast have a long history within Western art. In the nineteenth and early twentieth century a large body of writing on the subject variously traced examples from classical sources to illustrated satirical magazines, giving a picture of a continuous tradition. Eclectic examples are cited from many mediums as diverse as sculpture, illuminated manuscripts and broadsheets, alongside the experiments of the great painters. Their depiction of bawdy tales, grotesque heads and popular symbols illustrates the diverse images of bodily and facial distortion used by artists.

Satire that developed in London in the eighteenth century, which is the basis of graphic satire as we know it today, arose from two quite distinct visual traditions and is a dynamic hybrid of the two. These traditions of satire and caricature are nowhere better illustrated in two types of prints by Wenceslaus Hollar (1607–77), who provides us with examples of the two traditions before they were combined into the distinctive satirical images that this book considers. The prints of Hollar, 'which we now see at the Print-Shopps',[7] were well known in London. Hollar's employment by the Earl of Arundel, one of the greatest collectors of his age, meant that the artist had access to his employer's collection. Amongst the collection were the drawings of grotesque heads by Leonardo da Vinci, which were transcribed by Hollar in great detail into prints before being sold in the city. The drawings, and Hollar's prints after them, were extremely influential in laying the ground for the development of caricature in London. In *A Young Man with a Hideous Old Woman* (1646) [fig. 6] (possibly by a follower of Leonardo), the image contrasts beauty and ugliness, age and

youth, a characteristic of many later English satirical drawings, particularly those of Thomas Rowlandson. Caricature, which developed as an individual art form in Italy, reputedly originated by Annibale Carracci (1560–1609), claimed a high art tradition and traced its pedigree back to these very drawings of Leonardo and his followers.

Another kind of image produced by Hollar and known as satire was completely distinct from caricature in the seventeenth century. *The world is ruled by opinion* of 1641 [fig. 7] is typical of such satire and depicts the figure of public opinion, blindfolded with a tower of Babel on her head, a chameleon on her arm depicting the changeability and hence fickleness of opinion. She sits in a tree that is watered by a fool and bears the fruit of 'idle books and libel'. The satire is typi-

cally explained in verse, in this case taking up half the page. The end of the verse echoes the very nature of satire itself: 'Opinions found in everie house and streete/ And going ever never in her waie.'

The difference between the two traditions typifies the unique position of later satirical imagery and its ability to utilise diverse influences. Caricature, or the systematic distortion or exaggeration of personal appearance, was associated with high art, with an academic tradition that drew on anatomy, rules and theory. Physiognomy provided the theory, whilst rules and instructions emerged for drawing, identifying it as a distinct discipline. It is an art of wit and politeness. In contrast, satire was associated with low culture. Its images were often symbolic and drew on popular and folk imagery such as the symbolism of popular emblem books. Text was an important element in expounding its point beyond ambiguity. It often lacked humour and can be characterised by its bigotry and service of propaganda at a time of religious and political divide in London. The imagery that it showed was often crude and came in the form of

cheaply produced woodcut broadsheets as well as etchings and engravings for sale in print shops. *Cocker's English Dictionary* of 1704 is telling in its entry that defined 'Anything sharp or severe is called a Satyr.'

Satire as it developed in London in the eighteenth century drew on both the popular tradition of 'sharp or severe' emblematic satire and the pictorial possibilities of caricature. The unique blending of these visual forms, which were intimately linked to literary satires and popular culture, formed a very distinctive English tradition. The interplay of word and image, for example, was developed as an important element within the picture, from integral scrolls and balloons of text, through pointed titles to the one-liners of the later cartoons, a kind of graffiti of pointed and often crude text. Satire's ability to draw on a variety of sources accounts, in part, for the vitality of the images that were produced. The polite and witty import of 'caricatura' particularly suited social satire in creating visual archetypes of Londoners across all classes, just as it was appropriate for the satire of recognisable individuals, from politics and society.

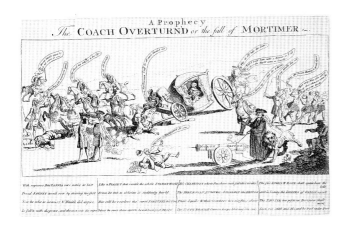

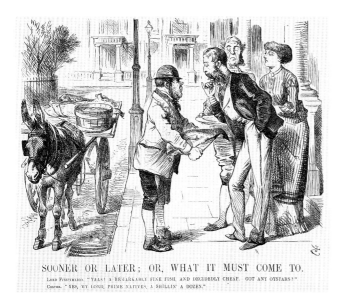

Caricature, as a recognised branch of art, had come to London through connoisseurs and travellers on the Grand Tour. Thomas Patch's *Caricature* (c. 1771) is a book of engravings of full-length profiles and is typical of the connoisseur's approach to the subject. The first page, containing etching No. 1, is titled *Tommaso Patch Autore* (c. 1771) [fig. 8], and depicts the author himself with an exaggeratedly large forehead and small snub nose measuring the proportions of a classical mask of a satyr. The image exemplifies the art of caricature as it was when it came from Italy to London. The artist is a gentleman connoisseur who has studied the masterpieces of Italian art and has produced alongside his copies of the masters this politely witty diversion of caricature portraits. Although such examples represent a virtually private publication, as most were, the influence of the language of 'caricatura' was widespread amongst the polite classes.

The introduction and success of caricature in London was, in part, due to the efforts of Arthur Pond. He began two sets of caricature prints in 1736, which 'caught on so quickly with the London audience. Their timely appearance – contribut[ed] to the popularisation of caricature drawing as a polite form of entertainment...'[8] Two other key figures were Matthew and Mary Darly who founded their print business on teaching amateurs to draw and etch 'carrick.' In around 1762 Mary Darly published *A Book of Caricaturas*, providing the instruction that 'any carrick will be etched and published that the authoress shall be favoured with, Post paid.'[9] New premises at 39 The Strand, which solely published and sold caricatures, was wonderfully illustrated in the etching *The Macaroni Print Shop* [fig. 21], published in 1772 by Matthew Darly after Edward Topham.

Interest in caricature continued to flourish in London through the 1760s to the 1780s and saw further instructional texts from Carington Bowles in his *Polite Recreation in Drawing* (1779), and from Francis Grose's *Rules for Drawing Caricaturas with an essay on Comic painting* (1788) [fig. 13]. Grose's text, which outlines the basis of the humour, provides graphic examples of facial distortion. Its essay on humorous painting could not fail to cite, more than once, the

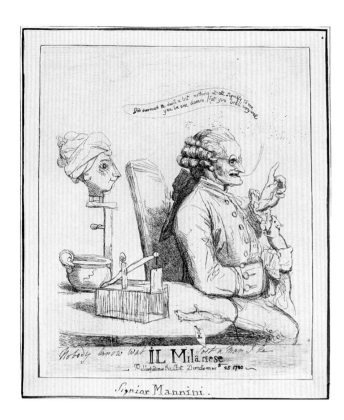

example of William Hogarth despite the artist's polemic against 'caricatura'. This was an indication that by 1788 caricature had fully assimilated itself into English satire and the lessons offered by Bowles and Grose had parallels in the many instructional books of drawing in general. Each of these books taught how to create a caricature face through assembling it from a selected a group of exaggerated features, such as figure 5 in Francis Grose's book of 1788 [fig. 13]. Grose, on describing the face, comments that 'the contour is convexo-concavo, nose snubbed, mouth blubbered, chin double, eyes goggle, eye-brows pent-housed.'[10]

Lessons in drawing caricature demonstrated that through using abstract shapes the artist could produce a host of humorous and grotesque faces. However, the exaggerated, but still recognisable features could not be simply seen as a playful diversion that had no equivalent in reality. Mary Darly instructed her students to use observation with the

elements in her book; 'then by comparing your observations with the samples in the book,' she advised, 'delineate your Carrick.'[11] The instructions for drawing caricature followed, to some extent, the example of physiognomy, so that each variation reflected the character and meaning of the type of person that the face depicted, in terms of both personality and expression.

The most influential text that provided the basis for later theories of Physiognomy was Giovanni Della Porta's (c. 1542–97) *De Humana Physiognomia* (1586) [fig. 14], a book known to many artists and caricaturists. John Caspar Lavater's *Essays on Physiognomy designed to promote the knowledge and love of Mankind* (1775–78) was translated into English and was widely available in London. Lavater makes it clear that the idea of physical deformity, or divergence from the norm, is an indication of a character flaw. In Lavater's words, 'Disproportion in the parts of the face has an influence on the physiological constitution of man; it decides concerning his moral and intellectual imperfections.'[12] Caricature, too, albeit in a far less pseudo-scientific way, retained elements of physiognomical moralising. It certainly relied upon divergence and contrast for its humour and in Grose's lessons he instructs that the student should begin to draw the human head, from one of those drawing-books where the forms and proportions, constituting beauty to the

European idea, are laid down.[13] From the ideal or norm the student can then play with distortion to produce a comic image.

Physiognomy and caricature converged further in the parallels that they both made between the human and animal face. Lavater illustrates an image from Della Porta's book, comparing a human face with that of an ox. 'Gross brutality, rudeness, force, stupidity, inflexible obstinacy, with a total want of tenderness,' Lavater writes, 'such are the characters portrayed in the form and features of these caricatures of men forced into the resemblance of an ox.'[14] Attributing animal characteristics to humans, as well as creating zoomorphic figures, had long since been part of the vocabulary of satire. Grose notes:

> Many human faces have striking resemblances to particular animals; consider what are the characteristic marks of each animal, and procure or make accurate drawings of their heads and features; and from them sketch out the human face, retaining, as much as possible, the leading character of the particular animal resembling your subject. Many examples of this kind are exhibited in Baptista Porta's Treatise on Physiognomy. Hogarth has also given some instances of these resemblances...[15]

In spite of attempts at linking caricature drawings to reality to give a comic commentary, for many practitioners and consumers the drawings remained fairly abstract and nothing more than a polite diversion. Hogarth particularly objected to caricature and famously expressed his disapproval through his print *Characters and Caricaturas* of 1743 [fig. 17]. To Hogarth, 'caricatura' was simply a fashionable trend from Italy, practised in London by amateurs for the collections of connoisseurs. Its basis in deliberate distortion rather than observation was the main reason for Hogarth's objection who made the distinction between character and caricature. Depicted along the base of the image of *Characters and Caricaturas* are examples of the contrasting approaches, character being exemplified by Raphael and 'caricatura' being represented by one of Leonardo's grotesque heads alongside

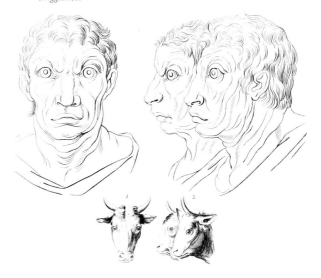

Ghezzi and Caracci. Hogarth also notes on his plate that 'For a further Explanation of the Difference Betwixt Character & Caricatura see ye Preface to Jos Andrews.' In the Preface to his novel, Henry Fielding praises Hogarth's ability 'to consist in the exactest Copy of Nature; insomuch that a judicious Eye instantly rejects any thing *outré*... Whereas in the *Caricatura* we allow all Licence. Its aim is to exhibit Monsters, not Men; and all Distortions and Exaggerations whatever are within its proper Province.'[16]

Yet the clear distinctions between 'caricatura' and Hogarth's approach are less easy to define in retrospect when the forms became so merged in later artists. As an isolated amateurish occupation that emerged from two dimensions,

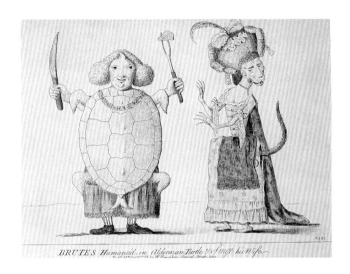

BRUTES Humaniz'd in Alderman Turtle & Singe his Wife

15. Mark, *Brutes Humaniz'd in Alderman Turtle & Singe his wife*, 1775. Etching, 1775.

16. Anonymous, *The celebrated Lecture on Heads*, 1784. Etching. Reproduced in *A Lecture on Heads, as delivered by that Celebrated Comedian Mr. Lewes, at the Theatres Royal of London, Dublin and Edinburgh*, London 1784. Guildhall Library, Corporation of London.

Right:

17. William Hogarth, *Characters and Caricaturas*, published in 1743. Etching.

'caricatura' could be a limited and sterile experiment. With observation and commentary on society, the distortion and exaggeration of character was altogether more meaningful. This merging, ironically, owed much to Hogarth who made satire a relevant contemporary art form and raised its profile. As Diana Donald has written, 'perhaps Hogarth's most important legacy to his successors was the dissolution of hard and fast distinctions between "high" and "low" culture – in his work, one constantly infiltrated the other.'[17]

Furthermore, the development of satire was not connected simply to visual culture: graphic satire was informed by literary satire as well as vice versa. The visual images of caricature and satire found their way into text, stage plays and even popular performances. The stage comedies of the great urban fairs such as Bartholomew and Southwark were widely seen. More particularly in London between 1767 and 1783, it was possible to see an extraordinary performance entitled 'A Lecture on Heads', by George Alexander Stevens. In it Stevens staged a live satire of over sixty characters through a series of heads made of wood and papier mâché that were brought to life by Stevens acting out the character around them through the intonation of his voice and gesture. Like graphic satire the selection encompassed individuals and types from the 'Fox and North Coalition' to the recognised London types such as the 'Cit', 'Stock Jobber', 'Billingsgate'

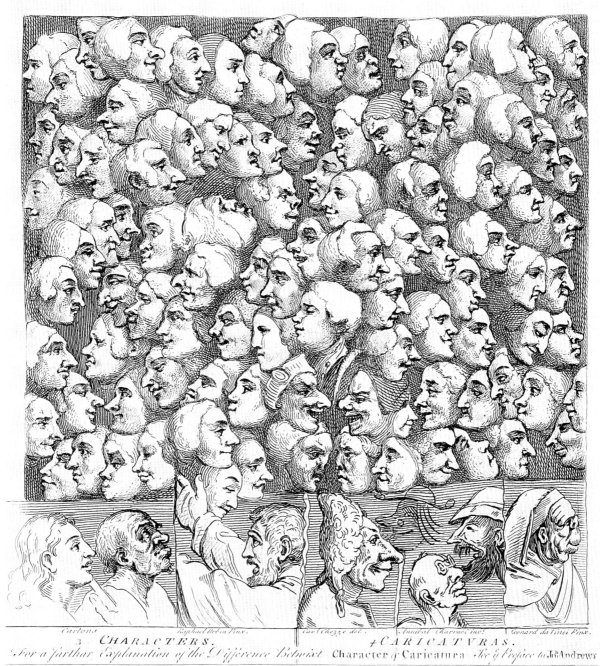

and 'Quack Doctor.' It became such a famous and popular event that it was published many times and after Stevens death in 1783 it continued to be performed by 'that Celebrated Comedian, Mr Lewes'. M D'Archenholz recalled the performances in his 1789 book on the customs and manners of the English:

A person of the name of Stevens, who died in 1783, was the inventor of an entertainment equally singular and original, which he called *Lectures on Heads*. This consisted in comical and satirical observations upon all the ranks and classes in the nation.

The author displayed a thorough knowledge of the world, much wit, and a great deal of gaiety in his representations. To animate his narration, and give force to his ideas, he procured a prodigious number of portraits, the physiognomy and dress of which were expressive of those characters, and occupations, which he ridiculed.

He knew how to imitate the voice, their looks, and their manner, with the most happy adroitness. Women of the town, barristers, physicians, clergymen, merchants, officers, men of learning, artists, ladies of fashion, and billingsgates; in one word, all the professions, copied by Stevens, were caricatured before the public with the utmost humour and gaiety.[18]

In the eighteenth century perennial London stereotypes evolved in all forms of satire, and you were just as likely to come across a fat Mammon worshipping City Liveryman in plays, satirical prose and verse as you were in a print.

The use of distorted facial characteristics in performance has continued in London since the eighteenth century. In the nineteenth century, for example, performances of mimickery and clowning based on graphic satire were staged.

Productions such as in Pierce Egan's 'Life in London' contained the visualisation of the images of the Cruikshank brothers. But there is perhaps no better example of this than the use of caricature puppets, from Punch and Judy to *Spitting Image*. In all these manifestations the roots are the same and satire continues to be as eclectic as they ever were.

Caricatura, the language of visual satire arising from satirical broadsheets, and the example of William Hogarth, has evolved and absorbed changes but has remained remarkably cohesive to a distinct tradition. Hogarth's enormous influence paved the way for professional artists to turn their attention exclusively to satirical imagery, notably the two professionally trained artists James Gillray and Thomas Rowlandson, whose images provide the pinnacle of a satirical tradition in the late eighteenth and early nineteenth century. Despite this, no other British artist has achieved the status of Hogarth, who is rightly acknowledged as a great painter as well as printmaker and satirical commentator of the social scene. The boundaries between the high and low culture that Hogarth blurred became distinct after his death and satire became an almost exclusively graphic medium. Satire was the art of line and watercolour, not of oil paint. In addition to this, the technological developments in printing, which led to the birth of the illustrated journal, sounded the end of the single satirical print and saw the rise of the editor and the satirical illustrator. As a result,

the Victorians never found the contemporary 'Hogarth' they so wished to find – their artistic sensibilities would not allow it. Satire was relegated to popular culture and mass production, high art to oil painting and the walls of the Royal Academy. Furthermore, Hogarth's images in the Victorian period were often considered too gritty for a generation that liked to view the eighteenth century as an age of elegance and politeness. Despite the change in the status of satire, the nineteenth century did provide a rich body of satirical images spearheaded by the extraordinarily prolific and inventive George Cruikshank. Cruikshank, who emerged from the Georgian period, led the way into the Victorian era, and, perhaps more than any other artist, defined his own age with his distinctive satirical observations.

The relationship between text and image that had been important in early satires found an equally important, albeit very different, relationship in the nineteenth century. The title and annotations of images had always been a significant element within satire, but with comic journals the text was even more pronounced, sometimes taking predominance over

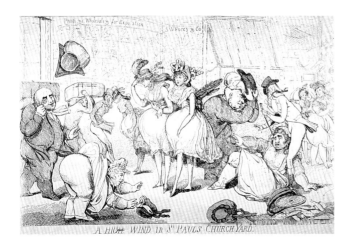

A HIGH WIND in St PAULS CHURCHYARD.

the image. This can be nowhere better illustrated than in George Cruikshank's arguments with Charles Dickens over the invention of *Oliver Twist* where Cruikshank claimed he had created several of the characters.[19]

In the twentieth century satire has become associated with political comment, one-liners and cartoons in periodicals, in the main because it retained the language from the eighteenth century that was universally understood.

The London Print Trade and the Audience for Satire

> There are now I believe as many Booksellers as there are Butchers & as many Printshops as of any other trade. We remember when a Print shop was a rare bird in London…
> *William Blake*, 1800 [20]

> In our loitering perambulation round the outside of Paul's we came to a picture-seller's shop, where smutty prints were staring the church in the face. *Ned Ward* [21]

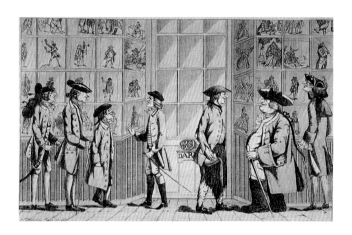

The production and distribution of individual satirical prints in Britain in the eighteenth and nineteenth centuries were centred in London. Satire formed an integral part of the print trade and satirical prints were bought and sold alongside fine prints imported from Europe as well as those by British artists. It was only in the mid-to-late eighteenth century that certain publishers began to specialise in caricature and comic images, such as the 'Fun Merchants' Matthew and Mary Darly, who opened their shop in 1762. Until then print shops had included satire as a genre that they sold alongside any other genre. Even given the growing number of shops that exclusively sold satirical images, general print shops continued to sell a range of prints including satire and caricature, and as a result the distribution of satire increased rapidly.

The London print trade flourished in the late eighteenth century, as William Blake recalled in 1800. Print sellers had long been a presence in London, with many having stalls in places of popular resort, notably the Royal Exchange and Westminster Hall, but the enormous demand for prints led

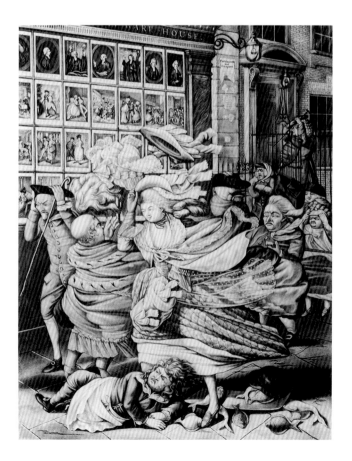

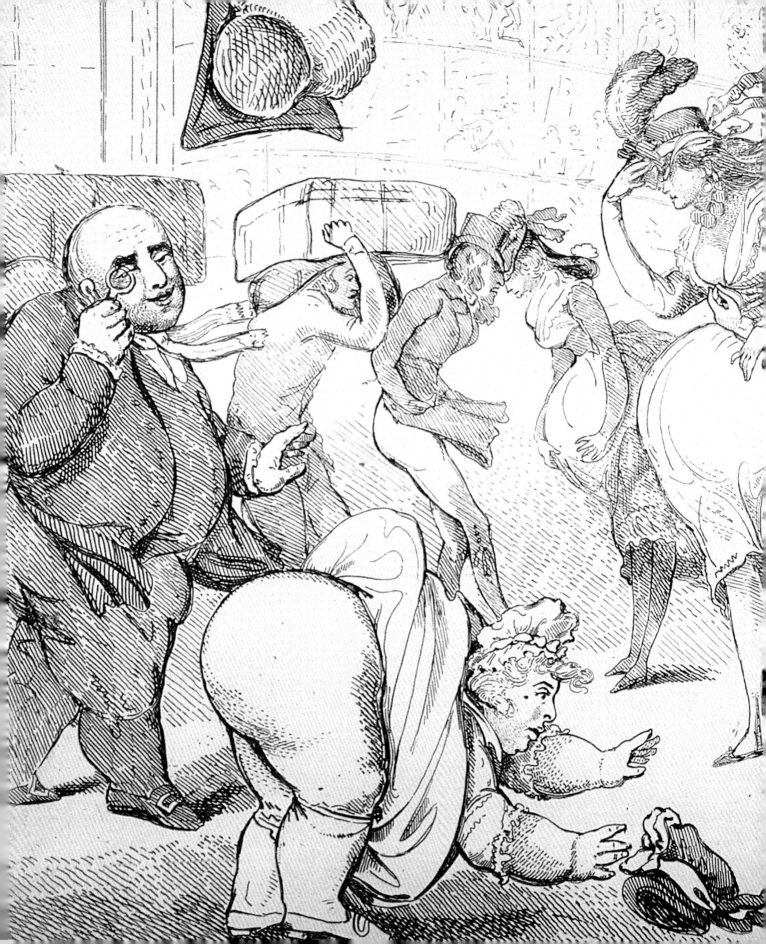

to the proliferation of shops throughout the city. The shops provided an area to display and sell satirical prints, although this was not the only way in which the prints were distributed, as a flourishing European trade proved. In 1802 the artist and diarist Joseph Farington recalled one example of the European craze for London's satirical prints on a visit to Calais: 'At the Commissary's Office a Soldier stood as a guard. The room was decorated with a great number of Caricature prints, – ridiculing the English Marching to Paris, – Fox in several situations, – &c &c – but I believe all of them imported from England'.[22]

From the end of the seventeenth century newspaper advertisements had provided a useful means by which artists and publishers could promote their images as well as utilising the free pages at the end of books. Print auctions had also been held in London since the seventeenth century. These often took place at coffee houses and gained momentum at the end of the eighteenth century when the old stock of failed businesses were sold off. Publishers also produced prospectuses and catalogues, which were key to the wider distribution of the prints alongside their sale in the metropolis. Specific groups also provided an important vehicle for print circulation amongst its members, from gentlemen's clubs to political movements and subversive groupings. Yet until the mid-nineteenth century Londoners predominantly bought individual images of satire from the print shops and stalls. With the development of illustrated newspapers and pictorial journals, however, which became the main medium for satire, came a wider distribution and the consumption amongst the metropolis reached a staggering size.

At the end of the eighteenth century old established businesses and entrepreneurs made up the rich body of growing print-shop fronts, with artists, printers and publishers vying for trade. Pictorial sign boards such as the Black Horse, the City Arms and the Golden Buck marked the locations of the print sellers John Bowles, Samuel W. Fores and Robert Sayers. The shops were generally run by the publisher, who owned the premises and presses, and employed the artist and printers. Individual print production consisted of a collabo-

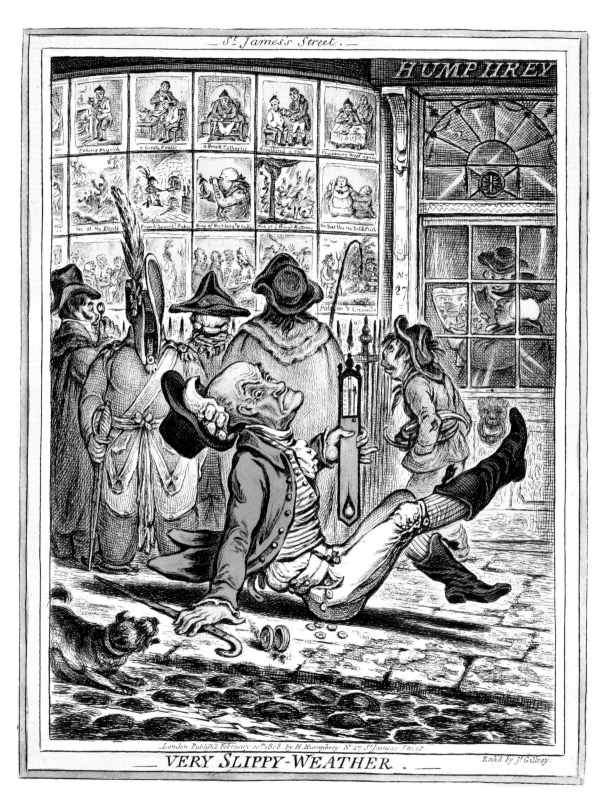

25. James Gillray, *Very Slippy-Weather*, 1808. Hand-coloured etching.

ration between an artist and publisher, apart from the few cases where artists published themselves. The artist would provide a painting, a drawing, or in some cases, work the plate directly. The publisher would employ the plate printer, engraver and colourer. Adding colour by hand made the prints more attractive and expensive and could even hide a multitude of sins on a plate that was wearing thin, a practice that materialised suddenly in the 1780s. The completed prints would then be exhibited in the publishers' shop, listed in the catalogue and advertised in newspapers.

By the end of seventeenth century print shops were firmly established in London, principally around St Paul's and Fleet Street, alongside publishers and booksellers. Peter Stent (c. 1642–65) and John Overton (1640–13) are two of the most important print sellers of the seventeenth century. Stent's broadsheet, produced between 1649 and 1653, is the earliest recorded catalogue for an English print seller, and contains both Hollar's versions of Leonardo's grotesques as well as seventeenth- century political and religious satires. Overton's premises were well enough known to be celebrated in verse

and John Gay's *Trivia: or the art of walking the streets of London*, (1716) includes the lines:

> Where Titian's glowing pain the canvas warm'd,
> And Raphael's fair design, with judgement charm'd,
> Now hangs the bell-man's song, and pasted here,
> The coloured prints of Overton appear.[23]

The rivals to Overton were the Bowles family whose family business, which survived into the mid-nineteenth century, was based at St Paul's Churchyard. Tom Brown, in his satirical saunter around London, described the popularity of the shops in the area. Entering St Paul's Churchyard he wrote:

> We turned right, where booksellers were as plenty as pedlars at a fair... I observed there was more people gazing at these loose fancies of some lecherous engraver than I could see reading sermons at the stalls of all the neighbouring booksellers. Among the rest of the spectators, an old citizen had mounted his spectacles upon his nose, and was busily peeping at the representation of the gentleman and the milkmaid.[24]

John Cluer, for example, set up The Printing Warehouse at the nearby Bow Churchyard and sold cheap woodcuts and engravings that included ballads and satire. His business was taken over by William Dicey, who continued to produce popular satires such as *The Folly of Man* and *The Lawyer's Coat of Arms*. Dicey represented the most popular end of the satirical print market and had an eclectic mix of prints for sale including those aimed at children. James Boswell nostalgically recalled in his *London Journal* on Sunday, 10 July, 1763:

> I went to Bow Church, the true centrical temple for the bluff citizens. I had many comfortable ideas. And here I must mention that some days ago I went to the old printing-office in Bow Church-yard kept by Dicey, whose family have kept it fourscore years. There are ushered into

the world of literature *Jack and the Giants*, *The Seven Wise Men of Gotham*, and other story-books which in my dawning years amused me as much as *Rasselas* does now.[25]

Robert Hulton (fl. 1710–48), another publisher who carried satirical publications alongside topographical and imported prints, was an exception in setting up business in St James's, the most fashionable area of Westminster. In the *Craftsman* of 2 June, 1730, and 13 February, 1731, advertisements appeared for Hulton's *The Stage's Glory* and *The Answer to the Rabbit Woman's Epistle*. The location for Hulton's business in the new developments around St James's was unusual in the early 1800s and it was not until the latter half of the century that the area became the new centre for prints

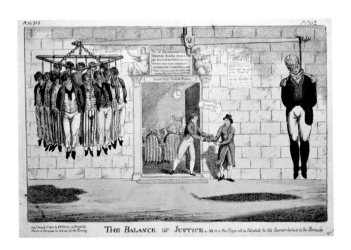

and satire which had branched out westward along Fleet Street and the Strand to St James's.

In the mid-eighteenth century the Darlys had paved the way for selling caricatures. Based in the West End of the city, their example was followed by the presence of Mrs Humphrys, Samuel William Fores and William Holland. The Darlys had been successful in popularising caricature in London, and the image of *The Macaroni Print Shop* [fig. 21], with the straight caricatured profiles outside 39 Strand, illustrates the formulaic and amateur emphasis of the business, which included teaching amateurs to draw and etch caricatures. Another print seller, James Bretherton, followed the trend and set up at 134 Bond Street by 1771, specialising in caricature and produced prints mostly after the work of Henry Bunbury, the gentleman amateur.

Mrs Humphrey's shop, whose bow-fronted window is immortalised in the print *Very Slippy-Weather* (1808) [fig. 25], took satire and caricature to new heights. Her extremely successful partnership with James Gillray led to the fame of her shop at St James's Street. William Holland, who specialised in satire, and had also commissioned works from Gillray, opened exhibition rooms in the late 1780s at No. 50 Oxford Street and charged visitors a shilling entry. A very rare interior view of 1794 by Richard Newton shows the exhibition, which displayed unframed prints attached to the wall from the floor to the ceiling.[26] His advertisements frequently claimed that 'In Holland's Caricature Exhibition Rooms may be seen, the largest Collection of humorous Prints and Drawings in Europe.'[27] Samuel William Fores (c. 1761–1838), who was Holland's main rival, set up exhibition rooms at No. 3 Piccadilly, where he made equally bold claims that his 'Grand Caricatura Exhibition' was 'the most complete Collection. Ever exposed to public View in this Kingdom.' In order to further draw crowds and outdo his rival, he went to the lengths of exhibiting 'the Head and Hand of Count Struenzee', (possibly plaster casts) who was beheaded in Denmark.[28]

Rudolph Ackermann's smart 'Repository of Arts' on the Strand sold many caricatures to the burgeoning respectable middle-classes. It did not specialise in satire, however, but

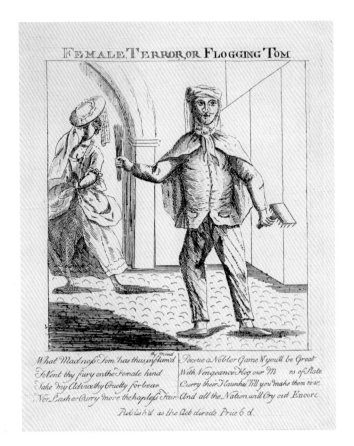

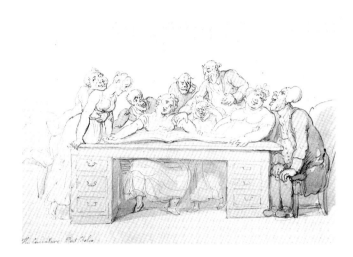

also published books, designs, fine art prints as well as a magazine, the *Repository of Arts*, which ran from 1809 to 1828. Its first caricatures were produced in about 1798, one of the first being Thomas Rowlandson's *Cries of London*, engraved by H. Merke in 1799. Rowlandson worked with Ackermann on a number of projects including *The Microcosm of London; or, London in Miniature* (1808–10), which contained 104 hand-coloured aquatint plates by J. Bluck, J. C. Stadler, T. Sutherland, J. Hill, and Harraden, after Rowlandson and Pugin.

Thomas Tegg (1776–1846), who like Ackermann flourished in the early nineteenth century, was based at Cheapside and commanded a different section of the market. His 'Apollo Library' represented a cheaper version of Ackermann's Repository, selling cheap reprints and abridgements. He did, however, commission many artists, particularly George Woodward, Rowlandson and George Cruikshank, publishing many important satires. An aquatint of about 1830, *A London Conveyencer* [fig. 26], published by Lewis and Johnston, shows a group of people staring at the window of a caricature shop in Cheapside. Ackermann and Tegg were publishers who represent a changing point of print sales in the nineteenth century. Increasingly prints were bound and not sold individually. Text became an important element and the illustrated book stimulated a change in satire. With mass production and the rise of illus-

trated journals, the individual satirical print ceased to be the colourful presence it had been on the London streets. Images were rarely independent of a book or journal, and caricature print shops were rapidly replaced by bookshops and newsstands.

Satirical prints were bought by a very wide-ranging audience, from traders to aristocrats. The cost of many individual prints was relatively modest and so price was not the deterrent that many fine art prints represented. Hogarth, for example, sold prints that were relatively expensive due to the care and time they required to produce. In 1746, a subscription for the print of his *March to Finchley* cost seven shillings and sixpence. In contrast, an anonymous etching from the period, such as *Female Terror, or Flogging Tom* (mid-eighteenth century) [fig. 29], would cost about sixpence. Carington Bowles's prices in 1790 were typical of the prices in the late eighteenth century, selling folio mezzotints (10 x 14 inches), for one shilling (plain) or two shillings (coloured), while small mezzotints cost six pence (plain) and one shilling (coloured).[29] William Holland, as well as selling individual prints, sold bound folios directly aimed at collectors for five guineas (plain) and seven guineas (coloured).

How satirical prints were displayed by their consumers was as varied as the consumers themselves, who were represented by most echelons of society. Prints could be found in the folios of gentleman connoisseurs, or framed and displayed in print rooms of the landed gentry. William Holland advertised specifically to 'Caricature Collectors' who 'May be now be supplied with the greatest variety in London, of political and other humorous Prints, bound in Volumes, and ornamented with an engraved Title...'[30] In the cases where a buyer did not wish to commit to a folio, Samuel Fores offered that 'Folios of caricatures' could be 'lent out for the evening', for a fee of 2s and 6d and a deposit of a pound. In a rare drawing by Thomas Rowlandson, *The Caricature Port Folio* [fig. 30], now in The British Museum, we can see a group of figures enjoying such a folio.

Prints were also assiduously collected by the middle class who hung them in their London houses. Carington Bowles's print catalogue of 1790 reveals their appeal to just such an

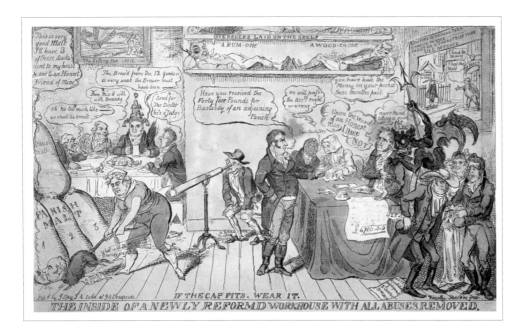

31. George Cruikshank, *The Inside of a Newly Reformd Workhouse with all Abuses Removed*, etched by Timothy Teas, coloured etching, 1813. Guildhall Library, Corporation of London.

Right:
32. William Elmes, *Prime Bang up at Hackney*, published by Thomas Tegg, 12 August, 1811. Hand-coloured etching.

audience in listing its mezzotints after John Collet's comic paintings:

THIRTY-FOUR HUMOROUS PRINTS, From the Pictures of John Collet, Esq. in the possession of Carington Bowles. *When framed and glazed they make a handsome appearance and Fashionable Furniture, and are always kept ready finished… An assortment of the above are always kept ready framed and glazed, and make genteel Furniture.*[31]

Although many satirical prints could be offered as fashionable furniture, such as the mezzotint social satire, many others could not. Political prints and those that were vulgar and even pornographic had a different role, and at this end of the market prints were disposable, images that could be pasted up whilst still topical. It has even been recorded that some satirical prints were used to decorate the inside of chamber pots.

Satirical prints were sold to a greater number of people on the London streets through their display in print-shop windows. 'Caricature shops are always besieged by the public…', wrote the London visitor, Johan Christian Hüttner, in *London und Paris* in 1806.[32] A crowded window displaying prints is a common subject featured in many satires. Yet the showing and viewing of satire through such means was often considered as immoral by commentators. These public exhibitions were furthermore regarded as dangerous spaces, reflective of riotous assembly, reflective of satire itself, an incendiary that might ignite the popular crowds with morally corrupting and politically subversive ideas. John Corry, writing in his *Satirical View of London* of 1801, wrote a chapter on 'Caricature and Printshops', which is worth quoting at length:

When brought to the tribunal of reason, it will be found that the greater part of such caricatures, prints, and paintings, as appear in the windows of our printsellers, are injurious to virtue.

This humorous mode of satirising folly is very prejudicial to the multitude in many respects: — in the loss of time to those who stop to contemplate the different figures; the opportunities given to pickpockets to exercise

their art; and that incitement to licentiousness occasioned by the sight of voluptuous painting. The indecent attitudes, obscene labels, and similar decorations, must have a powerful effect on the feelings of susceptible youth; and it is an authenticated fact, that girls often go in parties to visit the windows of printshops, that they may amuse themselves with the view of prints which imbue the most impure ideas. Before these windows, the apprentice loiters unmindful to his master's business. And thither prostitutes hasten, and fascinating glances endeavour to allure the giddy and the vain who stop to gaze on the *Sleeping Venus*, the *British Venus* and a variety of seductive representations of naked feminine beauty. Are these witty but profane and indecent labels, and this display productive of any good? – do they not rather tend to the depravation of the mind, and contribute to relax the moral ties of Society? If such be their tendency, his majesty would deserve the gratitude, not only of the present generation, but of millions yet unborn, by the suppression of those paintings and engravings, which, through the medium of the eye, empoison the purity of the human heart, and mislead the laughing victim into the paths of folly and vice.[33]

Corry was not the only one concerned about the exhibition of satirical prints on the London streets. In around 1795, the history painter James Barry wrote a letter to the Dilettanti Society:

With respect to the arts, our poor neglected public are left to form their hearts and their understandings upon these lessons, not of morality and philanthropy, but of envy, malignity, and horrible disorder, which everywhere stares them in the face, in the profligate caricatura furniture of print shops, from Hyde-Park Corner to Whitechapel. Better, better far, there had been no art, than thus to pervert and employ it to purposes so base, and so subversive of everything interesting to society.[34]

As Richard Godfrey has suggested, Barry's view appears to be tinged with more than a little jealousy. Satire had the

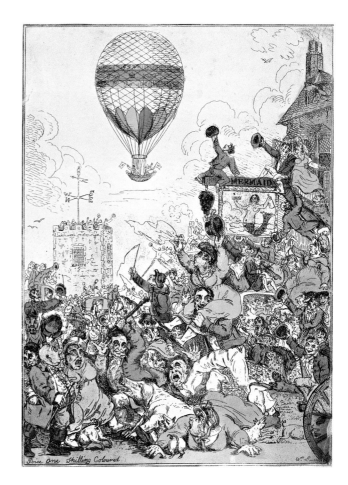

ability to reach across the spectrum that his serious history painting could not do. Other critics of caricature were those personalities directly depicted in the prints, who were publicly mocked and laughed at in the London streets. How frequently objections were made to individual print sellers is difficult to gauge, but probably not that frequently for no other reason that an aggressive complaint was likely to spur interest. On 1 December, 1797, Mrs Humphrey published a print by James Gillray entitled *Notorious Characters No.1*, depicting Samuel Ireland. On 9 December Joseph Farington noted in his diary that: 'Steevens said Ireland has threatened to prosecute Mrs. Humphry for publishing Gillray's portrait of Ireland.' Later that month, on 21 December, he tried to buy a copy: 'I went to Mrs Humphrey's shop for the portrait Ireland, but she would not sell it.' The libel of £5,000 initiated by Ireland was eventually dropped on the advice of council. Print sellers did occasionally face imprisonment, but this was for producing what were considered seditious political pamphlets rather than satirical images.

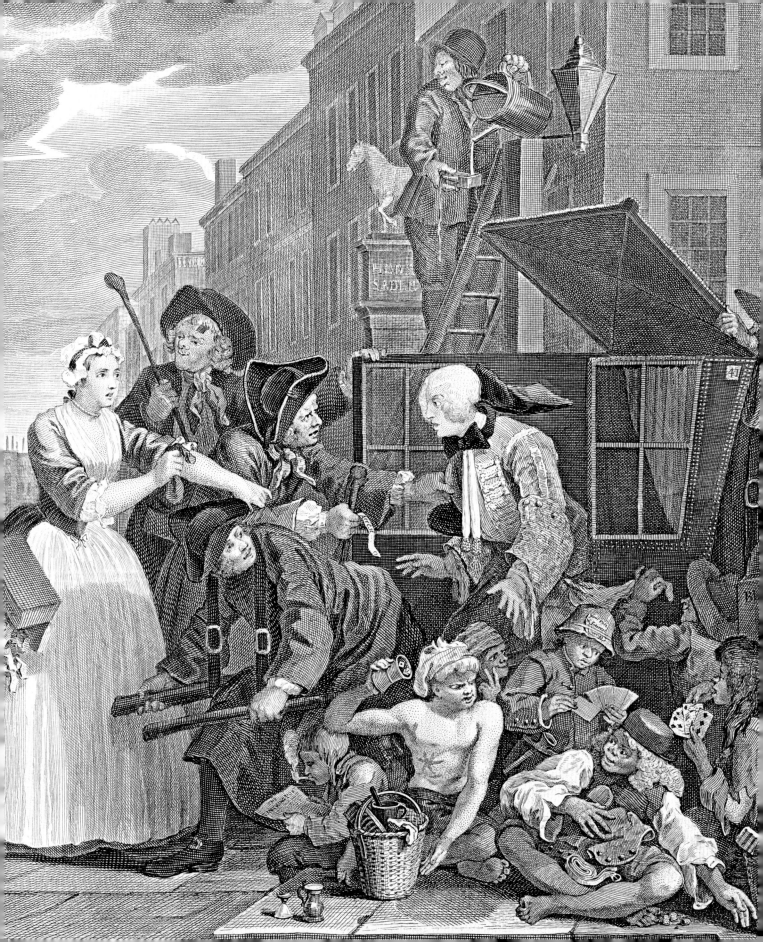

33 (*below and detail left*). William Hogarth, *A Rake's Progress*, Plate 4, published in 1735. Etching and engraving.

The case between John Smith and William Wood on 20 January, 1813, provides an interesting and typical case study into how satire could be used by publishers for libellous attack and avoiding prosecution. The print *The Inside of a Newly Reformd Workhouse With all Abuses Removed* (1813) [fig. 31] transforms John Smith, surgeon and apothecary, into a rat eating the parish malt, whilst William Wood, who is standing in the centre of the image, accuses the vestry clerk of receiving £45 for bastardy of an adjoining parish. John Smith's action was 'to recover [from William Wood, a boot and shoe maker of City Road] a compensation in damages for publishing a gross, scandalous, and malicious libel, in the form of a caricature print.' The presiding judge, Lord Ellenborough, found insufficient evidence despite such a clear image of alleged corruption, which illustrates the extent to which the ambiguity of visual images could not prove conclusive in such cases. Lord Ellenborough concluded: 'I certainly feel for this gentleman, and the exposure of his wife in such a way; but upon this evidence the action cannot be sustained.'[35]

Undoubtedly, London print shops allowed an outlet for the freedom of expression with a ferocity of attack that disappeared in the pages of *Punch* and *Vanity Fair*. Recent libel cases involving *Private Eye* serve to show that satirists hit their mark and that some contemporary satire has regained that early bite. In one sense satire was extremely moral in reproaching vice and corruption whilst on the other hand it played to an audience. Yet it had a role within the exercise of politeness, control and freedom in metropolitan life. The London audience was able to laugh at itself.

London as a Subject for Satire: The City and its People

London provided more than just a backdrop for satire's human comedy; its areas and their associations were as familiar to its audience as were the city gent or the chimney sweep. Just as satire mocked the stratas of society, it also created a satirical topography of the city. Dangerous streets, fashionable haunts and the marginal areas of entertainment where wealth and poverty collided were depicted by satirists who presented a comic and moral map of London. Satire provided a comic journey through London that revealed a wide variety of urban life. Although the form it took changed through two centuries, many elements remained the same.

Ned Ward, in *The London Spy*, and Thomas Brown, in *Amusements serious and comical, calculated for the meridian of London*, began a literary tradition of satirical tours which were popular in the early eighteenth century and which informed and influenced the visual depiction of the city by satirical artists. Over a century later, Pierce Egan's *Life in London* created a satiric tour for his contemporaries, which was similarly enormously popular. The Cruikshank brothers' brilliantly illustrated Pierce Egan's *Life in London* (1820–21), and George Cruikshank's *The Art of Walking the London Streets* are brilliant in their comic visual circumnavigation of the city streets.

The uniqueness and appeal of any tour is in its eye-level viewpoint; to allow the onlooker to explore the vastness of the city. From the eighteenth and nineteenth centuries, the breadth and diversity of the metropolis is central to the satirist's vision. The individual is drawn into viewing one's surroundings with a comical, wide-eyed innocence at the diverse life of the ever-expanding city. London is seen as a

LONDON going out of Town. — or — The March of Bricks & mortar.!

microcosm of the world, as David Bindman has written; 'with the allegorical dimensions of a modern-day Rome or Babylon.'[36] In 1700 Tom Brown (1663–1704) began his perambulation of London with this sentiment:

London is a World by itself. We daily discover in it more new Countries, and surprising Singularities, than in all the Universe besides. There are among *Londiners* so many Nations differing in Manners, Customs, and Religions, that the Inhabitants themselves don't know a quarter of them. Imagine then what an *Indian* wou'd think of such a Motly Herd of people, and what a Diverting Amusement it would be to him, to examine with a Traveller's Eye, all the remarkable Things of this Mighty City.[37]

Like many wishing to describe the great city, Tom Brown saw all aspects of life contained in its parameters. Wealth and

poverty existed cheek by jowl as opera did with street cries at Covent Garden. In his attempt to define London he took a journey that could only be expressed in humour. A century later John Corry made a similar observation: 'London being inhabited by an assemblage of people of various nations, they must consequently exhibit a curious diversity of character.'[38]

Visual satire shared this view of London and with a mocking and ironical eye depicted many areas of London. A political debacle at the Hustings outside St Paul's Church, Covent Garden, Bartholomew Fair, or the activities at Billingsgate, all provided the rich subjects for satire. The vast city was populated with a diverse body of people passing each other in the same streets. Congestion, the London mob and the hazards of city life remained consistent images in visual satire.

The specific London location was an important element within the images and if the buildings are represented as

34. George Cruikshank, *London going out of Town – or – The March of Bricks & Mortar!*
Published in 1829. Etching.

35. Anonymous, *Dick Swift, Thieftaker of the City of London*, mid-18th century.
Etching and engraving.

generic and anonymous, then a street name is inserted to give the viewer bearing. For the location often gave away the activity being acted out: an area of prostitution, a fashionable haunt or a poor area all provided an important context for the action and a moral geography to the city

If it was the city that gave the context to many of the images, it was the people who inhabited them that gave them their meaning. In topography, politely arranged figures serve to give scale to the architecture. In satirical images, it is London life and the activities of metropolitan population that provide the central focus. No stratum of society was exempt and images exist of royalty just as they do of chimney sweeps.

Well-known characters from the court, aristocracy and Parliament featured in political satire, Westminster being the centre of government. The squint-eyed phizog of John Wilkes, for example, appears in many prints of London scenes, as does the lecherous 'Old Q', the fourth Duke of Queensbury. With regards to the middle- and lower- classes, even when individual characters were not instantly recognisable, their stereotype was. A 'beau', London citizen or 'cit', 'macaroni', quack doctor, soldier and sailor, parson, harlot, and fish-seller were all part of the canon of London types at the satirist's disposal.

The crowds are an essential part of the vision of the city, including the fashionable and aspiring set at the Mall, the poor at St Giles, and all classes meeting and colliding at Covent Garden at an election rally or Southwark Fair. When nineteenth-century painters turned to the contemporary crowd, critics accused them of vulgarity and of being too close to caricature, whereas Hogarth, whose example they followed, had been able to move effortlessly between high and low cultural sources.

The categorisation of the London type was by class and occupation, all presented with their own stereotypical and archetypal individual foibles. In this, satire, as well as acting as a moral commentator and hence a social control, could also reinforce social hierarchy. The mock gentleman and lady or the fraudulent class jumpers were a consistent target for the satirist's pencil. In 1738, the 'True-born Englishman' wrote:

People of Quality's Mien and Behaviour being sufficient to discover them without any great Dependence upon *Taylors*, and *Manteaumakers*; those of real Rank carrying an Air of Dignity and Greatness in their Aspects... the *Ludgate-hill Hobble*, the *Cheapside Swing*, and the general City *Jolt* and *Wriggle* in the Gait, being easily perceived through all the Artifices of the *Smarts* and *Perts* put upon them.[39]

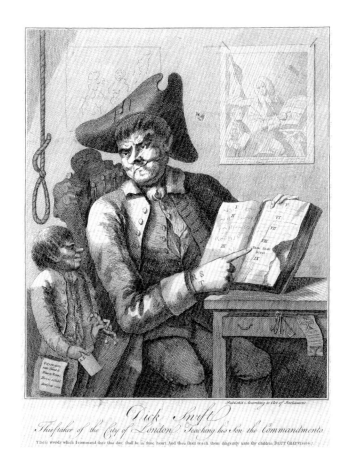

Dick Swift
Thieftaker of the City of London Teaching his Son the Commandments
These words which I command thee this day, shall be in thine heart: And thou shalt teach them diligently unto thy children DEUT CHAP VI vers 6

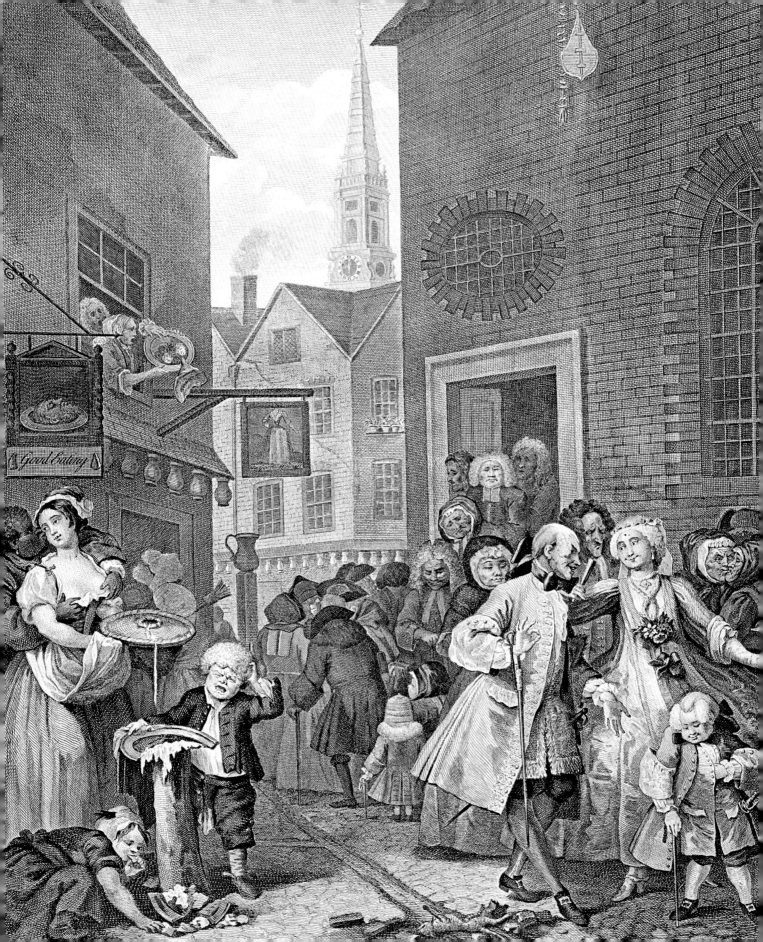

The Age of Hogarth

'The London streets live in Hogarth's prints.'
Dorothy George[1]

'But Lord! To see the absurd nature of Englishmen,
that cannot forbear laughing and jeering at everything
that look's strange.' *Samuel Pepys*[2]

William Hogarth, *Noon* from *The Four
Times of the Day*, published in 1738
(detail of fig. 49).

Satire in London in 1697, the year of William Hogarth's birth, and satire in 1764, the year of his death, are worlds apart. Hogarth transformed satire into an entirely new genre, and over the centuries since his death he has been accorded the position, amongst many others, as the father and greatest of all English satirists. As a result, this giant figure stands apart from his contemporaries, and he has until recently, been divorced from the context of other graphic satire. Hogarth's brilliant and highly original depictions of London drew deeply on the rich visual and literary satire that already existed there. Recent studies of graphic satire in the age of Hogarth have made explicit the importance of this context and have given new insights into his satirical prints.[3]

Seventeenth-century England and its capital experienced great political and religious turmoil during the Civil War, Restoration and the 'Glorious Revolution'. In this period of government censorship, of plots and suspicions with bitter and malicious outpourings in popular literature and imagery, satire drew upon high and low forms of art, predominantly reflecting emergent political and religious divide. Satire's ability to draw upon a high fine-art tradition as well as the basest of images became its liberating influence, although in the late seventeenth-century satire tended to make many of its dogmatic points both crudely and in damning terms. Seventeenth-century satires were a defined genre and represented only a small part of the print market, that functioned 'simultaneously as a specialised commodity within the print market, and as pictorial interventions in the realms of public debate, they constituted an important part of the capital's visual culture.'[4] Allegorical figures, spewing devils, imps and Janus-headed priests inhabit the prints alongside rays of illumination, a symbolically detached eyes and symbolic images ultimately derived from allegorical art.

The satires of Wenceslaus Hollar (1607–77), and more particularly of Francis Barlow (active 1648–1704), are perhaps the best known of the late seventeenth century, but no artists worked exclusively in this form. Robert White (1645–1703), who was particularly renowned for his portrait prints, engraved several satires, such as *Britania* (published in 1682) [fig. 36] and *Thus black look't Heav'n* [fig. 37], designed for J Nalson's *An Impartial Collection of the Great affairs of State from the Beginning of the Scotch Rebellion in the year 1639 to the Murther of King Charles I*, also published in 1682. Like many engravings produced as frontispieces, they were also sold separately as individual prints. The two images exemplify satirical material available in London in this period and are particularly interesting in their London setting, offering us allegorical depictions of the city as the centre of religion and politics in Britain. Their images are typically explained at length in an accompanying text. *Britania* [fig. 37], the image for the first volume, shows the figure of Britannia who '… sits forlorn; Expos'd to Foreign and Domestic scorn.'

The symbolically crumbling church is clearly based on old St Paul's, just as the fire in the background signifies London's Great Fire of 1666 whilst simultaneously referring to the country's political strife. The Janus-headed priest, half Puritan and half Jesuit with a cloven hoof reflecting religious divide, an all too familiar figure of seventeenth century satire, can be seen on the right of the engraving standing on the Bible.

White's print for the second volume shows a similarly allegorical depiction of the state of the nation. The image, far from being an 'impartial' account, rails against the execution of Charles I, who is symbolically depicted as a captain hoisted overboard. The setting is Westminster, showing St Stephens, the meeting place of the House of Commons since the sixteenth century, as the text describes:

> From that adjacent HOUSE, behold the cause
> Of all this Tempest, whence perverted Lawes,
> Unpresidented, undetermine'd Power
> Blasted our Hopes, and did our land devour.

The print is particularly interesting in that it contains an early satirical depiction of the London mob who can be seen fighting amongst themselves and who are described in the text: 'But, see the temper of the barbarous Croud, (Whom nothing satisfy's but Spoil, and Bloud).'

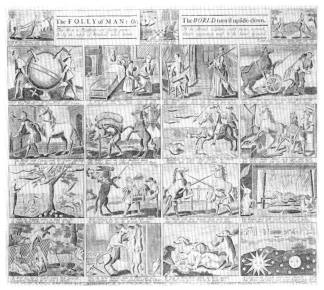

Such satire, with its strong and unambiguous religious and political bias, was typical of images being produced throughout Europe in this period. It was a tool to incite hatred as much as laughter, a point made clear in Samuel Pepys' diary entry from 1663 where he noted a Dutch satire with some disgust:

> Today for certain I am told how in Holland publicly they have pictured our King with reproach. One way is with his pockets turned the wrong side outward, hanging out empty; another is with two courtiers picking off his pocket; and a third, leading of two ladies, while others abuse him; which amounts to great contempt.[5]

English prints in the late seventeenth century are very similar to their European counterparts, in form if not message. It was not until the eighteenth century, in particular with the efforts of William Hogarth and the widespread use of caricature, that London satire adopted its distinctively English form.

Closer to Hogarth's vision are the popular satires of the early eighteenth century, which give a direct context for his graphic satires and the rise and development of satirical prints in London. William Dicey of Bow Churchyard published many such prints, including *The Folly of Man or The World turn'd upside-down* (c. 1720), which shows eighteen scenes in which natural order is reversed. In one scene, 'The Ox turns Butcher' and slays the man, in another the husband becomes the nursemaid and the wife becomes hunter. The social satire of reversed roles was a perennial theme of satire and this early print illustrates the popularity of such subjects. Like many renowned satirical images, this particular print was reprinted, in this case for Bowles and Carver in around 1733 under the new title of *The Folly of Mankind Expos'd or the World Upside Down* [fig. 38].[6]

Hogarth transformed popular and amateur forms to create an art that was new, dynamic and, most importantly, directly depicted the contemporary life of London. Satire was a new language that married observation with satirical allegory, a form of 'modern moral narrative', the originality

36. Engraved by R. White, *Britania*, designed for J. Nalson's *An Impartial Collection of the Great affairs of State from the Beginning of the Scotch Rebellion in the year 1639 to the Murther of King Charles I*, published in 1682. Engraving.

37. Engraved by R. White, *Thus black look't Heav'n*, designed for J. Nalson's *An Impartial Collection of the Great affairs of State from the Beginning of the Scotch Rebellion in the year 1639 to the Murther of King Charles I*, published in 1682. Engraving.

38. Anonymous, *The Folly of Man Expos'd or the World Turned Upside Down*, published by W. Dicey, c. 1733. Engraving.

of which he openly advertised as a 'new way of proceeding *viz*. painting and Engraving modern moral Subject a field unbroken up in any Country or any age.'[7] In his morality tales of modern urban life, the lofty moral intention of high art combined with the images of the extreme fringes of city life from low satirical culture, blurring the boundaries between the two. In doing so, Hogarth reached a wider audience and transcended social barriers. He was an accomplished printmaker as well as a painter, and with the distribution of his prints after his paintings, he achieved an unprecedented popularity. He produced a commercial and urban art form, with an immediacy of imagery that reached

a wide London public, a new commodity in an expanding commercial environment. In his images we see London and its specific streets, its prisons, its fashionable houses and its places of entertainment. Such satirical observations of mid-eighteenth-century London was not exclusive to Hogarth but the development of images of the social scene owe much to his vision of the city. His influence on his fellow artists, whether high or low, was profound, and his contemporaries took up a position either for or against him, but rarely indifferent to him.

John Collet (1725–80) followed Hogarth's example, both stylistically and in terms of his predominantly London

39. William Hogarth, *The Cockpit*, published in 1759. Etching and engraving.

The PRETTY BAR MAID.
From the Original Picture by John Collet, in the possession of Carrington Bowles.

40. John Collet, *The Pretty Bar Maid*, 1770. Mezzotint.

41. Paul Sandby, *The Magic Lantern*, 1753. Etching.

42. William Hogarth, *Paul Before Felix Burlesqued*, published in May 1751. Etching with some mezzotint.

subjects. He was seen by many critics of the time as his heir and was described as 'in Humour, a second Hogarth with much better colouring.'[8] In the fifteen years between 1765 and 1780, like Hogarth he made an enormous number of prints after his paintings, produced by Thomas Bradford, Robert Sayer with Smith, and later Bennett and Carrington Bowles. His *Pretty Bar Maid* (1770) [fig. 40], which represents a military officer, wearing the macaroni club and sabre and eating custard whilst eyeing the barmaid, profiles through caricature his lasciviousness thoughts. Such an

43 (*below*). Paul Sandby, *The Butyfier. A Touch upon the Times, Plate 1*, September 1762. Etching.

44 (*right*). Paul Sandby, *An English Balloon*, 1784. Aquatint.

image, in this case the interior of a London pub, is typical of 'posture' size mezzotints published by Bowles, which will be considered in the next chapter.

Paul Sandby, one of the greatest British draughtsman of the eighteenth century, articulated in Hogarth's own language – satire – his antipathy to the artist. Sandby's satirical prints attack Hogarth on a number of levels, yet they essentially stem from three objections: Sandby's dislike of what he believed to be Hogarth's enormous conceit as a great painter of sublime history; his consistent objection to an art academy in London, and his theorising in his book, *The Analysis of Beauty*, which expounds the artist's theory about the 'line of beauty'.

Hogarth's satires reflected his strength of opinion, an opinion which Sandby pilloried in his own satires. In 1753, Sandby brilliantly etched *The Magic Lantern* [fig. 41], based upon a print by Hogarth, which satirised his own paintings *Paul Before Felix Burlesqued* [fig. 42] (published in May 1751). The plate was used by Hogarth as a subscription for the works he gently mocked: *Paul before Felix* and *Moses brought to Pharaoh's Daughter*, two of Hogarth's serious paintings, to which Sandby so objected. In the print, Hogarth took the opportunity to criticise Rembrandt's etchings, which were all the rage in London in 1751, made explicit in the added text on the print: 'Designed & Etch'd in the rediculous manner of Rambrant by Wm Hogarth.'

Sandby's response was to produce an etching in the manner of Rembrandt, which showed the inside of Hogarth's studio. Published in the same year, Sandby mocked the very pictures that Hogarth was advertising in his subscription. The first of these, *Paul before Felix Burlesqued*, can be seen projected from Hogarth's mouth as the artist is acting as a magic lantern. At an easel by Hogarth's side is his other painting, *Moses brought to Pharaoh's Daughter*. Like Hogarth, Sandby inscribed the print in earlier editions with 'in the rediculous Dutch manner' and later states, 'in the rediculous manner of Rembrant.' Sandby, unlike Hogarth, uses a dazzling etching to celebrate Rembrandt's technique.

Although many of Sandby's attacks on Hogarth culminated in the 1750s, his criticisms did not cease. In 1762 he

etched a London satire based upon Hogarth's print *The Times Plate 1*, in which Hogarth set out to defend the unpopular ministry of John Stuart, Third Earl of Bute (1713–92). Sandby's response was to produce *The Butifier. A Touch upon The Times Plate 1* [fig. 43]. The viewpoint is taken from St James's Street, looking down towards the entrance of St James's Palace, and makes explicit reference to the Stuart minister, his Scottish heritage and alleged subversion of his ministry in its French influence. On the corner of St James's Street and Pall Mall is the 'Scotch Car Pit Manufac' (Tory), a carpet hanging on a pole over Pall Mall. The big ape to the right of the picture is a representation of Lord Bute accompanied by a Scottish bagpiper.

The central image, however, is reserved for Hogarth, who can be seen painting, or more correctly, white-washing the statue of a jack boot on a plinth, which represents Bute. Although the main thrust of Sandby's criticism is Hogarth's

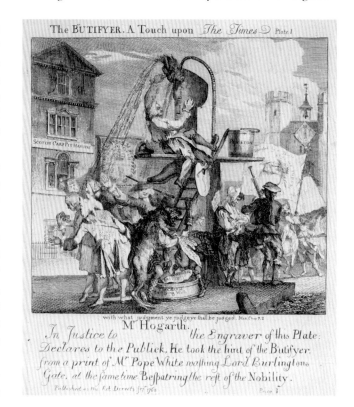

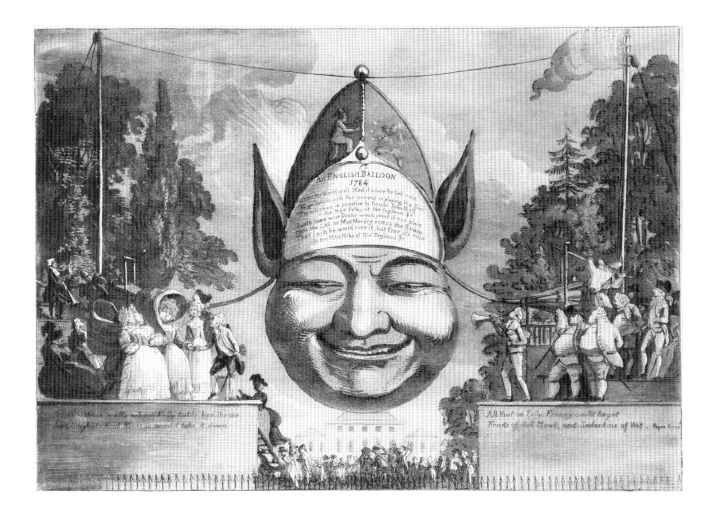

defence of Bute, white-washing what Sandby believed to be a corrupt and foreign ministry, he also takes opportunity to mock his artistic theories – in the print the jack boot is referred to as the 'Line of Booty'.

Although Sandby is less known for his satires, he did create some of the most original and convincing examples in this period. In particular his images of the lower classes, especially London's itinerant street traders, stand out as an important commentary on London life in the mid-eighteenth century and contain a significant satirical influence. Sandby continued to work long after Hogarth's death and produced a series of London satires in aquatint in 1784 around the craze for balloons inspired by Vincenzo Lunardi, who first manned a balloon flight in England at the Military Grounds at Moorfields. On 15 September, before a crowd of 15,000, which included the Prince of Wales, Lord North, Pitt, Burke and the Duchess of Devonshire, Lunardi flew his colourfully

striped silk hydrogen balloon to the fascination of the crowd. Sandby saw the whole scene as absurdity encroaching upon madness, which he expressed through *An English Balloon*, which is directly in front of the façade of Bethlem Hospital. The text begins, 'When the world is all Mad, it is sure the best rule; To go smooth with the current in playing the fool.'

London in the age of Hogarth was a city of continuity and change, where wealth and poverty co-existed and new money competed with old. Society was shifting with the growth of an aspirant middle class, reflected in London's spaces such as the growth of commercial entertainments where classes mixed. In addition to this, London saw a massive increase in its population with the resultant rapid expansion of building. Immigrants came from abroad, as well as from Britain, and were often resented by the city's native population. In his satirical saunter the 'True-born Englishman' (attributed to

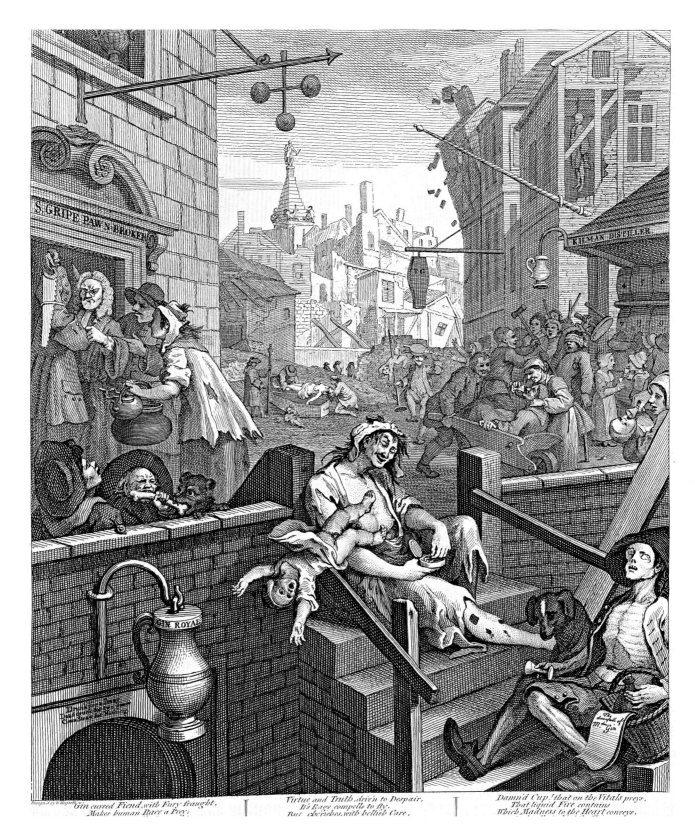

S.GRIPE PAWN BROKER

GIN ROYAL

KILMAN DISTILLER

The downfall of Mr Gin

Design'd by W. Hogarth. *Gin cursed Fiend, with Fury fraught,*
Makes human Race a Prey;

Virtue and Truth, driv'n to Despair,
It's Rage compells to fly,
But cherishes, with hellish Care,

Damn'd Cup! that on the Vitals preys,
That liquid Fire contains
Which Madness to the Heart conveys.

Erasmus Jones), Jones writes with prejudice about influx and assimilation. In particular Jones's satire, like much of its visual counterparts, rails against social mobility and the erosion of traditional and hierarchical order:

> London, like the Ocean, that receives the muddy and dirty Brooks, as well as the rapid Rivers, swallows up all the *Scum* and *Filth*, not only of our own, but of other Countries... Here the Foreigner finds Food and Footing, soon grows Great, forgets his Nakedness, and cruelly insults the Natives: 'Tis here the wearied Plowmen and rest, first becomes *Servants*, next *Masters*, and then *fine Gentlemen*. 'Tis here the distressed Country-Wench discharges her *Burthen*, gets into Place, marries her Master and becomes a gay Madam.
>
> *France* and *Italy* supply this Town with *Cooks*, *Catcalls*, and *Valet de Chambres*; while *Scotland* and [end p. 1] *Ireland* furnish their annual Quota's: the former of *Quacks*, *Beggars*, and *Pedlars*; and the latter of *Robbers*, *Bullies* and *Evidences*. But whoever will lend an impartial Ear on a *Court-Day* or *Opera-Night*, may find the Principality of *Wales* has pour'd more *Coachmen*, *Chairmen*, *Footmen*, and other servile People into London than all the Countries and Nations besides...
>
> The *Germans*, indeed, of late Years have greatly infring'd upon them, by importing large numbers of Slaves of their growth into *London*; ... [9]

Tom Brown's satirical tour begins by outlining London as representing of the entire globe:

> If any man therefore has an Inclination to divert himself, and Sail with me round the Globe, to supervise almost all the Conditions of Humane Life, without being infected with the Vanities and Vices that attend such a Whimsical Perambulation; let him follow me, who am going to relate it in a Stile, and Language, proper to the Variety of the Subject.[10]

Satire, which focused upon the foibles of urban life, often used polite representations of the city as the basis of its humour. Canaletto and Joli had visited London in this period and represented the city as an elegant and fashionable metropolis, comparing it visually to Venice and Rome. John Strype wrote of the expanding London in 1755 in similar terms: 'it may boast itself the largest in extent, the fairest built, the most populous, and the best inhabited, and that by a civil, rich and sober people, of any in the world.'[11] In graphic topographical art, surveys of London reflected order and refinement; for example, William Henry Toms's (fl. 1723–58) engraving of Bow Church [fig. 46] for William Maitland's *History and Survey of London* (1753–56). The focus is architecture and the figures signify respect, order and politeness. Shop signs can be seen to the left and the cobbled streets are orderly and even.

Yet if an image of regularity prevailed in polite topography, an image of chaos prevailed when it came to satirical accounts of travelling the streets. Babylon replaced Rome as the model for the city. Here the crowd was very much in evidence – disorder, chaos and rudeness predominate. Fights break out and customary behaviour is challenged. Yet although each satirical representation by its very nature represents exaggeration, it encompasses a more human level and more varied depiction of London life. The lower classes are visibly represented, and aspects of the city that are glossed over or invisible in topography become visible in satire. The down-trodden, dangerous areas of London are pictured. St Giles, where the criminal folk hero Jack Sheppard emerged, was immortalised in Hogarth's *Gin Lane* (published in 1750/51) [fig. 45], notoriously representing poverty and crime and made up of what was known as a 'rookery', a title it shared with other areas of infamy in London, including the east side of Temple ('Alsatia'), at the angle of St Martin's Lane, and The Strand ('Bermudas') and 'Thieving Lane' near Westminster Abbey. Even in the more respectable areas of London, the busy streets were often in appalling condition, and the reality of horse traffic, street traders, noise and smell were only partially envisaged in satire. Contemporary accounts of the state of London streets reflect that satire was often closer to reality than topography.

Most London streets, for example, were made from round-based cobbles, which sank into the earth in wet weather. A French visitor to London in 1765 wrote:

> In the most beautiful part of the Strand, near St Clement's Church, I have, during my whole stay in London, seen the middle of the street constantly foul with a dirty puddle to the height of three to four inches, a puddle whose splashings cover those who walk on foot, fill the coaches when windows happen not to be up and so bedaub all the lower parts of such houses as are exposed to it. In consequence of this the 'prentices are constantly employed washing the lower parts of the houses in order to take off the daubings of dirt which they had contracted over night.[12]

In his satirical tour, the 'True-born Englishman' highlighted the hazards of travelling by coach on the uneven streets:

> ... the Passages leading to both Houses of Parliament are in much disorder, that a Man is tos'd about like a Gin Informer... and some of the Members have been so jumbled about in their Chairs and Chariots, that it has been near an e're they recover the use of their Limbs and proceed to Business.[13]

The streets themselves are the veins of the city where life flows, people collide and which abound with visual representations of popular culture. Such manifestations in the print sellers windows, but also in the street signs that existed in London before street numbering, influenced satire. These emblematic and often satirical images, 'Specimens of genius... truly English', harked back to the older tradition of satirical imagery.[14] Signboards, in particular, became a very important device within satire of the period, reflecting and commenting on the main action of the image. A strange and obscure satirical painting by an unknown hand, dating from around 1730, which itself resembles a signboard, depicts Cheapside with its proliferation of signboards. In the *Curds*

and Whey Seller, Cheapside (c. 1730) [fig. 47], three chimney sweeps are buying curds and whey for their refreshment from a blind vendor. In the background can be seen the wonderful array and variety of signs that existed along Cheapside where sweeps touted for business.

46. William Henry Toms, *Bow Church*, 1756. Engraving.

Hogarth consistently uses signboards in his images and, in an extraordinary event of 1762, organised an exhibition of signboards which was in itself a satirical event. The exhibition was, on the one hand, Hogarth's patriotic gesture in its celebration of native English genius; on the other hand, it mocked the exhibitions of the Free Society and the Society of Artists of Great Britain. A central placard which quoted from Book V of Horace's *Ars Poetica:* 'SPECTATUM ADMISSI RISUM TENEATIS' (having been admitted to observe this, restrain your laughter), indicated the self-mocking intention. Hogarth, as he did in his graphic satire, took popular art and placed it within the context of high art, here quite literally so, from the street to the gallery. The exhibition also contained amusing labels to accompany each signboard, which followed the labels of the academies, mocking their pompous style:

> 5. A Ship and Castle. *Thomas Knife*, written under. But it is not known whether this is the Name of the Artist or the Publican...
> 12. An Heroe's Head, unknown. By *Moses White*. With the least Alteration, may serve for an Heroe past, present or future.[15]

William Hogarth's satirical images of London are very specific to their place. He, like his audience, knew all the areas of London and their reputations. As David Bindman has argued, they represent a kind of moral geography of the metropolis:

> Because it was the place where wealth was generated (and spent or lost), and the centre of government and justice, London's institutions and neighbourhoods took on strong identities, immediately recognisable to contemporaries. The City of London meant commerce, the West End aristocracy and the Court of St Giles poverty, and so on. Such places became moral signs in themselves, so that the progress of an individual's life might be represented as the journey through London, the virtuous hopefully ending in orderly prosperity in the City of London

or the West End, and the vicious on the gallows at Tyburn...[16]

Perhaps the most famous of the visual perambulations around the city is William Hogarth's *The Four Times of The Day* (published in 1738) (figs. 48–51]. In it Hogarth leads the viewer through morning, noon, evening and night, showing Covent Garden, Hog Lane, Islington and Charing Cross in winter, spring, summer and autumn through the ages of man. The use of Times of the Day by artists dates back at least to Michaelangelo's *Allegories* of the Medici chapel, and became a consistent European tradition, particularly within northern art.[17] What Hogarth's images do for the first time is to use that tradition to perform a satirical transformation in their representation of London. The Dutch

and Flemish prints, to which Hogarth's images refer, are almost unrecognisable in their metamorphosis. Like many satires that followed, the series took a high art tradition to the present moment, deflating it of its pretensions by contrasting reality with its elaborate and artificial structures. In literature John Gay exposed the absurdities of eighteenth-century Italian opera in his *Beggar's Opera*. In Hogarth's images, the goddesses of Aurora, Meridies, Vesper and Nox are transformed into the less-than-divine figures on a London street, the pastoral backdrops replaced with urban settings. Through these means Hogarth humorously exposed the hypocrisies of contemporary London life.

The series was painted around 1736 for Jonathan Tyers as a decoration for a pavilion at Vauxhall Gardens. In January of 1738 an advertisement appeared in the *London Daily Post* announcing that Mr Hogarth is 'now engraving… four representing, in a humorous Manner, Morning, Noon, Evening and Night…The Pictures, and those Prints already engrav'd, may be viewed at the Golden Head in Leicester Fields, where Subscriptions are taken in.'[18] The scenes and types described by Hogarth were familiar to his London subscribers, and the humorous contrasts between polite representations of the areas that Hogarth depicted in his series and their less than salubrious associations were understood by his audience. So, too, were the literary models, the jokes on the street, the amusing broadsheet that the images drew on. The Times of The Day was understood by the audience who knew London intimately and the satirical and comic that was circulated there. As Mark Hallett has written, such graphic satires were 'critical hybrids that reworked a wide range of literary and pictorial materials circulating in contemporary London.'[19]

Urban life is portrayed in four scenes but '… there is only one scene laid out of town', wrote John Ireland, Dean of Westminster, in 1791, 'and that may, I think, be properly enough called a *London pastoral*, for it is in the pleasant village of Islington. The three others are described as in the most public parts of the metropolis, and exhibit a picture which will give a very correct idea of the dresses and pursuits of London in 1738.'[20]

The first of Hogarth's 'times of day' is morning in winter, and the setting is Covent Garden at 6.55 am, made apparent by the clock on St Paul's church. The rendering of the scene is, as Ireland pointed out, quite accurate in most of its details except the position of Tom King's coffee house; also, the images of the prints are reversed.[21] The central figure, associated with Aurora, is that of an old spinster who is making her way through the cold towards St Paul's, her footboy following with her prayer book. She at once represents the season of winter, cold and skeletal, yet she is also an archetype of comic London character known to Hogarth's audience. The satiric question is raised as to what this pious old maid is doing early in the morning in an area of ill repute? We know that she is going to St Paul's church for her devotions, but the unholy scenes around her and her attitudes towards them suggests that she is not the prudish spinster, but rather the hypocrite, going for sexual assignation rather than religious edification. Ned Ward wrote of this archetypal figure in his *London Spy*:

'These,' says my friend, 'are a pious sort of creature that are much given to go to Church, and may be seen there every day at prayers, as constantly as the bell rings; and if you were to walk the other way, you might meet as many young gentlemen from the Temple and Gray's Inn, going to join them in their devotions.' (22) If literary satirical genres influenced visual satire, which they clearly did, the reverse is also true and Hogarth's dressed-up old maid acted as the model for Bridget Allworthy of Henry Fielding's *Tom Jones*.[23]

Covent Garden at this time was notorious for its taverns and brothels, which in effect served each other, as Sir John Fielding observed: 'For this design the bagnios and lodging houses are near at hand.'[24] Hogarth moves the position of the most famous of the taverns, Tom King's Coffee House, situated opposite St Paul's Church, to become central to his image of *Morning*. The inn was owned by Tom King, formally an Eton scholar, who died a year before this print was published. A satirical print was produced commemo-

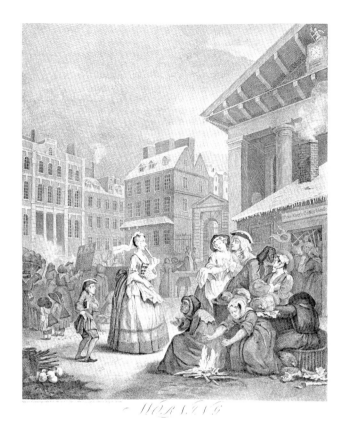

MORNING

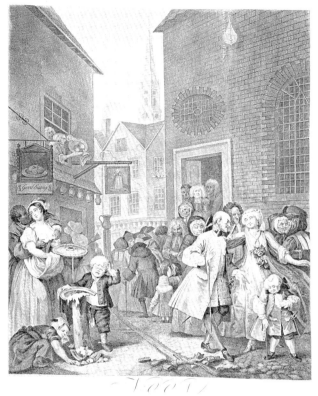

NOON

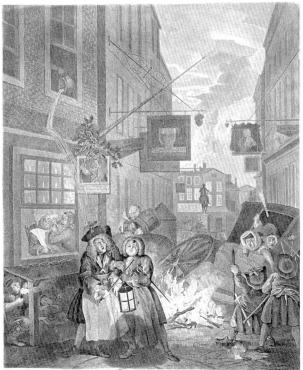

NIGHT

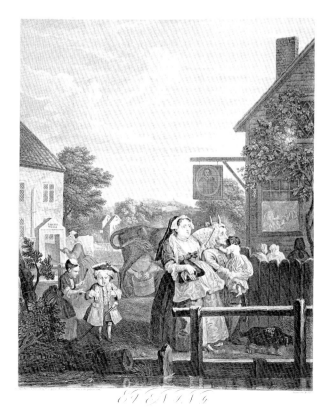

EVENING

rating his death, imitating a monument and peopled by drunks and harlots. Tom's wife, Moll King, took over running the tavern for two years after his death and was the owner at the time of this image. The business came to an end in 1739 when Moll King was fined £200 and imprisoned 'for keeping a disorderly house'.[25] Dr Rock, another famous London character associated with Covent Garden, appears to the left of the image. The quack doctor, a recurrent character of satire, can be seen preparing his sign to sell his venereal pills and panacea for all ailments.

The disorderly tavern and the overspill into the cold morning air is represented by the lustful couples, who signify the moral disrepute of the neighbourhood. Covent Garden was a marginal area, where wealth and poverty met in their search for entertainment: prostitutes, criminals and artists. Bagnios were the main industry of the area, and, according to Hogarth and Ned Ward, it was also the place of female as well as male indiscretion. '"This market," says my friend, "and that church hides more faults of kind wives and daughters among the neighbouring inhabitants than any pretended visits to my cousin at t'other end of town, or some distant acquaintance."'[26]

In the second of Hogarth's twenty-four-hour visual perambulation, it is Noon and we are at Hog Lane, which became Crown Street and is now part of Charing Cross Road. In the background, the clock of St Giles'-in-the-Fields shows us that is in fact 12.30 and the sour-faced congregation is leaving the French Church. The picture is divided by a kennel or gutter which runs down the middle of the street and is blocked with rubbish which includes a dead cat. On the right of the image are the Protestant Huguenots, French refugees from religious persecution, who were by this time well established in London. The group of parishioners is led by a beau, his wife and son, exuberant in elaborate French dress. To the left, however, the native inhabitants are also construed with the finery and affected manner of the French.

Evening is set at Sadler's Wells, Islington, which at the time was a village on the outskirts of London. The area was used as a resort by middle-class Londoners, to enjoy nature and to eat syllabubs and cakes. As Ned Ward wrote, 'This we gobbled up (being hasty to be gone) with as much expedition as a citizen's wife does an Islington Cheesecake.'[27] In the seventeenth and eighteenth centuries London citizens would take their wives and sweethearts there to taste the cakes and enjoy the scenery and perhaps to indulge in a little duck hunting in the ponds.

The couple in Hogarth's Evening are man and wife, a couple of 'cits'; he a dyer, revealed by his blue hands. The season is summer and the great heat is manifested in the drooping dog and by his wife's fan. It is about 5.30 – when milking took place. The cow is positioned so that its horns are placed behind the husband's head, showing him to be a cuckold. The two children mirror the adults – both the boy and his father are hen-pecked. Francis Grose, in his theory of comic painting, explaining its basis in contrasts and humorous juxtapositions, cites Evening as an example of this theory:

In the four times of day [figs. 48–51], what can be more truly consonant with these principles, than the scene near Islington, where the sultry heat of summer, a number of fat citizens are crowded together in a small room, by the side of a dusty road, smoking their pipes, in order to enjoy the refreshment of country air?[28]

The last of Hogarth's day tour of London, Night, is set at the south corner of Rummer Court. The topography has been altered so that the bronze statue of Charles I at Charing Cross is visible, whereas in fact in would have just been out of sight. From the oak leaves clustered around the barber's pole and in the people's hats we know it is 29 May, the anniversary of Charles II's 'Restoration'. The sign of the rummer confirms the location, and a glass tumbler hangs on the corner, with the Cardigan's Head just further back. The New Bagnio or the 'Turk's Head Bagnio' was a disreputable bathing and sweating house run by Mr Richard Haddock and Hogarth uses it to show the proliferation of bagnio brothels.

The central character in the foreground with the carpenter's square, a Masonic insignia, is reputedly Sir Thomas de Veil (1684–1746), a notoriously strict Bow Street magis-

trate, disliked by many Londoners. On one occasion his house was set alight by an angry mob. In *Night*, de Veil is receiving a piss pot full of urine, Hogarth clearly in line with popular opinion and feeling. To the left of de Veil is the barber-surgeon shop advertising, 'Shaving Bleeding & Teeth Drawn with a Touch Ecce Signum.' The barber, who is in the act of shaving a customer, looks tired, and appears to be butchering his client. Underneath the stall two of London's homeless are asleep. Beside them, a link-boy, whose job it was to guide people through the dark night streets of London with a pitch torch, is blowing on his link to either extinguish or stimulate it.

The overturned vehicle, the flying coach to Salisbury, so named because it travelled from London to Salisbury in a single day, has hit the fire in the street. Hogarth again shows us the terrible condition of London's streets and reveals the coach to be an often hazardous and uncomfortable form of transport. The 'True-born Englishman' recalls the over-turning of a coach near Charing Cross, where the beau passenger ending up being pelted by the London crowd.[29] Ned Ward also warned against it: 'Would you have me,' said I, 'undergo the punishment of a coach again, when you know I was so great a sufferer by the last, that it made my bones rattle in my skin, and has brought about as many pains about me, as if troubled by rheumatism?'[30]

Urban festivities in London centred around the many city fairs which date back to well before the seventeenth century. The most famous of these was Bartholomew Fair, held at Smithfield, and which in the mid-eighteenth century lasted fourteen days from 24 August. It appears in many of the satirical writing on London and, in 1701, a four-page quarto was published whose writer went 'to support the yearly customs of debauchery'.[31]

Ned Ward described the scene in some detail:

At the entrance our ears were saluted with Belfegor's Concert, the rumbling of drums, mixed with the intolerable squeaking of cat-calls and penny trumpets, made still more terrible with the shrill screeches of lottery pick-pockets... we went into a convenient house to smoke a pipe, and overlook the follies of the innumerable throng, whose impatient desires of seeing merry-andrew's grimaces had led them ankle deep into filth and crowded as close as a barrel of figs... The unwholesome fumes of such a crowd mixed with the odoriferous effluvia that arose from the singeing of pigs, and burnt-crackling... we had been in danger of being suffocated.[32]

The fairs embodied entertainment, vendors, performance and more often than not riotous and criminal activity, yet they were lively events that brought many Londoners together. Many of the entertainments were satirical, whether they were acted on stage, in the puppet theatre or through the emblematic signs that advertised the events. Ward noted the satirical buffoonery of the perennial comedic character of Merry Andrew, and the low humour of the crowd:

Mr. Andrew, he begins a tale of a tub which he illustrates with abundance of ugly faces, and mimical actions, for in that lay the chief of the comedy, with which the gazers seemed most to be affected.

Between these two, the clod-skulled audience were lugged by the ears for an hour; the apes blundering over such a parcel of insignificant nonsense that none but a true English unthinking mob could have laughed, or taken pleasure at their empty drollery.[33]

Diceys published an image of Bartholomew Fair around 1733 [fig. 52], showing the wonders that were available to the audience, such as Yeate's puppet version of Theobald's pantomime, *Perseus and Andromeda*, harlequins and Christopher Pinchbeck's magical clock. The visual extravaganza of comic and emblemic signs advertise the entertainments, as the print expresses:

See here exprest in Emblem true,
The merry Fair of Bartholomew;
The Ensigns of each various Show
Attract the gazing Crouds below:

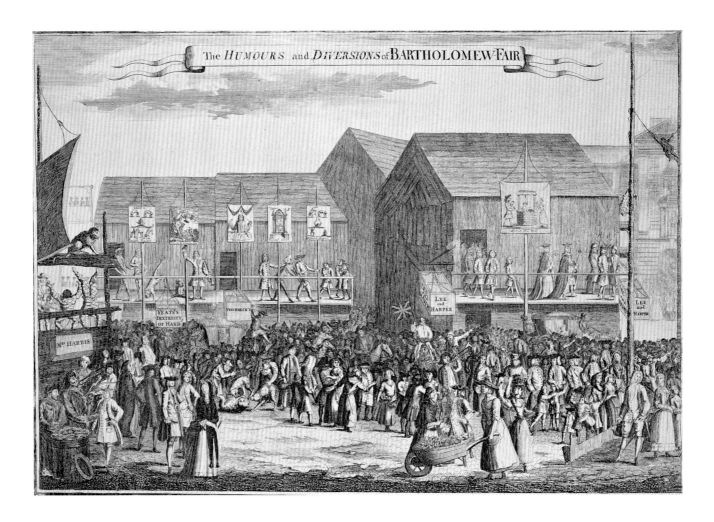

The sign to the right of the print illustrates *Hob in the Well*, produced by Lee and Harper. In the early 1720s Mrs Hannah Lee and Jack Harper began a partnership, successfully staging several plays around the character Hob and his wife.[34] Comedies were enormously popular at fairs and those performed at Bartholomew Fair include *The Distressed Beauty or the London Prentice*, *The Recruiting Officer* in the 1720s, as well as a staged version of Hogarth's *The Harlot's Progress* in 1733. The plays were often satires, such as those performed at Bartholomew Fair in the 1720s, for example, *The True and Ancient History of Richard Whittington*.

Southwark or Lady Fair was held on 7, 8 and 9 September, and spread throughout Southwark but was based in Borough Street near St George's Church. The notoriety of the riotous crowds that attended it and its associations with vice and crime finally led to its closure in 1762.

Hogarth's image of Southwark Fair (published in 1733)

[fig. 53] is slightly later than Dicey's Bartholomew Fair, yet also features Lee & Harper and other theatrical performances. If Dicey's crowd is somewhat flat, Hogarth's foreground teems with the life of a London fair. To the left a dwarf operates puppets with his left foot whilst playing the bagpipes, next to a small gambling table. To the right, a pickpocket can be seen in action taking easy pickings from the wide-eyed innocent who is most probably from out of town. The chaotic hedonism and vice evokes the spirit of this quintessential London experience of an urban fair.

Tyburn Fair came eight times a year and was to all intents and purposes a public holiday. Henry Angelo recalled that tradesmen reminded their customers: 'a hanging day, my men will not be at work.'[35] The crowd assembled around nine in the morning outside Newgate prison, when the bell tolled and prisoners were put into the carts which took them across to St Sepulchre's Church for spirits, before they

52. Anonymous, *The Humours and Diversions of Bartholomew Fair*, published by W. Dicey, c. 1733. Etching and engraving.

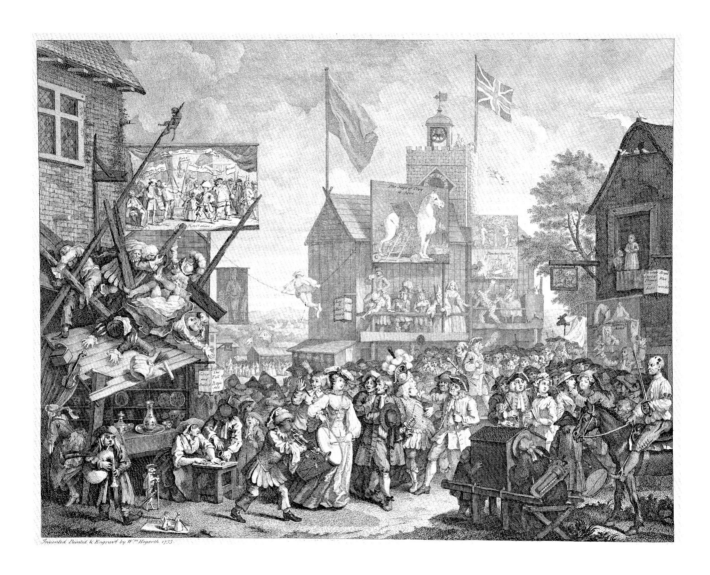

53. William Hogarth, *Southwark Fair*, published in 1733. Etching and engraving.

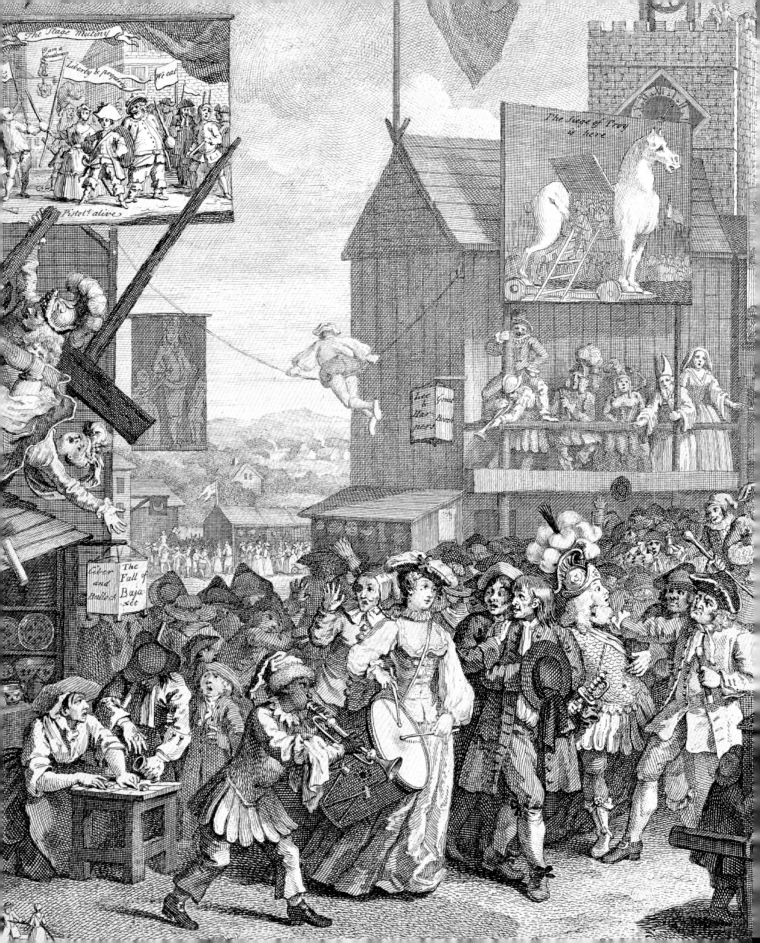

The IDLE 'PRENTICE Executed at Tyburn.

Proverbs CHAP: 1. Vers: 27,28.
When fear cometh as desolation, and their destruction cometh as a Whirlwind; when distress cometh upon them, then they shall call upon God, but he will not answer.

moved on to Tyburn and to cheers or jeers. The crowds that flocked to the events elicited warnings in guide books such as *The Foreigner's Guide… Le guide des étrangers*, first published in 1729, which cautioned:

> About 11, the prisoner is carried in a cart to the gallows called Tyburn, where a clergyman attends to assist him in his devotions. The rope being put about his neck he is fastened to the fatal tree… These executions are always attended with so great mobbing and impertinences that you ought to be on your guard when curiosity leads you there.[36]

Hogarth's *The Idle 'Prentice executed at Tyburn* [fig. 54], from his series *Industry and Idleness* (published in 1747), shows Tom Idle at the famous three cornered gallows. A grandstand has been created to accommodate the colossal crowd. Burlesque figures haunt the crowd, such as 'Funny Joe' and 'Tiddy Doll' the latter who is dressed in finery, to the right of the print, selling gingerbread. The woman at the centre is the familiar figure of a London street trader selling the last confessions of those about to be executed.

Popular public entertainments very often contained a strong satirical vein. John Collet's *May Morning* (c. 1760) illustrates one such event, where a traditional and long-

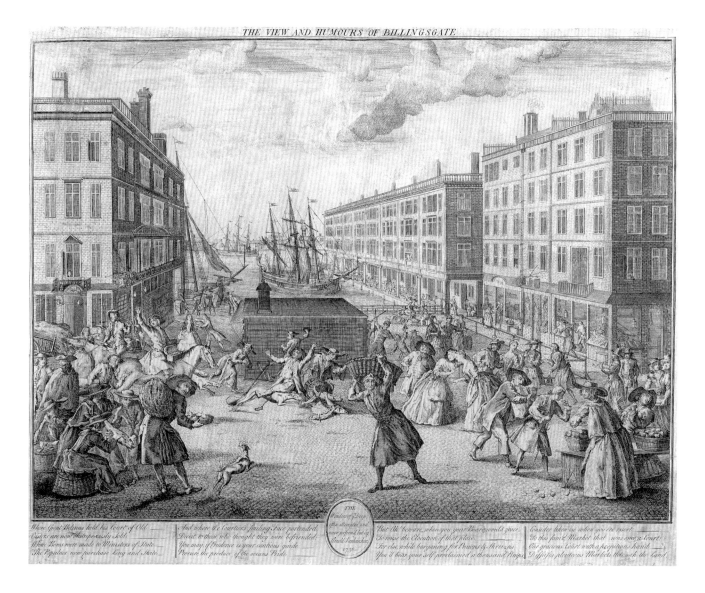

Where Great Belinus held his Court of Old ___
Oysters are now obstreperously Sold ___
Where Items were made to Ministers of State ___
The Populace now purchase King and State ___

And where the Courtiers smiling Face portended,
Deceit to those who thought they were befriended;
You may, if Prudence is your cautious guide
Procure the produce of the oceans Pride. ___

THE
Wonders of Deep
often attempted and
never performed but by
Arnold Vanhaeken
1736.

But Ah! beware, when you your Beare would grace,
To rouse the Elocution of that place;
For else while bargaining for Prawns & Herrings,
You'll hear your self proclaimed a thousand things.

Consider likewise when you are resort
To this fam'd Market that twas once a Court;
Our gracious Court with a propitious hand ___
Diffuses plenteous Markets through the Land.

standing folk event has been transformed into a more comic format in which the city's poor receive alms. The burlesque nature of the event echoes the other urban festivities of the time; in this case the Lord and Lady of May, poor caricatures of beauty, are set against the backdrop of a Westminster street, turning the folk tradition on its head. If the urban fares provided the satirist with a defined areas of comedy, the street, and more particularly known spaces, were used similarly in comic imagery.

The engraving by Arnold Vanhaeken, *The View and Humours of Billingsgate. The Wonders of ye Deep* (1736) [fig. 55], shows the famous hithe at Billingsgate, with ships moored, one in the process of being unloaded. Vanhaeken's

portrayal of the crowd around Billingsgate centres on collision and unruliness against the backdrop of trade. An image of the significance of Billingsgate complete with accurate topography contrasts with the comic crowd. Oyster- and fish-sellers collide because of a truant dog, and whilst a gentleman puts an oyster to his lips, a wag attaches a fish to the bag of his wig. A quack doctor on horseback is heralded by his trumpet-blowing attendant. The central archetype of this image is the 'Billingsgate', a Londoner, whose name enters Bailey's Dictionary of 1736 as a synonym for a 'scolding and impudent slut'.[37] Ned Ward further evokes a scene full of Billingsgates: 'Having quitted the stink of sprats and the untenable clamour of the wrangling society,

we passed round the dock, where some salt-water slaves, according to their well-bred custom, were pelting names at one another.'[38]

Louis-Philippe Boitard's (fl. 1733–65) *The Imports of Great Britain from France* (1757), published by John Bowles, Black Horse, Cornhill, is set at the Custom's House Quay at Billingsgate, showing the Tower of London visible in the background. A French package boat unloads its service and commodities to the London Quay. Satirising the British trade for all things French, this elaborate print was published at the beginning of the Seven Years War (1757–63). It was 'Humbly Addressed to the Laudable Associations of the Anti-Gallicans, and the generous promoters of the British Arts & Manufactories.' Boitard, as he explains in his lengthy description at the base of the print, shows the disembarkation of French services in the form of archetypal

'foppish' dancing masters, chefs and fashionables. In the foreground a boy holds his nose at the smell of cheese around a group of goods that supplied fashionable society from France clearly labelled as camembert, champagne and burgundy.

If Tyburn and Billingsgate represented areas in which large and diverse crowds met, two other London districts unambiguously represented a predominant social class that were often humorously contrasted. St Giles was almost exclusively populated with the poor, while its opposite was the fashionable St James's, the home of high social class and its aspirants. In particular, the fashionables would meet at the promenade at St James's Park. L'Agneau's *View of the Mall* (1752) [fig. 57] is a caricature of bodily distortions and, as part of the macaroni tradition, the puppets have enormous and exaggerated heads. The 'True-born Englishman', reflected in visual satire, mocked the high reputation and

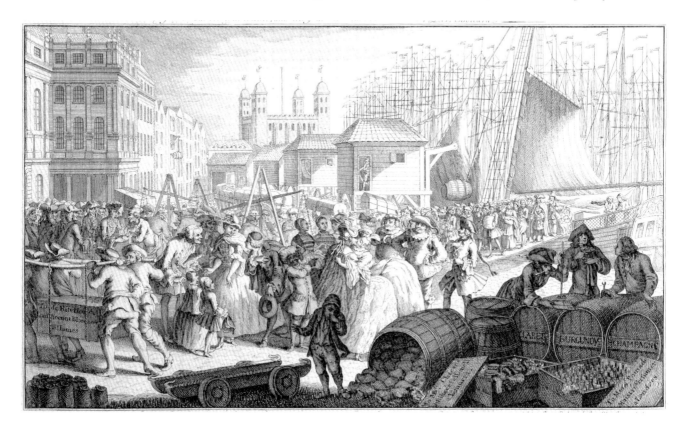

57. L'Agneau, engraved by John June, *A View of the Mall*, 1752. Etching.

58. Louis-Phillipe Boitard, *Taste à la Mode 1735*, 1745. Hand-coloured etching.

59. John Collet, *The Female Bruisers*, 1768. Oil on canvas.

exclusivity of this area: 'The Beauty of the Mall, especially at this season, is almost past Description; what can be a more glorious Sight than the Body of the Nobility of our three Kingdoms in a fine Spring. Morning in so short a Compass, and when freed from mix'd Crowds of Saucy Fops and City Gentry...'[39]

As the 'True-born Englishman' was aware, the exclusive haunts of the privileged were also the grounds of social climbing, a stage of pretence as well as a backdrop of sexual assignation of whores, liars and pretenders. Similarly, Boitard's *Taste à la Mode, 1735* and *1745* [figs. 58, 60], uses the arena of St James's Park and the Mall as an early caricature on the changeability of fashion through the decades.

Whilst in the Mall, or in the exclusive areas of the West End, the fashionable are at home, but when they walk the London streets they are depicted as distinctly out of place, juxtaposed with street characters, who serve to make their fashions and vanities all the more outrageous, subject as they are to the plebeian gaze. In John June's *The Lady's Disaster* (1746) [fig. 64], the scene is The Strand, the subject explained on the print as 'Drawn from the Fact. Occasion'd by a Lady carelessly tossing her Hoop too high.' The bawdy sexual humour is displayed through a small sweep looking up the lady's dress, her alarm and embarrassment providing the hilarity of the diverse crowd which includes beggars, one whose dog urinates on a fashionable dress. The Strand is a

busy thoroughfare, and a place that demonstrates the growing consumerism and luxury goods available in London at the time. As well as displaying social antagonism and burgeoning consumerism, the print also refers to prostitution in relation to fashion and consumer culture (this is the part of The Strand adjacent to Drury Lane that was notorious for its prostitutes). The street signs, ever suggestive, here show a bishop's hat, signifying the brothel and contraception. The ambiguity between lady and streetwalker is made clear in John Gay's description of how to know a prostitute:

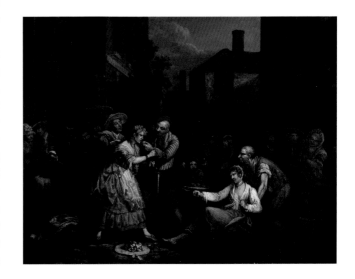

60. Louis-Phillipe Boitard, *Taste à la Mode, 1745*, 1745. Etching.

61. William Hogarth, *The Harlot's Progress*, Plate 1, published in 1732. Etching and Engraving.

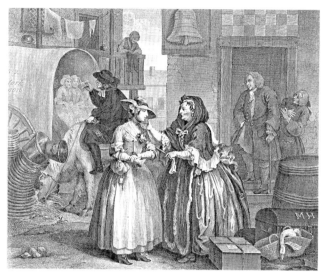

And trudge demure the rounds of Drury-lane.
She darts from farsnet ambush wily leers,
Twitches thy sleeve, or with familiar airs,
Her fan will pat thy cheek; these snares disdain,
Nor gaze behind thee, when she turns again.[40]

For many women in mid-eighteenth century London, poverty was very real and prostitution provided an intermittent income at times of need. In literary and visual satires we are most often given a very different viewpoint of a professional prostitute, ready to pick pockets and spread disease. A clear example of this endemic attitude is a short section from an anonymous satire of the period:

In every street, women are parading to prostitute charms which vanish as the day appears. Their dress betrays Londoners in its negligence, tawdriness in its finery, vulgarity in its fashion, and wretchedness in its starchified frippery. The art of these women is to vary prostitution beyond what the most vicious imagination might conceive... whose only pleasure is to invent new ways of sacrificing to the Cyprian Goddess. While these wretches press you in their arms, they plunder your pocket.[41]

Both written and visual satire, on the whole, follow the opinion of its consumers, in taking a moral standpoint whilst assiduously consuming stories and images about it. This contradictory stance, not unknown in today's tabloid press, can be seen in the satires that deal with prostitution. At one extreme, text and images were openly pornographic, whilst most others, although less overtly explicit, were most definitely voyeuristic in their imagery, despite their moral tone.

The most famous graphic images of prostitution in this period appear in Hogarth's series, *The Harlot's Progress* [Plate 1, fig. 61], a moral narrative on a social problem. Its enormous popularity is well recorded and was well known in London, not merely through the images themselves, but also through a stage version adapted by Theophilus Cibber and entitled *The Harlot's Progress; or, The Ridotto al Fresco*. George Vertue attributed Hogarth's motives in producing *The Harlot's Progress* not to their high moralising purpose, but to a cynical exploitation of the sensational subject which would guarantee sales. Vertue writes that Hogarth:

... had daily Subscriptions came in, in fifty or a hundred pounds in a Week — there being no day but persons of fashion and Artists came to see these pictures... before a twelve month came about whilst these plates were engraving he had in his Subscription between 14 *or fifteen hundred*.[42]

The first plate of Hogarth's *The Harlot's Progress* is set at the yard of the Bell Inn, possibly Wood Street, Cheapside, which had a pub of the same name. Mary Hackabout, the young woman who has arrived on the wagon from York, is naive and unfamiliar with city ways. The wide-eyed country innocent being immersed in a cynical urban environment provides a comical archetype that continued throughout the eighteenth and nineteenth centuries.

Hackabout, whose name implies the street-walking profession that she is about to adopt, is met by Mother (Elizabeth) Needham. Mother Needham actually existed; she was a well-known figure in London running a brothel at Park Place near St James's, who evoked public hatred and was pilloried a few days before her death. The man in the doorway, Colonel Francis Charteris, a similarly unpopular figure, was a seducer and rapist, who elicited such enmity with the London mob that at his funeral his hearse was attacked and his tomb filled with dead cats and dogs. If Needham and Chateris were depicted as villains who corrupted innocence, Hackabout represents the innocent who in turn becomes the corruptor.

In John Collet's *The Female Bruisers* (1768) [fig. 59], two prostitutes fight over a potential client just arrived from the country. The two well-dressed women are seconded in the usually male sport of fisticuffs. The wide-eyed rural innocent provides ripe pickings, not just for the prostitutes, as we can clearly see his pockets are being picked. Two comic horrified gents watch the scene from the background, but to the traders it is the sport of the street. The fight is echoed in the fighting cocks and the bill poster for *The Rival Queens*, either a play by Nathaniel Lee (1655–92) of 1677, or more probably a verse burlesque on the play by Colley Cibber of 1729. In this scene the hardened London prostitutes are equated with masculinity.

The representation of prostitutes as moral corruptors, thieves and spreaders of disease occasionally incited the London mob. Boitard's *The Sailor's Revenge or The Strand in an Uproar*, 1749 [figs. 62, 63], evokes a riot around a Strand brothel that took place on 2 July, 1749, prompted by group of sailors who were robbed there. The women in the print,

one who cries 'A joyful Riddence', are shown as applauding the actions, for with the prostitutes banished they might receive more attention from their husbands. Such response had its equivalent in literary satire, the 'True-born Englishman' noting that: 'Some Ladies rail against Bawdy-Houses, because there are Men who, when they can have a fine Woman for a Guinea, will not give themselves the Trouble of Addressing where it must cost Time and Protestations, and perhaps more Money too.'[43]

He also exposed the hypocrisy of such vilification of prostitution, described in 'The Hackney Harlot'.

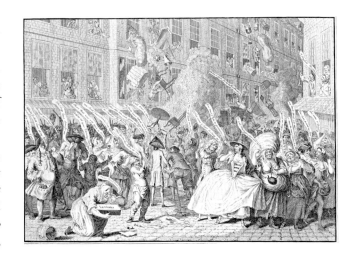

When Shopkeepers *Wives we pass by,*
Forgetting their Husbands horn'd Heads;
Aloud from their Doors they will cry,
Lewd Strumpets, base Hussies, *and* Jades:
Thus the Sinner who acts in the Dark,
Her Crime's to the Publick unknown;
But the Harlot *that ambles the* Park,
Is the Scorn and Reproach of the Town.[44]

Punishments for prostitution, metered out at Bridewell Prison, Tothill Fields, Westminster, were also subject to hypocrisy. Female flogging, until it was finally abolished in 1791, provided opportunities for the sexual voyeur. As Ned Ward complained of Bridewell: 'I think it is a shameful indecency for a woman to expose her naked body to the sight of men and boys, as if it were designed rather to feast the eyes of the spectators than to correct vice, or reform manners...'[45] The fourth plate of Hogarth's *The Harlot's Progress* [fig. 65] is set in Bridewell with Mary Hackabout beating hemp, contrasted with the other inmates who are inappropriately well-dressed. Her fall is imminent, and presented as an inevitable outcome of the profession she has adopted.

The satirical categorisation of Londoners by their occupation extended far beyond the image of the disreputable prostitute to the more respectable forms of employment. Dicey's popular satire, *The Lawyer's Coat of Arms* (c. 1733)

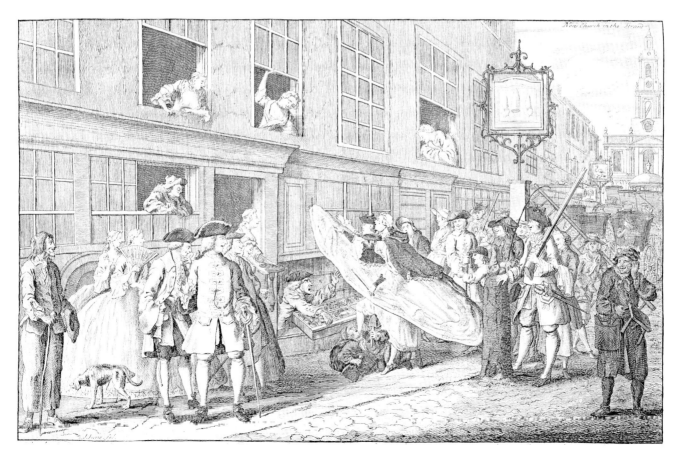

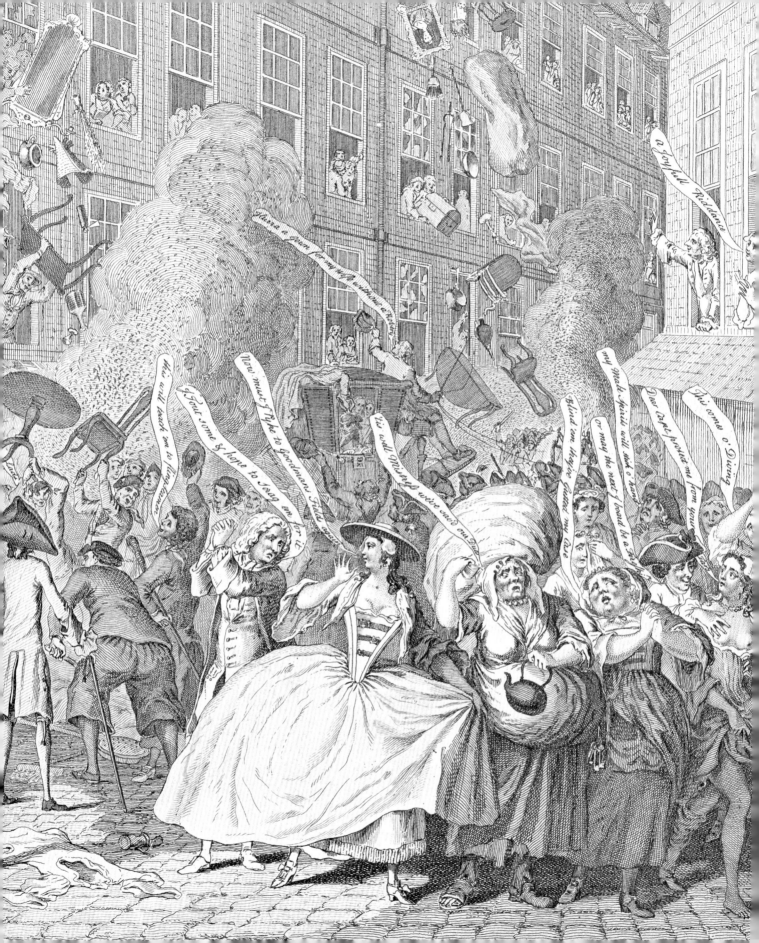

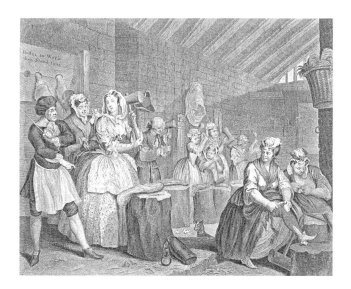

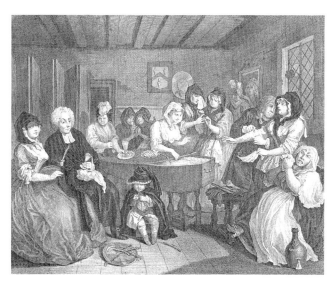

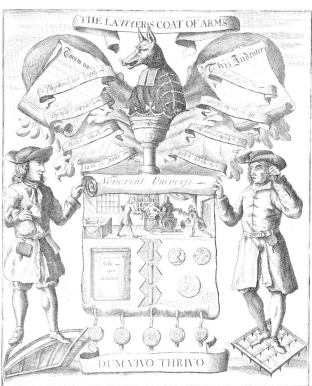

65. William Hogarth, *The Harlot's Progress*, Plate 4, published in 1732. Etching and engraving.

66. William Hogarth, *The Harlot's Progress*, Plate 6, published in 1732. Etching and engraving.

67. Anonymous, *The Lawyer's Coat of Arms*, published by W. Dicey, c. 1733. Etching.

[fig. 67], is typical of social satire that stereotyped the professions. The satiric coat of arms, a popular device, reveals in this case the archetypal unscrupulous London lawyer, protecting his own monetary interests above those of his client. 'Lawyers by subtle querks the Clients fleece,' the print notes, comparing him to Raynard the fox who appears as the head image, 'The Golden Fee alone is his Delight'.

Images of London's itinerant street traders were also centre stage in a series of street cries, which appealed equally to the satirist, as they did the illustrator and journalist. Paul Sandby produced a series of twelve etchings and numerous watercolours of London street traders which merges satiric elements with intricate observation.[46] *Rare Mackarel Three a Groat Or Four for Sixpence* (1760) [fig. 68], is No. 8 in the series. The low and vulgar standing of the seller are emphasised by Sandby as she argues with the servant from a

68. Paul Sandby, *Twelve London Cries, No.8, Rare Mackerel, Groat Or Four for Sixpence*, 1760. Etching with roulette work.

69. Paul Sandby, *A hot pudding*, c. 1759. Pen, brush, ink and watercolour.

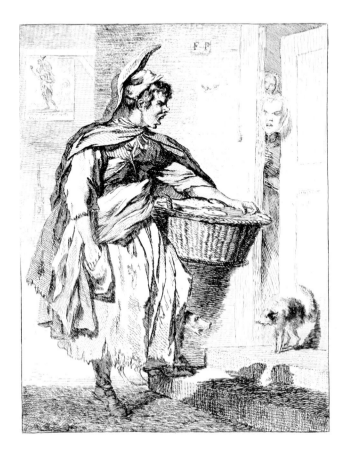

household peering from behind a door. The energetic and characterful portrayal of the figure is mirrored in the satirical echoes of people, animals and objects. The two women scowling at each other are reflected in the dog barking at the hunched cat. Sandby, like Hogarth, uses a signboard to emphasise the action of the print, in this case the popular emblem of 'A Man Loaded with Mischief'. Furthermore, the pub sign itself has been wrongly attributed to Hogarth for 414 Oxford Street, although the image is derived from a much older source and can be traced to Adriaen van de Venne in Jacob Cats' emblem book, *Spiegel van den ouden ende nieuwe tijdt*, published in The Hague in 1632. A later print illustrates the sign in a street scene derived from the background of Hogarth's *Gin Lane. Matrimony, Drawn by Experience* (copy of a c. 1751 print) [fig. 70] shows a man

with a padlock entitled wedlock around his neck, his wife on his back with a glass of gin, a monkey and a single magpie. A nineteenth-century book of inn signs linked it to '… the sign of an alehouse in Oxford Street. The original said to be painted by Hogarth, is fastened to the front of the house… An engraving of it is exhibited in the window…'[47]

Hogarth was embroiled in London's popular culture, his dynamic language having absorbed the images of the street. His prodigious abilities as a fine artist transformed popular satire into an art form revolutionising popular satirical forms and acting as an influence on visual satire that continues today.

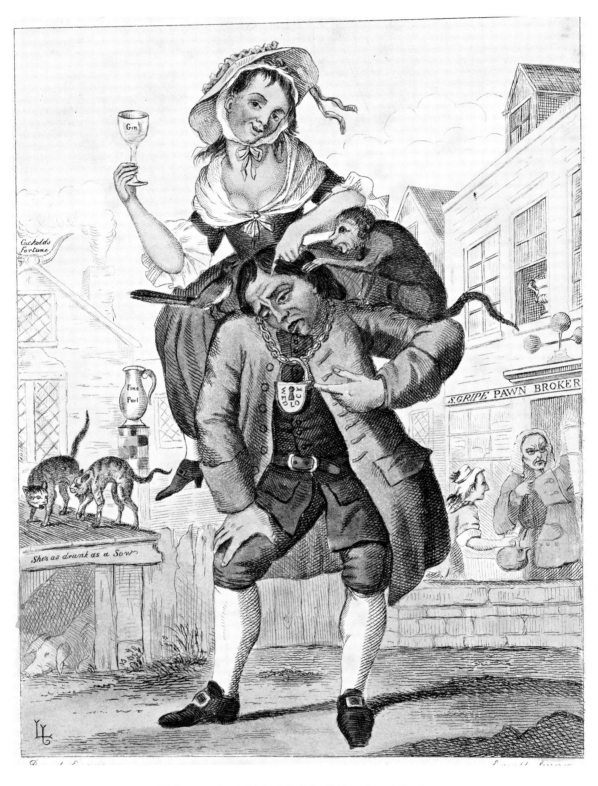

70. Anonymous, *A Man loaded with Mischief, or Matrimony. Drawn by Experience – Engraved by Sorrow*, copy of a c. 1751 print. Hand-coloured etching.

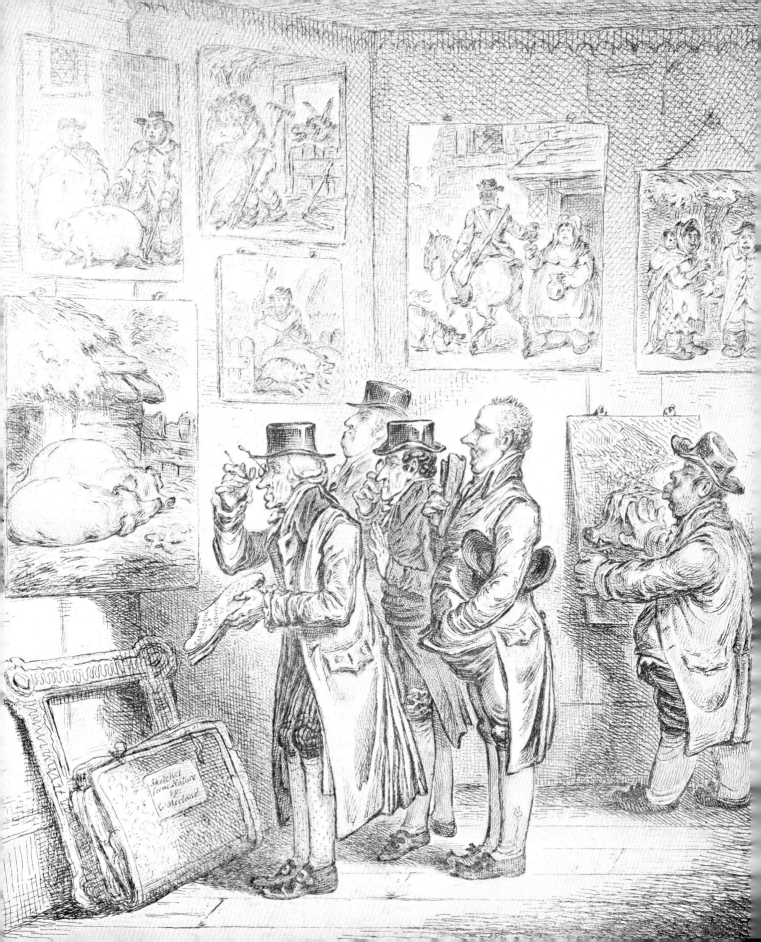

From Drollery to Gillray

'It may be said, that with the death of Hogarth, almost all
the old school of humorous designers disappeared. He was
the great luminary of this species of art, and when his
light went out, all the lesser lights were extinguished.

One of the earliest of the succeeding school of publishers
of satirical prints was the famous Matt Darly, who had a
shop opposite Hungerford Market, in the Strand.'
Henry Angelo[1]

71. James Gillray, *Connoisseurs examining
a collection of George Morland's*, 1807.
Etching with aquatint.

So summarised Henry Angelo (1756–1835) [see p. 71], the fencing master and close friend of Thomas Rowlandson, in his anecdotal but insightful *Reminiscences*. Indeed, the death of William Hogarth left a gap within English art that was not easily filled: the spirit of his satire; his belief in a distinctive native British art; his creation of a modern moral narrative, and, moreover, his ability to draw on wide cultural sources. Yet his influence lived on, not only in the prints, which continued to be reissued and sold in large numbers, but also in his inspiration to subsequent artists. The cultural climate, which he fought against throughout his lifetime, changed irreparably after his death with the creation of the Royal Academy in 1768. No other artist until the twentieth century would be able successfully to bridge the gap between the high art enshrined in the Royal Academy and the popular satirical print. The emergence of the draughtsmen geniuses James Gillray and Thomas Rowlandson were of a different order to Hogarth: the Academic groves could not be fully reconciled with caricature and street prints, oil paint with pen. The admirers of Hogarth in the nineteenth century, who painted contemporary scenes of London, such as William Powell Frith and George Elgar Hicks, remained on the other side of the divide from the draughtsmen George Cruikshank and John Leech. They may have emulated Hogarth, as Frith himself commented on his series the 'Road to Ruin', in which he evoked the moral narratives of Hogarth, but avoided the satirical:

> For a long time I had the desire to paint a story in a series of pictures, and I began to make chalk studies of the different groups for five pictures called 'The Road to Ruin'... I thought I could show some of the evils of gambling; my idea being a kind of gamblers progress, avoiding the satirical vein of Hogarth, for which I knew myself to be unfitted. I desired to trace the career of a youth from his college days to his ruin and death – a victim of the most fatal devices.[2]

72. Anonymous, *Moderate Interest*, published by M. Darly, 1 June 1772. Etching.

73. Robert Dighton, *George III aged 72, 1810, Reigned 50 Years: A Royal Jubilee*, 25 October, 1810. Hand coloured etching.

MODERATE INTEREST.
20 P. Cent.

George the IIIrd aged-72-1810.
REIGN'D-50-Years. A ROYAL JUBILEE.
Taken at Windsor by R Dighton. Spring Gardens.

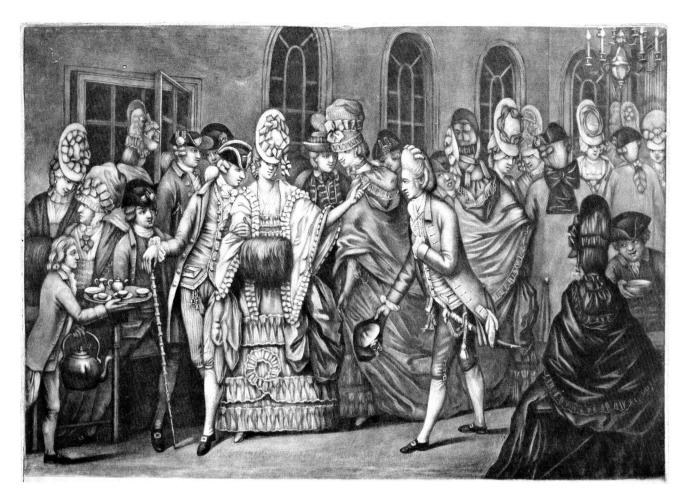

74. John Raphael Smith, *The Bread and Butter Manufactory, or the Humors of Bagnigge Wells*, 25 June, 1772. Mezzotint.

Contemporary critics, in line with Frith's dichotomy, recoiled at any hints at exaggerated physiognomy or overt comedy, viewing it as a lesser art.

The period immediately after Hogarth's death also saw the flourishing of amateur caricature that was somewhat of an anathema to the great artist. As Angelo described, it was epitomised by the Darly's of the Strand. *Moderate Interest* (published in 1772) [fig. 72], drawn by Edward Topham and published by Matthew Darly, is typical of such plates, and its stereotypical portrayal of a Jewish money lender illustrates how satire often reflected popular prejudices and stereotypes. On the whole, Darly's images of this period represent a shift from political to social satire alongside the growth in amateur caricature and reflect the tenor of satire immediately following Hogarth's death.

As the century progressed, the popularity of caricature and satire grew and created an enormous demand, which in turn influenced the creation of a particular art form, indigenous to London. The great age of English caricature was born and reached its peak in the works of James Gillray, Thomas Rowlandson and many others. Like Hogarth, Gillray and Rowlandson drew on popular imagery and opinion, taking it, through their skill and invention, to a higher level. Unlike Hogarth, they were not natural painters, and any limited attempts at work outside caricature were not successful. The English hybrid of satire and caricature reached its zenith in this period and the terms became interchangeable. This popularity was reflected in the greatly increased number of London print vendors selling caricature prints. '... the number of shops appropriated to the sale of Caricatures,' wrote Malcolm in the first history of caricature, 'as a proof of the importance the Publick has attached to them.'[3] Indeed, in his 1790 Guide to London, the Rev. Dr

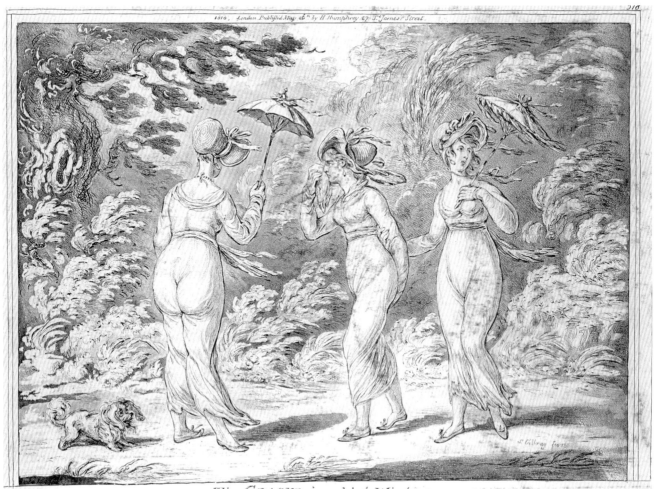

1810. London Publish'd May 26th by H. Humphrey 27 St James's Street.

The GRACES in a high Wind. — a Scene taken from Nature, in Kensington Gardens.

Trusler gave fourteen rules on walking the London streets, number 5 being: 'Never stop in a crowd, or to look at the windows of a print-shop or shew-glass, if you would not have your pocket picked.'[4]

This chapter will look at London satire produced within the flowering of the print, a period which has become known as 'The Golden Age of Caricature', which approximately covers the reign of George III (1760–1820). Ironically, satirical imagery of the Royal Family flourished within this period, like no other, with an irreverence that shocked and amused visitors to London. Frederick Augustus Wendeborn noted that:

Frankness and freedom are likewise a characteristic of English manners. In many countries even though they are not free; and a person suspected of heresy, either in

matters of state or religion, cannot always avoid persecution. In England, thank heavens! not only thoughts, but even the tongue, the pen, and the press, are free. An Englishman has no reason to be a hypocrite; he may speak as he thinks, and act as it appears to him just and proper.[5]

England was alone in Europe in allowing such criticism and mockery of its own monarchy. When Sophie von la Roche visited London in 1786 she kept a diary which recorded the public mockery of the Prince of Wales:

I saw a number of people standing near an engraver's, [St James's] in front of some caricatures, the subject of which was the life and marriage of the Prince of Wales; they are sold to the public. The bridal-chamber struck us... and partly because of the three ostrich feathers, the Prince of

75. James Gillray, *The Graces in a High Wind – a scene Taken from Nature, in Kensington Gardens*, 1810. Etching.

76. James Gillray, *A New Administration, or the State Quacks Administering*, 1783. Etching.

Wales' crest since 1346. We laughed at the change wrought by 440 years.[6]

The demands for such prints outweighed any ideas of unquestioning deference, and the attitudes of Londoners themselves is illuminatingly illustrated in the reporting an address of a Livery of London that touched upon the caricature print shops and the scurrilous nature in which they represented the monarchy:

It was there said, that 'the most reprehensible means were resorted to for the purpose of bringing the person and government of the Sovereign into contempt.' ... one of the most reprehensible modes for effecting that object was the publication of caricature. By that system, the private conduct of the Sovereign was held up to contempt; and... if any person had done this more than another, exposed in his windows immoral and disgusting prints, calculated to ridicule and insult the Sovereign, and to instil vicious ideas into the minds of youth that person was one of the gentlemen who signed the loyal declaration of the ward of Cheap. (Laughter, and cries of 'Tegg'.) If they would go to a caricature shop not 100 miles from Cheapside, they would find the greatest ridicule cast on the reigning Sovereign... Those caricatures were not only sold, but printed and published by one of those who signed the loyal declaration. (Laughter.)... But did it follow, because some disloyalty and disaffection existed, that the great body of the people were tainted? ...The other day... their Sovereign himself... freed the people from all imputation of did loyalty. (Laughter.)[7]

Arguably, James Gillray's greatest achievements were political allegories, most of which lie outside the scope of this survey, yet his ability to depict both politics and social satire make him a brilliant and invaluable commentator upon London. Rowlandson, whose human comedy so often revolved around the metropolis, gives him a special position in his depiction of London and Londoners, and he will be explored more fully in the following chapter. Between the

death of Hogarth and the emergence of Rowlandson and Gillray, amateur caricatures like those produced by the Darlys predominated alongside a body of social satire prints known as 'droll' mezzotints. Mezzotints, a laborious process of creating smooth tones, appealed to collectors, and listings of these prints appear in numerous print catalogues of the time as 'drolls' and 'posture' prints. *The Bread and Butter Manufactory* (published in 1772) [fig. 74], for example, shows the Long Room at Bagnigge Wells tea gardens at Kings Cross and depicts an elegance and polish in many of these satires which masks, for today's eyes at least, the satiric intention. Bagnigge Wells is a satire on the perennial themes of social climbing, pretension and prostitution.

Mezzotint was a relatively skilled process, and not one easily adapted for either the amateur, or for speedy responses to events and incidents. Etching, predominantly used by Daly, was far more appropriate, as a line drawing could be quickly transformed into a print. This process of scratching into wax was also the main medium of James Gillray, who used it to create some of the most engaging images of the late eighteenth and early nineteenth century. It had a fluidity which mezzotint did not have, and suited both the amateur and professional. *A New Adminstration*, Gillray's etching of 1783 [fig. 76], illustrates the ease and smoothness of line that was achievable and Gillray's skill in mastering it to produce, in this case, a satire on the coalition of Fox and North.

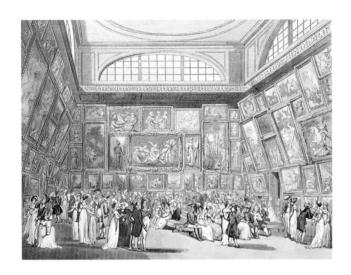

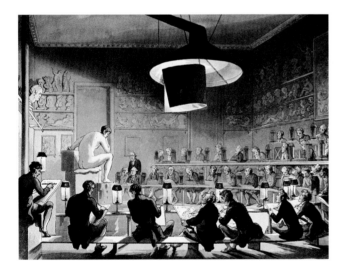

Satire and the Art World

As already indicated, the establishment of the Royal Academy set a schism between high and low art, with satire and caricature being placed firmly outside the academic grooves. By its nature, the Academy championed art of high subject matter – history or portraits of distinguished sitters – connected by classical allusion. The forms, serious and uplifting, were based upon the study of anatomy and the antique: high-minded, professional and erudite. In contrast, the art of satire was connected to the street – irreverent, amateur and often crude in its humour. As James Barry wrote, '[satire's] purposes [was]so base, and so subversive of everything interesting to society.'

The Academy taught its artists to raise the standard of art in London. The Academy especially celebrated the classicism of its figure painting, which perfectly illustrates dichotomy between high art and satire in its approaches to its subjects. *Exhibition Room, Somerset House* [fig. 77], illustrated by Rowlandson and Pugin as the first plate in Ackermann's *Microcosm of London* of 1808, shows students making careful studies of the human form. Such life study, in conjunction with study from the idealised form of antique classical sculpture, laid the basis of the art of the Academicians.

Within satire and caricature, the approach was entirely the reverse: the model was the reality of the everyday and highlighted the follies of every echelon of society. The human figure was shown with its corruptibility, imperfections and individuality. Yet caricaturists were not realists, and their depiction of the human figure was exaggerated, and was in fact, in direct contrast to the ideal. Its starting point, in one sense, was the ideal, which was then distorted in order to highlight reality. This is no better illustrated than in Gillray's *The Graces in a High Wind – a Scene Taken from Nature, in Kensington Gardens* [fig. 75] of 1810. In this scene, set in the fashionable gardens, we see three urban graces, in an almost Arcadian Kensington, blown by zephyrs, so that their drapes mould and fold to their outline in antique fashion. Their classical poses accentuate the unclassical nature of their bodies and the of ill-proportioned anatomy in terms of the classical ideal.

The treatise of Francis Grose, which I discussed earlier, is in many ways an amateur's handbook. His rules of transforming and perverting an ideal are clear, yet there is, underlying much of satire, a standard use of form and language, a body of recognisable types. Satire followed a chaos of ideas and theories which encompassed popular prejudice regarding

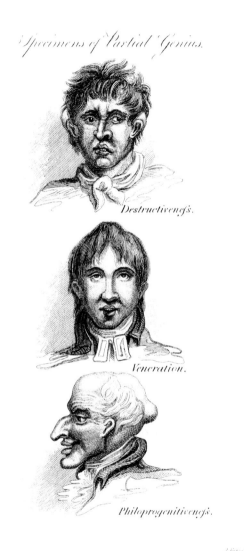

stereotypes, literary models and the physiognomical. Of course this body of material had few consistent hallmarks beyond its belief that the outward features – both facial, bodily and gestural – reveal the character of an individual. This popular belief was elevated by some to a pseudo-science, although its manifest theories were evident in varied forms of exposition, both serious and light-hearted, from fortune telling, satirical lectures and physiological studies. Popular periodicals of fortune-telling such as *The Conjuror's Magazine or Magical and Physiognomical Mirror* illustrated and annotated pages from Lavater by Barlow and Fuseli and advertised, 'Three capital Copper plates; the first, a frontispiece; the second and third, Portraits of the Miser and the Brute, from Lavater, accurately copied.'[8] *The Golden Cabinet,*

77. Thomas Rowlandson and Augustus Charles Pugin, *Exhibition Room, Somerset House*, published in 1808 by Rudolph Ackermann as part of *The Microcosm of London; or, London in Miniature* (1808–10). Hand-coloured aquatint.

78. Thomas Rowlandson and Augustus Charles Pugin, *Drawing from Life at the Royal Academy*, published by Rudolph Ackermann as part of *The Microcosm of London; or, London in Miniature* (1808–10). Hand-coloured aquatint.

79. Anonymous, *Specimens of Partial Genius*, 1816. An illustration from *Craniological Physiognomy*, City Philosophical Society, 1816. Engraving. Guildhall Library, London.

80. James Gillray, *Tatianus Redivivus or The Seven-Wise-Men consulting the new Venetian Oracle, a scene in the Academic Grove No. 1*, 1797. Etching and aquatint.

or, the Compleat fortune-teller. Wherein the meanest capacities are taught to understand their good and bad fortunes, not only in the wheel of fortune… but also by… palmistry [sic] *and physiognomy etc*, of around 1790 contained small woodblocks illustrating its physiognomic predilections and contained such wisdom as: 'A ruddy complexion, not being over fat, shew a person cholorick, and given to vexation and law-suits.' Whereas 'A high white complexion shew a good nature, an affable temper, a keeper of secrets but effeminate.'[9]

The period also saw more serious and atypical studies, and even satires such as John Clubbe's *Physiognomy* [dedicated to Hogarth] of 1763 discussed such fortune-telling work as belittling of a science: 'The modern pretenders to this science have brought it into disrepute, particularly the Gypsies, by confining it to lewd prognosticks of love, and by joining Palmistry, or the art of picking pockets to it.'[10]

The crude and necessarily exaggerated nature of the illustrations to physiognomical work made it immediately like caricature, such as the illustration, *Specimens of Partial Genius in Three Familiar Lectures on Craniological Physiognomy* [fig. 79], by a member of the City Philosophical Society in 1816. Similarly, Stevens's lectures on heads comically paraded his specimens in a pseudo-scientific manner following and mimicking serious studies and investigations.

It is against this background that satire in this period stood in direct contrast to the Royal Academy. Even if Rowlandson did exhibit at the Royal Academy Summer Exhibitions, there was enmity epitomised by Barry's complaint and from Rowlandson and Gillray, who rallied against the effeteness of the Academy with its narrow and hierarchical views. Their acceptance could only be nominal and peripheral, despite being professional artists.

Gillray's *Titus Redivivus; — or The Seven-Wise-Men consulting the new Venetian Oracle, — a scene in the Academic Grove. No.1* (1797) [fig. 80] is an elaborately and brilliantly conceived attack on the London art establishment. Gillray depicts seven Royal academicians seated along the front on a wooden bench painting the headless statue of Apollo Belvedere: Joseph Farington, John Opie, Richard Westall, John Hoppner, Thomas Stothard, Robert Smirke and J. F. Rigaud, are all exposed with their weaknesses as painters. The pretensions of the Academy are, in this case, revealed through an exposé of a confidence trick by Ann Jemima Provis, who claimed to have an early Venetian manual of painting.[11]

If the art establishment took satirical flak for its exclusive and hierarchical position, its benefactors and patrons were equal game for the satirists' pencil. In *Connoisseur's examining a collection of George Morlands*, [fig. 71] Gillray mimics the stupidity of the 'connoisseur' peering at the overtly sentimental rusticity of George Morland (1763–1804), who played to this audience by producing a large number of pot boilers. Interestingly, one of the identified figures in this print is the London banker, Mitchell, and Gillray was making a snide comment on merchants' gentrification and assimilation into fashionable society through collecting art. 'The title of Connoisseur' was, as Goldsmith wrote, 'the safest passport in every fashionable society.'[12] In satirical London, the connoisseur was a despised and pilloried figure, characterised by the symbol of magnifying glass or thick spectacles, an artificial aid to defective vision or as an instrument to focus on detail whilst missing the entire point. George Morland's popular and charming *A Tea Garden* (1790–91) [fig. 81] could not be in greater contrast to the satirical view that we have of Bagnigge Wells.

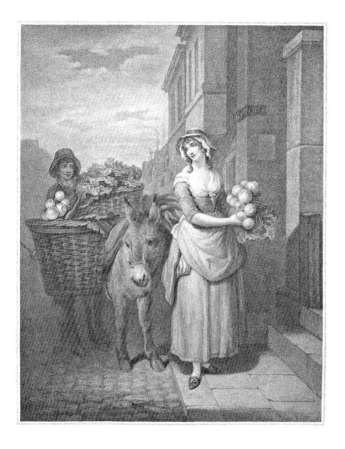

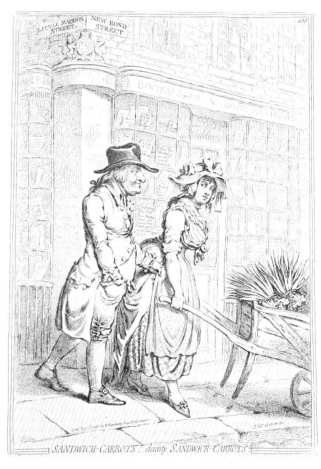

SANDWICH-CARROTS! dainty SANDWICH-CARROTS!

The division between the polite, lofty ideals of Academicism and satire can be seen in the subject matter itself. As Sir Joshua Reynolds proclaimed in his *Discourses*:

The painters who have applied themselves more particularly to low and vulgar characters, and who express with precision the various shades of passion, as they are exhibited by vulgar minds (such as we see in the works of Hogarth) deserve great praise; but as their genius has been employed on low and confined subjects, the praise which we give must be as limited as its object [13]

It is not surprising that the largest body of contemporary scenes of London life in the late eighteenth and early nineteenth century are those of satire and caricature. Landscapes and cityscapes aside, such subjects were not consistent with history painting and aristocratic portraiture. When serious art did depict everyday life, it was either hopelessly sentimental in its portrayal, or moved into the direction of caricature of itself, depicting low life as comic. Social realism did not fit well into the fixed framework of representation taught by the Royal Academy.

Francis Wheatley RA produced a sustained series of London's street cries, which proved enormously popular although they bore little resemblance to the life of the itinerant trader on London streets. Sentimentalised *in extremis*,

these saccharine works present an untypical and unreal view of London's street sellers towards the end of the nineteenth century.[14] In the 1920s Malcolm Salaman praised their charm and in so doing indicated their complete detachment from reality:

> [Those] fragrant pictures of Wheatley's ... where there is no suggestion of crowd or noise, no woman or girl who is not comely, the girls, in fact, all appealingly pretty, and even the men having a tendency towards good looks; where the elegant... There is no mud in these streets to bespatter wayfarers withal, nor are pickpockets here to snatch their purses... never a raucous note is heard...[15]

Rowlandson reacted with a series of his own in 1799, published by Rudolph Ackermann, with an earthy and irreverent rebuff. The first response, though, came in 1796 with

James Gillray's *Sandwich Carrots! Dainty Sandwich-Carrots* [fig. 83], which satirised the lecherous Lord Sandwich, known as 'Lord Twitcher'. The groping and furtive gestures of Sandwich are compliantly received by the voluptuous carrot seller on the corner of little Maddox Street and New Bond Street, near to Mrs Humphrey's shop. In satire, saccharine was replaced with a beggars' comedy that mocked polite forms of representation and gave London streets its mud and pickpockets. We see all echelons of society from the street beggar through the professional to the aristocracy, all involved in their daily life and work.

London in the Age of George III

London being inhabited by a medley of various nations, it must consequently exhibit a most curious diversity of character. To delineate these with the pencil of satire; to

trace deception and vice to their secret haunts, and expose them to ridicule and detestation, wherever they may be found; is the proper business of the honest satirist. It has ever been his privilege to shoot folly as it flies, and if some readers feel that they are exhibited in colours too glaring, let them relinquish those follies which are subjects of ridicule, and the censure will no longer be applicable to them.[16]

In Leicester Square at Castle Street, visitors could see Barkers' Panorama of London in its vastness. The 360-degree viewpoint was taken from the roof of Albion Mills (1792) [fig. 84] and showed the scale of the city in one great perspective. Here, satire revealed the detail of this city, the view from the inside, the life and follies of its people, their interactions, hierarchies and the associations of its areas. It is street level, eye to eye with its subject, and the literary satires of the city like that of John Corry's *Satirical View of London*, took the guide book as the model for its ironic and comic perambulations. Essentially, London's satirical images were about people and more specifically Londoners. Familiarity and popular opinion gave the audience an immediate understanding of the satires in the print shops, but the device of ignorance and innocence, one step back, enabled the satirist to show how ludicrous the people and customs could be. So in literary satire we are given a guide, comically addressed to and written by the unknowing or stranger and enjoyed by the Londoners themselves. We are fortunate in having many contemporary accounts, both humorous and serious, of Londoners and the experience of London, for it is this eye-level viewpoint that helps us interpret the satirical images. It is worth considering the images against contemporary satirical texts, to reveal the opinions and prejudices expressed in the satire and prevalent within London at the time. More specifically, they reveal Londoners attitudes toward themselves, to others, and to the status of London itself.

By all accounts, during this period Londoners were apt to have a very high opinion of themselves. Corry wrote:

They imagine that these strangers are drawn hither by the fame of the capital, and come to admire its inhabitants... and they really consider themselves as the greatest people in the world. A citizen of London! Enviable pre-eminence! Which no deficiency of genius can deprive the happy possessor of! This alone confers an imaginary dignity on every rank of citizens, from the smutty sweep-chimney to the gambling stock jobber.[17]

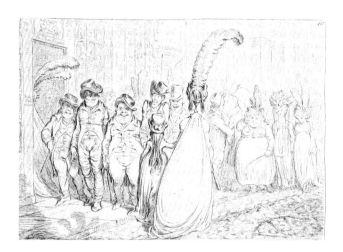

Frederick Augustus Wendeborn, in his account of England and the English, detected a similar attitude: 'I have reason to believe, that even an English beggar, at the sight of a well- [page end] dressed Frenchman or any other stranger, still thinks himself superior, and says within himself, I am glad that I am not a foreigner.'[18]

Such attitudes, manifest in satire, played to popular metropolitan prejudices. As the voice of such opinions, politicians learned to use and fear satire, which could be employed to directly manipulate public opinion. In terms of the depiction of the French, particularly common in metropolitan imagery, opinion had turned on the wider political horizon of Europe. The Frenchman in London occurs again and again, reinforcing a stereotype that was made popular through the wars with France and later through the response to the French Revolution. Typically, the satire of the French is in direct contrast to the English: just as the French satirised

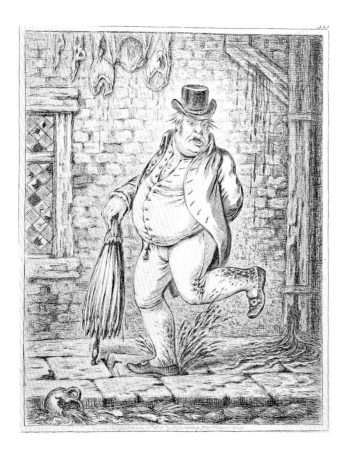

French customs and fashions are introduced and by some eagerly adopted...'[19]

The French Revolution and the threat of revolution in England caused a strong reaction towards the French and French influence within London. Liberty and slavery were themes ironically exploited by Gillray although the situation, according to observers, was often not so clear cut. Wendeborn suggests that attitudes towards the French were tempered by the revolution: 'The French used to be the great object of English national dislike and jealousy; but this seems now to be greatly abated, especially since the late revolution in France has given the English rather a more respectful opinion of the French nation.'[20]

Gillray's *High-Change in Bond Street, – ou – La Politesse du Grande Monde* [fig. 85] of 1796 illustrates and criticises the French influence through the fashionable crowds of Bond Street. An image of social disorder is depicted as five young men force two ladies into the guttering of the street. Such

the coarse and unfashionable English in Paris, the English presented the pretentious and effeminate fop in London. In John Collet's *Le Françoise à Londres* (1770) [fig. 88], we have a typical image that reveals the satiric stereotype. He is presented as weak, lazy, cowardly and effeminate in his over-dressing, manners and gesture. His assailant is an English butcher, represented as brave, wholesome, hard working, down to earth and strong. As Wendeborn commented, this condemnation of the French was customary, although he goes on to indicate that a more positive stance, particularly amongst fashionable circles, was also apparent: 'When I first came to London the appellation of French dog was a compliment, paid by the populace in every street, to a stranger not dressed in the English manner; but at present

The Hopes of a Family!!!

imagery of social dissolution and breaking up of hierarchy threatened by the French was manifest in many prints of this period, such as *The Hopes of a Family!!!* [fig. 87], published by Holland in 1793, in which the young heir is presented as a hopeless and ridiculous victim of French fashion.

In Gillray's Bond Street, the difficulties of navigating the London streets, which contained their own particular hazards, provide a perennial theme with satire. Several guides warning of such hazards ready to ensnare the uninitiated of metropolitan life give an insight into such visual humour. *The London Advisor and Guide* by the Rev. Dr Trusler, of 1790, for example, contained 'every instruction and information useful and necessary to persons living in London and coming to reside there,' and devoted a section 'on walking London Streets'.

86. James Gillray, *Sad Sloppy Weather*, published by Hannah Humphrey (after John Sneyd), 10 February 1808, Etching.

87. Anonymous, *The Hopes of a Family!!!*, Published by William Holland, 1 January, 1791. Hand-coloured etching.

88. John Collet, *Le Françoise à Londres*, 1770. Hand coloured mezzotint. Guildhall Library, Corporation of London.

89. James [?] Wilson, *Light your Honour?* Published by William Humphrey, 1772. Mezzotint.

Caution no. 10 of walking the London streets is directly illustrated in Gillray's *Sad Sloppy Weather* [fig. 86]: 'In wet weather look where you step: if you would not be splashed, don't tread on a loose stone.'[21] The dangers of London's streets were not limited to the natural hazards; the greatest dangers were presented by the crowd and the criminal. Walking through a London crowd was described as a grim experience by Wendeborn who noted:

> The streets in London are continually crowded with people, pushing along, and most of them with counte-nances as ferocious as if their heads were full of the most weighty affairs. This will strike the foreigner, who has met on the continent many more cheerful faces than he

will meet [page ends] with when he perambulates the metropolis.[22]

The criminal dangers of the metropolis were outlined in detail in a number of texts aimed at visitors to, and residents of, London such as Richard King's *The Frauds of London detected; or, a new warning-piece against the iniquitous practices of that metropolis*. This warned against:

> The many shocking crimes committed in and about London, as well as Frauds and cheats daily practised on the unwary tradesman, mechanic and deluded country-man, call aloud for detection and discovery.... But as too much praise cannot be bestowed on Virtue, so neither can too much be written in pourtraying Vice in its proper deformity... [23]

London at night contained many more dangers for the unwary visitor. Yet the image of night was not predomi-nantly one of danger, and the image of night as a cloak for sinful activity was exploited in satirical images of London. In *Light Your Honour?* [fig. 89] of 1772, the subtitle reads: 'Men love Darkness rather than Light because their deeds are evil,' and depicts a link-boy offering to light the path for a gentlemen who is with a prostitute. The gentleman's caricatured and monstrous face crudely shows his sinful nature.

Fashionable London

> Public amusements... are peculiarly calculated to give us an insight into the manners and taste of a nation; as comedies are often satires on existing follies... Even farces and pantomimes are not to be overlooked, as they generally exhibit caricatures of the fashionable frivolities of the day.[24]

Images of the fashionable world have long been a subject of satire. In the London of the 1770s they gained a pre-eminence in their reflection of metropolitan society, soon

reaching wider areas of the metropolis. Images, commentaries and advertisements went hand in hand with the development of London's fashionable areas and haunts.

The pleasure garden at Vauxhall had long been established, while the Ranelagh, opened in 1742, and the spa at Bagnigge Wells in 1758. The 1760s and '70s, however, saw a flourishing of new fashionable pleasure haunts in London: Almack's Club at 50 Pall Mall was founded in 1762 by William Almack and the assembly rooms set up by Mrs Cornelys (Theresa Imer) at Carlisle House, Soho Square. Almack's Assembly Rooms at King Street, St James's, was designed by Robert Mylne in 1765 as a rival to Mrs Cornelys' rooms. On 27 January, 1772, The Pantheon opened in Oxford Street, a grand venture that had taken over two-

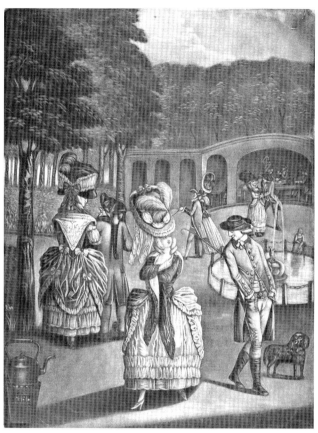

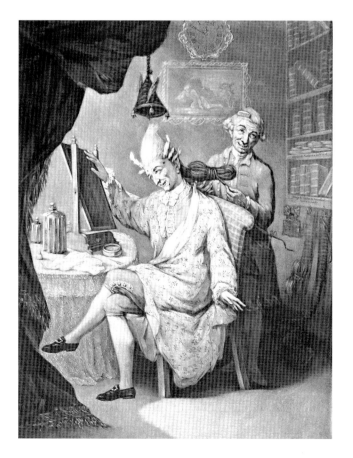

and-a-half years to build and which hosted masquerades, concerts and *ridottos*.

A 1772 'droll' mezzotint by Charles Brandoin illustrates the inside of the newly opened Pantheon [fig. 90], the highly suggestive gestures of the young girl to the left of the image emphasising its covert role as a place sexual assignation. Another mezzotint published by Robert Sayer in 1778, *The Beauties of Bagnigge Wells* [fig. 92], shows the spa fountain of the garden as a backdrop for a similar portrayal of sexual liaison. If this is how London's pleasure haunts were portrayed in its mezzotints, the majority of prints of fashionable London focused on the followers of fashions and the extremes of fashions that they wore. What is clear is that fashion was portrayed as a vice of the city. This is nowhere

— *From the Haymarkett*

better illustrated than in *The Farmer's Daughter's Return from London* [fig. 97], published by Humphrey in 1777. In it the farmer's daughter returns to her family in the latest city fashion, with her *tête* brushing along the ceiling, her family recoiling in horror. The immorality and 'perverse' nature of London ways is the theme of the print in which natural order, represented by the simple rural family, is challenged and turned upon its head, the fashionable world seemingly against common sense.

The establishment of venues in London coincided with the forming of highly fashionable clubs. Around 1770, Almack's premises at Pall Mall became the centre for two relatively short-lived, but influentially establishments: the Ladies Coterie, a fashionable club for both sexes which flourished between 1769 and 1771; and the Macaroni Club, a group of aristocratic young men recently returned from the Grand Tour, which flourished between 1764 and 1772, but reached its heights in the early 1770s. The Macaronis became synonymous with extreme fashion, effectively replacing the beaus of the mid part of the century. They were popularly perceived as fops who affected continental fashions, and even though the Macaroni Club was short-lived the associations remained, as can be seen in *From the Haymarket* (published in 1790) [fig. 93], a brilliant etching by Philip James de Loutherbourg of an Italian singer. The puffed up exaggerations of de Loutherbourg was echoed in the observances of Henry Angelo who recalled:

It will scarcely be credited now, that the fops of this date actually wore their hair frizzled out on each side of their head to more than a breadth of the visage, and that a solid pound of hair powder was wasted in dressing a fool's head!... the fashions of the day, which, indeed, were subjects fairly obnoxious to every species of satire and ridicule. Ladies, old and young, at this period what preposterous pads behind; and, as if this fashion wanted a counterbalance, enormous false bosoms well contrived of puffed gauze, so that they might be compared to pouter pigeons.[25]

Matthew Darly's *The Macaroni Print Shop* has already been mentioned, but it is interesting to note a series of caricatures by the leading satirist Henry William Bunbury (1750–1811) and published by Bretherton of New Bond Street in 1772. These illustrate humorous adaptations of Macaronyism with specific locations of London and include a City Liveryman, Temple and Middle Temple, Fish Street, Houndsditch, St James's and Covent Garden macaroni (George Colman). *A Macaroni Liveryman* (published in 1772) [fig. 94] shows the stereotypical City Liveryman in his official garb with added macaroni flourish. His portly demeanour and knife and fork portray the satirical stereotype of a City merchant whose real passion is for food, rather than the arts. As John Feltham

later wrote in 1802: 'The wicked arts of the last age were wont to observe, that the taste of the citizens was confined to their palates; that they gave the best dinners of any people in the universe; but, as for prints, pictures, or statues, they knew no more about them than a Hottentot…'[26] The poor area of Houndsditch, known for its second-hand clothes trade, provides the background for *The Houndsditch Macaroni* [fig. 95], a poor imitation of a macaroni with a crude profile of stereotypical lower-class physiognomy, pretentiously dressed in second-hand clothes. The image is redolent of the widespread awareness of macaroni culture and the criticism of its aping nature, the British dandy aping foreign fashions, and here, the plebeian aping the aristocrat.

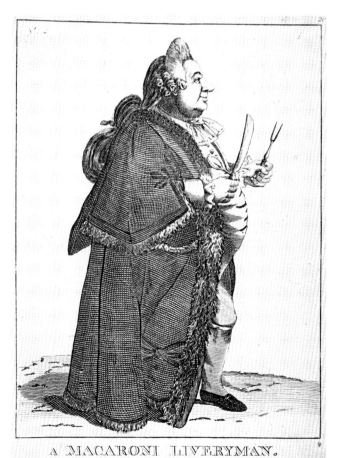

A MACARONI LIVERYMAN.

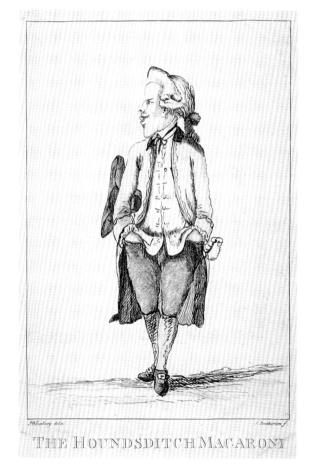

THE HOUNDSDITCH MACARONI

Gillray's *Following the Fashion* (1784) [fig. 96] gives a hilarious and ironical perspective on the identical theme. Using the same fashionable style of 'the Ton', he contrasts women of different physiques and background to emphasise the physical distortions. On the left is the slender aristocratic woman of St James's, whom Gillray labels 'a Soul without a Body', whilst the short and plump lady to the right is from Cheapside, 'aping the Mode, a Body without a Soul'.

Satirical images of London fashion contained an underlying morality, which formed the basis for much of the humour. Christian objections to outlandish fashion were inherent in puritanical attitudes, a criticism expressed in Methodism through Charles Wesley as well as being intrinsic to Vanity Fair of Bunyan's *Pilgrim's Progess*. It was vanity and vain-glory *in exes*, the extremes of the fashionable world being viewed as against nature and therefore against God and as a mockery of the natural state of mankind. Such ideas are clear in many of the satires, such as the farmer's daughter returning from the corrupt city of London, in Biblical terms, Babylon. Yet satire's criticism of modes of fashion went beyond such moral dimensions, for extreme fashions were also seen as inherently impractical. This belief, manifest in the unsuitability of certain fashions, such as enormously high wigs and bustles, ran counter to what was believed to be the prided English national characteristic of common sense. So, too, extreme fashion was accorded the status of a French characteristic in direct opposition to that of the English attitude, as Stevens displayed in his lecture which contrasts the English and French head (John Bull and Monsieur de la Grande Nation): '[of the English head] This is a plain, honest, well meaning, manly sentiment-speaking counte-nance.' In contrast fashionable excess 'with a French grin and simper... [to the English head] "Sir you have no complai-sance."'[27]

In satire vanity is most commonly portrayed when it appears at its most apparent, through the vehicle of the aged wishing to look young. As Corry sarcastically commented, 'While a superabundance of paints and lotions renovate beauty... that we may soon to be able to boast of female portrait-painters who will excel even Sir Joshua Reynolds

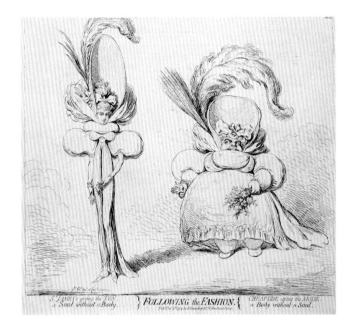

himself!'[28] The mezzotint, *The Old Beau* (1773) [fig. 91], showing the ecstasy of the vain and aged beau staring admir-ingly into his looking glass, clearly illustrates this point.

Another theme of criticism within satire was the domi-nance of the female above the male within the fashionable world. The nature of Englishness, which was written about at length alongside the major characteristics of other European nations, was seen as essentially masculine, as opposed to the stereotypical and perpetuated image of the effeminate French. The urban fashionable world was seen as a subversive threat to the masculine image and satires encompassed this viewpoint in their criticisms. *Under Hoop & Bell, The World or Fashionable Advertiser* (1787) [fig. 98], produced by Boyne and Walker, makes this viewpoint explicit through the actress Mrs Wells and her lover Major Topham. The subservient major has taken the place of the clapper of the bell with a ring piercing his nose on a rope held by his assertive mistress, whose petticoat is the bell. The sexual innuendo and power place require little expla-nation.

Despite its humorous criticisms, satire's role remained

typically ambiguous, servicing a fashion commentary as well as offering a moral reprobation of fashion. Within satire, which had always mocked fashion, the prints became a more fashionable commodity themselves. 'They liberally censure each other, not from any gratification which they receive from satire, but purely for mutual edification. This love of scandal, which so generally prevails among the natives of London, is cherished by their circumscribed situation.'[29]

When Wendeborn visited London, he commented on the ineffectiveness of such images as moral censure:

Neither caricatures exhibited at the windows of printshops, nor satirical paragraphs in newspapers, against ridiculous fashions, prove of any effect, the former are stared at and laughed at, on passing them in the streets, and the others produce merely some merriment for those who read the papers, without effecting the least reformation in them whom they particularly concern. This rage for finery and fashion spreads from the highest to the lowest; and in public places…[30]

Fashionable arenas such as the Pantheon and Almack's were commercial ventures, which charged for events or annual subscription. They formed the infrastructure of the metropolis's leisure industry and were part of the burgeoning consumer culture of the eighteenth century. They were, above all, public amusements where all of society could go if they could afford a ticket – the aristocrats (despite disap-

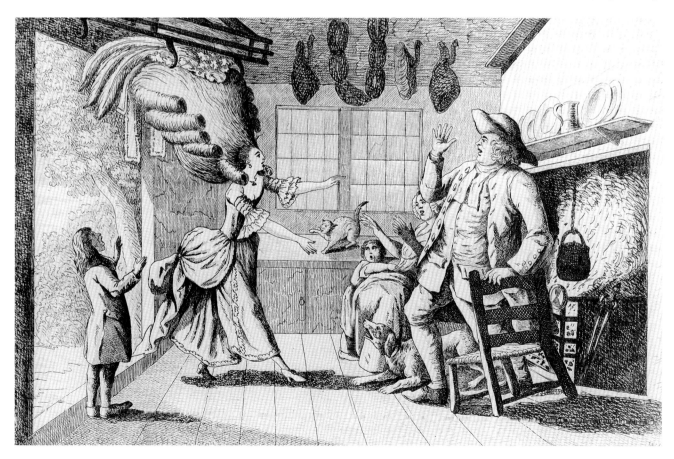

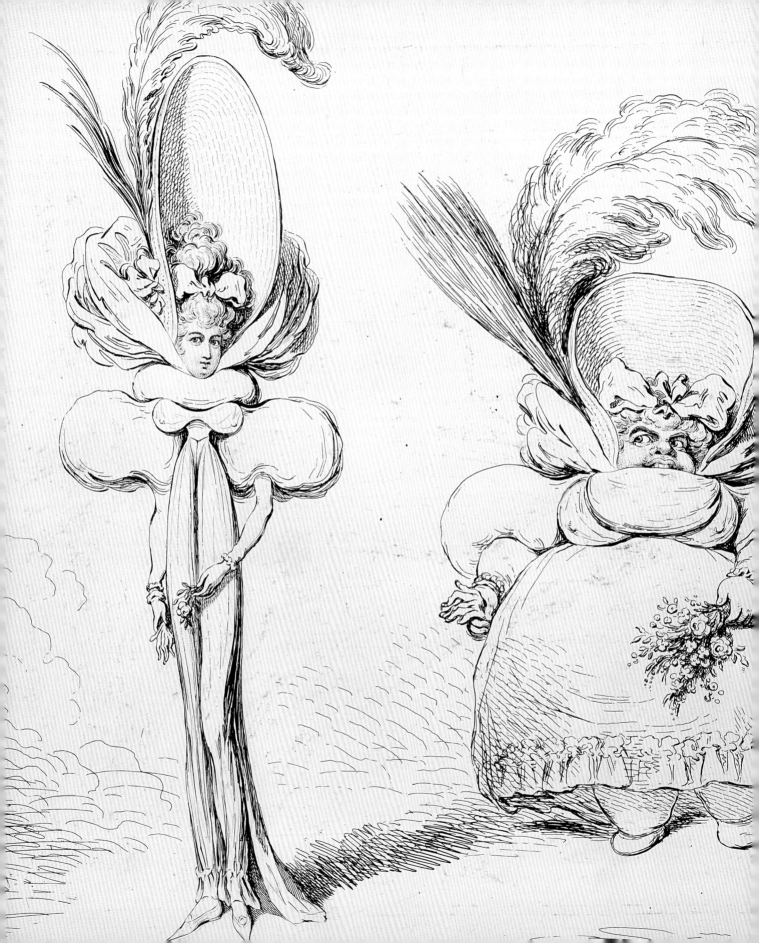

proving conservative elders) attended, as did the socially rising. Fashion offered a passport into polite society representing the outer image of the London citizen where an identity could be grasped in an instant. But if fashion was an identifier, by the same token it could offer a disguise in which to hide, a prop with which to reach social aspiration. The greatest costume of disguise was the popular masquerades in which all are masked and intermingled for the evening. In the print *View of all the principal Masquerade Figures at the Rotunda May 12th 1789* [fig. 100], the procession of the rich costume and caricatured crowd are seamlessly interwoven.

The fashionable crowd, in their more familiar everyday costumes, would promenade in the west end parks of London, particularly St James's. Such subjects, as we have seen, were familiar to satirists in the mid-eighteenth century, where social aspirants rubbed shoulders with the landed gentry. In Edward Dayes's *The Promenade in St James's Park* (1793) [fig. 99], the elegance of the scene is paramount. The obsessive interest in refinement, manners and etiquette that existed in the period is manifest in the construction and depiction of the scene. Order predominates, and we are given a picture of genteel London, where chivalrous acts are played out within firm social structures. Its influence is French, its genre metropolitan. Essentially only one class of people are represented, with no street cry to jar the polite chatter, and elegant slim bodies display an almost unnatural uniformity, the physiognomy refined. An air of polite decorum radiates the poses and movements, which mimic the formal stances of the full-length Georgian portrait.

The same scene is depicted in a watercolour by John Nixon, *Entrance to St. James's Palace*, but here Nixon gives us variety. As a result we sense a greater reality about a scene where fashionable society and beggars are shown together. So too, the physiognomies, body shapes and gestures are equally varied. Children do not simply stand politely as ornaments to their parents: they play. Individuals condescend, sneer, gossip and snatch private moments. Each print in its turn follows a format of depiction, but within it the satire of Nixon offers us a wider spectrum of life in London than

UNDER HOOP & BELL

98. Anonymous, *Under Hoop & Bell, The World or Fashionable Advertiser*, 1787. Etching.
Opposite:
James Gillray, *Following the Fashion, St James's & Cheapside*, 1794 (detail of fig. 96).

Dayes's idealised vision of social order ever could. As Edward Dayes himself wrote: '...dirty, ragged ruffians, accompanied with trash and common-place objects, are not only beneath the dignity of painting, but may corrupt young minds...'[31]

London's Street Life

Nevertheless, in no country are more poor to be seen than in England, and in no city a greater number of beggars than in London.'[2]

After an evening of entertainments the fashionable world descended onto the streets to return home. As Hogarth had shown the return of the rakes from an evening's debauchery in the early morning of Covent Garden, so Robert Dighton (Snr., 1751–1814) depicts the return of the fashionable belle from the night's revelries in *The Return from a Masquerade – A Morning Scene* (1784) [fig. 101]. Dressed in a picturesque bucolic shepherdess costume, she slumps out of the side of the sedan chair, the urban reality amusingly contrasting the faked rural idyll. With apelike grimacing physiognomy, the sedan chair carriers and a young boy smile at the antics of a young chimney sweep. The London sweep, a recurrent figure in eighteenth-century satire, is typically represented as a figure of fun, an impish presence that makes a humorous commentary on the action. Here he holds the lady's masquerade mask in his left hand and leers directly at the dirty urchin behind the pristine façade. Dighton had begun life as a portraitist and it is interesting to note how he has used physiognomy in contrasting the high and low life of a London's street, the delicate features of the belle contrasted with the rough and earthy features of the chairmen and boys.

A grey wash drawing by Dighton from around 1786, *Lady being carried through the streets of London in a Sedan chair* (c. 1786) [fig. 102], depicts a similar but contrasted scene where the crude physiognomy of the liveried chairmen exude misery as they carry an ugly caricature of a lady with her lapdog through the streets of London. The drawing is insightful in its observation of peripheral detail, giving us a rare view of a London street, particularly to the right, where under a group of posted bills a female boot black is sitting on the pavement cleaning a pile of boots and shoes.

Many of Dighton's London scenes were made into prints by the publishers Carington Bowles (1724–92) whose print establishment, at 69 St Paul's Church Yard, is wonderfully portrayed in Dighton's print of *A Windy Day*, 1783 [fig. 22].[33] Dighton's mild caricatures contain a rare degree of observation and unusually good depictions of everyday street

99. Edward Dayes, *The Promenade in St James's Park*, January 1793. Etching and Aquatint.

100. Anonymous, *View of all the principal Masquerade Figures at the Rotunda May 12th 1789*, 1789. Engraving.

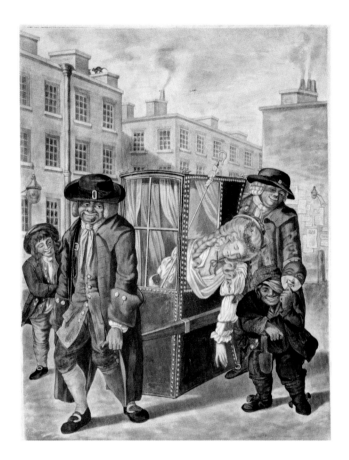

life. He produced a large number of images of the professions and trades operating in London. *Quarrelsome tailors*, *The Pretty Oyster woman*, *The London Dentist* and *The Lamplighter* are just a few examples of this genre. His drawing of a pea cart [fig. 103] from around 1786 depicts a pea seller with his cart. Two shire horses stand harnessed in front of the cart, which contains an attached placard which reads, 'Simon Pod, Battersea.' On board, a woman, most probably his wife, pours peapods into a fat woman's apron, a child holding out his hat to catch any going astray. 'Simon Pod' (a typically punned trade name) stands to the left of the picture holding a whip in his left hand and holding his other hand to his mouth whilst calling his wares. A later watercolour by Dighton, *A Jewish Clothes Trader and a Butcher* of 1807 [fig. 104] presents us with a stereotypical image of a London Jew. Jewish hawkers of second-hand garments were a familiar sight on London streets within this period and clothes were either sold or used for barter, which is being depicted here. The trader is hunched forward with a wig in his left hand and several hats stacked on his head. The fat butcher, sucking on a clay pipe, with a hand in his apron, is wearing an ill-fitting wig, and the barter of a wig for a piece of meat provides the basis of the drawings humour.

The London Crowd: Pageantry, Public Amusements and the Mob

> I was so close Imprisoned by the Bums and Bellies of the Multitude that I was almost squeez'd as flat as a Napkin in a Press. *Ned Ward* [34]

London, the largest urban conurbation in England, and at several points in history, the largest urban area in the world, has always known the crowd. This may be the crowded throng of a narrow thoroughfare, or the bustle of the everyday where individuals collide in the pursuit of their own tasks, or the crowd that has assembled for a singular purpose. With the crowd in St James, we have seen a promenade, a casual grouping where the individual in Edward Dayes has been consumed in homogeneity, but which in

101. Robert Dighton, *The Return from a Masquerade – A Morning Scene*, 1784. Hand coloured mezzotint.

102. Robert Dighton, *Lady being carried through the streets of London in a Sedan chair*, c. 1786.

satire the individual, or rather different 'types' succeed in showing the variety of the crowd. It is the crowd that has joined for a particular reason that characterise many satirical prints, from the formal and the casual, to the politically motivated. In each of these images the role of the individual and their relationship to the common purpose is an overwhelming theme; how distinctive an individual can be in a mob for example, and how we can detect different motives within the individuals depicted.

Civic and state pageantry has traditionally connected the rulers and the ruled, a display and celebration of that rela-

tionship. In these formal and grand occasions, in opposition to the faceless throngs of state portraiture, satire focused upon the riotous nature of the crowd. It spied the pushing, the jostling, and the thieving, and presented a host of individuals enjoying and abusing the event. John Nixon's *A City Pageant* [fig. 38] displays the events of 19 April, 1802, when Sir John Eamer, the Lord Mayor, entertained the Prince of Wales in lavish manner in the City. The procession of royalty and dignitaries began at Temple Bar where the Prince was escorted to the Mansion House. The following day *The Times* described the scene in great detail.

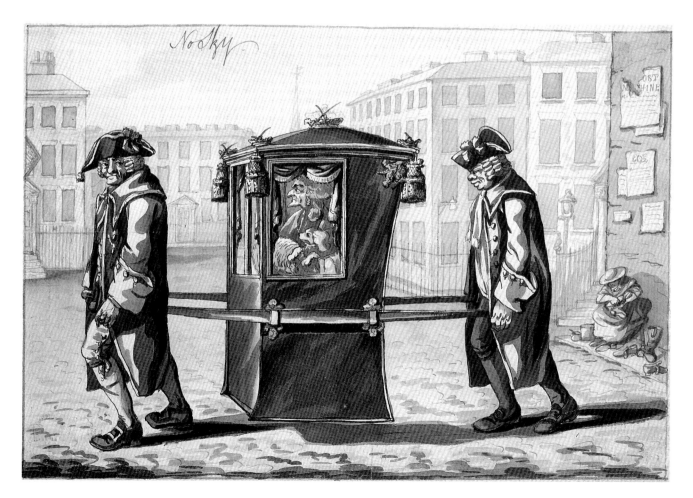

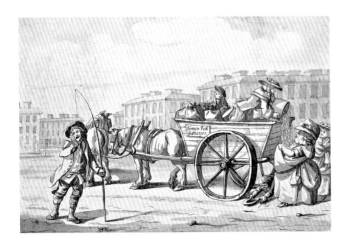

103. Robert Dighton, *Pea Cart*, c. 1786. Pen and grey wash.

104. Robert Dighton, *A Jewish Clothes Trader and a Butcher*, 1807. Watercolour over pencil, 24 x 21.4 cm. Inscribed lower right: 'Dighton – 1807'.

The circumstance of the Prince of Wales honouring the Lord Mayor with his company at a public festival in the City, naturally created much expectation and caused great preparations to be made for his reception in a manner suited to his high birth, and the munificence of the Chief Magistrate of the first City in the world.

The Prince of Wales was met at Temple-bar by the City Marshals, whose intention it was to escort his Royal Highness to the Mansion-House; but his carriage had scarce entered the City, when the populace took the horses from his coach, and drew him with loud huzzas. At the Old Bailey, a detachment of the City Militia was stationed as an escort, though it was of little use, as the mob would not forego the satisfaction of drawing the Heir Apparent.'[35]

Nixon focuses on an incident where Sir John Eamer struggled with his horse and showed 'an approved method (of) Riding a Restive Horse without danger.' The pretensions of Sir John Eamer and of socially aspiratiring merchants is depicted through the reference to 'Grocer' and his discomfort and difficulty in riding the horse. Nixon's watercolour was made into an aquatint and published by Hewitt as a humorous memento of the event.

If Lord Mayor's Pageants attempted, if sometimes fruitlessly, to impose order on the crowd, fairs and festivals were a much more casual and local saturnalia where entertainments had a more direct engagement. J. Pitts's large engraving of *A Smock Race at Tottenham Court Fair* (1784) [fig. 106] gives a rare view of Tottenham Court Road in 1784. At this period, Tottenham Court Road led from Oxford Street to Tottenham Court and was a semi-rural area of London. As such, the jollities being played out are essentially rural but with an urban cast and setting, and the image of a chimney sweep riding a cloven beast in the mid-ground is redolent of this juxtaposition. The central image is the smock race where four young women can be seen racing towards a makeshift finishing line, with one stumbling over a boar and scattering its piglets. Around the race the crowd

105. John Nixon, *A City Pageant*, 1802. Pen and wash drawing.

106. J. Pitts, *A Smock Race at Tottenham Court Fair*, 1784. Engraving.

107. John Nixon, *Bartholomew Fair*, 1813. Watercolour.

has assembled and there is a chaos of homemade entertainments. Lacking the sideshows and amusements of the large London fairs, the market animals provide most of the high jinx created with a bucking donkey and tossing bull. The amateur hand that created the scene has used several stock images from earlier prints, such as the fallen fruit seller whose wares have become scattered at the front of the print. Nevertheless, the print represents a rare depiction of particular amusements at the edge of an expanding city, for although the buildings depicted are generic, naive and awkward, the street signs give us an exact London location. Here we see only one class of audience enjoying the moment, an early celebratory and essentially suburban image.

John Nixon's watercolour of Bartholomew Fair [fig. 107], and the print made from it shows the great London fair in 1813, some years after Dicey's image of the same event.[36] This famous event in London's calendar attracted a much wider social mix than a local fair such as that at Tottenham Court Road. Based at the south side of Smithfield, entertainments at this time ranged from Polito's Menagerie to theatre performances, swings and other sideshow rides. Nixon makes a feature of the illuminations appearing at twilight when the fair came to life. Similarly, Rowlandson and Pugin depict the fair as a nocturnal scene with the magical light sources that the text describes as, 'the gaudy glaring lights of various booths.'[37] In common with

Tottenham Court and Billingsgate before it, Nixon's satire focuses on the accidents and collisions of the populace.

London as the home of Parliament provided the platform for British politics. Electioneering, political riots and rebellions centred on the metropolis. Nowhere was this better symbolised than by the Westminster elections at Covent Garden. Robert Dighton produced three successive watercolours of the Westminster elections held in 1784, 1788 and 1796. The large-scale watercolours represent the most important group of paintings on the election theme since Hogarth's Election series. The location for each of the paintings is Covent Garden, where the Piazza provided a large open area for the crowd to congregate. The hustings, or temporary election platform where the nominated candidates stood and addressed the crowd, can be seen on each erected in front of the portico of St Paul's. The crowd is integral to the composition and the relationship between the politicians and audience are explored through both composition and individual representation. In each successive election Dighton reveals the changes in this shifting relationship and the series is particularly interesting in recording the significant changes that occurred in the running of an election between 1784 and 1796.

In *Westminster Election, 1788* [fig. 108], the scene depicted is the Westminster by-election where Lord John Townshend (1757–1833), Fox's ally, faced Admiral Lord Hood (1724–1816), campaigning for re-election in order to serve as Lord of the Admiralty. Banners for both sides can be seen in the vast and packed crowd. The figure of Charles James Fox (1749–1806) in conversation with Duke of Norfolk appears below the ornate phaeton. The three central figures are Lord John Townsend, Georgiana, the Duchess of Devonshire, and her sister Lady Duncannon. 'There is', writes Diana Donald, 'an unmistakable air of aristocratic detachment in these figures, as though in disavowal of the ministerial accusations of complicity in mob violence.'[38]

Other identifiable persons include John Wilkes (1725–97), then Chamberlain to the City of London, with his famous squint, who is being distracted by a pretty ballad seller whilst being the victim of a pickpocket. The Prince of Wales

108. Robert Dighton, *Westminster Election, 1788*, 1788. Pen and watercolour.

109 (*right*). Robert Dighton, *Westminster Election, 1796*, 1796. Pen and watercolour.

110. Richard Dighton, *A Pillar of the Exchange*, [Nathan Meyer de Rothschild], c. 1815. Pencil and watercolour.

111. Richard Dighton, *A Firm Banker*, [Sir William Curtis of the bank Curtis, Robarts & Curtis], 1824. Hand-coloured etching.

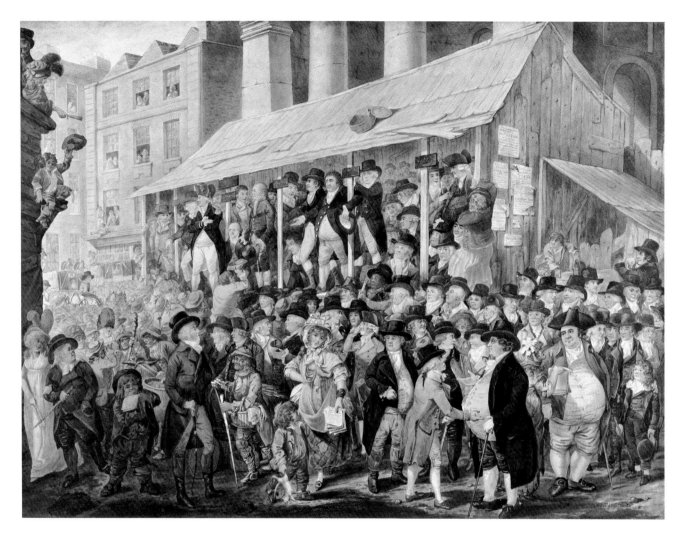

can be seen with Mrs Fitzherbert driving a large ornate phaeton through the crowds. He is greeted by a Foxite emblem of a stuffed fox raised on a pole and the hats raised by the welcoming public. The background depicts the house fronts of Covent Garden's south piazza, the hustlings outside St Paul's visible to the left.

The scene is a mildly satirical and decorative. Within its many details are motifs and familiar images of electioneering. The portraits retain a naturalistic physiognomy whilst the lower orders are subject to caricature. The elegantly coiffured hair of the Duchess and her sister is compared to the Pomeranian dog at her feet and linked to the Prince of Wales and his escort. In contrast to this, a dog to the left is scavenging the contents of a broken pitcher bewailed by a small boy. A man on the right sells cherries which he weighs above an ass's head and which the boy to the right finds too sour.

The two ballad sellers, dressed almost identically, are contrasted: the sly and pretty with the fat and loud.

The 1796 Westminster election was fought between John Horne Tooke, (1736–1812), Admiral Sir Alan Gardner (1742–1808/9) and Charles James Fox. In Dighton's watercolour *Westminster Election, 1796* [fig. 109], all of the candidates can be seen standing on the hustings within the various bays sign-posted with their parishes: St Annes, St Paul's and St Martin's-le-Grand and so forth, informality and inclusion giving way to formality and divide. Such watercolours, complex in composition and large in size, were engraved by subscription for an exclusive audience. The artist's own position is formalised as almost journalistic, and the watercolour contains a self-portrait of Dighton who can be seen sketching the scene to the far right of the picture. The contrast between 1788 and 1796 is considerable, and, as

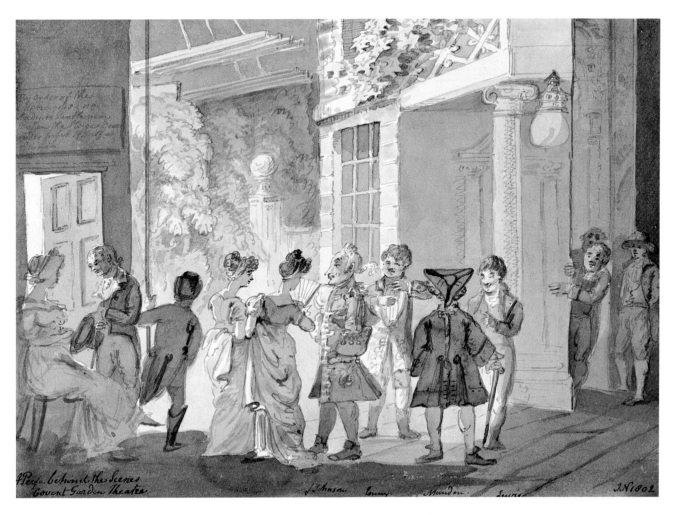

Diana Donald has brilliantly argued, the latter watercolour represents the end of a genre. 'Despite the scale and complexity of the composition, there is now a sensation of uncomfortable stasis... The signs of popular participation in the election are reduced to a minimum, and have subtly changed in character.'[39] The formality of the portraits of the politicians belies their distance from the crowd, which is much more orderly and clearly separated: the appearance reflecting the political change.

London Individuals and Comic Portraiture

The art of 'caricatura', through its emphasis on facial distortion, encompassed portraiture, where the distinct features of the sitter were exaggerated to create a recognisable portrait. This could be as lax as a verbal or symbolic reference or as detailed as a portrait, in the case of single head or figure caricatures. The distinctive caricature portraits and cartoons of individuals that are familiar in later nineteenth- and twentieth-century images, particularly the famous *Vanity Fair* portraits, and many others, had their roots in Georgian caricature, and more particularly crystallised in the works of Robert Dighton and his son Richard Dighton. Robert Dighton had begun his career as a serious portraitist. A 1798 advert in the *Morning Chronicle* read:

> CORRECT LIKENESS. Mr. Dighton, No.12 Charing Cross informs the Public that he continues to take correct elegant likenesses in miniature for half a guinea, in half an hour & in a manner peculiar to himself, & which have given such universal satisfaction to employers.[40]

Dighton's portrait of the auctioneer Mr Christie is an excellent example of such caricature portraiture. Entitled *The*

Specious Orator (1794) [fig. 113], it is humorously subtitled *Will your ladyship do me the honor of say £50,000 – a mere trifle – a brilliant of the first water an unheard of price for such a lot, surely*. It is difficult to imagine that such an essentially polite representation could cause any offence. Its success is due to the subtle merging of character and occupation reflected in both its setting and through its mildly caricatured physiognomy. Dighton's experience as a portraitist, his familiarity with capturing the likeness and the demands of individual patrons, allowed him to move with relative ease to produce professional caricature portraits. It also determined a convincing likeness and a certain politeness of representation which distinguishes his work from the acerbic satires and amateur caricatures of his peers. The brilliant series of well-known figures were compiled into two volumes, *City Figures* and *West End Characters*, reflecting London's make up of the City and Westminster.

Satirical watercolours, many of which did not make their way into print, succeed in giving us rare images of London life. John Nixon's *A peep behind the scenes: Covent Garden Theatre* (1802) [fig. 112], for example, drawn from life, is at once intimate and revealing, beyond its comic depiction. But from the late eighteenth and the early nineteenth century, the most prolific and brilliant body of watercolours of London were produced by the hand of Thomas Rowlandson, whose unique contribution we shall consider in the following chapter.

THE SPECIOUS ORATOR.
WILL YOUR LADYSHIP DO ME THE HONOR TO SAY £50·000
— A MERE TRIFLE, — A BRILLIANT of the FIRST WATER,
an unheard of price for such a lot, surely.

113. Robert Dighton, *The Specious Orator*. [Mr Christie] *'Will your ladyship do me the honor to say £50,000 – a mere trifle – a brilliant of the first water, an unheard of price for such a lot, surely'*. 25 March, 1794. Hand-coloured etching.

Thomas Rowlandson's London

'Every one at all acquainted with the arts, must well
know the caricature works of that very eccentric genius,
Rowlandson.' *Henry Angelo* (1756–1835)[1]

'His genius was unmistakably for the comedy of everyday
life, and by and large he sensibly kept firmly within this
range of common experience.' *John Hayes*[2]

Amongst the vast body of engraved images that emerged from the golden age of satire, those of the watercolours and drawings by Thomas Rowlandson define the era. These images, reproduced in their hundreds by the prolific hand of a master draughtsman, are as familiar as the print productions of James Gillray. It is difficult to know exactly how well Rowlandson's images were known to his audience as contemporary records of his life and influence are frustratingly scarce, but the large number of copies made by Rowlandson himself and the considerable number of his imitators suggest a substantial popularity. Today, Gillray and Rowlandson stand as the leading figures of their own time, mainly because of their sheer brilliance of draughts-manship and invention, which went far beyond that of their satirical colleagues. Both were prolific and individual in the development of their respective styles, yet they could not be more different. Both studied in the life class of the Royal Academy and used their natural and nurtured talents as draughtsmen for satiric and caricature images, and as a result were marginalised.

The satire of Gillray was predominantly political and, if social, clearly honed. Known individuals predominantly feature, the attacks aimed towards specific targets, and applied to explicit and publicly known events. His approach was marked by outrageously and imaginatively forged excesses, which symbolically and allegorically serve the thrust of the visual argument.

Rowlandson, in contrast, presents to us a more generic, everyday human comedy. He is, in effect, far closer to the fine-art tradition than Gillray. He won prizes at the Royal Academy Schools and his style is directly comparable to other great drawing masters of the eighteenth century.[3] Despite this, his own unashamed inclination towards carica-ture resulted in his being sidelined to the fringes of the academic world. His subjects, too, were an anathema to the idealism and classicism that held sway at the Royal Academy [see chapter 3]. His drawings do not represent a timeless ideal, but rather the timeless folly of mankind; they record the particular, the momentary and the exaggerated human imperfections of the everyday. The great events of history championed by the Royal Academy become the dramas and catastrophes of the common place, the recognisable regular incidents in contemporary life, even if they are heightened for the comedy to emerge. Undoubtedly coarse in his humour, and happily, for us, free from the moralising and hierarchical distinctions of the acceptable and unacceptable, Rowlandson drew the world around him from his eye-level perspective. There is within his drawings a freshness, vitality and urgency of line, appearing to be drawn at speed, with conviction. Indeed, his apparent ease of drawing and prolific output was in itself a concern to the Academy, as his close friend Henry Angelo indicated:

> His misfortune, indeed, was, as I have been assured by capable authorities, who noticed his juvenile progress, that of possessing too ready an invention: this rare faculty, strange as it may seem, however desirable to the poet, often proved the bane of the painter.[4]

Rowlandson stands apart in that he was free from the verbiage and literal nature of popular satiric prints. In other words, his drawings present a complete and self-contained visual image, free from written commentary or verbal witti-cisms, and free, in effect, from the literal tradition of satirical prints. Instead, they are reflective and observational, and the comedy is purely visual. In the same way, his drawings are not didactic, they do not teach, preach or offer any moral standpoint. They are reflective of life in their humour of irony and stark contrast, with the figure of death often at hand. His 'ordinary' response to the world, noted by John Hayes, was typical of both the man's character and his approach to life and art. In his insightful study of Rowlandson, Hayes presents us with a convincing analysis of his character:

> His character and outlook on life reflected his normal good health. He was well-balanced, though inclined to the normal excesses of the period, hard drinking, gambling and promiscuity; good-mannered, sociable, on the whole mild-tempered and lacking in indignation, ready enough

to accept life as it was, not taking anything too seriously; somewhat contemptuous of the weak, and insensitive to human sufferings and infirmities, at any rate when he was not personally involved.[5]

It is worth briefly considering Rowlandson's life, training and associations, to give a context for the themes in his work and the importance of his London images. Thomas Rowlandson was born in July 1756 in Old Jewry, London, the son of William Rowlandson, a prosperous wool- and silk merchant. When Thomas was two, his father was declared bankrupt, and Thomas was sent with his younger sister, Elizabeth, to live with their aunt and uncle. The artist's first and formative impressions were of the streets of London, his schooling taking place in Soho Square. At sixteen he entered

the Royal Academy schools, where he continued, as was the practise, to study for several years with intermittent trips to the continent. In 1787 he moved to 50 Poland Street, where he lived from April 1789, when his aunt left him a substantial inheritance. As the *Gentleman's Magazine* wrote in his obituary:

He then indulged his predilection for a joyous life, and mixed himself with the gayest of the gay... He was know in London at many of the fashionable gaming houses, alternatively won and lost without emotion, till at length he was minus several thousand pounds ... he had frequently played throughout a night and the next day; and that once, such was his infatuation with the dice, he continued at the gaming table nearly thirty six hours.[6]

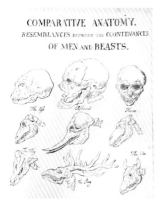

115. Thomas Rowlandson, *Comparative Anatomy. Resemblances Between the Countenances of Men and Beasts.* Pen with different coloured inks and watercolour over pencil. © The British Museum, London.

116. Thomas Rowlandson, *Miseries of London –or– a Surly Saucy Hackney Coachman*, 1814. Copperplate.

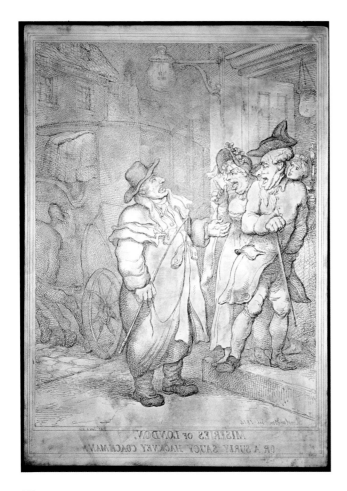

Gambling was clearly part of Rowlandson's character, and it was fortunate that his draughtsmanship provided him with alternative means, as he experienced the inevitable financial ups and downs of a gambler.[7] In 1792 he moved to 52 The Strand, and the following year to the basement of 2 Robert Street, Adelphi, for three years. It is known that he lived between 1800 and 1827 at 1 James Street, Adelphi. Rowlandson was a happy collaborator and he was closely associated with many characters of the period such as the fencing master, Henry Angelo, the wit 'Peter Pindar' (John Wolcot 1738–1819), Henry Wigstead and the publisher Rudolph Ackermann. As Angelo later recalled:

Well do I remember sitting in this comfortable apartment, listening to the stories of my old friend Peter Pindar, whose wit seemed not to kindle until after midnight, at the period of his fifth or sixth glass of brandy and water. Rowlandson, too, having nearly accomplished his twefth glass of punch, and replenishing his pipe with choice *Oronooko*, would chime in. The tales of these two gossips, told in one of those nights, each delectable to hear, would make a modern *Boccaccio*.[8]

The development of Thomas Rowlandson's visual style began when he joined the Royal Academy schools on 6 November, 1772. His first serious recorded subject dates

from 1775, entitled *Dalilah payeth Sampson a visit while in prison at Gaza*. Unfortunately the work did not survive, although the title itself indicates that the high aims of the Royal Academy did not fail to make an impression upon him. Furthermore, the Royal Academy's life room, which he later depicted in drawings and prints,[9] featured strongly in the student's study and reflected in the style, ease and accuracy with which Rowlandson depicts the human form. John Hamilton Mortimer (1740–79) strongly influenced the young Rowlandson, but it is the influence of 'caricatura' that mostly concerns us here. In Rowlandson's draughtsmanship we see observation tied with exaggerated form which directly links him to the grotesques of Leonard da Vinci, Ghezzi and Caracci (see Hogarth's *Characters and Caricaturas*). It is entirely consistent that he was also interested in the physiognomic theory that accompanied this, and several pages of sketches survive in the British Museum [fig. 115] and elsewhere of a projected book on comparative anatomy between animals and humans.[10] On one sketch, Rowlandson notes the importance of Giovanni Della Porta's (c. 1542–97) *De Humana Physiognomia* (1586), and the comic potential of such theory:

Porta most has observed the resemblances between the countenances of Men & Beasts and has extended this enquiry furthest. He as far as I know was the first who rendered this similarity apparent by placing the countenances of men & beasts beside each other – Nothing can be more true than this fact.[11]

The significance is that not only does the human character visually resemble the animal, but the human counterpart expresses the characteristics of that animal. The comparison of animal and human skulls, for example, highlights the timidity of vegetarians with the ferocity of carnivores, or a puffed-up bird with the arrogant squawks of a fat gentleman with upturned nose.

Physiognomy represents but one strand of Rowlandson's imagery; the remarkable beauty of his economy of line and the great complexity of his style reveals other influences that

he was exposed to, expressing an acute awareness of the trends of artistic depiction of his own time, such as the theories of the sublime and the picturesque. William Gilpin's picturesque tours in particular can be seen, not only in Rowlandson's own rustic tours of the country, but also the in the anti-Gilpin satire of Dr Syntax, which he illustrated for the publisher Rudolph Ackermann. Beauty, after all, was essential to Rowlandson's satires, even if at times it acted simply as a foil to the grotesque. If caricature and its accompanying concerns influenced the imagery and forms that Rowlandson adopted, the quality and masterly line owe much more to the fine art tradition, and in many examples within Rowlandson's oeuvre one can detect Gainsborough and Canaletto.[12]

It is in the tinted drawing that Rowlandson created his most important works and the many prints and illustrations that he made essentially began life as fluid drawings. This, in itself, separated him from most other satirists and caricaturists of his age. His prolific output ensured that his images were widely known, as Henry Angelo commented:

I think it may be safely be averred, that he has sketched or executed more subjects of real scenes, in his original, rapid manner, than any ten artists, his contemporaries, and etched more plates than any artist, ancient or modern.[13]

The artist was not averse to making copies of work and a large number of examples illustrate his willingness to make replicas of his successful works. His prints could thereby reach a larger audience and many of these retain some of the energy and masterly line of the drawings. Rudolph Ackermann, Samuel Fores and Thomas Tegg stocked and sold them in enormous quantities. The copperplate of *A Surly Saucy Hackney Coachman* of 1814 [fig. 116] illustrates the process of etching as it appeared on the plate having been transferred from an original tinted drawing. This particular 'Misery of London' depicts a grotesque elderly couple arguing with a hackney coachman over the fare, a recurrent London archetype and situation.

117. Thomas Rowlandson, *An Irish Member on His Way to the House of Commons*, c. 1801. Pen with different coloured inks and watercolour over pencil.

118. Thomas Rowlandson, *Gaming at Brooks's Club*, c. 1810–15. Pen with different coloured inks and watercolour over pencil.

London as the Stage of the Human Comedy: Themes and Motifs in Rowlandson

Rowlandson was no philosopher, and so his uncontrollable spirit, sweeping over the prescribed pale, took its excursive flights, and caught its thema upon the wing.[14]

The subject and recurrent motifs of Thomas Rowlandson arose from his own observation of everyday behaviour. These were enhanced with comic theory and comic types current in popular consciousness and perpetuated in popular literary and visual satire. Rowlandson's images often depend upon the humour of contrasts and in particular the themes that emerge from these contrasts. As Francis Grose had written in his *Rules for Drawing Caricaturas*, 1788, 'contrast alone will sometimes produce a ludicrous effect…'[15] The contrasts that Rowlandson uses are strikingly visual: the grotesque and the beautiful; the young and old; the fat and thin; the tall and the small; the masculine woman and feminine man; the graceful and the brutal; the healthy and the infirm, and the living and dead. These contrasts form part of the comic catastrophe that Rowlandson chooses to represent, whether that be age marrying youth or ugliness lusting after beauty, themes explored in Ronald Paulson's engaging book on Rowlandson.[16] The figure of death often appears to show the fleeting foolishness and triviality of these collisions, but they are in Rowlandson the very essence of life. Sometimes the contrast was developed in pairs of images such as the *English* and *French Reviews*.[17]

In staging his human comedy, Rowlandson developed many of what are essentially stock-in-trade characters that were popularly understood, a pantheon of characteristically Rowlandson creations that related directly to comic archetypes known to his contemporaries in London. In Stevens's celebrated lecture on heads, a popular manifestation of comic types, and London satires such as those by John Corry,[18] we can see many parallels with Rowlandson's characters. Stevens, for example, comments:

… these Old Batchelors are bullies in love… As a punishment for their infidelity, when they are old and superannuated, they set up for suitors; they ogle through spectacles… This laced coat and solitaire, and bag-wig, shew what he would be, and this fool's cap is what he is.[19]

In Rowlandson's *An Irish Member on His Way to the House of Commons* (c. 1801) [fig. 117] we have a large pot-bellied and amorous old gentleman ogling a lady through a monocle in Lisle Street, Soho.[20] The contrast of age and youth, beauty and grotesquery is played outside a bawdy house emphasised by the three couples on the carriage and the old madam opening the door. The animal passions of the lecherous old goat himself is echoed through the attentive dog moving towards the brothel, and one is reminded of the descriptions on drawing eyes in Grose:

Eyes themselves differ exceedingly in shape as well as magnitude; and also in the form of their lids; some being globular and projecting, vulgarly called goggles; others small and hollow… The mouth and eye-brows are the features that chiefly express the passions; thus, an open mouth, with elevated eyebrows, marks astonishment and terror…[21]

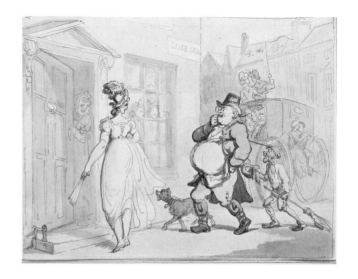

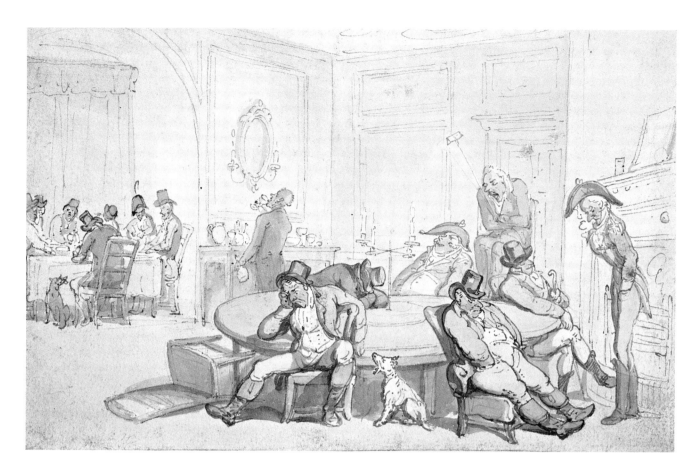

Rowlandson himself was a gambler, a figure which appears in his drawings, including a large number of versions of *Gaming at Brooks's Club* (c. 1810–15) [fig. 118], which depicts the enormously popular pastime.[22] In terms of the smart and the wealthy, this meant the exclusive clubs of St James's, London's most fashionable district, such as Brooks's and Crockford's. In Rowlandson's tinted drawing, a group of dejected gamblers reflect the visage characterised in Stevens: 'This is his original face; a heavy, vulgar, incurious, down-looking countenance... And this was his face that he awoke at midnight with; when Conscience, assisted by memory, commanded him to undergo a self examination...'[23]

The Quack Doctor and Physician had long been a figure of fun: 'The head of the Quack-doctor,' Steven's lectured, 'is exhibited to shew the weakness of wisdom, and the strength of folly; for if wisdom were not too weak, would such fellows as carmen, cobblers, and porters, be permitted to vend their unwholesome mixtures, under letters-patent?'[24] In *Touch for Touch or a Female Physician in Full Practice* [fig. 123] (c. 1810–11), Rowlandson humorously presents the prostitute as

physician, being paid by an amorous old gent. The work also serves as a satire for electoral reform, as Rowlandson notes on the back of the drawing: 'Bribery and Corruption / an old Member trying to get into a Rotten Borough.' This is a reference to the 'rotten' borough of Old Sarum (drawn on the door), a notorious ancient borough of miniscule population (only eleven in 1832), which returned its member to parliament, whilst London, with a population of 1,878,214, returned only ten members of parliament.

If Rowlandson developed a cast of archetypes, their stage was often London, and his drawings of the metropolis give us a picture of the commonplace and everyday of life in the late eighteenth and early nineteenth century. Rowlandson lived in London for all of his life; he knew its areas, buildings and the people who lived there, the social mores, its leisure haunts and infamous areas. In the *Microcosm of London* (1808–10) he populates 104 separate images of London, a singular achievement in its evocation of the metropolis.

Rowlandson's comedy of contrasts – beauty and grotesque – is applied to the city through comparing the picturesque

landscape of the rural tours with the gritty urban landscape of London. In terms of its population, this translates as the streetwise Londoner contrasted with the country innocent or 'bumpkin'. In '*Mirth versus Misery, The Pleasures of Human Life: in a dozen dissertations on male, female & neuter pleasures, etc.*', by 'Hilaris Benevolus' (London 1807), illustrated with five drawings by Thomas Rowlandson, the disparity between London and country and metropolitan prejudice is explored through a short fashionable vocabulary:

Vernacular Terms	Fashionable Sense
Age	An infirmity nobody owns.
Country	A place for pigs, cattle and clowns.
Debt	A necessary evil.
Dressed	Half naked.
London	The most delightful place.
Low	Vulgar, mechanical; generally applied to tradesmen, and authors.
Style	Splendid extravagance.
Scandal	Amusing conversation.
World	St. James's and its vicinity.[25]

Rowlandson's cast of characters emerges from his skill as an artist, his knowledge of Londoners and the prejudices of his age. His fascination is for the interaction of people, incidents and everyday disasters, in effect a unique social commentary. With a cool eye – for Rowlandson was not empathetic to the sufferings of others – he laughs, not pities, those encountering the pitfalls of urban living. As John Hayes aptly described in his introduction to a catalogue of the Museum of London Rowlandson collection:

As long as one remembers the emotional limitations and comic exaggerations of Rowlandson's art, one can find in his work the mirror of an age, and endless and fascinating commentary both on the appearance of things, and on the customs and peculiarities of life. Taken together with the *Microcosm of London*, itself, the Rowlandson drawings in the Museum [Museum of London] provide a remarkable survey of an era of London life, and the only further *caveat*

119. Thomas Rowlandson, *Westminster Election, Covent Garden*, c. 1808. Pencil drawing. Art Institute of Chicago.

120. Thomas Rowlandson and Augustus Charles Pugin, *Westminster Election*, published by Rudolph Ackermann as part of *The Microcosm of London; or, London in Miniature* (1808–1810). Hand-coloured aquatint.

121. Thomas Rowlandson and Augustus Charles Pugin, *Bartholomew Fair*, published by Rudolph Ackermann as part of *The Microcosm of London; or, London in Miniature* (1808–1810). Hand coloured aquatint.

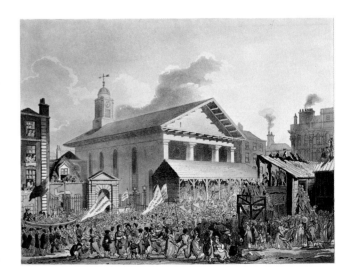

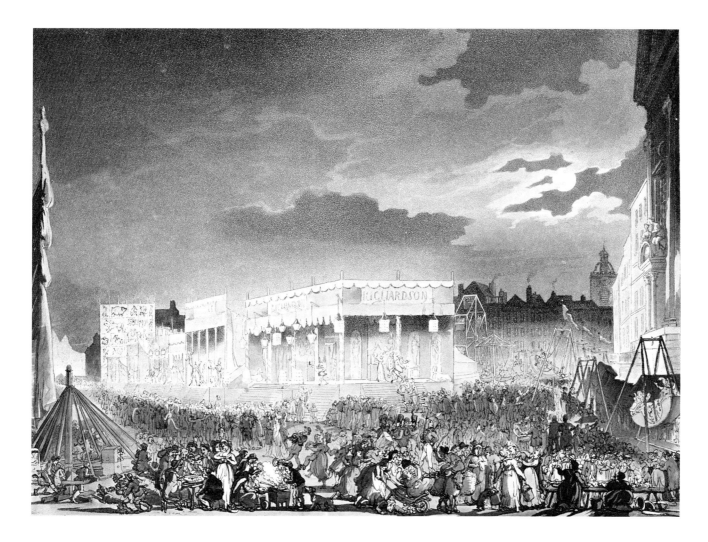

to be added concerns the frequent carelessness of his detail – a drawing by Rowlandson is unlikely to be a useful and precise source for the architectural historian, the archaeologist or the topographer.[26]

Rowlandson's Comic Topography of London

Rowlandson found a lifelong friend in the publisher Rudolph Ackermann, who supported the artist in life and eventually acted as a pall-bearer at his funeral. Their collaboration resulted in many successful series of prints, including the *Street Cries of London* of 1799. Books such as *The Microcosm of London* (which published *Westminster Election*) [fig. 120] were the first of Ackermann's large-scale publishing ventures and were to bring together a body of authors and illustrators to provide an ambitious survey of contemporary London. Its

uniqueness and success lay in the exceptional illustrations which were central to its conception: hand-coloured aquatints printed on quarto vellum paper. The survey was published in twenty-six monthly parts between 1 January, 1808, and 1 February, 1810, with four plates an issue, before being bound in three volumes containing all 104 prints and selling for the grand sum of thirteen guineas. The illustrations were drawn jointly by Augustus Charles Pugin and Thomas Rowlandson, a brilliant conception of Ackermann's, for Pugin would provide the architectural drawing and Rowlandson would bring them to life with the figures. Ackermann made very clear the novelty of his scheme in his initial adverts: 'In publications of Architecture, the buildings and figures have been invariably designed by one person, and the figures have been generally neglected, or are in a very inferior style...'[27]

In this, *The Microcosm* radically differed from other topographical surveys and Rowlandson's drawings succeed in enlivening the prints and evoking the scenes depicted. Figures in topography, as Ackermann rightly observed, were relegated to objects that gave scale to a drawing, unconvincing as depictions, acting simply as foils to the architecture. Topography, for the most part, gives us neither crowds, variety or character. In *The Microcosm* Rowlandson gives us all three, all imbued with his characteristic vein of humour, although Pugin evidently found it hard to accept figures taking such an important role within the topographical plates.

An insight into the making of the series is provided by the existence of a master copy, now in the Art Institute of Chicago. The copy contains proofs of all 104 illustrations, 118 drawings and watercolours, and perhaps most interestingly, the comments of the illustrators themselves, suggesting alterations and revealing the process of two artists working together on the same images. The marginalia is dominated by Pugin and he comments on Rowlandson's figures either being too big, too small, too many, or not the right character. In contrast, Rowlandson did not record his reactions, with one notable exception. In the drawing for *Westminster Election, Covent Garden* (c. 1808) [fig. 119] he writes neatly across the top: 'With submission to Mr. Pugin's better judgement Mr. Rowlandson conceives if the light came in the other side of ye Picture, the figures would be sett off to better advantage.'[28]

The Microcosm of London was a great success and it continued to sell throughout Rowlandson's life. The preface to the volumes noted the importance of the figures in giving the 'general air and peculiar carriage' of each of the areas depicted.[29] This represents the success and the uniqueness of the book, for the views of London are convincingly brought to life by the figures which give the general character of the place, in other words populated by the people that you would expect to see there. This is not to say that there is not variety: in *Bartholomew Fair* the varied crowd dominate the image, as the text describe the plate as 'a spirited representation of this British Saturnalia'.[30]

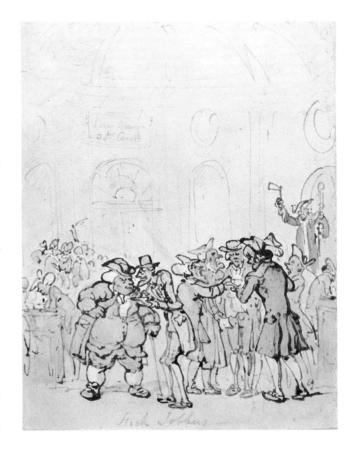

The streets of the metropolis may have been crooked and interconnected, but the divisions of status and kind were as clear to every Londoner as they were to every satirist. When Robert Southey (1774–1843) penned his three volumes of satirical *Letters from England*, he used the name Don Manuel Alvarez Espriella, with the characteristic ploy of comically plotting London, through the fresh eyes of the stranger who can see the ludicrous ironies and practises and record them in all innocence. Don Esperiella writes:

London is more remarkable for the distribution of its inhabitants than any city on the continent. It is at once the greatest port in the kingdom, or in the world, a city of merchants and tradesmen, and the seat of government,

123. Thomas Rowlandson, *Touch for Touch or a Female Physician in Full Practice*,
c. 1810–11. Pen and watercolour over pencil.

124 (*below and detail right*). Thomas Rowlandson and Augustus Charles Pugin, *The Great Hall, Bank of England*, published by Rudolph Ackermann as part of *The Microcosm of London; or, London in Miniature* (1808–10). Hand-coloured aquatint.

125. Thomas Rowlandson, *Loan Contractors*, c. 1794–1801. Pen with different coloured inks and watercolour over pencil.

where men of rank and fashion are to be found; and though all these are united together by continuous streets, there is an imaginary line of demarcation which divides them from each other. A nobleman would not be found by accident to live in that part which properly called the City, unless he should be confined for treason or sedition in Newgate or the Tower. This is the Eastern side; and observe, whenever a person says that he lives at the West End of the Town, there is some degree of consequence connected with the situation... A transit from the City to the West End of Town is the last step of the successful trader, when he throws off his *exuviae* and emerges from his chrysalis state into the Butterfly world of high life.[31]

In Rowlandson's *The Great Hall, Bank of England* (published 1808–10) [fig. 124] we are in the centre of the City and observe an interesting mix of people, none of them nobility. The moneymen going about their business predominate and Rowlandson shows them with their anxious avariciousness. Amongst these, we see other pairs of people, for example, the young couple who appear to be visitors to this grand temple that personifies the success of the City. To the right, a couple from the country stand out with their rustic dress and open mouths at the splendour of the scene. To the left a fat old gent stares through his goggles at his account sheet accompanied by his young wife, a testament to the power of money.

The City's wealthy appear as very definite types in many satires and are depicted as either fat and vulgar, their greed represented by their exaggerated waistline in the case of aldermen and liverymen, or as the emaciated, sinewy, heartless and ruthless in the case of miserly city financiers. Rowlandson drew the City's figures on a number of occasions including *Stock-Jobbers*, (c. 1802) [fig. 122] which is set in the Rotunda of the Bank of England. In it Rowlandson shows the fat and thin stereotypes contrasted in their dealings, intent on the prize or 'avidity of gain'. The figures suggest uproarious clamour and the scene is nowhere better described than in the *Microcosm of London*:

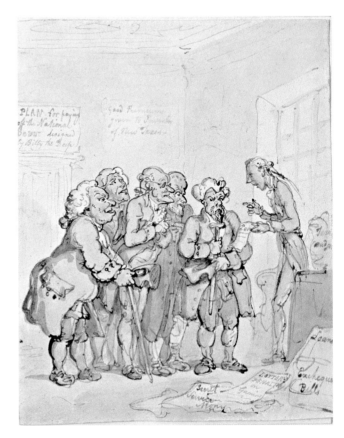

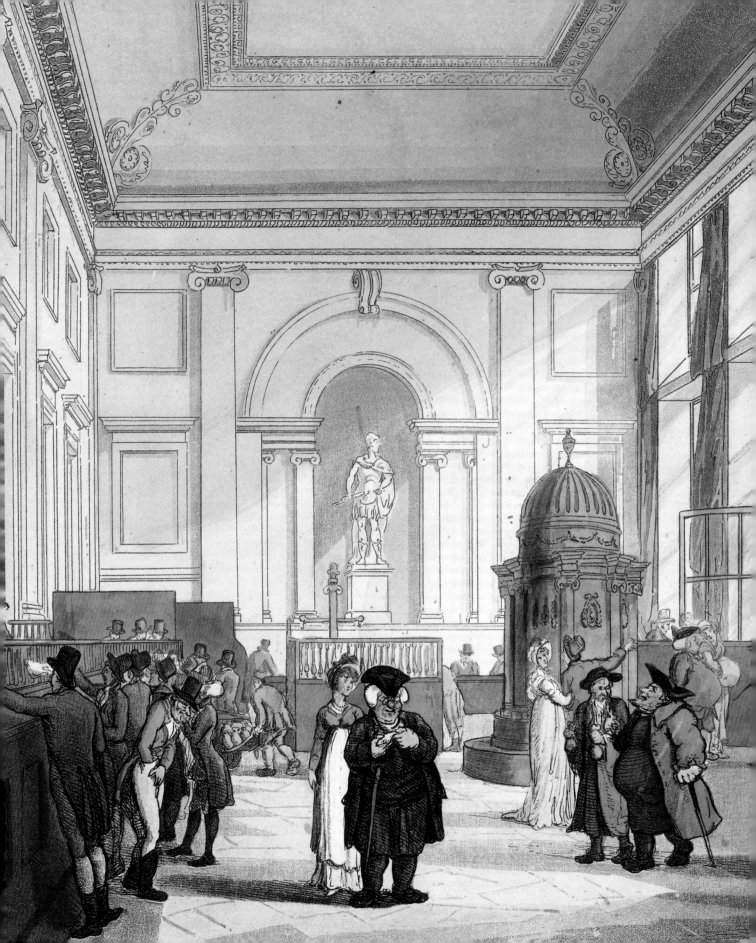

On the east side of this entrance is a passage leading to a very spacious apartment, which is called the Rotunda, where the stock-brokers, stock-jobbers, and other persons meet for the purpose of transacting business in the public funds... Here, from the hours of eleven to three, a crowd of eager *money-dealers* assemble, and avidity of gain displays itself in a variety of shapes, truly ludicrous to the disinterested observer. The jostling and crowding of the jobbers is so excessive, and so loud and clamorous at times are the mingled voices of buyers and sellers, that all distinction of sound is lost in a general uproar: on such occasions, which are not infrequent, a temporary silence is procured by the beadle or porter of the Bank, in the following manner: Dressed in his robe of office, a scarlet gown, and gold-laced hat, he mounts a kind of pulpit, holding in one hand a silver-headed staff, and in the other a watchman's rattle. By a powerful exercise of the rattle, he soon silences the vociferous and discordant clamour, and produces a temporary calm.[32]

In *Loan Contractors*, (c. 1794–1801) [fig. 125] the artist makes a satire on the government loans of William Pitt the Younger who is represented on the right of the drawing proposing a new loan to a group of financiers. Labels pasted to the wall emphasise the main thrust of the satire, which advertise a 'PLAN for paying off the National DEBT designed by Billy the Deep.' The group of financiers typically show an intentness of expression and engagement which is brought through the discussion of money. As Stevens noted in his lecture of Heads

This is the Stock-Jobbers head... We struck one shilling against the other; the chink of the money alarmed the organ; and on our striking one guinea against another, the ear expanded to its utmost extent... In other subjects there are certain vessels between the head and the heart, called the nerves of humanity! in the Stock-jobber they were all eaten away by the scurvy.[33]

In the *Microcosm of London* there is a clear dichotomy of styles between the rigid and accurate lines of Pugin and the flowing lines of Rowlandson's figures. It is a contrast that is effective. As Hayes noted, Rowlandson's drawings are 'unlikely to be a useful and precise source for the architectural historian, the archaeologist or the topographer.' What Rowlandson achieves at the expense of architectural detail is an organic whole, which provides the setting and echoes the action, as satire does in general. Yet with Rowlandson we have a higher level of detail and greater sense of place than most satire. *The Elephant and Castle Inn* (c. 1810–15) [fig. 126] evokes the busy junction of roads by the roadside inn, where carriages stop, cattle are driven and small groups of people assemble. There is a sense of the picturesque in such works, in which the figures are integral to the urban landscape of London.

Richmond Bridge (c. 1808–15) [fig. 127] has all the charm of a rural scene, viewed as it is from Twickenham looking south towards Richmond village and the bridge. This is deceptive for the area as we see it is in the process of urbanisation. The bridge was built between 1774–77 to replace the ferry, and wealthy Londoners were building villas on this area just outside the city. The large number of pleasure boats on the river and the picnicking group on the bank to the right show its popularity with Londoners and illustrate that the city's boundaries were moving outwards. *Careening a Coaster at Rotherhithe* (c. 1795–1800) [fig. 128] is a fascinating riverscape, where the figures merge entirely into the scene. The drawing contains little satire, but succeeds in suggesting the busy tidal Thames and the increasing number of buildings around the water's edge. Close to topography, the distinctive figures added by Rowlandson give it a distinctive comic element and bring the scene to life.

Londoners: High and Low

Most scenes by Rowlandson that depict the heart of the metropolis focus upon the everyday incidents of Londoners, in which the townscape is secondary. A *City Chop-House* (c. 1810–15) [fig. 130] wonderfully illustrates the eating establishments where a plate of a meat and a pint of ale or porter

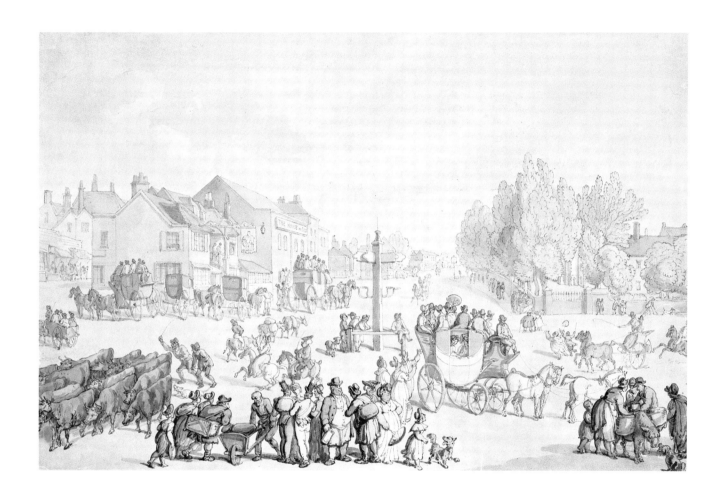

126. Thomas Rowlandson, *The Elephant and Castle Inn*, c. 1810–18. Pen and watercolour with traces of pencil.

127. Thomas Rowlandson, *Richmond Bridge*, c. 1808–15. Pen with different coloured inks and watercolour over pencil.

128 (*below and detail left*). Thomas Rowlandson, *Careening a Coaster at Rotherhithe*, c. 1795–1800. Pen with different coloured inks and watercolour over pencil.

could be ordered at a small cost. The wooden partitions, and the serious and matter-of-fact business of eating, shows the practice which Don Manuel Alvarez Espriella describes as peculiar to London:

> The English ordinaries and eating houses offer an inexhaustible source of observation on the national character and manners. You meet not only with all descriptions of London people, but likewise with French, Irish, Scotch and country people; and you may choose your company from the most humble to the most exalted... A Londoner generally enters the room and observes nobody, plants himself at a table in a dead position, breaks his bread in halves, *with an air*, falls to, says not a word during his dinner, which he eats rather slowly, yet swallows too quickly for his health, rises from table in resolute reserve, and retires from the room as he would from a cavern.[34]

This is not to say that eating was an entirely uncomplicated business for Londoners who sought delicacies from abroad. One of the caterers for more sophisticated tastes was Barto Valle, who ran the 'Old Italian Warehouse, at no. 21 Haymarket, St James's'. His advertisements regularly announced new stock, such as the following from *The Times* of 1793:

> Double and Single Tuberoses, New Parmesan, &c. — BARTO VALLE and Co. beg leave to acquaint the Nobility, Gentry, and their Friends in particular, they have just landed an excellent assortment of the above roots. They are also happy in observing, they are the finest roots that will be imported this season...
>
> N.B. Have also just landed, their New Parmesan Cheeses, which for fine quality and flavour they can warrant superior to any in this kingdom, independent of their being of the porous kind.[35]

Valle himself was a well-known character, and his business successfully ran from 1761 to 1911 at the Haymarket.[36] Rowlandson's drawing [fig. 131] shows three customers

129. Thomas Rowlandson, *The Piccadilly Farce*, c .1795–1800. Pen with different coloured inks and watercolour over pencil.

130. Thomas Rowlandson, *A City Chop-House*, c. 1810–15. Pen with different coloured inks and watercolour over pencil.

131. Thomas Rowlandson, *Barto Valle's Italian Warehouse, Haymarket*, c. 1805–10. Pen with different coloured inks and watercolour over pencil.

sampling wine aided by a grimacing shop assistant. Set against the backdrop of Valle's rich assortment of food, it is a satire on the over indulgence of the senses and in direct contrast to the straightforward way of eating presented in *A City Chop-House*. Each of the three figures in turn representd the senses – smell, taste and sight. These are encapsulated in the man with the large pointed nose stuck in the end of a bottle, the gin-blossomed nose and pot-belly of the man in the centre and the seated man who looks through his goggles, mocking his sight as a connoisseur. All three are gluttons.

William Douglas (1724–1810), the 4th Duke of Queensbury, was a notorious London character, who earned himself the nickname 'Old Q'. For the most part living in his Piccadilly residence, he was a bachelor who indulged his love

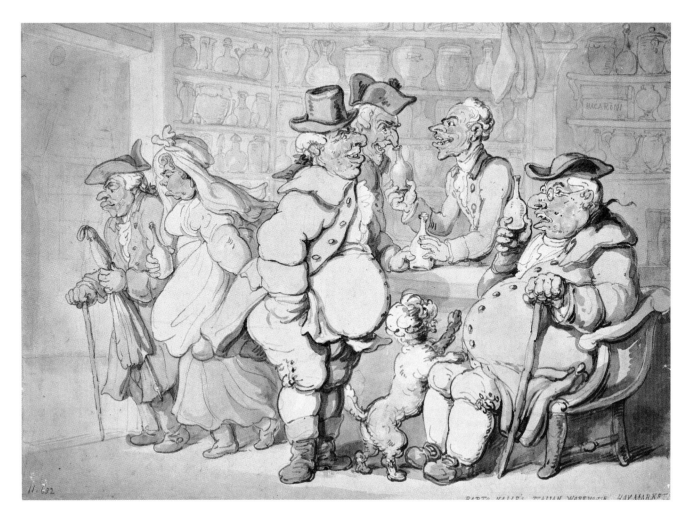

of gambling, racing and his passion for women, for which he gained a reputation as a lecher. In Rowlandson's *The Piccadilly Farce* (c. 1795–1800) [fig. 129] the lecherous old aristocrat is being carried upstairs by his maidservants with candle and warming pan. 'Old Q' was a familiar figure in both visual and literary satire. Corry's description illuminates the scene evoked by Rowlandson:

Old Q★★★ is another titled debauchee who delights to riot in the spoils of female honour. This senator has a *glass-eye*, and happy would it have been for many a lovely girl if the only optic of this Cytherean Cyclops had also been vitreous. He keeps a kind of *harem*, thus assuming the exclusive possession of a number of fine women, who might, in a married state, have contributed to the happiness of many a husband.[37]

The breadth of Rowlandson's depictions of London included on the one hand the dissolute aristocrat, on the other, the mostly nameless body of the poor and the itinerant street traders. The artist produced three sets of London street cries, in 1799, 1804 and 1820, which show with varying detail the hawkers of London's streets.[38] Don Manuel Alvarez Espriella's account gives a vivid impression of their sheer number and the noise that they created:

The clatter of the night coaches had scarcely ceased, before that of the morning carts began. The dustman with his bell, and his chaunt of dust-ho! succeeded to the watchman; then came the porter-house boy for the pewter-pots which had been sent out for supper the preceding night; the milkman next, and so on, a succession of cries, each in a different tone, so numerous, that I could no longer follow them in my inquiries.[39]

One such familiar cry on the London streets was the seller of last dying speeches, the crudely printed sheets containing the last words of those executed which were sold throughout London, most particularly on execution day. In *Last Dying Speech and Confession*, (c. 1798) [fig. 134] Rowlandson shows one such pitiful character, shoeless on one foot, screeching out her cry, although the cautionary tales that she is hawking has little effect on the young pickpocket who can be seen plying his trade in the background. In *An Execution Outside Newgate Prison* (c. 1805–10) [fig. 136] a panoramic view of the scene includes a last dying speech seller to the left being barked at by a runaway dog, a familiar motif in Rowlandson's drawings. Thse hangings provided entertainment to the crowds until 1868 when they were moved behind the prison walls. In this scene, a wealthy voyeur in a coach has come forward in order to observe the scene more closely. Such executions, however, were relatively commonplace, as *The Times* announced: 'the RECORDER ... made his report of the prisoners under sentence of death, convicted in January last... *Andrew Barton* and *James Frampton*, on Friday next, the 14th instant, at the usual place of execution before Newgate.'[40]

It is not clear where the setting for *An Execution* (1803) [fig. 135] takes place; the trees in the background suggest a park, but without the infamous triangular gallows of London's Tyburn (around where Marble Arch is today). The crowd are rapt, awaiting the 'drop' of the unfortunate prisoners who are receiving the last rites of the priest whilst the ropes are tightened around their necks. This point in the proceedings allowed the pickpockets, featured here in the foreground to the right, to steal from the absorbed onlookers. Such an assembly and barbarous event was viewed with mixed feeling, a point Don Manuel Alvarez Espriella makes clear in his description of an execution: 'The miserable man... begged the hangman to hasten his work. When he was turned off they [the crowd] began their huzzas again... This conduct of the mob has been called inhuman and disgraceful; for my own part, I cannot but agree with those who regard it in a very different light.'[41]

Rowlandson's own attitude towards crime and execution

132. Thomas Rowlandson, *Hackney Coachman*, from Rowlandson's *Characteristic Sketches of the Lower Orders, intended as a companion to the New Picture of London: consisting of Fifty-four plates, neatly coloured (rule)* London, 1820.

133. Thomas Rowlandson, *A Watchman Making his Rounds*, c. 1795–1800. Pen and watercolour over pencil.

is made clear by an incident that happened to him in the late 1780s whilst he was living at 50 Poland Street, where he is less than the dispassionate observer. The event is recounted by Henry Angelo:

Having walked one night with Rowlandson towards his house, when he lived in Poland Street, we parted at the corner. It was then about twelve o'clock, and before he got to his door, a man knocked him down, and, placing his knees on his breast, rifled him of his watch and money. The next day he proposed we should be accom-

panied by a thief-taker, to try to find him out, as he was certain he should know him again. We first repaired to St. Giles's, Dyot Street, and Seven Dials, but to no purpose…

Although Rowlandson was not successful in finding this criminal, he discovered another criminal responsible for robbery in Soho Square who was duly sentenced and hanged for the crime. 'This pleased my friend mightily,' Angelo wrote of Rowlandson, 'for, though I got knocked down,' said he, 'and lost my watch and money, and did not find the

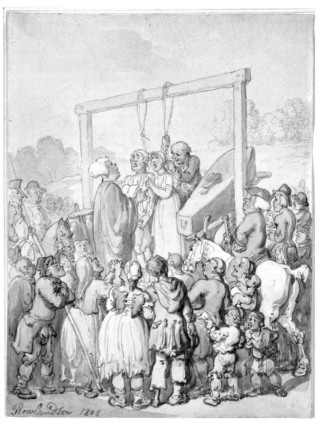

134. Thomas Rowlandson, *Last Dying Speech and Confession*, c. 1798.
Pen and watercolour over pencil.

135. Thomas Rowlandson, *An Execution*, 1803. Pen and vermilion and watercolour
over pencil.

Left:
136. Thomas Rowlandson, *An Execution Outside Newgate Prison*, c. 1805–10.
Pen with different coloured inks over pencil.

thief, I have been the means of hanging *one* man. Come that's
doing something.'[42] Such an attitude, not untypical of the
time, goes someway to indicate the approach to life that
Rowlandson gives us in his drawings of Londoners. There is
not deep empathic irony, but more a sense that he is
observing life the way it is. Similarly, tradesmen requesting
seasonal bonuses in *Calling for a Christmas Box* (c. 1800–05)
[fig. 137] and the misery of *A Gin Shop* (c. 1800–10) [fig. 146]
are subject of Rowlandson's humour.

If Rowlandson offered humorous observation rather than
ironic commentary, his observations covered all classes. The
London drawing room is the central meeting place of the
wealthy home. Rowlandson depicts the most fashionable, the
royal apartments, in *A Drawing Room at St James's Palace* (c.

137. Thomas Rowlandson, *Calling for a Christmas Box*, c. 1800–05. Pen with different coloured inks and watercolour.

138. Thomas Rowlandson, *Watching the Comet*, c. 1811. Pen with different coloured inks and watercolour over pencil.

1808) [fig. 145]. Despite its grandeur, the cycle of life and human foibles invade and caricature betrays it, as Corry observed in his satire:

> Can such elevated beings, exulting on the summit of pleasure, look down and sympathise with the miseries of the indigent? – Shall wretchedness approach the habitation of grandeur? – Can sorrow and pain invade the '*rich and perfumed chambers of the great*?' Yes, sometimes these intruders will pay a temporary visit; nay, even death itself violates human happiness in those delicious abodes![43]

A Rout at the Dowager Duchess of Portland's (c. 1811) [fig. 144] is most likely set at Margaret Cavendish's (Dowager Duchess of Portland, 1714–85) drawing room in Privy Garden. The scene centres on a servant, whose foot is being attacked by a dog (Duchess of Portland was infamous for her menagerie!), sending the contents of the tray over two old ladies. Virtually every character is subject to grotesque caricature, from the two old ladies as wailing harpies to the puffed-up officer to the left of the drawing. The drawing-room setting is particularly detailed and outlines the remarkable collections amassed by the duchess, whose name is forever associated with the most famous cameo-glass vessel from antiquity: The Portland Vase (now in The British Museum).

Two of Rowlandson's most important watercolours of London were exhibited at the Royal Academy Summer Exhibition of 1784, *Vauxhall Gardens* [fig. 139] and *Skaters on the Serpentine* (fig. 4). The subjects they take are two fashionable leisure haunts, the first at the pleasure gardens at Vauxhall, the second on the frozen Serpentine. In form they owe much to the elegant and polite art of the period, integrated with elements of caricature. In this they have an affinity with the large finished watercolours of Dighton, although they display greater sophistication in drawing, composition and colouring. The large scale of the works, and their elegance of composition and picturesque setting, are brilliant examples of fine art. On closer inspection we see caricature and the polite representation of

figures carefully merge in the compositional whole. It is here that there is a tension between the elegant skaters and the tumbling caricatures. As Ronald Paulson has observed:

> Contrast remains the structural principle of the major watercolours exhibited at the Royal Academy in the 1780s. *Skaters on the Serpentine* presents a situation in which people are contrasted as to their graceful or awkward behaviour. Rowlandson pictures the Serpentine during a winter freeze, with the lovely sweep of the riverbank, the delicate tracery of the trees, and, high up in the sky, a dim sun. Then in the lower part of the picture, crowded into a long squashed serpentine line, are young, graceful,

skilful skaters juxtaposed with others who through size, clumsiness, stupidity, or lack of skill cannot stay on their feet or are in some way immobilized.

> Ice retains a significance for Rowlandson: it tests ones ability to be graceful, and failure leads to collapse, heaps of bodies scattered about, or a fall *through* the ice with only heads, arms, and legs showing.[44]

Vauxhall Gardens similarly contrasts the elegant with the inelegant, where the ungraceful are looking at the graceful. It is populated by London's most fashionable figures, from the Prince of Wales through celebrated performers such as Mrs Weichsel (the vocalist) to the macaroni Colonel

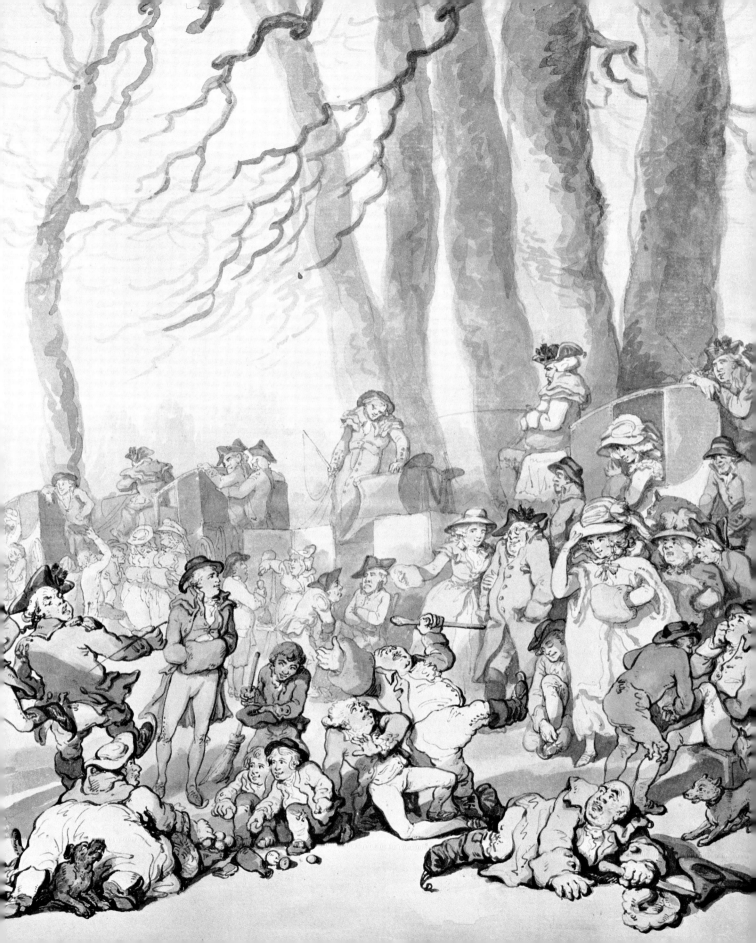

140. Thomas Rowlandson, *Mr Accum Lecturing at the Surrey Institution*, 1809. Pen with different coloured inks and watercolour.

141. Thomas Rowlandson, *Taking Tea at the White Conduit House*, 1787. Pen and watercolour over pencil.

142, 143. Thomas Rowlandson, *The Old Price Riots*, c. 1809. Ink drawing.

Topham, owner and editor of *The World*. Interwoven are the flashy 'cits' and their wives, servants, opportunists and common prostitutes. As we have seen, in images of the Mall and the recurrent themes of satire, Rowlandson is using this long tradition to create an enormously brilliant and varied image of London life: ambition, politeness, vulgarity, class and social mores collide and contrast in one of the most important social satires of late eighteenth-century London.[45] His prolific production of original drawings was greatly sought after and his willingness to make copies of his drawings meant that many of his most important works have several versions alongside prints that were produced after them.

In *Vauxhall Gardens* we see celebrated individuals and generic London types, the incident created to bring together an almost encyclopaedic social scene. Specific London events and characters are depicted in a number of Rowlandson's drawings including *Watching the Comet* (c. 1811) [fig. 138],

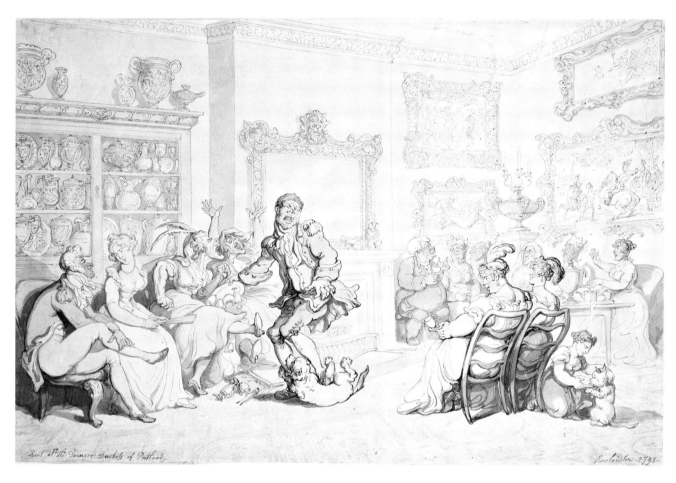

which depicts what is probably St Martin in the Field's steeple. This was drawn around 1811, the year that the Great Comet, which was first spotted in March and became visible in London in the autumn. As *The Times* noted: 'The Comet discovered at Viviers on the 25th of last March... will be visible every night even to the naked eye.'[46] The watercolour shows London's population leaning out of windows and emerging out onto roofs to view the comet, visible in the top left of the image, through telescopes and the naked eye.

Mr Accum lecturing at the Surrey Institution, (1809) [fig. 140] depicts the interior of the institute in Blackfriars Road, Southwark. Friedrich Christian Accum (1769–1838) is shown

conducting a chemical experiment to an admiring, amused and confused crowd. The scientist himself is not subject to caricature, unlike the crowd that encircles him. As a friend and admirer of Accum, Rudolph Ackermann supported him through the publication in 1815 of *A Practical Treatise on Gaslight* embellished with seven colour plates, which included a tribute to the use of gas-lighting in every part of Ackermann's business. Ackermann was one of the first businessmen to utilise gas lighting in his premises, and his enthusiasm for spreading Accum's work included translating the book into French, and publishing several other of his treatises, including *Culinary Chemistry* in 1821. A poor pastiche print after the style of Rowlandson from *Dr Syntax in London*

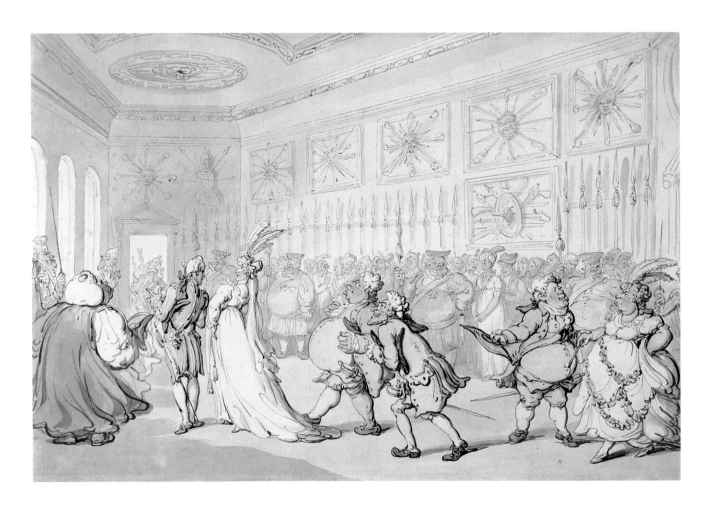

depicted the equivalent London Institution and was accompanied with the verse:

> Like quack amid his laboratory
> Pitting full many a harmless phial
> And spirit to a fiery trial.[47]

In both its weak style and the misplaced satire, the print stands in opposition to Rowlandson's drawing.

Rowlandson's brilliant and prolific output has left us an invaluable record of London, from the masterful conceptions of *Vauxhall Gardens* to the quick, on the spot sketches, such as those of Covent Garden Theatre for the 'Old Prices' riot prints.[48] Referring to the riotous crowd that object to increased prices, Rowlandson mocks the institution and notes on one of his sketches that the theatre boxes remind him of pigeon holes.

145. Thomas Rowlandson, *A Drawing Room at St James's Palace*, c .1808.
Pen with different coloured inks and watercolour over pencil.

146. Thomas Rowlandson, *A Gin Shop*, c. 1808–10. Pen with different coloured inks over pencil.

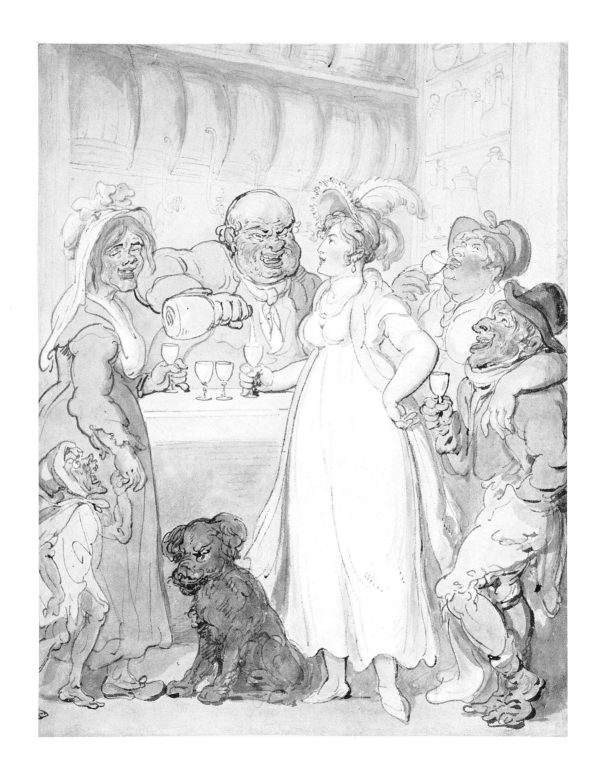

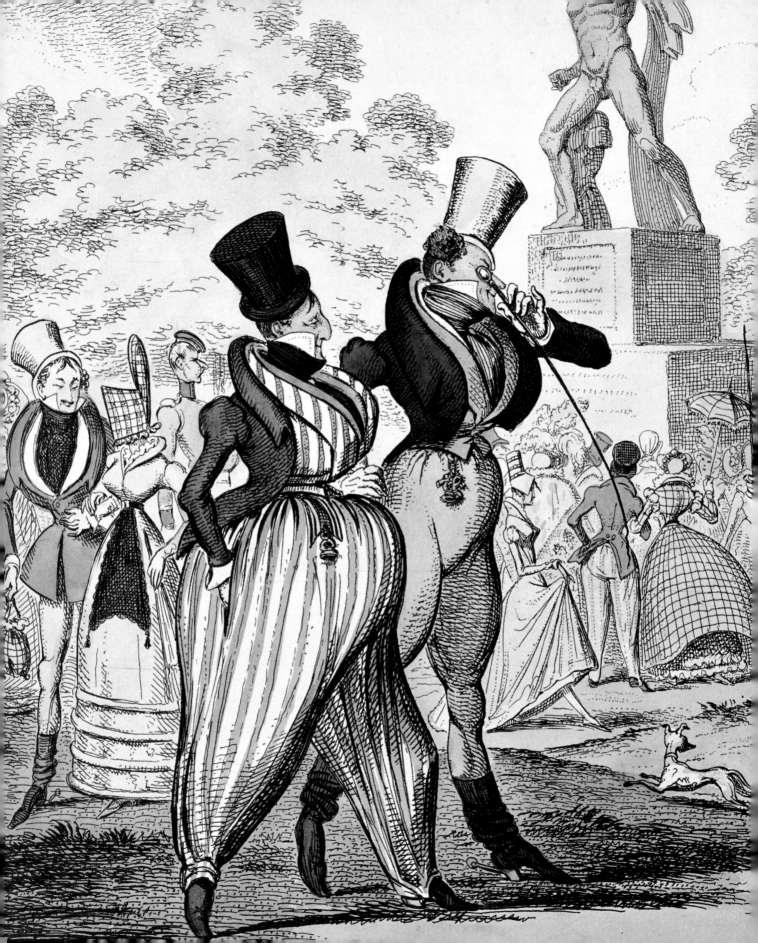

Progress and Transition: Cruikshank and Regency London

'The EXTREMES, in every point of view, are daily to be met with in the Metropolis; from the most rigid, persevering, never-tiring industry, down to laziness, which, in its consequences, frequently operates far worse than idleness. The greatest love and contempt of money are equally conspicuous; and in no place are pleasure and business so much united as in London. The highest veneration for and practice of religion distinguishes the Metropolis, contrasted with the most horrid commission of crimes'. Pierce Egan, *Life in London* (1820–21)[1]

George Cruikshank, *Monstrosities of 1822*, published 19 October 1822 (detail of fig. 160).

147. George and Robert Cruikshank, *Frontispiece*, published in Pierce Egan's
Life in London (1820–21). Coloured aquatint.

Indeed the Metropolis is a complete CYCLOPAEDIA, where every man of the most religious or moral habits, attached to any sect, may find something to please his palate, regulate his taste, suit his pocket, enlarge his mind, and make him happy and comfortable... In fact every SQUARE in the Metropolis is a sort of *map* well worth exploring... There is not a *street* also in London, but what may be compared to a large or small volume of intelligence, abounding with anecdote, incident and peculiarities... and even the *poorest* cellar contains some *trait* or other in unison with the manners and feelings of this great city... Pierce Egan, *Life in London* (1820–21)[2]

In 1810, when George III's madness had effectively ended his reign, the Prince assumed the Regency. Turmoil and radicalism characterised the transition from Georgian to Victorian society. The agitation for reform was a major force and the march of progress, both social and mechanical, spasmodically lurched forward. Satire is reflective of the social and political turmoil and its images of London are at times redolent of Georgian satire in their uninhibited ferocity, and at other times convey a new restraint and a burgeoning morality. By the time of Victoria's ascension to the throne in 1837 and the launch of *Punch* in 1841, satire had altered beyond all recognition. Society changed, and satire responded to this, not only in its subjects, but also in the form that it took. The print seller was gradually replaced by the editor and editorial boards, and the hand-coloured individual print was replaced by the pages in a comic periodical. The written word began to predominate over the image and the 'golden age' of satire had ended. Yet this is a fascinating period of London satire when narratives of the metropolis became expressed in visual images, and in which pictures of the city were reaching a yet wider audience.

This chapter covers the wealth of satirical images that emerged from this period of turmoil and transition. It looks at the plethora of political events that satire covers in its colourful gazetteer, which reflect the impact of these events as they acted upon London. The move towards greater democratisation and reform had an enormous effect upon satire, particularly on its medium and its changing audience.

Until the movement for the Reform Bill London's political incidents had remained comparatively uncoordinated. Isolated outbursts did occur, such as the Cato Street Conspiracy of 1820, when a group of radicals, led by Arthur Thistlewood, was arrested for plotting to kill the entire cabinet, a subject exploited by many satirists. Despite large-scale radical action being focused on England's provincial cities, the working-class movement was to some extent focused on London, if for no other reason than that it was the home of Parliament. The radical press, which flourished in London, used satire as a tool for its political voice. Furthermore, the need for electoral reform was nowhere more marked until the Great Reform Bill of 1832, before which time London was the most under represented of urban populations whether in relation to its wealth or population, returning only ten members of parliament.[3]

London provides satire with the background for these political battles, particularly the struggles of the Reform Bill, although the more general social move towards democratisation is visible in most social satire of the period. The signs of social change were everywhere; the population was growing at an enormous and accelerated rate and the city's boundaries were moving quickly outward. Literacy was increasing within London's population and the strict social hierarchy was becoming less defined – the middle class and monied ranks had prospered, and it was easier to move between social circles. Change was spasmodic, as Dorothy George commented in her book on social change in graphic satire, 'The Regency was a strange mix of the unregenerate eighteenth century and what was to be called Victorianism.'[4] Social satire reflects the struggles between old and new values, using its most humorous weapon: the contrast of extremes.

The universality of satire had not changed and the notions of human frailty prevailed in the images. Recurrent themes and its eclectic nature continued with pictorial inventiveness at the fore, expounded most prolifically and successfully in this period by George Cruikshank. The ludicrousness of the

fads of fashion, a theme humorously explored in many eighteenth-century prints, continued in images epitomised in the monocled dandy. Contrasts continued to be drawn upon and the metropolis was still seen as the world in a city, an encyclopaedia of extremes. As Egan Pierce noted in his satirical romp through London, 'the EXTREMES, in every point of view, are daily to be met with in the Metropolis.'[5] The humour of Regency satire often revolved around key themes of contrast reflective of society: high and low life; change and tradition; ideal and reality; fashion and nature, and the idle and the industrious.

The dominant character of satire in the Regency period is the man of leisure: the dandy, and later, the 'Corinthian' or 'swell'.[6] It seems ironic that this figure, which directly connects to the satire of the eighteenth century, should predominate against a background of a dramatically changing society. Yet the dandy, whose equivalent was the macaroni and beau of earlier times, radically changed in the Regency in favour of the 'swell'. The dandy was a figure of fun, whereas the 'Corinthian' of Pierce Egan was a figure who made fun. He was not the butt of the joke but the practical joker himself. In *Life in London*, published in monthly parts between October 1820 and June 1821, the rambling tale narrates three young men's journey through the high and low life of London in their initiation of Jerry Hawthorn into urban lifestyle and manhood. The serial was illustrated with thirty-six coloured aquatints by George and Robert Cruikshank who appear in the novel alongside the author as Corinthian Tom (George Cruikshank), Jerry Hawthorn (Robert Cruikshank) and Bob Logic (Pierce Egan).

The frontispiece of *Life in London* (published 1820–21) [fig. 147] visually outlines London society in terms of a simplified hierarchical make up, positioning Londoners into their allotted pigeonholes. Created to 'afford a space to delineate the varieties of LIFE IN LONDON',[7] it sets the background to the subsequent ramble. Society is allegorically presented as a Corinthian column with 'The Roses, Pinks and Tulips: the *flowers* of SOCIETY.'[8] at the capital, represented by the King and his court. At the base is a sweep and his family in a dark cellar, surrounded by the outcast and ruined 'Turn-

ups'. A framed circle showing the main protagonists drinking and making merry is representative of a wheel of fortune and dominates the centre of the column. Above and below them are the 'Ups and Downs of Life in London,' and to their sides are its 'Ins and Outs'. The four angles 'represent the different classes of society in the *Metropolis*,' the noble, respectable, mechanical and 'Tag, Rag & Bobtail.' The 'noble' dandy in his dress and posture signifies the clinging exclusivity of the high born ready to give the all important 'cut', or to brick-wall someone, an art to which Beau Brummel was apparently a master. As Egan expressed, '(high birth; on such good terms with himself that if a *commoner* accidentally touch him in crossing his path, he looks down, with a sort of contempt, muttering, "D-n you, *who are you?*)'[9] The 'respectable' denotes the merchants, the 'mechanical' with foaming pint and hammer, the artisans and 'Tag, Rag & Bobtail', calling the last dying cry, the itinerant London street trader. The wheel of fortune of Tom, Jerry and Bob is devoted to pleasure and implies a certain ease, if determined by fortune, with which they travel through all the varieties of London life. The tour through London was a well-worn satirical genre, but *Life in London* is a new kind of book,- in its striking illustrations and its wider appeal is indicative of a new and changing metropolis.

The Form and Audience for Satire in Regency London

The London print seller and the individual satirical print had characterised the age of George III. In the Regency period the print trade went full circle – the book trade predominated over the individual print seller and caricature, in effect, became a sideline of book and print sellers. The watercolour of a print-shop owner outside his shop shows a typical window of the Regency period (c. 1812–23) [fig. 148]. What is very noticeable is that the shop still retains its exhibition window where the viewers could assemble to view the prints, but although images are still predominate, text is taking up more and more space on the paper. The illustrated sheet, pamphlet and book has eclipsed the individual print. One immediately recognisable image is an edition of *Boxiana*,

or, Sketches of Ancient and Modern Pugilism by Pierce Egan, illustrated by George and Robert Cruikshank, which ran between 1812 and 1824 and was sold by 'Sherwood, Neely and Jones, Paternoster-row; and all booksellers and newsmen throughout the kingdom.'[10] Théodore Géricault used the series in his lithographic series *Combat de Boxe* of 1818.

The Regency still had its great satirical print sellers including Thomas Tegg with his Apollo Library and Caricature Warehouse, No. 111, Cheapside, Thomas McLean's Repository of Wit and Humour, No. 26, Haymarket, William Hone, and Samuel William Fores. However, a greater diversification was called for as the century moved on. Caricature was only a small part of Tegg's business, largely books, which moved to 111 Cheapside in 1803, until his move in 1824 to 73 Cheapside, the former residence of the Lord Mayor, known as The Old

Mansion House.[11] Another example of a publisher who produced satire is Charles Tilt of 86 Fleet Street, predominantly a bookseller. His shop is reminiscent of the 'golden age' in Cruikshank's wood engraving *March* [fig. 150], produced for his 1835 *Comic Almanack*, which shows extreme winds outside panels of glass exhibiting prints. In the shop itself, George Cruikshank can be seen in conversation with the owner, Charles Tilt.

The caricature shop declined hand in hand with its reputation. The warnings about the dangers of standing outside caricature print windows are brilliantly evoked in Robert Cruikshank's *Dandy Pickpockets* and in George Cruikshank's *A Pickpocket in Custody* of 1836 [fig. 149], an illustration from Dickens' *Sketches by Boz*. These warnings are born out in the numerous newspaper reports listing incidents outside shops such as *The Times* who reported:

> An honest Malster has had his pocket picked of no less than eighty pounds while he was in the act (innocent man!) of looking at a Caricature Print-shop in the City. Little did the unsuspecting countryman imagine, while he was enjoying himself in the luxury of gaping at the felicity, with which our heroes of the pencil Take-off the persons, characters and actions of the great, that another description of metropolitan artists, equal in the expertness of their fingers with the former, were employed dextrously, the hard cash and good notes he had just received for his cattle or his corn![12]

The dangerous and immoral reputation of print-shop windows was not limited to theft, but also prostitution, and other sexual crimes such as homosexual offences were reported in the Regency period. In one case, Samuel Fores (bap. 1761–1838), a leading print seller, came forward as a witness against the prosecuted Edward Everett regarding an incident outside his shop. The report is worth quoting at length:

> BOW-STREET – *Edward Everett* was charged with gross improprieties with James Baker... at the caricature shop,

the corner of Sackville-street, Piccadilly, on Monday evening, between five and six o'clock; also with George Crocker, a lad between 15 and 16 years of age, whom he enticed into Green-park... Here Mr. Fores, who keeps a print and caricature shop at the corner of Sackville-street, in Piccadilly, came forward, and said he had something to state.

Mr. Fores was then sworn, and said, that he had known the prisoner a long time as a most detestable character; he has often observed him through his window, at which there is generally collected a crowd of persons, the prisoner make his way gradually through them, until he got close to some youth. (Mr. Fores here described the most scandalous practices of the prisoner.)... Witness has

often endeavoured to make the prisoner aware that he knew what he was at; and, if possible, to shame him away from the place by holding up to his face a print of the Bishop of Clogher; but instead of going away in consequence, he stood and looked at with the utmost unconcern.

'And this you, Mr. Fores,' said the prisoner, 'who comes forward against me – a man whom I have patronised, and done material services to?'

'Done me a service,' said Mr. Fores: 'I would not accept a service at the hand of such a wretch. I believe you once laid out 4s or 5s in prints at my shop, if you call that a service: but you know I know you well, and have seen your practices at my window...'[13]

What this passage demonstrates is a growing tightening of moral standards in the Regency period, as we see from Fores holding up a print of the Bishop of Clogher to avert the practices of Edward Everett. Yet it must not be assumed that this was a direct appeal to religious piety, for the infamous bishop was an exposed homosexual, tried and pilloried by the mob and satirised by caricaturists.[14] In her survey of social change in graphic satires, Dorothy George observes a growing morality and prudery in the period. This in turn had an impact upon the way in which prints were produced, and in effect censored images.

Samuel Fores is a good example of a print seller and publisher whose business survived from the Georgian to the Regency through greater diversification, and who advertised himself as a 'Bookseller, Stationer, Engraver, Printseller, Publisher, and Frame Maker, No.50, Piccadilly, Corner of Sackville Street, and at 312, Oxford Street. Letter Press and Copper-Plate Printing in every Branch.' The display of prints, as we have seen, included their exhibition in the window of his shop as well as loaning sets of satirical prints for the evening, as one of his surviving labels states:

Folios of Caricatures Lent out for the evening. London, THIS FOLIO must be returned by the person hiring it on the following day by twelve o'clock, or pay a second Half-

A PICKPOCKET IN CUSTODY.

149. George Cruikshank, *A Pickpocket in Custody,* published in Charles Dickens' *Sketches by Boz,* 1836. Etching.

a-Crown; and, to secure a return of the Folio in proper time, and the Prints correct, a Deposit of Twenty Shillings is required. The person to send 2s. 6d. with the Folio, and the Pound will be returned.[15] [See chapter 1, fig. 30]

There was, and is, a great attraction in viewing caricatures in large numbers, not solely looking at a single image. This stems from the speed with which many of the images are read and enjoyed with spontaneity, so that a series can be more satisfying than a work of art hanging in a gallery or on an exclusive wall for prolonged study. Caricatures were often exhibited in very large numbers. Series of caricatures

became increasingly attractive and the loan of folios in one sense looked forward to the development of books, bound folios, broad sheets and ultimately periodicals and magazines that were created around their satirical illustrations. Such developments allowed a theme to be more fully explored through a series of comic incidents, or even the unfolding of a comic narrative. This burgeoning trend is indicative of the transitory nature of satire of the Regency as it changed from print to novel to become the predominant popular art form. Out of this emerged a flourishing of comic visual narratives that flowered in and reflected life in the metropolis.

The interesting point about the Regency period is that image remained paramount, even though text was becoming

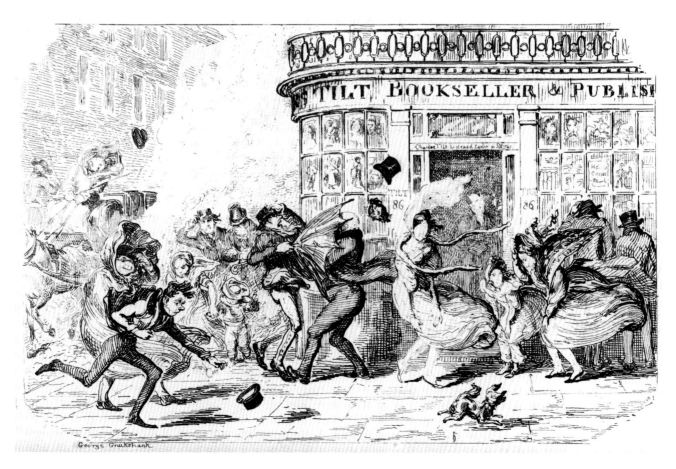

increasingly important. The relationship between word and image was now an essential element, and it is from this genre that some of the most revealing images of London life emerge. Monthly journals which included satirical illustrations had long existed, such as Almon's *Political Register* (1767), *The Court and City Magazine* (1784) and *London in Paris*, but the caricature magazine was an entirely new genre.

A proliferation of satirical magazines emerged in the early Regency period, many illustrated by George Cruikshank. Most notable is probably the *Scourge; or Monthly Expositor of Literary, Dramatic, Medical, Political, Mercantile, and Religious Imposture and Folly*. It was founded by William Naunton Jones in January 1811 and was sold by Goddard in Pall Mall and Johnston in Cheapside, the former withdrawing its sales after July due to its blunt assaults. The periodical managed to avoid libel, but was dogged by financial difficulties and the series finally folded in 1816. *The Satirist, or Monthly Meteor* ran between October 1807 and 1813 and *The Meteor, or Monthly Censure* from November 1813 to July 1814. The characteristics of such monthly periodicals, like *The Black Dwarf*, (Francis Place) was verse satire, radical and crude in format. The accompanying images were often coarsely produced woodcuts, although as the form developed so too did the interplay between text and image.

Then came the introduction of a new form of satire: the caricature magazine. The exact time of its emergence is unclear, although Dorothy George states the first caricature magazine produced in London was *The Looking Glass* [fig. 152], published by Thomas McLean on 1 January, 1830 and running for six years.[16] It differed from other journals such as *The Satirist* and *The Meteor* in being made up entirely of images in a comic book format. The term caricature magazine had been coined for over a decade in London, but referred rather to bound folios of individual prints with a consistent title page, in effect a new way in which prints could be sold, rather than an entirely different format. The earliest of these appears to have been produced by Thomas Tegg (1776–1846), who advertised that it was: 'To be continued every Fortnight, containing Two coloured Prints, Price 2s. The Caricature Magazine, or, Hudibrastic Mirror.

Being a most capital collection of caricatures... Published by T. Tegg, at the Apollo Library and Caricature Warehouse, No.111, Cheapside.'[17]

The quality of the prints, reproduced in number at a standard size, often reprints, was questioned in a letter to *The Times* from 'A Book-Buyer', in which he compared the distinguished plates of Bernard O' Rilley, *North West Passage to the Pacific Ocean* that contained, 'several plates in aquatint, by Lewis, That would disgrace Tom Tegg's Caricature Magazine;...'[18]

The Looking Glass (published in 1830) [fig. 152] and their counterparts, such as *Every Bodys Album and Caricature Magazine* [fig. 151] (begun in 1833), had captions and inscriptions but no separate text. The use of lithography, introduced into London in the 1820s, greatly facilitated the printing of such publications. Printed by C. Motte of 23 Leicester Square, *The Looking Glass* imitated newspapers and responded to political events. This unique form of caricature was relatively short-lived, until the emergence of comic books much later, and was effectively eclipsed by satirical journals which contained both image and text. One of the leading and most influential examples of this, for it had many imitators, was *Figaro in London*, which was launched a year after *the Looking Glass*, on 10 December, 1831. It sold for one shilling, two shillings cheaper than its rival.[19] The projector, proprietor and editor was Gilbert à Beckett, and the title consisted of four weekly pages of letterpress illustrated by wood engravings designed by Robert Seymour.

Unlike *The Looking Glass*, *Figaro in London* (1831–36) merged caricature and journalism, and was closer to *Punch* than to a comic book. In its wake there was a proliferation of many short-lived titles published in London, such as *The Wag*; *Punchinello* (the first illustrated by I. R. Cruikshank, but which ceased running after its tenth number); *Asmodeus in London* (illustrated by Seymour, and similarly short-lived); *The Devil in London* (started on 29 February, 1832), with illustrations by I. R. Cruikshank and Kenny Meadows; *Penny Trumpet*; *The Schoolmaster at Home*, and *The Whig Dresser*. What the journals represent is a radical change in how satire was produced and received. The images themselves have

152. Robert Seymour, *The Looking Glass Volume 1st, No. 12*, published 1 December 1830. Lithograph.

153. George Cruikshank, *Oliver Claimed by his affectionate Friends*, 1837, published in *Bentley's Miscellany* in the serialisation of Charles Dickens' *Oliver Twist*. Etching.

George Cruikshank: Art and London

George Cruikshank was born in London in 1792 and died there nearly a century later in 1878, his extraordinary career as a leading satirist and illustrator lasting over sixty years. Within that time he was brought up amongst Georgian caricature, through his father, the caricaturist Isaac Cruikshank (1762–1811), who made his name with the social and political satire of the Regency. George Cruikshank illustrated a large number of books and periodicals including *Life in London* (with his brother Robert), *Oliver Twist*, *Comic Almanack* and the *Tower of London*. Furthermore, he successfully made the transition into the Victorian period and produced *The Bottle*, a series of temperance prints in 1847, works around they Great Exhibition of 1851, and the astonishing painting *The Triumph of Bacchus* in 1863 and the prints produced after it.[20] In this wide and prolonged output Cruikshank is unique, successfully spanning the gulf between Georgian caricature and Victorian comic illustration, his brilliance as a draughtsman evoking admiration from the leading lights and critics within his lifetime and after.

become less important, with the textual elaborations and journalistic commentary becoming more so. As a result, writers, editors and publishers had a greater say in the creation of the images. Despite this, during the Regency it was still predominantly the image upon which the text revolved, and these periodicals are quite different from the later Victorian comic ones. Yet the position was to change even further. When George Cruikshank worked with Charles Dickens on *Sketches by Boz*, Cruikshank was celebrated, and the author as yet unknown. A decade later and their positions are almost reversed.

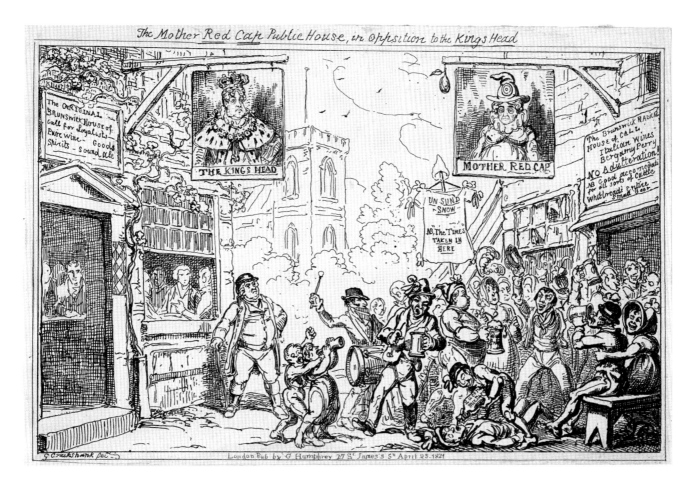

London is at the very heart of Cruikshank's work. He knew the city intimately, from its famous sites to its back streets. His expression of the full breadth of urban life is exceptional, from the London dustman, through the middle classes to the 'flowers of society'. In his illustrations, the features of London are intertwined with the action that unfolds the characters' lives. His fascination with London life is evident from his *Metropolitan Grievances; or, a Serio-comic Glance at Minor Mischiefs in London and its vicinity* (1812), *Life in London* (1820–21), *Mornings at Bow Street* (1824 and 1827), *London Characters* (1827), *Sunday in London* (1833), *Sketches by Boz* (1836), *Oliver Twist* (1837–39) and *Tower of London* (1840).

Within the Regency period Cruikshank produced a large number of social satires published by several of the leading prints sellers of the period. His political work was a result of a fruitful partnership with the radical publisher William Hone, for whom he produced satires between 1815 and 1821. Hone's propaganda of parodies and squibs led to his trial in 1817, of which he was to write later, 'the 18th, 19th, and 20th of December, 1817, are memorable dates in my wayward life, for those days gave my name publicity.'[21] Hone had a shop on Ludgate Hill, which, through his contentious political agenda and eye for publicity, he had made an extremely popular attraction. Cruikshank, writing later of his *Bank Restriction Note*, a satire on the production of easily

155. George Cruikshank, *Gambles on the River Thames Feb 1814*, published by Thomas Tegg, February 1814. Hand-coloured etching.

GAMBOLS ON the River THAMES. Feb.y 1814.

forged bank notes and the capital offence for passing them, 1819, noted the activites outside at the shop window; '… it created a great sensation, and the people gathered round his house in such numbers that the Lord Mayor had to send the City police (of that day) to disperse the CROWD.'[22]

With Cruikshank's political prints we follow the tradition of Gillray and, similarly, the artist's political affiliations were subject to flux, whether due to seeing both sides of the argument or as an opportunity for career and pen. The Loyalist Association asked Cruikshank to etch plates for their *Loyalist's Magazine* in support of George IV. One of

these, *The Mother Red Cap Public House*, *in opposition to the King's Head* (1821) [fig. 154] features a very well-known London location, the Mother Red Cap, an inn on Tottenham Court Road. The tavern is depicted to the right of the etching with the Mother Red Cap sign as Queen Caroline, a tricolour cockade on her witches hat, haggard and overseeing the disreputable scene around the pub below her. References to her adultery and political ambitions are exhibited through the text and banners around the pub and its dissolute crowd involved in heavy drinking. Opposite to the left is the King's Head with a portrait of King George IV wearing his regalia,

his ministers visible through the open window where all appears in good order. The vine that grows up the wall suggests a firm and long-standing tradition of monarchy. The image was produced as a frontispiece (reduced), and, for the Loyalist Association, as a separate plate published by Mrs Humphrey.[23]

Cruikshank's social comedy was primarily published by Mrs Humphrey at the west end of town in St James's and by Thomas Tegg in the City. *Gambols on the River Thames Feb 1814* [fig. 155], published by Tegg, depicts the frozen Thames in January 1814, and the frost fair that was held between London and Blackfriars Bridge until 5 February, just prior to the ice breaking up a day later. London Bridge overshadows the scene, which is populated with halted coaches and a crowd of people looking down on the scene below. Grotesque revelry dominates and the kitchen tent of the Shannon reveals lechery and matrimonial discord reminiscent

of Rowlandson. A fat woman falls on her back, breaking through February's thin ice, and a man's wooden leg punctures the ephemeral stage. To the left a print seller, set up with press, advertises a 'copperplate print done in the best style by J. Water – Wagtail & Co'. The printer, preparing a plate for production, wonderfully illustrates the position of popular prints within London in this period, competing as they are with gin and gingerbread.

Both Gillray and Rowlandson studied at the Royal Academy, but Cruikshank only toyed with the idea of contacting Fuseli about the possibility of studying there.[24] His ambitions did include painting, and a small number of his oil paintings were submitted and accepted for the Royal Academy Summer exhibition, although it was never an area in which he was to succeed in despite his enormous canvas, *The Triumph of Bacchus*. This Leviathan of a painting, although containing a fascinating body of satirical narratives,

A CHANCERY-LANE NODDLE.

Now this is the noddle that takes proper time
To digest the disputes of this quarrelsome clime,
That hates to decide without *seeing* the facts,
And will not believe, without *reading* the acts;

Indeed, to describe the numerous beauties CORINTHIAN-HOUSE contained would require a complete and extensive catalogue. It was a perfect model; a combination of taste and excellence... All that ART could produce had been effected... In the selection of paintings, exhibited upon one side of the PICTURE GALLERY, a correct knowledge of *old masters* had been displayed it was admitted by all the connoisseurs who had seen them. Upon the other side of this splendid apartment the contrast was equally fine and attractive. The beauties of the MODERN SCHOOL OF PAINTING, rising proudly in an improved state of grandeur, were viewed, challenging, as it were, the OLD MASTERS to the scale of *competition*. The works of Sir Joshua Reynolds, West, Lawrence, Fuseli, Opie, Westall, Gainsborough, Loutherbourg, the eccentric Barry, Beechy, Turner, Wilkie, Haydon, &c. &c. shone forth in all that vigour of expression, softness of touch, and brilliancy of colouring....[26]

is not a great work of art, and is much more successful as a print. Cruikshank stood well outside the walls of the Academy; the illustrator and caricaturist were seen as an entirely different kind of artist. High art and popular art continued to be further divided, a division cast in stone in the Victorian period, to the despair of many satirists, including Cruikshank. As a contemporary noted in 1833:

> Cruikshank is shocked at the evil fate which consigns him to drawing sketches and caricatures, instead of letting him loose in his natural domain of epic or historical picture. Let him content himself; he can draw what will be held in honoured remembrance when ninety-nine out of every hundred of the great 'masters' of our 'schools', and a still larger proportion of all the R.A.'s and A.R.A's that ever existed, or ever are doomed to exist, will be forgotten.[25]

Yet Cruikshank was painfully aware of the distinction between high and low art. In training to be a swell, Jerry is given the model of Corinthian Tom:

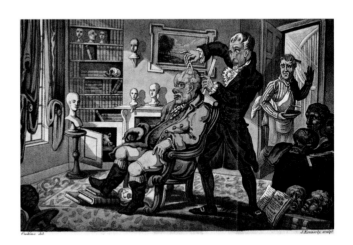

157. Anonymous, *A Chancery Lane Noodle*, published in *Black Dwarf*, 1820. Wood engraving.

158. Anonymous, *Craniological Physiognomy*, City Philosophical Society, 1816. Coloured etching and aquatint. Guildhall Library, Corporation of London.

159. George Cruikshank, *Philoprogenitiveness*, published 1 August, 1826 in his *Phrenological Illustrations; or an artist's view of the Craniological Systems of Doctors Gall and Spurzheim*. Hand coloured etching. Guildhall Library, Corporation of London.

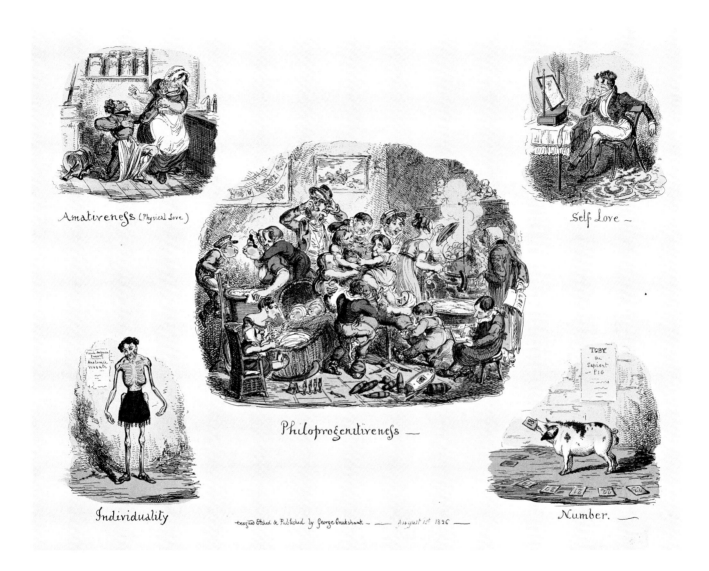

Amativeness (Physical Love)

Self Love

Philoprogenitiveness

Individuality

designed Etched & Published by George Cruikshank — — August 1st 1826 —

Number.

Cruikshank, like other caricaturists, was deeply aware of physiognomy – even if he did not take its claims too seriously – and he had his own copy of Lavater's influential book on the subject. The influence of physiognomy in the nineteenth century proved to be even wider than it had in the eighteenth century and made its impact equally on the world of fine art as it did on caricature and popular illustration. The seriousness with which Cruikshank took the theories of physiognomy and phrenology are perhaps echoed in his send up of those expressed by Francis Joseph Gall and Johann Christian Spurzheim. The two had lectured on

their theories in Britain and their ideas had a fashionable currency, J. De Ville setting up a phrenological consulting room on the Strand, and which Cruikshank satirised as *Bumpology* for Humphrey in 1826. A more sustained attack came in the form of his self-published *Phrenological Illustrations; or an artist's view of the Craniological Systems of Doctors Gall and Spurzheim* [fig. 159] in the same year. The radical magazine *Black Dwarf*, more in line with popular tradition, used physiognomy in its illustration of comic archetypes, where rough wood engravings accompanied satirical verse (*A Chancery Lane Noodle*) [fig. 157].

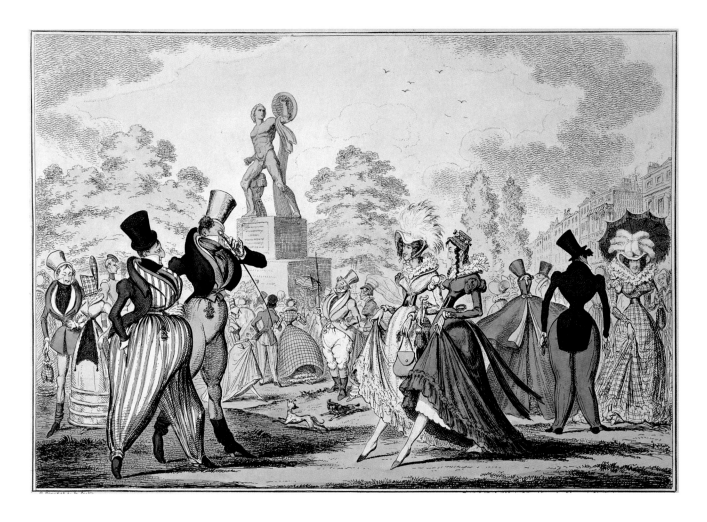

Fashion, Rampage and Life in Regency London

If any aspect of Georgian caricature moved effortlessly into the Regency period it was the satire of London fashion. William Heath's (Paul Pry) print, *Contrasts, Ancient and Modern Gentlemen, 1729–1829* [fig. 163], published by McLean, makes this point in a direct and comic manner. The beau of yore, bedecked in beauty spots, bows graciously to his modern counterpart: the Regency dandy. The imagined eighteenth-century beau, somewhat of the nineteenth-century mode, is exaggerated to mark the similarities between them. The outward appearance may have changed, but the effect is presented as equally preposterous.

The craze of dandyism swept the Regency metropolis. Its style was characterised by high, thin waists, ballooning pantaloons, pointed and spurred boots, gloves, exaggerated shoulders and, in particular, extremely high collars that cari-caturists used to exaggerate the facial physiognomy and to portray arrogance. Captain Gronow recalled the craze:

> How unspeakably odious – with a few brilliant excep-tions... were the dandies of forty years ago. They were a motley crew, with nothing remarkable about them, but their insolence. They were generally not high-born, nor rich, nor very good-looking, nor clever, nor agreeable, and why they arrogated themselves the right of setting up their newfangled superiority on a self-raised pedestal and despising their betters, Heaven only knows. They were generally middle-aged men, had large appetites and gambled freely, and had no luck. They hated everybody, and abused everybody, and would sit together in White's bay-window, or the pit boxes at the Opera, weaving tremendous crammers. They swore a good deal, never laughed, had their own particular slang...[27]

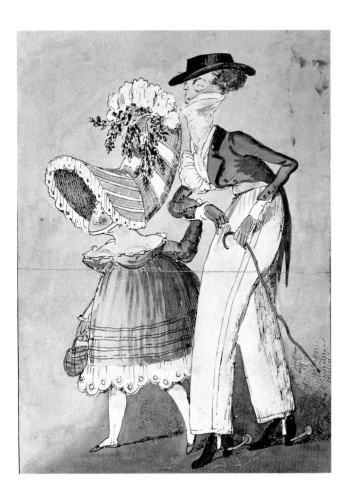

George Cruikshank's print, *Fashionables of 1817* [fig. 161], shows a dandy and his fashionable partner, equally ludicrous in appearance with a huge and over-decorated bonnet, with a short bell-shaped dress spouting from an empire line and her breasts pointing forward. The thin and frail effeminacy of the dandy, and the farcical women of fashion, are directly comparable to the satires of beau and macaroni.

Cruikshank's most sustained and brilliant development of the fashionable folly theme can be seen in his *Monstrosities of 1822* [fig. 160] series, published by Humphrey between 1816 and 1825. Taking the fashionable and increasingly exclusive London parks[28] as their backdrop, Cruikshank documents the fashion each year through elegant and wonderful exaggeration. *Monstrosities* is set in Hyde Park, with the houses of Park Lane clearly visible to the right. Overseeing the scene is Sir Richard Westmacott's statue of Achilles. Copied from Rome and cast in the bronze from captured French canons, the statue was unveiled to the public on 14 July, 1822. By the time this print was published Cruikshank had reacted to the statue's unveiling, and made fun of the ladies who raised £10,000 towards its creation and particularly the decision to add a fig leaf. Cruikshank uses the statue, with its perfect classical proportions, to highlight the absurd and unnatural exaggerations of fashion. Both men and women have extraordinarily wasp-like waists which fight against their natural body shape, for example, the plump gentleman in the middle of the print. The thin waists of the two main dandies to the left accentuate their ballooning clothes. The high collar of the man with the tent-like overcoat to the right almost obscures his face, whilst the two main women illustrate how a fashionable should walk by pointing their toes in step, uniformly raising their dresses.

Cruikshank's images, albeit more accomplished than most, reflect the craze for satirical prints of dandies, a continuation of the Georgian tradition of satires of fashion. Images like *The Haberdasher Dandy* (published in 1818) [fig. 164] typify such prints. The move from dandy to swell represents a radical *volte-face* in the depiction of the young fashionable male.

Jerry in Training (*Life in London*) [fig. 162] epitomises the age from the point of view of the young 'swell' or

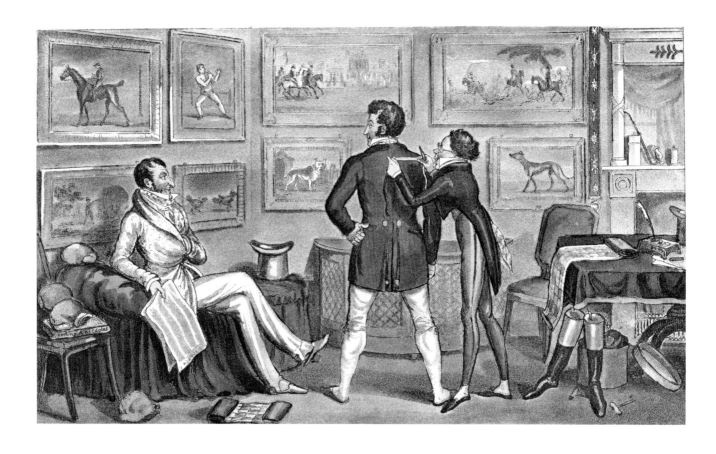

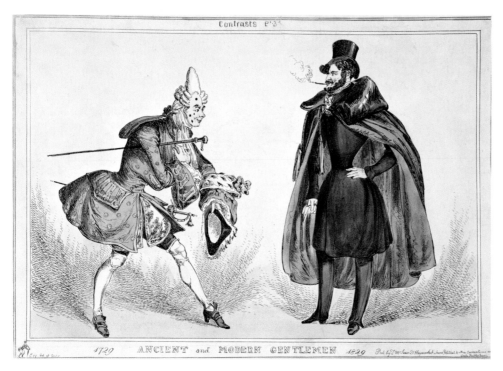

162. Robert and George Cruikshank, *Jerry in Training to be a Swell*, published in Pierce Egan's, *Life in London* (1820–21). Coloured aquatint.

163. William Heath (Paul Pry), *Contrasts, Ancient and Modern Gentlemen, 1729–1829*, 1829. Hand-coloured etching.

'Corinthian'. London was a playground of exploration for its main protagonists who consumed its varied aspects with enormous relish. Tom and Jerry (*Life in London*) [fig. 165] explore the 'gentlemanly' pursuits of pugilism, gambling, and dog- and cock-fighting, through their extended journeys to the farthest extents of the metropolis. Oiled by drink, their hedonistic and rakish rampage through the streets evokes the last vestiges of the eighteenth century, the major difference being that Hogarth was not on the side of the rake, whereas Egan and the Cruikshanks unambiguously are. *Life in London* is a perambulation through London, which harks back to the eighteenth-century satirical jaunt through the streets. It sees the world encompassed within the bounds of London, a world of diversity and extremes. The main protagonist, in this case the rustic Jerry Hawthorn, is a wide-eyed innocent, exploring London for the first time, finding strange customs and navigating the whole range of human experience. Unlike most eighteenth-century rambles it is also radically new in being illustrated, a crucial element which accounted for its enormous popularity. The images were well known, and were reproduced in many different formats from silk handkerchiefs to snuff-boxes and fans. *Life in London* also anticipated the social investigations that occur in the Victorian period, such as those of Henry Mayhew. The

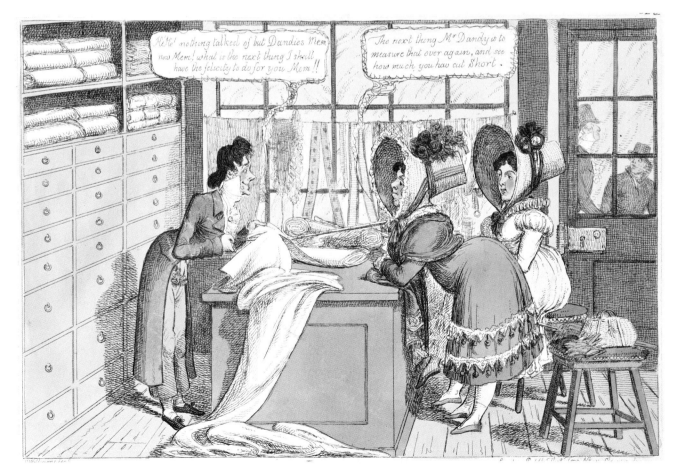

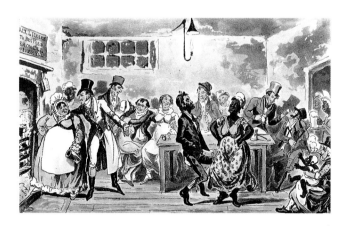

exploration of low life goes far beyond the comic descriptions of the eighteenth century. In terms of the book's frontispiece and in its representation of the metropolis, low life is the base on which the Corinthian column stands.

The contrast between the high and low life that exists within the city is explored and contrasted as the protagonists move easily between the two. One example is the punning of Almack's in the West End and All-Max in the East End. Almack's Assembly Rooms of King Street, St James's, was the most exclusive venue in London in the early nineteenth century and provided highly respectable places of public gathering outside the family homes for making marriage arrangements. All-Max, in direct contrast, is described as the 'Lowest Life' and unlike Almack's:

> It required no patronage; – a card of admission was not necessary; – no inquiries were made; – and every cove that put in an appearance was quite welcome: colour or country considered no obstacle; and *dress* and address completely out of the question... Lascars, blacks, jack tars, coal-heavers, dustmen, women of colour, old and young... were all *jigging* together.[29]

Life in London was extraordinarily popular and created something of a social phenomena, its imagining of London echoing the 'real life' of the period. *The Times*, for example, reported the death of Andrew Weston, 'King of the Beggars',

in 1826, a notorious London character made popular through his metamorphosis as Billy Waters in *Life in London*.[30] The book also evoked a craze of 'Charley baiting', or provoking the night watchmen. Such practical jokes were common, and satire records many similar events, initiated by what were described at the time as 'merry gentleman'. Atkinson's watercolour of *The Berners Street Hoax* (1809) [fig. 166] depicts a 'jape', in which pranksters call various tradesmen to converge on a poor unsuspecting victim at a specific hour. This particular prank became infamous in London and was the subject of several prints, as Malcolm describes:

> The Lady who was really the subject of this practical wit, starts back, amazed at the entrance of a groupe consisting of the first magistrate of a great city, a jew pedlar, an apothecary, an undertaker's man loaded with a coffin, a

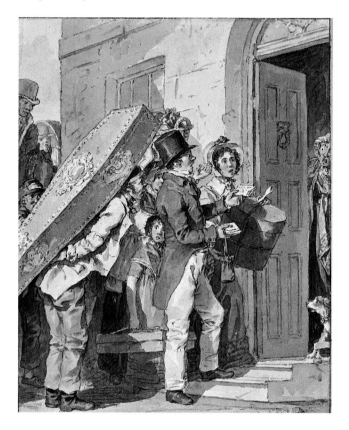

165. George and Robert Cruikshank, *Lowest 'Life in London' – Tom, Jerry and Logic among the unsophisticated Sons and Daughters of Nature at "All Max" in the East,* published in Pierce Egan's, *Life in London* (1820–21). Coloured aquatint.

166. John Augustus Atkinson, *The Berners Street Hoax,* 1809. Watercolour.

167. Anonymous, *The Midnight Hour,* c. 1820. Hand-coloured etching.

168. George and Robert Cruikshank, *Tom getting the best of a Charley,* 1820, published in Pierce Egan's *Life in London* (1820–21). Coloured aquatint.

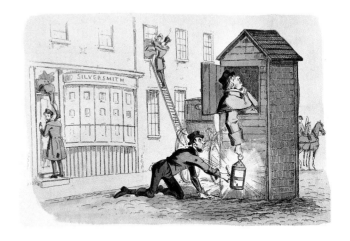

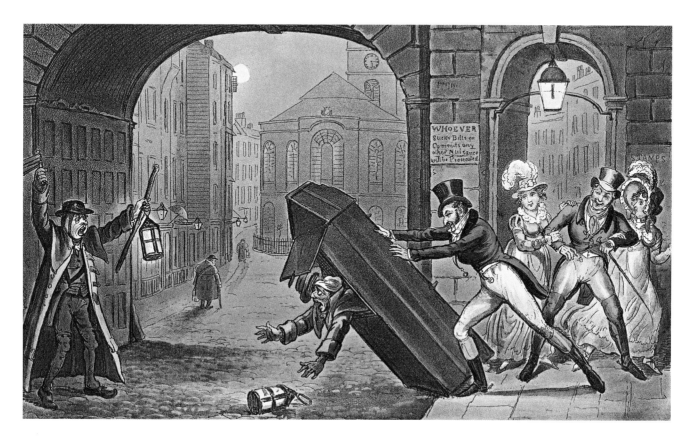

169. George Cruikshank, *Automaton Police Officers and Real Offenders*, published in *Bentley's Miscellany*, 1 May, 1838. Etching.

brewer, a gun-maker, an optician, frizeur, &c. &c. one of whom says, 'Madam, the street is full of trades-people after we have done.' 'OH lord, oh lord,' gasps the lady, 'what can all this mean: I sent for none of you; I know nothing about it – for 'sake do not torment me to death.'[31]

In satire, the Charley, or night watchmen, that existed before the Metropolitan Police Bill became law in 1829, was depicted, in line with popular opinion, as a joke. A satirical notice of 1821 advertised in jest for watchmen.

Wanted, a hundred thousand men for London watchmen.

None need apply for this lucrative situation without being the age of sixty, seventy, eighty or ninety years; blind with one eye and seeing very little with the other; crippled in one or both legs; deaf as a post; with a asthmatical cough that tears them to pieces; whose speed with keep pace with a snail, and the strength of whose arm would not be able to arrest an old washerwoman of fourscore returned from a hard day's fag at the wash-tub...[32]

This image of the watchman is found in numerous prints, including an anonymous etching entitled *The Midnight Hour*, (c. 1820) [fig. 167] which shows the incompetent watchman

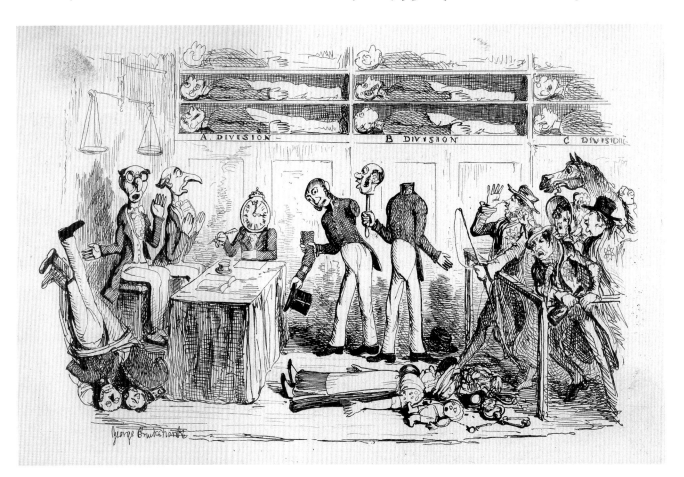

asleep in his hut, oblivious to an elopement and the robbery of the silversmith taking place behind him. Ironically, the establishment of the new Metropolitan Police drew equal humour in George Cruikshank's *Automaton Police Officers and Real Offenders* (1838) [fig. 169], in which the all too human watchmen have been replaced by hopeless machines, the marionettes also providing an ideal target for gentlemen to attempt to beat up the police without actually harming them.

A not unsurprising outcome of excessive drinking and celebration of lawlessness resulted in fights, and the image of brawls is commonplace in Regency caricature. A drawing by Theodore Lane from around 1824 [fig. 170] depicts a riotous scene at Covent Garden, where young bucks are engaged in drunken cavorting, despite the ineffectual attempts of the Charlies to stop it. This lively delineation is epitomised by the central figure, arms in the air with energy and exhilaration. In Henry Thomas Alken's lithograph, *A Touch of the Fine Arts* (1824) two nightwatchmen are seen receiving a punch in the face, in one case his assailant joyfully brandishing the stolen rattle. The image of fights is an image essentially of entertainment, in an age where boxing and pugilism was so well regarded and enjoyed by men of all social strata.

The March of Progress and Daily Life in London

...at the present period (1820)... it should seem that LITERATURE has kept pace with the new buildings of the Metropolis; and new streets and new books have been produced, as it were, by magic... These heroes of steam-engine velocity have not only produced *huge* quartos without being at the expense of one pennyworth of ink, but have also the *knack* of procuring high prices too. *Pierce Egan*[33]

All Londoners, from dustmen to gentlemen of leisure, felt the effects of progress and social change. The 'March' prints of Regency London mark the daily effects of democratisation, urbanisation and mechanisation. Futuristic visions tied with

the commonplace characterise the coming to terms with change, and Pierce Egan's comments in the introduction to *Life in London* acknowledges the changes taking place in the metropolis. William Heath's *The March of Intellect* (1829) [fig. 171] imagines a comic fantasy world of the future, mocking the strivings of change and reform, symbolised by the castles in the air scheme in the top right of the print. Travellers take a tube to India and the far-reaching effects of mechanisation create greater leisure and luxury for the lower classes, visible in the shoe black relaxing with his newspaper thanks to the 'Royal Patent Boot Cleaning Engine', and the dustmen enjoying pineapples. Furthermore, the education of the lower classes and increased literacy caused concerns about the

eroding of social barriers and hierarchies, and all this was expressed in satire.

The effects of mechanisation are most clearly manifest in the revolution of transport, in everything from steam-driven horses to the simple bicycle. In J. Sidebothem's *Perambulators in Hyde Park!* (1819) [fig. 175], unfortunate pedestrians are mown down by velocipedes ridden by young swells. Speed replaces the promenade of the park and machinery enters London's public gardens. In Cruikshank's *The Railway Dragon* (published in 1845) [fig. 177], a steam engine bursts through

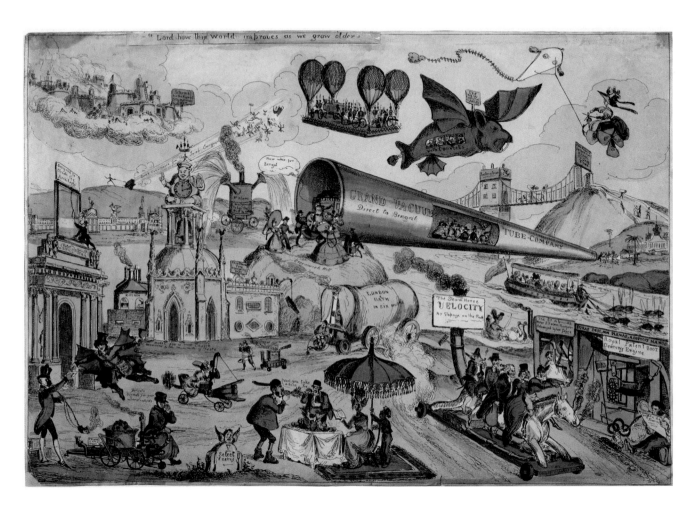

the wall of a London dining room and seizes the joint of beef and the plum pudding exclaiming, 'I come to dine, I come to sup, I come, I come… to eat you up!!'[34] In terms of urbanisation, Cruikshank's *March of the Bricks* [fig. 34] epitomises the relentless building and expansion of London into the surrounding countryside. The beleaguered, terrified and demoralised haystacks and cattle flee the rain of bricks emerging from the kilns of a brick factory. An army of figures made from hods, spades and picks leaving poorly built streets in their wake in which cracks are already appearing, march under the banner which reads: 'This Ground to be Lett on Building Lease Enquire of Mr Goth

Brickmaker Bricklayers Arms Brick Lane Brixton.' The mechanical process is represented as marionettes, free from all thought and consciousness, march on with a singlemindedness of purpose, relentlessly trampling through any obstacles. The general attitude of satire is to show the absurdity of the changes *in extremis* and its impact upon urban life.

Industrialisation caused very marked effects on London's environment, in particular on atmospheric conditions and the appalling state of the Thames. William Heath's *Monster Soup commonly called Thames Water, being a correct representation of that precious stuff doled out to us* [fig. 172], published in 1828

by Thomas McLean, amusingly reflects the unhealthy state of London's river. The horrified woman drops her cup and saucer at the sight of a magnified water sample in which all manner of monster thrives. If the river was a major problem, the effects of the London fogs was equally apparent. In *A Thoroughbred November & London Particular* of 1925 [fig. 173], aquatint evokes the haze of a thick fog, as an emaciated figure covering his mouth with his handkerchief to escape its effect steps out into the street into the path of two carriage horses appearing out of the mist. Heath's watercolour of The Strand in heavy fog (1821) [fig. 176] shows traffic grinding to a halt and evokes the chaos and misery that descended with the weather.[35]

If fog was a relatively new hazard in walking the London streets, the perennial dangers, outlined in earlier satires proved to be just as relevant. *Cigars* (1827) [fig. 177], by Heath, illustrated the craze for smoking cigars and the resultant nuisance it caused. The title from John Gay's eighteenth-century perambulatory satire, *Trivia: or, The Art of*

Walking the London Streets (1716) provided the title for George Cruikshank's (engraved by Woodward and published by Tegg) *The Art of Walking the Streets of London* [fig. 178] etched over a century later in 1818. Two plates are divided into four separate images each in which practical jokes and carelessness provide accidents and amusements. Umbrellas spike pedestrians on a busy street in 'how to carry an umbrella', whilst young bucks kick pedestrians out of the way in 'How to clear the streets'. Gillray's *Sad Sloppy Weather* [fig. 86] has its equivalent in 'How to make the best of mud', where a fat gent stamps on a loose paving stone, covering a fat lady with mud and causing an effeminate young man to shrink away in horror.

In *Life in London*, satirical metropolitan rambles change, and in Dickens's *Sketches by Boz* the ramble takes on a different character again. Imbued with more trenchant social observation, its journalistic nature and commentary sets the scene for the rest of the nineteenth century. Illustrated by George Cruikshank, the illustrations and text follow parallel

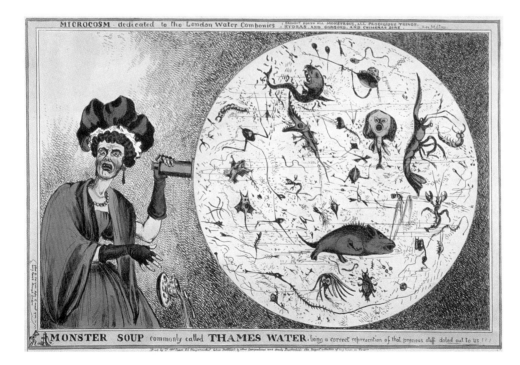

172. William Heath (Paul Pry), *Monster Soup commonly called Thames Water*, published by Thomas McLean, 1828. Hand-coloured etching. Guildhall Library, Corporation of London.

Drawn by M.E.Esq.ᵣ

Engraved

A THOROUGHBRED NOVEMBER

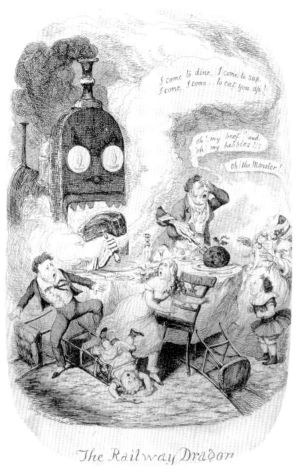

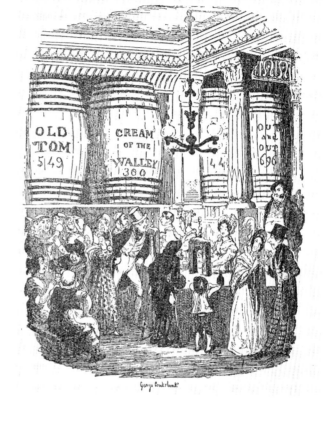

174. George Cruikshank, *The Railway Dragon*, published in Cruikshank's *The Table Book* 1845. Etching.

175. George Cruikshank, *The Gin Shop*, published in Charles Dickens' *Sketches by Boz*, 1836. Etching.

176. Heath, *Strand in Fog*, 1821. Coloured ink and watercolour. Inscribed, 'This drawing belonged to Charles Dickens.'

177. William Heath (Paul Pry), *Cigars*, published by Samuel Fores, 1827. Hand coloured etching.

but different courses. In *Life in London* the text to a large extent followed the images; in *Sketches by Boz* the illustrations follow the text. In Cruikshank's illustration *The Gin Shop* [fig. 175], we have a brightly illuminated scene with arguments, flirting and some signs of poverty portrayed by the beggar on crutches and the young boy leaning against the bar. It is still a far cry from the savage temperance prints of later Cruikshank, where gin is the feed of the malnourished and poverty stricken. There is little contrast in the image, although brilliantly drawn. Dickens' description, however, gives us a strong contrast, which makes patent the true

nature of the gin shop. The author's words lead us to the surrounding area:

> We will endeavour to sketch the bar of a large gin-shop, and its ordinary customers, for the edification of such of our readers as may not have had opportunities of observing such scenes... classical spot adjoining the brewery at the bottom of Tottenham Court Road, best known to the initiated as the 'Rookery'.

The filthy and miserable appearance of this part of London can hardly be imagined by those (and there are

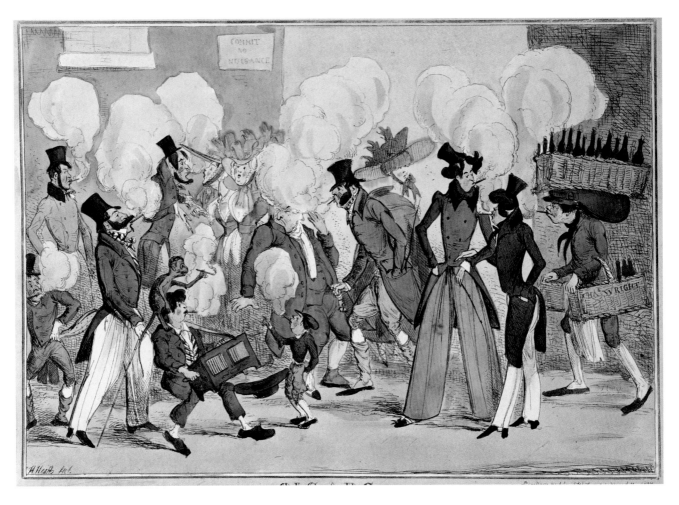

178. George Moutard Woodward, *The Art of Walking the London Streets*, plate 2nd, published by Thomas Tegg, 1818. Hand-coloured etching engraved by George Cruikshank.

179. J. Sidebethem, *Perambulators in Hyde Park*, 1819. Hand-coloured etching.

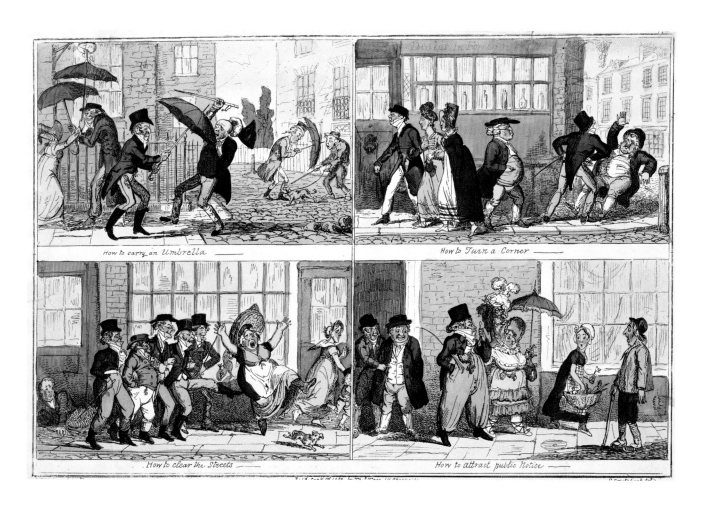

many such) who have not witnessed it. Wretched houses with broken windows patched with rags and paper... red-herring vendors in the front of parlours... girls of fourteen or fifteen, with matted hair, walking about barefooted... You turn the corner. What a change! All is light and brilliancy. The hum of many voices issues from that splendid gin-shop... Gin-drinking is a great vice in England, but poverty is a greater.[36]

Charles Dickens marks the beginning of the end of the golden age of satire. By the end of the Regency period and the beginning of the Victorian era, the print shop with its

visual images that had so influenced writers like Dickens and Thackeray had begun to die out, a fact lamented by Thackeray himself:

> Knight's, in Sweeting's Alley; Fairburn's, in a court off Ludgate Hill; Hone's in Fleet Street – bright, enchanted palaces, which George Cruikshank used to people with grinning, fantastical imps, and merry, harmless sprites – where are they? … his 'charming gratis' exhibition. There used to be a crowd round the window in those days of grinning, good-natured mechanics, who spelt the songs, and spoke them out for the benefit of the company, and who received the points of humour with a general sympathising roar. Where are these people now?[37]

It is interesting to note that amongst the predominantly illiterate working-class population the name of George Cruikshank was well known. Henry Mayhew, in his survey of London's poor, notes:

> The costermongers,' said my informant, 'are very fond of illustrations. I have known a man, what couldn't read, buy a periodical what had an illustration, a little out of

the common way perhaps, just that he might learn from some one, who could read, what is was all about. They have all heard of Cruikshank, and they think everything funny by him – funny scenes in a play and all. His "Bottle" was very much admired. I heard one man say it was very prime, and showed what "lush" did, but I saw the same man,' added my informant, 'drunk three hours afterwards.'[38]

The ferocity and bawdiness of much earlier satire had disappeared to be replaced by a softer edged humour. As Everitt recalled in his survey of nineteenth-century English satire:

> As the century passed out of its infancy and attained the maturer age of thirty years, a gradual and almost imperceptible change came [page end] over the spirit of graphic English satire. The coarseness and suggestiveness of the old caricaturists gradually disappeared, until at length, in 1830, an artist arose who was destined to work a complete revolution in style and manner of English caricature. This artist was John Doyle – the celebrated H.B. He it was that discovered that pictures might be mildly diverting without actual coarseness or exaggeration; and when this fact was accepted, the art of caricaturing underwent a complete transition, and assumed a new form.[39]

In 1838, Cruikshank engraved *Queen Victoria Enthroned* (1838) [fig. 181], which marked the beginning of a new era and character of London satire.

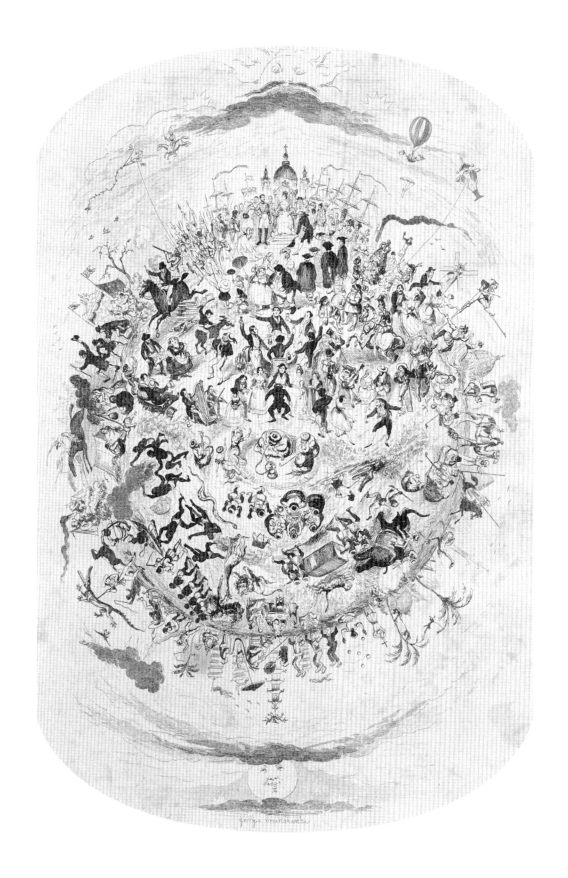

George Cruikshank

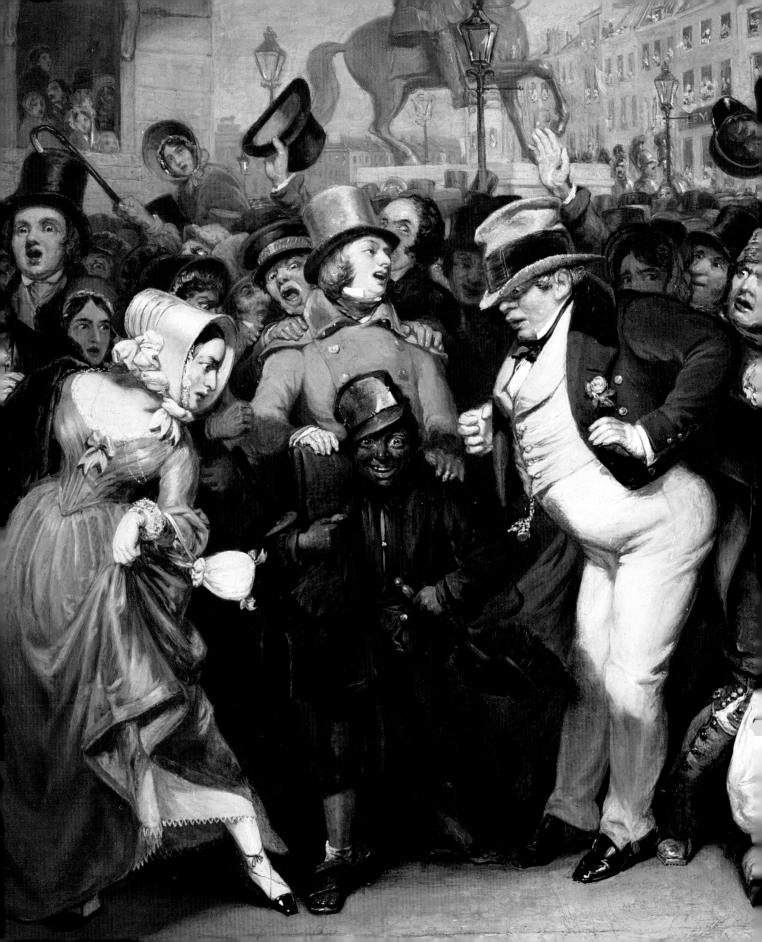

Victorian Satire: London, Poverty and the Birth of Cartoons

'I had formed an idea of the vastness of the city which covers sixty square miles... The size of London has not disappointed me, for the best of reasons, – I have never been able to see it all at once... I have seen a few square miles of blackened bricks and hideous chimney-pots, and all beyond the impenetrable cloud of smoke and dust and vapours. There is room enough under this smoky canopy for three millions of people and all the grandeurs of the great metropolis.' *George Augustus Sala, 1862*[1]

Robert Buss, *The Crowd*, 1841 (detail of fig. 190).

Dating from the honest but savage mirth of the coarse Saxon William Hogarth to the gentle smile of Kate Greenaway in our own day, a century and a half has passed away. Can it, indeed, be the same nation which receives with such delight the playful, sparkling banter of her charming productions after having so rapturously applauded the bitter, cutting sarcasm of the other? But it is quite possible. Hatred of vice and love of innocence are but different expressions for the same feeling.

Ernest Chesneau, *The English School of Painting*[2]

The march of progress and radical changes that began in Regency satire continued into the Victorian period. Comic magazines became weekly periodicals, mass production increased and the news stand effectively replaced print and booksellers as the main distributor of satirical images. London remained the heart of production and its main audience was a metropolitan one, just as the subject of London continued to dominate. The spirit of satire continued in a less radical and more didactic form, and its production in previously inconceivable numbers circulated in the metropolis and beyond. Satire changed as London changed. Technological advancements heralded new formats and allowed mass production, alongside a metropolis that was expanding at an enormous rate, its increasingly literate population more aware and concerned with poverty and injustices of the capital. The proliferation of images that for the most part populated the growing number of comic journals showed all aspects of London life with a new conscience, with an almost journalistic and investigative zeal. Ideas of morality and truth were at the forefront of the impulse to create satire. Within social satire this meant looking not simply at the personal foibles of individuals and types, which continued to feature strongly, but also the major social issues that echoed throughout metropolitan society. Satire was the result and commentator of the gargantuan metropolis, its forms and images reflective of developing attitudes. Art changed within this period, not only in terms of the highest art of the academy, which showed increasingly current and popular subjects, but in the illustrations in the

newly developed illustrated weeklies. This, in turn, affected satire, which had a new status and place within images of the city. Today's understanding of the word cartoon was first coined through John Leech's images for *Punch* in 1843. Text became increasingly important and images were framed and set within words that elaborated or provided the body of the illustration. The full-page image remained a pullout for the wall for a folio of amusement, as satirical prints always had been, but elaborative commentary and accompanying articles increasingly became the norm.

Satire did, however, retain characteristics from the late seventeenth century: it remained eye-level with the street. Ned Ward's satirical jaunts through London streets had its equivalents in the work of many writers, particularly George Augustus Sala, whose *Twice Round the Clock* was based upon

an eighteenth-century satirical circumnavigation of London. Contrasts, too, continued to provide the basis of humour, in particular in highlighting social problems. London types may have changed their dress, but recurrent characters were reiterated in such figures as the 'cheap gentleman' and the fashionable ninny. Hogarth was elevated to an unrivalled status, despite the problems the Victorians had with the perceived baseness of some of his images. His modern moral narratives inspired both painters and satirists alike. The softening of the image in the Victorian caricatures in their outward form, and avoidance of any risqué elements, was seen by many as lack of freedom, but within the form the spirit of satirical commentary continued. Satirical artists also gained editors, who were much more nervous of potential libel cases than the small print publishers of the eighteenth century. In spite of these legal implications, the spirit of satire and its heritage remained popular and continued to live in the woodcuts of the abundant periodicals. Thackeray, who spanned two eras of satire, contrasted the caustic line of Gillray, in his apposite definition of Victorian satire, and appealed to the universal spirit that linked him with the satire of his own day:

How savage the satire was – how fierce the assault – what garbage hurled at opponents – what foul blows were hit – what language of Billingsgate flung! Fancy a party in a country-house now looking over Woodward's facetiae or some of the Gillray comicalities, or the slatternly Saturnalia of Rowlandson! Whilst we live we must laugh, and have folks to make us laugh. We cannot afford to lose Satyr with his pipe and dances and gambols. But we have washed, combed, clothed, and taught the rogue good manners: or rather, let us say, he has learned them himself; for he is of nature soft and kindly, and he has put aside his mad pranks and tipsy habits; and, frolicsome always, has become gentle and harmless, smitten into shame by he pure presence of our women and the sweet confiding smiles of our children.[3]

The Rise of the Comic Illustrated Periodical

The distinct nature of Victorian satire was moulded by a number of factors. One of the major catalysts of change was

technological, which directly affected the form the image took and the audience that it reached. The medium that transformed the satirical image and the illustration was wood engraving.

Until now, the use of wood in printing images had been more prevalent in popular prints, whilst crude woodcuts continued to be the predominant medium. Being a quick, cheap and easy way in which prints could be produced for a street market, they represent a small part of satiric production, but interesting nevertheless. Such images include satirical valentine cards that took the trade of the intended recipient and made fun of the type. This can be seen in an image of coal heaver, *Thy face begrimed as black as soot*, (c. 1840s) [fig. 184] which depicts the familiar figure of the London coalman.

Wood engraving, on the other hand, was the form adopted by the illustrated weeklies, which were able to produce finer and sharper images. Unlike etchings, the predominant medium of Regency satire, wood engravings were more easily assembled in much higher numbers without losing their quality. Wood engravings became the most widely used method of reproduction until their eclipse by photolithography towards the end of the Victorian period. In the 1840s and through most of the nineteenth century wood engraving was unique in its ability to translate painting, drawing and photographs into print and allowed copies to be produced in phenomenal numbers. As Celina Fox highlighted: 'For wood engraving was not simply an art in its own right but was a vehicle for the art of others. Alone of all the graphic arts it could be printed with letterpress by steam, and it therefore presented the most readily exploitable means of diffusing art to mass audiences.'[4]

Wood engraving was produced with the end grain of a hardwood, usually box, a remarkable dense wood that allowed fine lines to be cut into it. Its main disadvantage was that the circumference of boxwood trees is quite small, a problem that was overcome by using a large number of blocks bolted together to create one large image together with an imported box that had a wider girth. It was an intensely laborious and intricate task to engrave the wood

and teams of engravers were employed, in the case of large prints often working on the same image. As a result, a large workforce of engravers emerged in London, employed in small studios or at home, working long hours at piece rates without the protection of a union. And when photolithography finally eclipsed wood engraving as the main method of illustration production, large numbers of engravers faced hardship.

The advantages of engraving were that a remarkably sharp image could be reproduced endlessly due to the metallic plating method (known as electrotyping), which enabled many copies of the block to be reproduced. This also meant that copies could be sent to publishers abroad, particularly to America, where the same illustrations were often used. William Luson Thomas, editor of *The Graphic*, describes the process in detail on one of the accompanying illustrations *The Engraving Studio* (1882) [fig. 183], giving us a direct insight into the working environment of the wood engraver. They were not artists, draughtsmen or illustrators – engraving was a mechanical process. Of course the most skilled engravers were sought by artists, yet its status at best was low and was never that of an artist; at worst it was hackwork.

Wood engraving was the perfect medium for periodicals and the illustrated magazine dominated the Victorian period. Two illustrated periodicals which took full advantage of wood engraving dominated the century, were *The Illustrated London News* (launched in 1842) and *Punch* (launched in 1841), the first illustrating, the second satirising. In the wake of these periodicals, a large number of imitators emerged, some more radical, some cruder, but most following a similar format and challenging their monopoly of the market place. *Punch* by no means had a monopoly on the talented authors and artists, and it is worth reviewing a list of the comic periodicals that emerged within this period. Although not being exhaustive, it does give an idea of the number of periodicals that were available. These were namely *The Squib* (1842), *Judy* (first of that name, 1842), *Cleave's Gallery of Comicalities*, (c. 1844), *Hood's Magazine and Comic Miscellany*, (1844–48), *Puck, a journalette of fun* (1844), *Joe Miller, the Younger,*

Published by A. PARK, 47, Leonard Street London.

Thy face begrimed and black as soot, 47
No lady fair, will ever suit;
No Beau art thou for lovers levee,
Thy mind is Bent on Pots of Heavy;
No Fan to thee is known, thou Flat,
Except thy ugly Fan Tailed Hat!
Thy spooney Face appears, good lack,
As if indeed you'd got the Sack;
If hauled you o'er the Coals—in fine
Who'd have you for a Valentine?

184. Anonymous, *'Thy face begrimed and black as soot'*, published by A. Park, London,
c. 1840s. Coloured woodcut. Valentine card depicting a coal heaver.

185. John Leech, *Substance and Shadow, Cartoon No.1*, 1843. Wood engraving published in *Punch*, 1843, p. 23.

(1845), *The Man in the Moon*, (1847–49), *Puck* (1848), *The Puppet-Show*, (1848–49), *Chat* (1850–51), *Diogenes* (1853–55), *Town Talk*, (1858–59), *Fun*, (1861–1901), *Comic News* (1863–64), *The Hornet* (1867–80), *Tomahawk* (1867–1870), *Judy* (the second so named, 1867–1907), *Iris: a Serio-Comic Magazine*, (1868–69), *Vanity Fair* (1868–1914), *Will o' the Wisp* (1869–70) *The Hackney Comic Sketches. An Illustrated Manuscript Magazine of Humour* (1871), *The Days' Doings*, (1871–72), *Moonshine*, (1879–1902), *The Alarum: A Panorama of the Times*, (1886–87), *Saint Stephen's Review* (1883–92), which continued as *Big Ben* (1892–93) and *Topical Times* (1884).

Many of the these were short-lived, but the sheer numbers of production give an indication of the audience that existed for such magazines. Due to the relative ease of production, the costs were fairly cheap – confined within pennies – allowing a much wider circulation than had been previously possible. The news stands were filled with satire

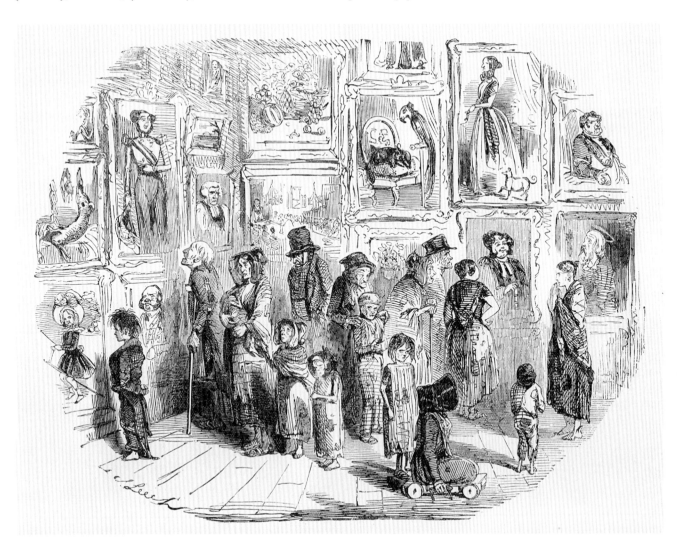

for a new metropolitan audience, and as the century progressed so too the numbers of periodicals produced. In 1841, the year of the birth of *Punch*, it is estimated that 472 newspapers were circulated in England and Wales. By 1900 that figure had ballooned into 2,323 magazines and reviews and 2,491 newspapers. In 1870 we have an idea of the readership of *Punch* (3d weekly), *Fun* (1d weekly) and *Tomahawk* (2d weekly), which amounted to 40,000, 20,000 and 10,000 copies respectively.[5]

The model and mark set for satirical periodicals was *Punch*. Before its arrival comic periodicals and comic journalism, albeit in a different form, had been in decline. Mark Lemon (1809–70) and Henry Mayhew (1812–87), founded the magazine to be, in part, modelled upon Philipson's *Paris Charivari*. The first edition of *Punch*, *The London Charivari*, was issued on 17 July, 1841, and it was an enormous success, continuing throughout the nineteenth century, consistently out-selling rivals. Its success was due to its ability to attract the most important illustrators of the age, in the beginning John Leech, Richard Doyle and Kenny Meadows, and later John Tenniel, Charles Samuel Keene, George du Maurier and Linley Sambourne. Although much of *Punch* was verbal humour, the inclusion of the full-page caricature, with its verso left blank in order to preserve the quality of the image, was reflective of the role of images to define the paper.

The influence of Punch cannot be understated, even though its dominance of the market has left other brilliant and short-lived journals unjustly neglected. Max Schlesinger, in his *Saunterings In and About London*, in which he reviews London newspapers, could not help to mention *Punch*: 'It is therefore not at all astonishing that the weekly press should have experienced an enormous increase within the last few years... *Punch*... is prosperous, easy, comfortable, and influential, as indeed it fully deserves to be.'[6]

If the format of *Punch* set the mark for other periodicals, its radical treatment of pertinent social problems was also a distinguishing feature of the humorous weeklies. The coining of the term cartoon, meaning a comic illustration rather than a serious preparatory drawing, emerged in the Charivari in 1843, with one of John Leech's most famous and influential

images, *Substance and Shadow* [fig. 185]. It was 'Cartoon No.1' of a series of images produced by *Punch* in response to the exhibition at Westminster Hall in 1843 of the cartoons for the decoration of the houses of Parliament exhibited at Westminster Hall. The graphic image makes explicitly clear *Punch*'s criticism of government policy, which favoured schemes of cultural, and by implication, moral improvement above tackling directly the problems of poverty. The commentary further explained:

> We conceive the Ministers have adopted the very best means to silence this unwarrantable outcry. They have considerately determined that as they can afford to give hungry nakedness the substance which it covets, at least it shall have the shadow.
>
> The poor ask for bread, and the philanthropy of the State accords – an exhibition.[7]

Its biting attack, even without the savage imagery of Gillray, hits its mark, and also serves to criticise fine art in avoiding depictions of contemporary society. The pitiful starved and hardened faces of the paupers look bemused at the vain and trivial subjects framed on the wall, similar to those of the Royal Academy. High art did not feature such subjects as the pathetic crowd assembled uncomfortably in the gallery, and the *Art-Union* magazine attacked *Punch* for degrading art to caricature.[8] The use of contrast, adopted by

Leech, is strikingly disarming and the starving boy, looking at the nourished and well-dressed girl in the picture, reflects the comments of John Fisher Murray in *The World of London* (1845): 'I have seen a poor family, ragged and hungry, the children running after an ugly pug-dog with a velvet jacket on, taking the air, and led by an attendant footman with gold-headed staff.'[9]

Punch or *The London Charivari* focused on an intimate portrayal of urban mores as a means of social criticism, an approach copied by many of its rivals. It is worth highlighting one of the many since forgotten journals that dealt almost exclusively with the capital. *Town Talk* epitomised the attitude of satire in tackling London's social concerns. A short-lived periodical, it produced only fifty-four issues between 1858 and 1859, but within that time dealt unflinchingly with social problems as they impacted upon London. Its heading is redolent of its content – a panorama of London, with the dome of St Paul's at its centre, the Monument and the Palace of Westminster visible interspersed with smoking chimneys: the Victorian metropolis.

High and Low Art, Paint and Pencil

I consider Graphic Satire, or, in the ordinary sense of the term, Caricature, as an important branch of the Fine Arts in this country, however contemptuously an art so popular may be regarded by some inconsiderate critics. Nor can the history and progress of the English school of art be complete without much more than a mere mention, or slight notice of Satiric Art.[10]

The position of satire within the art world has always been difficult to define. In the Victorian period its position continued to be ambiguous although its relationship with high shifted its position. The individual satirical print had almost disappeared and the role of satirist was very often synonymous with illustrator. Furthermore, wood engraving and mass production took the artist one further step away from the idea of an original work of art. A clear and apparently unimpeachable divide had been drawn.

During his lifetime, Hogarth was admired especially for the strong narrative content of his works and the morality he apparently espoused. The Victorians understanding and veneration of Hogarth was of course from their own perspective which looked upon elements of eighteenth-century satire as somewhat crude. 'High' artists such as William Powell Frith and George Elgar Hicks wished to avoid being labelled mere caricaturists, although it was effectively impossible; to the popular caricaturist, they could not

escape the confines of what was considered essentially a lower form of art. Yet by the same token, in the mid-nineteenth century, high artists deigned to look at the vast wealth of modern life around it as a subject for their art, and more often than not its models were the popular wood engravings and satires of the periodicals. As the predominant visual images of contemporary London life were illustrations, parallels were drawn and interplays inevitable. If Frith was breaking new ground in selecting Derby Day as a subject for

high art, the subject had been dealt with on several different occasions by the caricaturist's hand.

Both art forms were supremely popular, albeit that one was viewed on the walls of the Royal Academy, the other in a humorous magazine. The latter dealt with subjects that were accessible and fascinating to a widening audience. As a result, art critics looked with suspicion at the 'modern life' paintings of high art and often accused it of vulgarity and pandering to popular prejudice. The implicit criticism of

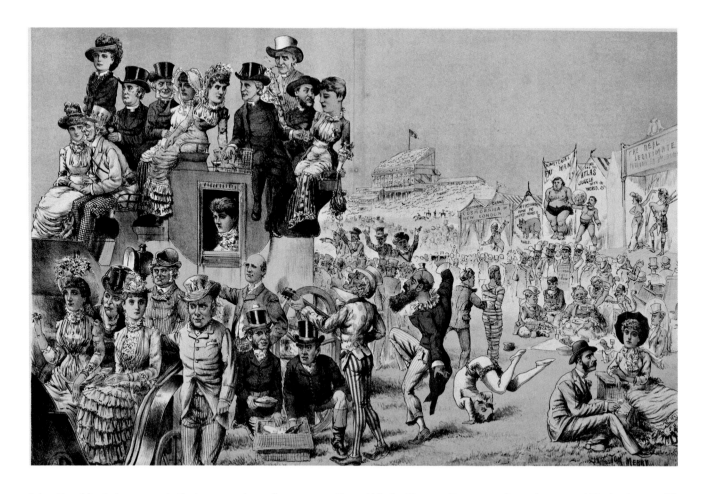

John Leech's *Substance and Shadow* may have been true of academic art in the 1840s but the situation was radically changed by the 1850s and '60s.[11] George du Maurier's drawing for *Punch* in 1887 showing a private view of the Royal Academy [fig. 186] demonstrates two very different and contradictory aspects: on the one hand it illustrates the retained exclusivity of Burlington House, in its role of fashionable arena; on the other, it indicates how widespread the interest in art had become, suggesting that every visitor was a critic and not just of the art. The aloofness of the Royal Academy remained a recurrent theme through its private views, yet when its doors opened to all and sundry record figures were recorded.[12]

Frith's important painting of Derby Day (1858) [fig. 187], of which the print sold innumerable copies, illustrates how caricatures relate to it both before and after it was conceived. Derby Day was a public holiday during which Londoners moved *en masse* for the day to Epsom to see the race, an event where all hierarchies of society rubbed shoulders.

Alfred Henry Forrester [pseudonym, Alfred Crowquill] (1804–72), drew *Stanley Thorn at Epsom*, for *Bentley's Miscellany* in 1840 [fig. 189], and shows many of the elements that were to make up Frith's painting – the tent, grandstand and coaches, with the poor moving around amongst them. In a more comical way, Richard Doyle's 'A View of Epsom Downs on ye Derbye Daye', from the *Manners and Customs of ye Englysche in 1849*, further illustrates what a popular subject Derby Day was for caricaturists. Frith's grand panoramic evocation in paint was new to the world of high art, but commonplace in the world of satire and illustration. Indeed, Frith's *Derby Day* became such an iconic and defining image of the mid-Victorian era that in the perennial satiric device of forming caricature around well-known works of art, the painting was used for the basis of many satires including, a 'Presentation Cartoon' for *Saint Stephen's Review* (31 May, 1884), a double-paged coloured lithograph entitled *On the Hill at Epsom* [fig. 188] and 'Animal Spirits on Derby Day' from *Punch*.[13] This illustrates, to some extent, the complex

relationship that existed between high art and caricature, its subjects colliding and its treatments growing closer: the artist acknowledging popular imagery and the caricaturist drawing from life.

Within art criticism the boundaries between art and caricature were made unambiguously clear, as Robert William Buss (1804–75) noted how 'contemptuously an art so popular may be regarded by some inconsiderate critics.' Like several satirists, including John Leech, he harboured the ambition, although he failed, to be a successful painter. In his painting of 1841, *The Crowd* [fig. 190], Buss depicts a cheering crowd of Londoners looking down Pall Mall, with Wyatt's statue of George III clearly visible in the background. The crowd, most probably celebrating the marriage of Victoria and Albert, are disturbed by the appearance of a chimney sweep who stares directly out at the viewer whilst moving out of the way to avoid the soot, to the annoyance of the crowd behind. The painting is a strange mix of popular caricature and fine art, and although looking forward to the modern life painting of over a decade hence, also harks back to the social comedy of John Collet. The types and physiognomy are too exaggerated for it to be taken seriously; in high art anatomy must be drawn accurately, as humorously illustrated by *Punch* in *A Good Excuse* (1864) [fig. 191].

Artists such as the Pre-Raphaelites would occasionally use caricature in gently mimicking their circle of friends. John Everett Millais's ink drawing of three rows of soldiers led by a drummer [fig. 192], produced in 1844 when he was about fifteen, similarly illustrates the awareness of satire and caricature as a unique form, an entertaining diversion by artists

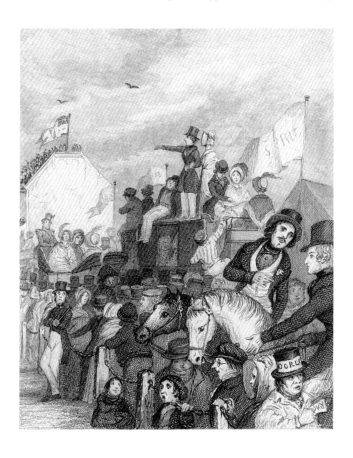

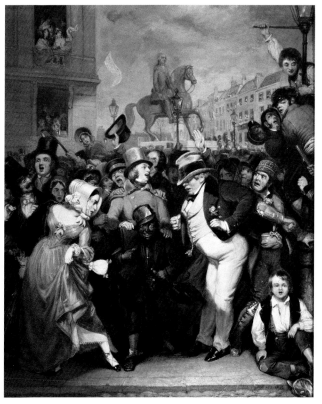

191. Anon, *A Good Excuse*, 1864. Wood engraving for *Punch*, January 16, 1864, p.28.

192. J. E. Millais, a parade of soldiers, all with the same caricatured face and upturned nose, 1844. Red ink brush drawing.

193. J. E. Millais, *It is the chapeau blanc, the white witness*, illustration for *Mokeanna; or The White Witness*, 1863. Wood engraving for *Punch*, March 21, 1863, p. 115.

A GOOD EXCUSE.

of the period. This amusing image takes the necessarily uniformity of soldiers' dress and applies it to their comic physiognomy. Millais later flirted with satire and provided an illustration to *Mokeanna; Or, The White Witness* for *Punch* in 1863 [fig. 193].

In his famous series of *The Rake's Progress* and *Marriage à la Mode*, Hogarth develops the narrative in a series of tableaux, an approach that appealed greatly to the Victorian imagination. Frith attempted, in two series, *The Road to Ruin* and *The Race for Wealth*, as well as an uncompleted *Morning, Noon* and *Night*, to emulate Hogarth's series, whilst simultaneously removing the satirical form. Within the realm of caricature, George Cruikshank also sought to emulate the eighteenth-century English master in *The Bottle*. This was a series of eight plates in glyphograph of 1847, a new medium which made print production easier but to a certain extent compromised definition of line, and a continuation of the narrative in *The Drunkard's Children* (a series of eight plates in glyphograph of 1848). The contrasting approaches of two different artists, one fine, one satiric, in attempting to create a contemporary Hogarthian genre, demonstrate the contextual inability of artists to move convincingly between high and low art forms as Hogarth did.

Hogarth's railing against caricature as opposed to character also had echoes within the Victorian period. When it came to caricature portraits, *The Daily News* accused the

famous portraits of *Vanity Fair*[14] of not being caricatures at all. The editor, Thomas Gibson Bowles (1842–1922), argued that they were exaggerations that were created for no specific purpose: 'There are grim faces made more grim, grotesque faces made more grotesque, and dull people made duller by the genius of our talented collaborator "Ape"; but there is nothing that has been treated with a set purpose to make it something that it was not already originally in a lesser degree.'[15]

A similar view was held by Charles Bennett, whose book *London People: Sketched from Life* of 1863 stresses the importance to him of his caricature having a truth to reality. 'The faces and figures were drawn from life in every instance, and under circumstances when the prevailing aspect and character of the persons selected were strongly brought out;...'[16]

Criticism consistently emphasises the idea that truth and character should take precedence over and above satirical fantasies and invention, in a position akin to Hogarth's argument of character over caricature. This stance was taken influentially by the critic John Ruskin, whose own features appear in more than one *Vanity Fair*. In an 1883 letter of criticism to the artist Franz Goedecker ('Goe') of *Vanity Fair*, Ruskin made his position plain, outlining the greater importance of satire and caricature in having an ethical role in highlighting the injustices of the metropolis, a purpose characteristic of Victorian satire.

I see no merriment either in the weaknesses of age or the abortions of vulgar form; and I sincerely hope that you will not waste your real powers in pandering to the malice or stupidity of those who *do*. If you add to your present gift of seizing or abnormal character the skill proper to a painter, you might take a position of most useful influence in representing the evils and dangers of our great cities and manufactories; and you might win for yourself such an honourable fame as that of Hogarth, instead of the momentary praise of amusing the idleness of evening parties.[17]

194. Leslie Matthew Ward ['Spy'], *Joseph Edgar Boehm with a bust of John Ruskin*, 1881. Watercolour for *Vanity Fair*, 22 January, 1881.

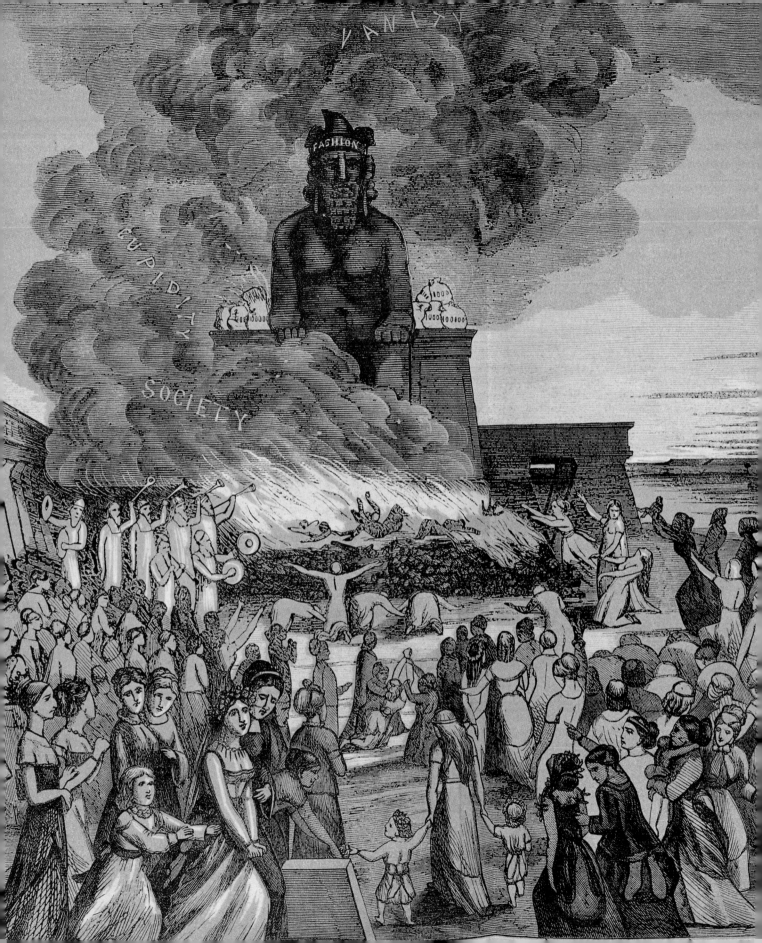

Satire, Morality and the State of the Metropolis

The predominant theme of London in Victorian satire is reflective of its audience, which although went well beyond the bounds of the city, particularly through the ease with which it could be posted, nevertheless remained essentially metropolitan in its subjects and concerns. The strands of social satire continued to change throughout the century, manifested in two distinct aspects. The first was the great body of material that criticised the structure of society, and more particularly, the plight of the poverty stricken and the physical state of London; the second the comedy of type and social nuance of living in London, closer to its eighteenth-century predecessors but far more polite in its humour. The comic street vendor, the lost foreigner and argumentative Hackney cabbie, archetypes that had already existed, continued to reappear in a proliferation of incidents of metropolitan foibles. Here the theme of ludicrous fashion can be seen in the mimicking of the aesthetic movement, the late Victorian equivalent of the dandy or beau. A gentler and in some senses, a more sterile humour than the eighteenth century, it provides a fascinating mirror of society and the perceptions Londoners had about themselves.

The harshest images were against poverty; as Ruskin indicated, 'the evils and dangers of our great cities…', and it is this body of work that we shall consider first. A large number of satires predominantly explored London as a corrupt and degraded environment: a modern Babylon, characterised by the march of industrialisation and excessive new building that were destroying the old London. The periodical *Tomahawk*, which ran from 1867 to 1870, and 'whose cartoons', according to Graham Everitt, the author of *English Caricaturists* of 1886, 'are certainly the most powerful and outspoken satires which have appeared since the days of Gillray,'[18] produced 'The Modern Moloch! A View of Society For 1870' [fig. 195]. Like Babylon, Moloch represents the Biblical associations of heretical dissolution, in this case the god of the Ammonites to whose shrine children were sacrificed. In *Tomahawk's* print, Moloch wears a crown entitled 'Fashion', and the sacrifice of burning children produces a

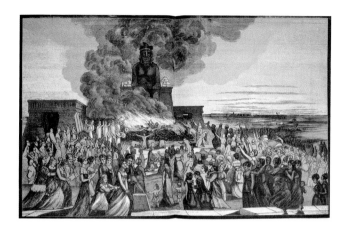

195. *(above and detail left)*. Anon, *The Modern Moloch*, 1870. Wood engraving for *Tomahawk*, 29 January, 1870, pp. 40–41.

196. Anon, *The Civilised Home… And this is the father lying there*, 1890. Wood engraving published in the Christmas number of *Truth*, 25 December, 1890, p. 39.

197. Frontispiece of *Town Talk*, 8 May, 1858. Wood engraving. By permission of the British Library, P.P.5267.

198. Anonymous, *Last Few Days of St Paul's*, 1863. Wood engraving for *Punch*, 8 August, 1863, p. 62.

long plume of smoke in which the words 'Society, Stupidity and Vanity' can be discerned whilst cymbals clash and trumpets blare. London is represented as an essentially immoral city, sacrificing the lives of its poor infants for the sake of superficial desires.

London as Babylon is a theme that weaves into many images of London in the nineteenth century. The physical state of the city through increased industry and new buildings, and the rise in numbers of the poor and destitute, provided a very real image of modern Babylon when contrasted with the wealth of leisured society. Industry and the chimneys of London, symbolically represented on the header of *Town Talk*, was a growing theme in satirical depictions of London. An anonymous illustration from *Punch* entitled the *Last Few Days of St. Pauls* [fig. 198], is explained by the commentary: 'In a very short time this remarkable edifice [St Paul's Cathedral] will become invisible, owing to the great improvements which the march of intellect and the progress of commerce, providentially force upon this Great Metropolis.'[19]

Further to this, the environmental effects of expanding industry became the character of London itself. As Max Schlesinger described in his *Saunterings In and About London*: 'the London sun is justly charged with a want of curiosity. It turns its back upon the wealthiest city in Christendom; and, in the presence of the most splendid capital in Europe, it insists on remaining veiled in steam, fog and smoke.'[20] And on street level, Schlesinger describes the awful effects:

A dense fog, with a deep red colouring, from the reflection of numberless gas-jets, and the pavement flooded with mud; a fitful illumination according to the strength of the gas, which flares forth in long jets from the butchers' shops, while the less illuminated parts are lost in gloomy twilight.[21]

The chaotic streets, an image consistently described by writers on London, was only surpassed by the image of London's great river. The state of the Thames provided a great cause for concern, in the 1850s and '60s referred to as

the Great Stink, filled with sewerage moved around and into surrounding housing with its tidal flow. A comic 'Design for a Fresco in the New Houses of Parliament', produced in a 1858 edition of *Punch*, graphically depicted disease and deformity as the children of the Thames.

LAST FEW DAYS OF ST. PAUL'S.

If a polluted London provided the backdrop for satire, the central image of Londoners, in terms of social concern, was one of a great divide: poverty and wealth. The homeless and the destitute were a common sight on London streets and their presence was increasingly apparent in images of Londoners. The casualties of metropolitan life – the poor – were portrayed as pitiable in contrast to satirical images of the eighteenth century. The immorality of a society that enjoyed great wealth and allowed such poverty was stressed in many images. In particular, the plight of the poor was epitomised through two very specific recurrent images: the poor working conditions of the seamstress, suffering on

FATHER THAMES INTRODUCING HIS OFFSPRING TO THE FAIR CITY OF LONDON

(A Design for a Fresco in the New Houses of Parliament.)

THE FOG, JANUARY 21ST., 1865.

Link-boys (Masters of the Situation). "IF YER DON'T GIVE US A SHILLIN' WE'LL SINGE YER WHISKERS!"

DIRTY FATHER THAMES.

199. Anonymous, *The Fog, January 21st, 1865,* 1865. Wood engraving for *Punch*, 25 February, 1865, p .73.

200. Anonymous, *Father Thames Introducing His Offspring To The Fair City of London*, 1858. Wood engraving for *Punch*, 3 July 1858, p. 5.

201. Anonymous, *Dirty Father Thames*, 1848. Wood engraving for *Punch*, Vol. IV, 1848, opposite p. 153.

202. Anonymous, *The Education Question "Move On!" Where? To The Prison, or the School,'*
1858. Published in *Town Talk, 8* May, 1858; pp. 6–7. © The British Library, London.

meagre or insufficient wages for the vanity of others; and the endemic alcoholism amongst much of the poor. The Christmas Number of *Truth* in 1890 shows a caricature entitled *The Civilised Home* [fig. 196], illustrating a poverty-stricken family, the father unconscious on the floor surrounded by empty and broken bottles, the mother, half dead stitching away surrounded by the weeping and sleeping malnourished children. The interesting point is that in direct contrast to Georgian satire, exaggerated features of the poor do not, and are not meant to, elicit laughter, but rather emphasise through deep irony, the tragedy of the situation.

In the visual arts, the cause of poverty was taken up by illustrators as well as caricaturists. The subject of the unflinching images were first drawn by the satirist's pen with irony and cutting-edge images of poverty, later depicted in the illustrated periodicals, such as the *Illustrated London News*. Much later, in the 1870s, social realism was engaged with by fine artists such as Hubert Herkomer, Frank Holl and Luke Files, who themselves had begun life as illustrators for *The Graphic*, begun in December 1869.[22]

In spite of the underlying social contains, the methods of humour employed were often the same as eighteenth-century

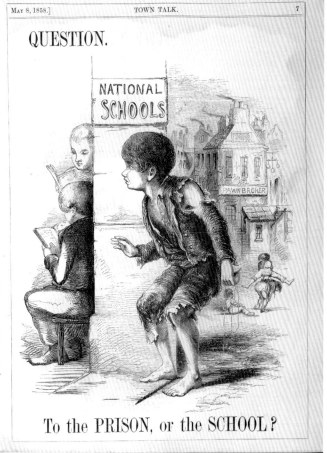

satire. In particular the method of contrast was used to great effect, especially in depicting the social divide. It is worth quoting at length John Fisher Murray's section on 'Contrasted Conditions' from *The World of London*:

To a man living on the shady side of life, whose poverty compels him to walk with his own feet, hear with his own ears, and see with his own eyes, the contrasted conditions of London Life afford much matter for painful contemplation. These contrasts are striking and forcible; they run the whole gamut of the social scale, from the highest treble to the deepest base; they exhibit human life in every colour, from hues of the rainbow to the deepest shadows and most unchequered glooms; and all this in a day's walk in the space of a few paltry acres; next door to luxury and profusion you have hunger and despair; the rage of unsatisfied hunger and the lusts of desire that no luxury can quench.

I have seen little children, fat enough for the spit, wrapped in woolpacks of fleecy hosiery seated in their little carriages, drawn by goats, careering over the sward of Hyde Park; and at the same moment, crawling from the

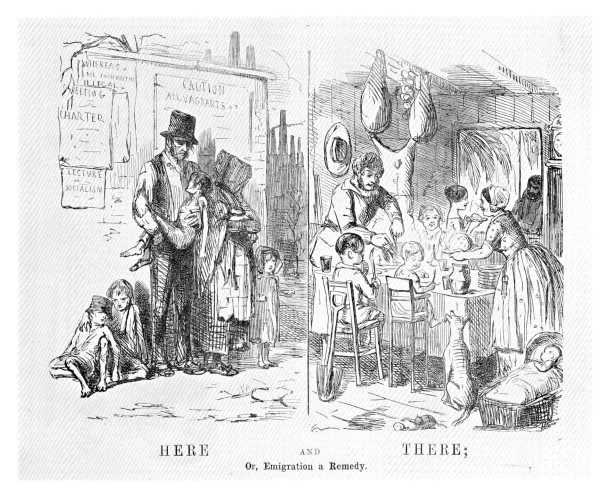

HERE AND THERE;

Or, Emigration a Remedy.

204. Anonymous, *Blood Money: How it is Made; How it is Spent*, 1870. Coloured wood engraving, published on a double spread of *Tomahawk*, Vol. VI, 19 February, 1870 pp. 70–71.

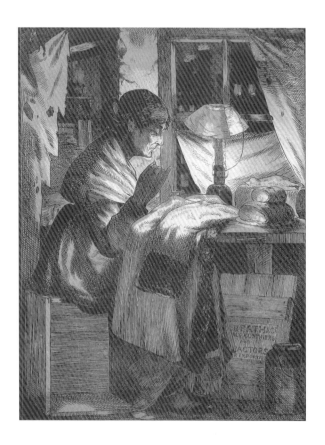

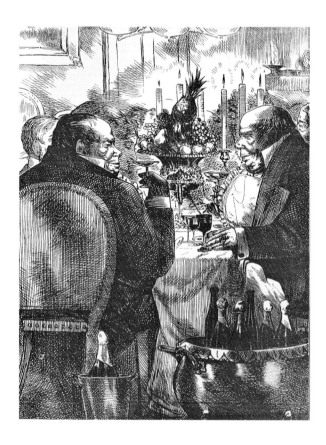

hollow trunks of old trees, where they had found refuge for the night, other children, their nakedness hardly concealed by a few greasy rags flapping against the mottled limbs of these creatures, heirs of shame and sorrow, the heritors of misery and its necessary crime.[23]

Satirical images sought to utilise this contrast in their presentation of poverty. If John Leech's 'What Wide Reverses of Fate are There' employs contrast in one image, the split image provided even greater opportunity of irony, as background details and settings could be also contrasted. Such devices had been used by Hogarth in *Before* and *After* and by Gillray in *Freedom* and *Slavery*. Victorian caricaturists employed the same device in highlighting poverty. John Leech's *Here and There* [fig. 203] (*Punch*, 1848, Treuherz)

contrasted a prosperous working family in the new world with a malnourished family in London, in order to illustrate the simplistic remedy of emigration to alleviate the poverty of the metropolis. *Town Talk* consistently used the device in its double-page spreads with images such as 'THE EDUCATION QUESTION: "Move on!" Where? To the Prison, or the School.' (1858) [fig 202].

The figure of the seamstress as a symbol of social concerns was initially expressed through the poem by Thomas Hood first published in *Punch* of 1843, entitled 'The Song of the Shirt'. Its influence was widespread, striking a chord in its epitome of the vain struggle of those who would work, but were hopelessly exploited. Ruskin recalled:

205. John Leech, *Pin Money, Needle Money*, published in *Punch*, December 1849. pp. 250–51. Wood engraving.

In poetry, the temper is seen, in perfect manifestation, in the works of Thomas Hood... and more or less in the works of George Cruikshank, and in many of the illustrations of our popular journals. On the whole, the most impressive examples of it, in poetry and in art, which I remember are *The Song of the Shirt*...[24]

The opening lines begin:

> With fingers weary and worn,
> With eyelids heavy and red,
> A Woman sat, in womanly rags,
> Plying her needle and thread –
> Stitch! stitch! stitch!
> In poverty, hunger, and dirt,

> And still with a voice of dolorous pitch
> She sang the 'Song of the Shirt!'[25]

John Leech's caricature, *Pin Money, Needle Money* [fig. 205], contrasted in two images the poverty stricken seamstress with the indulged woman of higher class. A more brutal image on the same theme was produced by *Tomahawk* entitled 'BLOOD MONEY'. On the left, the words 'How it is Made' introduce a seamstress, dressed in rags and straining her eyes, illuminated by a lamp. She is seated on the lid of the box that reads 'Death & Co. Manufacturers'. The contrasted image entitled 'How it is Spent' depicts two fat, Neanderthal-looking business men indulging their greed at a table laden with fine foods and wines [fig. 204].

The figure of the drunk represented the poor that could

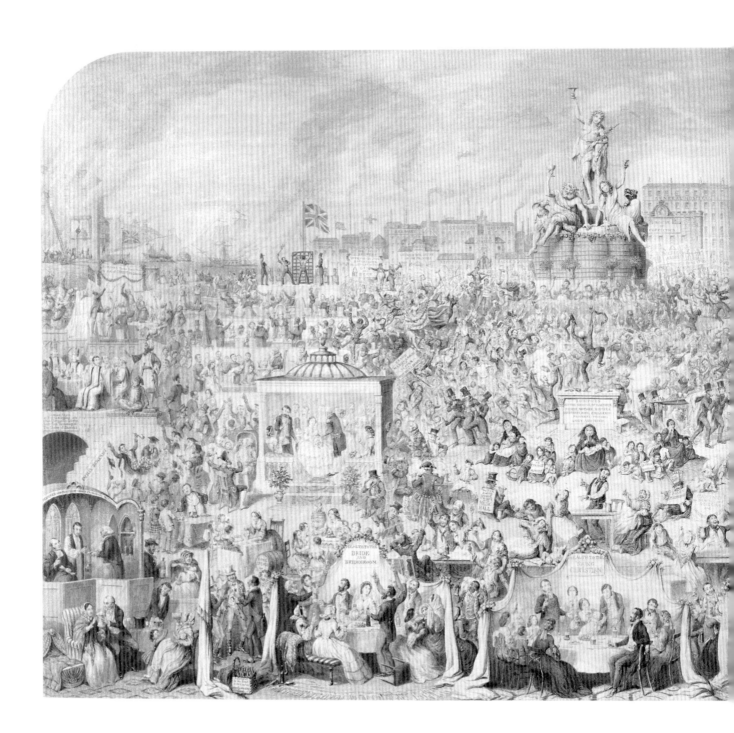

not, or would not work, drowning its sorrows. Moralising papers and the temperance movement emerged with the panacea of a metropolis rid of its drink problem. But as Dickens had rightly observed, alcoholism amongst the poor was a symptom of poverty rather than its cause. The Gin Shop, which Dickens had so brilliantly described in his *Sketches*, epitomised the problem. As John Murray observed: 'There is not in all London a more melancholy and spirit-depressing sight than the area of one of the larger gin-palaces on a wet night.'[26] The parallels of such places with the images of Hogarth were not lost on commentators and Murray continues: 'If your nerves are delicate, you had better not pass too close by the gin-shops, for as the door opens – and those doors are always opening – you are over-whelmed by the pestilential fumes of gin... What subjects for Hogarth on the narrow space of a couple of flagstones!'[27]

Indeed, George Cruikshank with his newly found temperance of 1847, followed this idea with his aforementioned series, *The Bottle* (1847) and *The Drunkard's Children* (1848), the first of which sold 100,000 in its first few weeks. In railing against the demon drink, he also produced one of the great Leviathans of Victorian art, *The Worship of Bacchus* (1864) [fig. 206].[28] Cruikshank's own stance on drink was far too moralizing and idealistic. 'Remove the drink,' he wrote, 'and you will stop murder... We should stop, if not all crimes, if not all offences, still the great majority of them; and that is what we are aiming at.'[29]

206. George Cruikshank, *The Worship of Bacchus*, 1864. Etching.

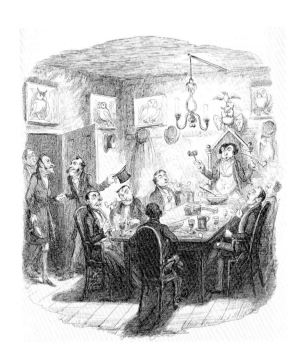

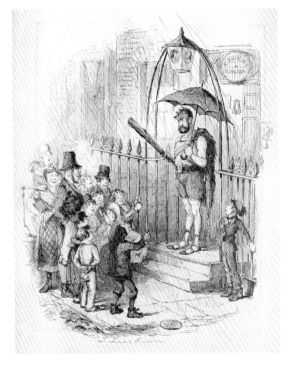

The case for social justice represents the radical aspect of Victorian satires of London. The other is the charming titters of society, the petty foibles and humorous anecdotes of life. John Leech could be strong in his attacks on poverty, yet he could be equally tame in his depiction of the rest of society. Ruskin maintained an admiration of this side of Leech's art which he expressed:

> It cannot be necessary for me, or for any one now to praise the work of John Leech. Admittedly it contains the finest definition and natural history of the classes of our society, the kindest and subtlest analysis of its foibles, the tenderest flattery of its pretty and well-bred ways, with which the modesty of subservient genius ever amused or immortalized careless masters.[30]

Satire of this kind relies upon the nuance of behaviour and expression. Its greatest exponents such as John Leech, and later George Du Maurier, expressed the subtlety of a brief moment's humour and irony. In depiction it was far from the extreme exaggerations of caricature and nearer to the close observations of facial expression. Ruskin admired such skill and praised the work of Du Maurier. He wrote:

> The acute, highly trained, and accurately physiologic observation of Du Maurier traced for us, to its true origin in vice or virtue, every order of expression in the mixed circle of metropolitan rank and wealth: and has done so with a closeness of delineation the like of which has not been seen since Holbein, and deserving the most respectful praise in that, whatever power of satire it may reach by the selection and assemblage of telling points of character, it never degenerates into caricature.[31]

207. John Leech, *Harmonious Owls*, 1842. Etching for *Bentley's Miscellany*.

208. John Leech, *Hercules returning from a Fancy Ball*, 1843. Etching for *Bentley's Miscellany*.

209. George Cruikshank, *Taking the Census*, 1851. Wood engraving.

London Heads: Physiognomy, Caricature Portraits and 'Types' in Victorian Satire

As we have seen, physiognomic theory had always been an element of satire, but it took on a greater importance within the Victorian period. Both fine and graphic artists acknowledged its theory, particularly in the depiction of the crowd where distinguishing yet generic characteristics were necessary in separating one type or class from another. Dress and activity were obvious ways in which characters are distinguished from one another; facial features, on which physiognomy mainly, though not exclusively, focused, were another. Crudely simplified, the narrow face, fine feature and high forehead represented the higher classes, whereas the low forehead, crude features and protruding jaw represented the lower classes. It is impossible to look through the enormous body of social satire in the Victorian period without seeing these associations. In the proliferation of physiognomic texts, the pseudo-science was expounded, with often alarming results. Take the somewhat shocking illustrations of Princess Alexandra and Sally Muggins, illustrated in S. R. Wells' *New System of Physiognomy* (1866) [fig. 214].

As we can see on looking at this image, the expounding of such theory relied on the exaggerations of its illustrations to make the point. What is perhaps most noticeable is the fact that the higher class is closer to illustration, the lower class closer to caricature. This has parallels with polite artists of the eighteenth century who, when they included the lower orders in their works, often adopted an element of caricature. Rowlandson represents an anathema to this approach and did not make such class generalisations.

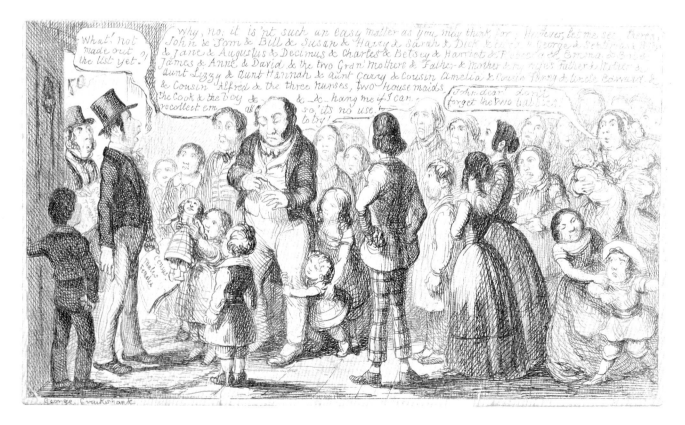

Fig. 745.—Princess Alexandra.

Fig. 746.—Sally Muggins.

Although the caricatures of the Victorian period acknowledge the general current physiognomic theories of the period, particularly in *Punch* and its followers, it also drew on the richer tradition of comic archetypes that had been current since at least the late seventeenth century. In particular, many of the comic London types that were perpetuated in the Victorian period were in essence the same as those pilloried a century earlier. In Charles Bennett's book, *London People: Sketched from Life* (1863), a host of individual characters are shown to resemble types, such as 'The Cheap Swell,' which the author describes as following: '...he is a Frankenstein raised by the cheap tailor... He is like a picture taken out of a certain handbook of East-end fashion, and usually labelled "in this style, forty-two and six.'[32] Compare this Victorian character with the social 'upstarts' of the early eighteenth century through the satirical 'True Born Englishman' of 1738, alluded to in the first chapter: 'the *Ludgate-hill Hobble*, the *Cheapside Swing*, and the general City *Jolt* and *Wriggle* in the *Gait*, being easily perceived through all the Artifices of the *Smarts* and *Perts* put upon them.'

The traditional comparative interplay between men and animals occurred less than the physiognomy of type and character relating to class, social type and moral inclination. Such comparisons were regarded as being outside the realms of science by physiognomy. It does contain, however, a great deal of humorous potential for the caricaturist. John Leech in his 'Harmonious Owls' for *Bentley's Miscellany* gently plays with the comparison of men and owls. The accompanying text expounds the joke:

> The Owl in the chair... was perched upon a roost more elevated than the rest. In his gizzard-wing he brandished an auctioneer's hammer... His little owlish eyes twinkled with drink and good-humour, and the expression of his countenance, taken altogether, was eminently characteristic of the species over which he seemed so worthily appointed to preside.[33]

Physiognomy and type had a further relevance, particularly through the work of Henry Mayhew, whose survey of

215. James Frank Sullivan, *The Triumph of Row. By our disgusted Hermit now visiting Town*. Wood engraving for the magazine *Fun* and published in the anthology, *The British Working Man by one who does not Believe in him*, 'Fun' Office, London 1878, p. 43.

216. James Frank Sullivan, *On the Power of the Human Eye*. Wood engraving for the magazine *Fun* and published in the anthology, *The British Working Man by one who does not Believe in him*, 'Fun' Office, London 1878, p. 57.

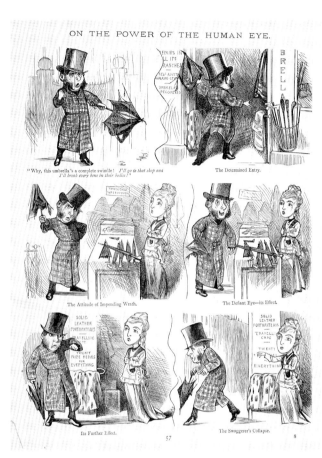

the London poor began with work for the *Morning Chronicle* in 1849, following an outbreak of cholera. There was a scientific method and thoroughness to his investigations, as seen in his great works, which assembled as *London Labour and the London Poor* (1861). Satire, although far less disciplined and far more selective in its inclusions, echoes this approach, and social science and comic archetypes are combined in caricatures of London types. *Heads of the People* (1840), illustrated with the drawings of Kenny Meadows and essays by Leigh Hunt, William Thackeray, Douglas Jerrold and others, is an early essay in such forms. An essay by an individual author humorously expounds the type, the illustration its caricature. The volume, as such, encompasses the obviously funny, pathetic and sad from the family governess to the omnibus

conductor. The family governess was described as follows: 'Of what had Lucy to complain? She was merely excluded from all that makes life a blessing; dragging on a lonely existence, languishing in a living death.'[34] The conductor is altogether more comic:

The conductor is a careless-dressing, subordinate, predominant, miscellaneous, newly-invented personage, of the stable-breed order, whose occupation consists in eternally dancing through the air on a squalid bit of wood, twelve inches by nine; letting people in and out of the great oblong box called an omnibus; and occasionally holding up his hand, and vociferating the name of some remote locality.[35]

Charles Bennett's *London People* took a similarly random sweep of Londoners, selecting comic types in expanding satire's underlying physiognomic theory. As the author explained in his introduction: 'my aim being to indicate the impress of habits and society upon the countenance of individuals who might be taken as types of the class they belong to.'[36] The magazine *Fun* drew a pictorial anthology of the working class entitled the *British Working Man* from its weekly pages, which depicted a range of workers with expressions that ranged from empathy to contempt.

Caricature portraiture reached its zenith in this period with the full-length caricature portraits of *Vanity Fair*. Founded in 1868 by Thomas Gibson Bowles (1842–1922), it ran until 1914 and was distinguished by its portraits, giving a visual dimension to the essentially literary magazine. Its first portrait was published on 30 January, 1869, and featured Disraeli by Pellegrini (who adopted the pseudonym 'Ape'), the first of over 2,300 caricatures. Its leading artists, Carlo Pellegrini (1839–89) and Leslie Ward (1851–1922), who adopted the pseudonym 'Spy'), developed a form which harked back to the comic portraits of Dighton, distinguished by its observation and gentle exaggerations. *Vanity Fair* was also unique in its first decade for using photographic lithographs in its reproduction. Everritt wrote: 'At present [February 1874], *Vanity Fair* is the only satiric art publication employing chromo-lithography, if we except some miniature caricatures recently given in the title pages of *Figaro*, but these appear to be coloured by hand.'[37] *Vanity Fair* also succeeded in attracting Tissot to provide some portraits, including a very fine and stylish watercolour of the

217. Harry Furniss ['Lika Joko'], *Sir Alma Tadema and Sir Henry Irving*, c. 1897. Ink drawing.

218. Harry Furniss ['Lika Joko'], *Mr George Grossmith*. Ink drawing.

219. Harry Furniss ['Lika Joko'], *George Du Maurier*. Ink over pencil drawing.

220. Sir Leslie Ward ['Spy'], *North East Bethnal Green, Sir Mancherjee Bhownaggree KCIE MP*, 1897. Chromolithograph for *Vanity Fair*.

221. James Jacques Joseph Tissot, *Portrait of Frederic Leighton*, for *Vanity Fair*, 1872. Watercolour.

artist Frederic Leighton. Caricature portraiture was not limited to the pages of *Vanity Fair*; indeed, in the last quarter of the nineteenth century there was a vogue for such portraits, led by artists such as Harry Furniss, whose caricature portraits include foremost artistic figures such as George du Maurier, Sir Lawrence Alma Tadema and George Grossmith.

Ramblings and Sketches through London's Streets

Satirical ramblings and navigations through London's streets had begun in the late seventeenth century, through the eighteenth and early nineteenth centuries. They continued in a renewed form in the Victorian era, often following the forms of earlier models, but imbued with a new journalistic zeal. This is nowhere better illustrated than in the famous rambles of George Augustus Sala, *Twice Round the Clock or the Hours of the Day and Night in London*, published in 1859 and brilliantly illustrated by William M'Connell. The book chronicles a day in the life of London, from 4 am at Billingsgate Market to 3 am at The Night Charges at Bow Street. In his autobiography Sala recalled:

> It is needless to say that the idea of thus chronicling, hour by hour, the shifting panorama of London life was not original... The scheme of 'Twice Round the Clock' was suggested by a little eighteenth century book, by an anonymous writer, called 'One Half the World Knows Not How the Other Half Lives,' which gives an account of the humours and sorrows of Metropolitan existence from midnight on Saturday until midnight on Sunday early in the reign of George III.[38]

The book, which had been given to him by Charles Dickens, is praised by Sala for its evocation of scenes worthy of Hogarth. Despite this, Sala, in his introduction to *Twice Round the Clock*, feels the need to excuse its elements of eighteenth-century coarseness, whilst simultaneously paying tribute to the social investigations of Mayhew, revealing the joint and often conflicting influences on Victorian satire.

What Sala and the brilliant illustrations of William McConnell present is a new kind of perambulation, based on perennial models alongside journalistic reflections with colourful moral narratives. Sala was not alone in his journeying through the city where illustration and text walked hand in hand.

Yveling Rimbaud produced *Little Walks in London* in 1875 around seven of the large number of drawings by John Leech entitled 'Children of Mobility', first published in 1841. Vignettes by the author, presented in both French and English, accompany the illustrations. The observational tour through London was traditionally taken from the perspective of an innocent eye; in this case the eyes of two children, Fanny and Henry, observe the poor children of London's streets. The commentary is marked by its sentimentality but there is comedy and genuine pathos, too, in some of the scenes. In one such vignette around the illustration entitled, 'Miss Adelina Harpagon', Rimbaud describes the appalling situation that John Leech has sketched:

> On reaching Belgrave Square a touching sight awaited them. Close to the pavement were three little children with naked feet, shivering with cold, in the black mud... The biggest was a poor thin figure, and bore upon his features the unquestionable marks of a terrible disease

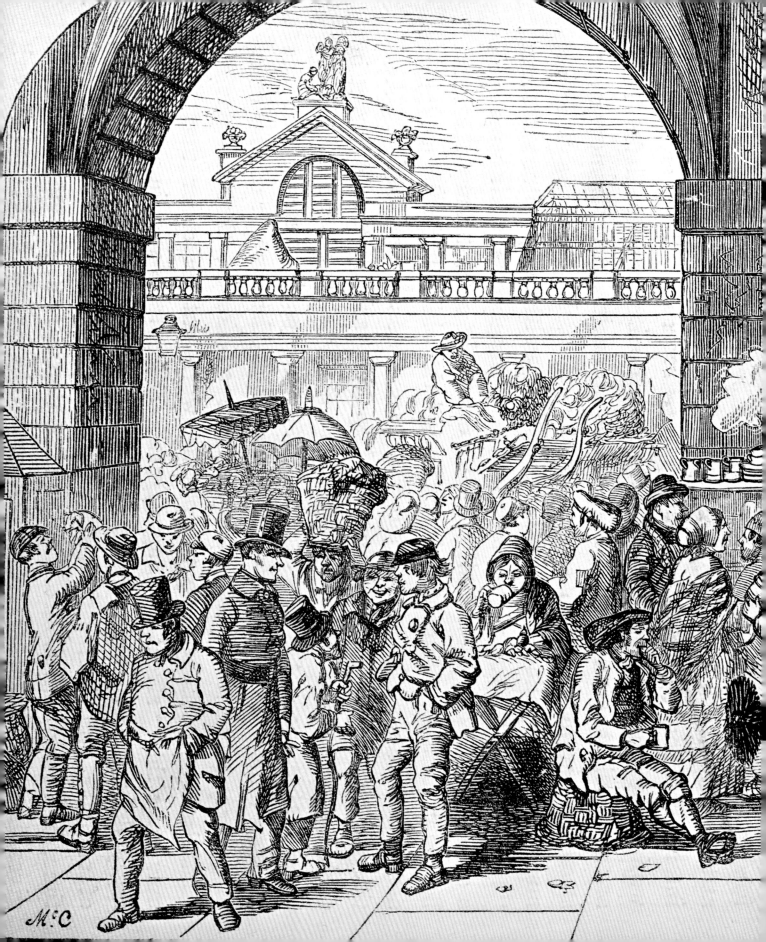

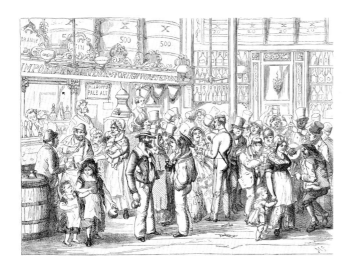

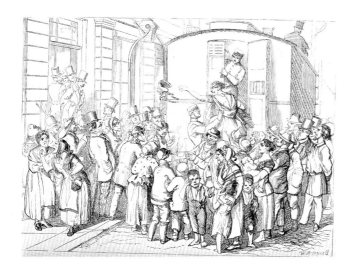

224. William McConnell, *Covent Garden Market: Early Breakfast Stall*, 1858–59 (detail).

225. William McConnell, *Gin Shop*, 1858–9. Wood engraving for *Welcome Guest*, which was compiled as George Augustus Sala, *Twice Round the Clock* London, 1859.

226. William McConnell, *Five O'Clock P.M.: The Prisoners' Van*, 1858–59. Wood engraving for *Welcome Guest*, which was compiled as George Augustus Sala, *Twice Round the Clock* London, 1859.

that never spares its victims; my young friends he was in consumption.

Here you see this boy dying of a disease brought on by cold, and one in which cold increases the suffering.[39]

Phil May Williams's *Gutter-Snipes*, of 1896 [fig. 232] offered an anthology of illustrations which represent the antics of London's poor street children. The mood and nature of their depiction have changed since Leech and enshrine a very visible charm, despite the elements of harsh poverty in the ragged and insufficient clothing of the urchins. *Twice Round the Clock* was first published in instalments in *Welcome Guest* in 1858 and include several journeys through London. Snapshots of metropolitan scenes made up 'Types of Thoroughfare' published in issues of *Fun* in 1869. Using a precise linear style developed and perfected by Richard Doyle and William McConnell, they define a wide variety of characters from London's streets. In *Types of Thoroughfares No.4 Chancery Lane*, [fig. 229] we can see 'Kings – Newspaper Office', where photographs, rather than prints, grace the window for an attentive audience. Throngs of people move down Chancery Lane interspersed with the legal profession brushing past criminal types. As the text was keen to emphasise: 'Cause and effect are close neighbours: there are the law courts, and here are the barred-windows and bolted doors of the sponging houses. The distance between them is very small indeed.'[40]

Richard Doyle (Pseudonym 'Dick Kitcat,' 1824–83), in a collaboration with his brothers James and Henry, published *Manners and Customs of Ye Englishe* in 1849 from a series of illustrations to Percival Leigh's text carried in *Punch*. *A Prospect of Greenwich Fair* [fig. 227], from the series, harks back to earlier images of London saturnalia such as those of Bartholomew Fair, although the softer and more polished illustrations are more evocative of fairy tales than of surreal urban revelry. Similarly, William McConnell's *Windmill Hill, Gravesend*, for *Town Talk*, presents us with a relatively picturesque view of the holiday resort around Gravesend, which the journal described at 'the Cockney Capri', in outlining some of the characters: the 'Little Puffins, from the

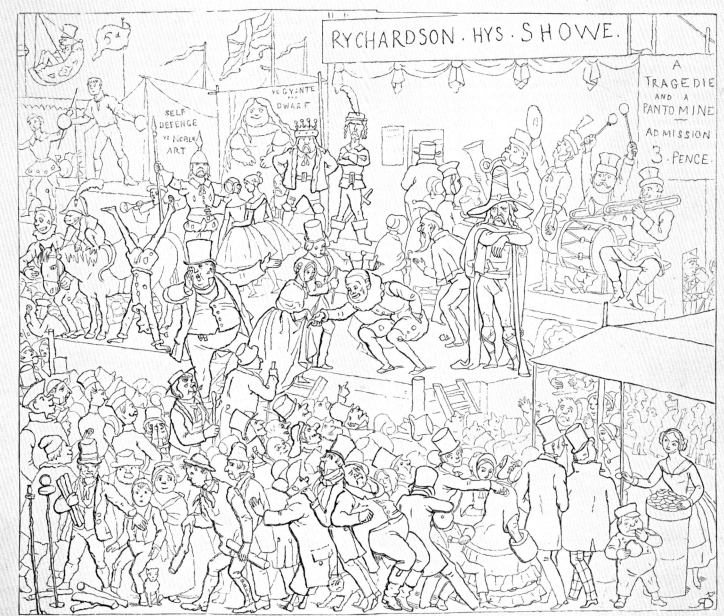

A·PROSPECT·OF·GREENWICH·FAIR.

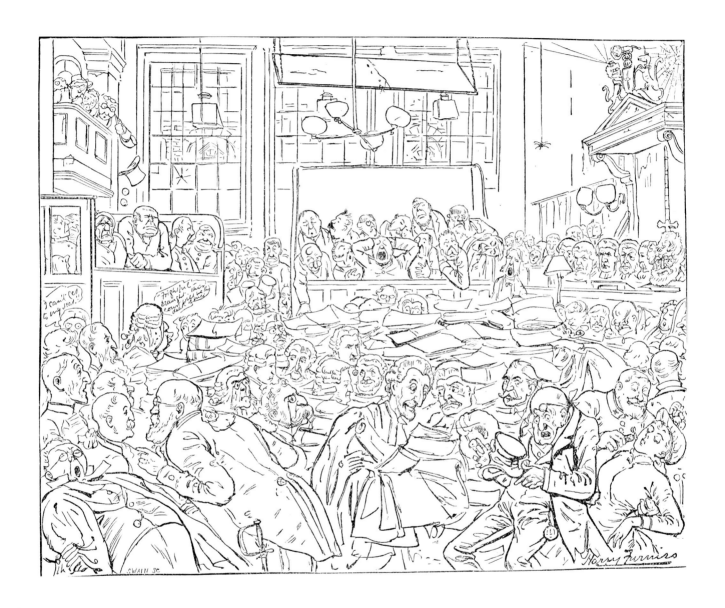

227. Richard Doyle ['Dick Kitcat'], *Mr Pips, His Diary: Manners and Customs of ye Englische in 1849. No.13. A Prospect of Greenwich Fair*, 1849. Wood engraving for *Punch* 1849, p. 227.

228. Harry Furniss, *Interiors and Exteriors, No.24, The Central Criminal Court*, 1885. Wood engraving published in *Punch, 7* November , 1885, p. 219.

A SWELL.

linen draper's shop, who is there in his two-guinea suit of tweed, "well-shrunk," looks superciliously upon the bluff old boy enjoying his game of romps…'[41] The wood engraving is the third of a series 'Summer Days, the holidays of the ordinary, comic adventures of a London crowd', and represents a light-hearted mocking of the lower orders living the high life, a comedy of contrasts and reversed roles.

Charles Keene's (1823–91) drawing for *Punch* illustrates a 'Difference of Opinion' through the perennial figure of the sage-like, and at times difficult, London driver, in this case an omnibus. The ink drawing and its manifestation in the *Punch* wood engraving illustrates the transition between the artist's projection and the translation by the wood engraver. Transport and the volatile and argumentative Hackney cabbie typifies the hectic state of the London streets,

engulfed in horse-driven carriages which increased throughout the century. As Max Schlesinger had observed in 1853:

> We look forwards towards St. Paul's, and back to Chancery-lane, up to Holborn on our left, and down on our right to Blackfriar's Bridge; and this vast space presents the curious spectacle of scores of omnibuses, cabs, gigs, horses, carts, brewer's drays, coal wagons, all standing still, and jammed into an inextricable fix.[42]

As we have seen in the image of Chancery Lane in the late 1860s with a shop full of *carte-de-visites*, photography was already a popular form that threatened to eclipse traditional printing methods. By the end of the nineteenth

century, the extensive use of photography in publishing satire and caricature had transformed its image into a form nearer to the cartoons we recognise in the newspapers and magazines of today. The newspaper and magazine cartoon, rarely achieving a high percentage of a page, was to emerge as one of the predominant forms of satire in the twentieth century, although the development of mass media and the eclecticism of post-modern fine art also meant that its spirit has appeared in differing forms, each in a different sense drawing from the tradition of popular prints in the 'golden age' of caricature.

229 (above). William McConnell, *Types of Thoroughfares, No.4 – Chancery Lane*, 1869. Wood engraving published in *Fun*, 13 November, 1869, p. 102.

230 (right). Harry Furniss, *Interiors and Exteriors, No.22, Charing Cross Station*, 1885. Wood engraving published in *Punch*, 24 October, 1885, p. 202.

Opposite:
231 (left). John Leech, *Miss Adelina Harpagon*, (first published 1841). Lithograph, originally published in the French-inspired *Children of the Mobility* (1841), from Yveling Rambaud [Frédéric Gilbert], *Little Walks in London*, 1875.

232 (right). Philip May William ['Phil May'], *A Swell*, 1896. Lithograph published in *Phil May's Gutter-Snipes*, London, 1896, drawing 27.

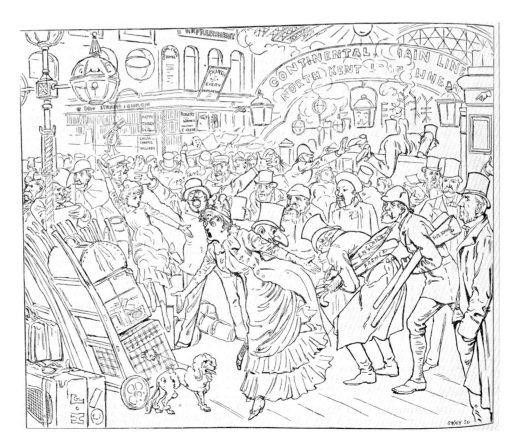

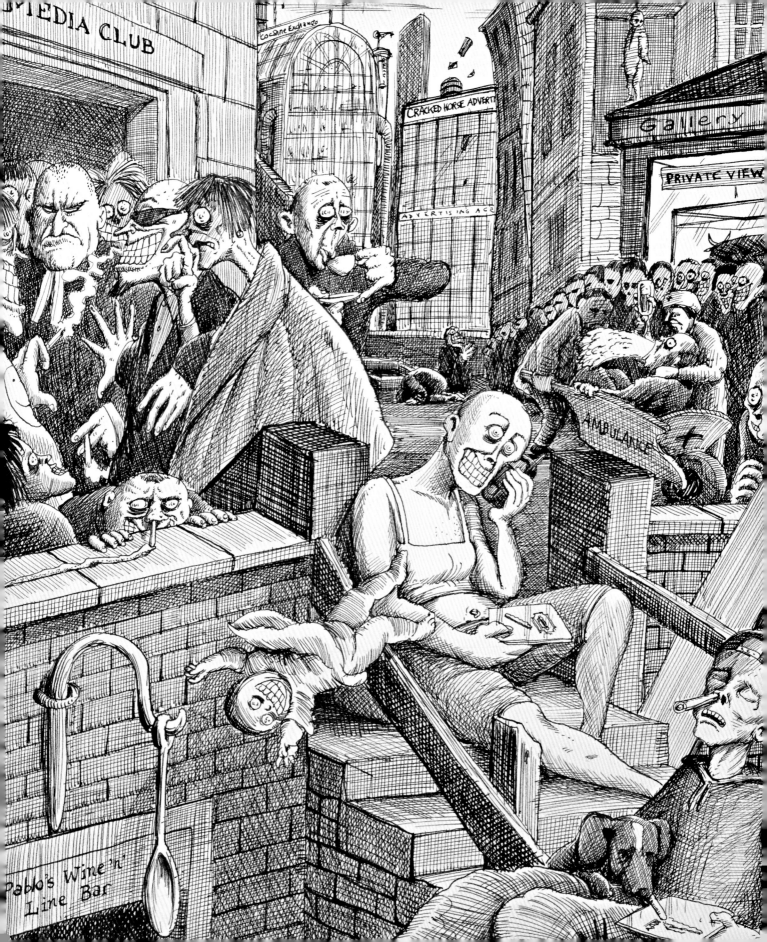

Afterword:
The Changing Faces of Satire

'Thus while the position of serious art becomes more
problematic every day caricature has given birth to a new
form of art, bristling with undreamed-of potentialities.
Nor has caricature proper failed to keep its place which it
won during the last three centuries. The most serious
question facing the modern artist – that of his contact
with the rest of the world seems not to arise for the
caricaturist.' *E. H. Gombrich and Ernst Kris*[1]

Martin Rowson, *Cocaine Lane*, 2001
(detail of fig. 240).

Visual satire in the twenty-first century is multi-faceted. The tradition from which it emerged has burst into many different directions. Within the last century, the accelerated change in society and huge technological advancements has affected the way in which visual satire is perceived and seen. In particular, the development of the mass media and new visual forms alongside the development of fine art, through its modern and post-modern manifestations, have affected the way in which satire is created and received.

The satiric and caricature tradition is discernable in a number of different offshoots, most obviously in the cartoons of newspapers and journals. Within this vast body of material, the influence of earlier satire is clearly apparent and not surprisingly, surveys of satire and caricature of the twentieth century take this to be its singular and continuous development of the tradition. Yet this does not account for many of the other areas of visual satire that exist, such as the predominantly visual comic books, cartoons and animation. The amateur caricaturist that loiters around the tourist areas of London, making on-the-spot exaggerated impressions of visitors, if not representatives of the best example of caricature is still very much part of the tradition. As we have seen, caricature and the amateur has long been in evidence in London. But if comic strips and comic books represent a new offshoot, the development of animation embodies a more contemporary reaction to caricature. The development of Disney and children's films is not part of this survey, but they give an indication of the pervasiveness of cartoon imagery, in part developed through caricatured physiognomy. If two-dimensional animation allowed for new scope in visual satire, puppetry and increasingly sophisticated computer generation has allowed for caricature moving in three dimensions. Television has allowed the broadcast of such visual satire on an unprecedented scale. Television's host of impersonators and sitcoms that mimic individuals and type also represent the satiric tradition, similar to that of Steven's lectures on heads. The London cabbie geezer, a recognisable type of television comedy, had its equivalent in the comic archetypes and stereotypes of the eighteenth and nineteenth century.

Within fine art, the boundaries that restrained Hogarth's followers have all but disappeared, and in the post-modern age artists have the freedom to take their imagery from any sources, both high and low, popular and arcane, to create images that are often satiric or ironic. Hogarth continues to be a strong influence, and it would be an almost impossible task to compile a list of images based upon his works. To present one tradition of visual satire in the twenty-first century would not give a true picture of how satire has profoundly influenced image making.

It is not within the scope of this book to fully explore every conceivable offshoot, nor indeed to try to indicate where the 'real' spirit of satire continues to be found. Certainly a detailed study of the impact of satire in the twentieth century, beyond the realms of illustration, would be an enormously interesting and important study. This brief afterward intends to look at some of the ways London has been represented in satire in the twentieth century, from the more traditional cartoon, to three-dimensional puppets.

The past hundred years has seen the publications of literally millions of cartoons in newspapers and journals; a worldwide phenomena. By its very nature such satire is ephemeral, dealing as it does with topical issues and responding to the demands of the modern editor. Within this period much has changed and a brief comparison between cartoons published in 1900 and 2000 clearly illustrates this. In 1900 caricaturists generally received a far more formal training than many self-taught cartoonists that there are working now. As a result, the visual style today is on the whole freer, more direct, eclectic and less formal, although both can be equally inventive. The Cartoon Centre at the University of Kent, Canterbury, the Political Cartoon Society and the Cartoon Art Trust are testament to the rich body of material produced within this period and the enormous interest and importance of twentieth century cartoons.[2] The following examples are mainly drawn from the Museum of London's own collection, and important figures may be overlooked.

In more recent times many great cartoonists have emerged who openly show their debt to Hogarth and Gillray. Steve Bell, for example, who like Gillray and Rowlandson before him, studied fine art, is an extraordinarily inventive and sophisticated talent. Steve Bell's ferocity of attack is characteristic of the late twentieth and early twenty-first century, in contrast to the relative softness of Edwardian caricature. It would be unthinkable, for example, to find an Edwardian satire that lampooned the Royal Family as *Spitting Image* lampooned the House of Windsor. The professional and amateur co-existing side by side, and a renewed acerbic imagery, is redolent of satire's 'golden' age. Yet the past century can also be characterised as a period of decline in traditional forms of satire in its relative reduction on the page. The full and double-page images that appear in the nineteenth- and early twentieth-century caricature are almost unknown today.

In 1909 London saw the arrival of David Low (1891–1963) and, at about the same time, Will Dyson (1880–1938). Dyson, who had arrived from Australia, brought with him a biting pen which he applied to a variety of periodicals, under the pseudonym 'Emu', before being paid £5 a week as political cartoonist for the radical *Daily Herald*. V. Palmer recalled that, 'There was a savage penetration about these drawings that fascinated the London Intellectual world.'[3] One such cartoon was *The New Advocate* [fig. 233], which appeared on the front page of the *Daily Herald* on 11 June, 1913. In the background the black and skeletal outlines of the Palace of Westminster overlook the single skeleton of a woman wearing a sandwich board, which reads, 'Votes for Women!' Dyson had moved from a country that had given women the vote in 1893, and makes clear in this striking

235. George Belcher (1875–1947), *Assistant: "I'm afraid we don't have anything in your size Madam." Piqued Lady: "Well, we ain't all run-up out of remnants, you know."* 1920s. Charcoal drawing.

236. Heath Robinson, *The Bank of England*, c. 1930. Pen and ink drawing over pencil. Reproduced by permission of the estate of Mrs J C Robinson & Pollinger Limited.

237. Cyril Kenneth Bird ['Fougasse'] (1887–1965) *Remarkable occurrence in the Heart of the Metropolis, The newcomers to No.21 use their balcony as a balcony...* c. 1930. Ink and watercolour.

humour was again based upon contrast, in this case that of humanity and machine. As Sir Kenneth Clark noted about the drawings of Heath Robinson, '[He] lived in the age of science triumphant, when machinery became a tyrant; and as we all know, the man who ridicules tyrants is the champion of humanity.'[5] His watercolour drawing of the Bank of England (c. 1930) [fig. 236] shows surpluses of money spilling into the street, being poured down coal holes, swept

image the injustices of the treatment of the suffragettes. David Low, a New Zealander, like Dyson moved to London in the same period, and was to make a similar impact to that of Dyson through his illustration for a variety of journals. Of particular note were his caricature portraits such as his satire of 'The Lord Chief Justice', [fig. 233] published as a supplement to *The New Statesman*, 19 June, 1926 (litho), where he is depicted travelling on the London Underground.

Class types were brilliantly and less patronisingly portrayed than in earlier centuries by George Belcher (1875–1947). Celina Fox described his characterisations of the indomitable Londoner which as, 'pillars of the community to be relied upon when so many other aspects of London life were in a state of flux'.[4] In a typical cartoon, the nonchalant rotund 'cockney' lady responds to the shop assistant: *Assistant: I'm afraid we don't have anything in your size Madam. Piqued Lady: Well, we ain't all run-up out of remnants, you know.* [fig. 234]

Much imagery of London that emerged from the first decades of the twentieth century was a reaction against the modernity of London, the tyranny of the machine age. The

238. Joseph Lee, *Giant Clock Embankment...* "*Excuse me, but is that blob minutes past blob o' clock or just blob minutes to blob?*" 1935. Ink drawing over pencil from Lee's *London Laughs* series. Associated Newspapers.

up and generally appearing as a nuisance in this City fantasy. Cyril Kenneth Bird's (pseudonym 'Fougasse') (1887–1965) cartoons explored the metropolitan in images such as 'Remarkable occurrence in the Heart of the Metropolis, The newcomers to No.21 use their balcony as a balcony...' [fig. 237] and 'Oh, so this is a flyover'. The changing face of London was further illustrated in Joseph Lee's *London Laughs* series, which includes 'Giant Clock, Embankment', where two bemused pedestrians enquire, 'Excuse me, but is that blob minutes past blob o' clock or just blob minutes to blob?' [fig. 238] Many contemporary cartoons respond to such topical concerns of technical advancements and its potential tyranny, such as Kipper Williams's cartoon for *Time Out*, entitled *The Lady and the Wimp* (1996) [fig. 239], which shows the levels of surveillance becoming apparent in London contrasted with the Museum of London poster for the exhibition 'London on Film'.

The magazine *Private Eye*, formed in 1961, was generous in its allowance of caustic images appearing amongst its satire. Its barbed journalism, which has in cases ended in litigation, and the images, initially of Ronald Searle, Ralph Steadman and Gerald Scarfe, in some ways represented the spirit of the 'golden age' of satire, and signified a freedom of voice that has influenced much satire since. Heath's fantastic vision of the greed of the City is in contrast to *Private Eye's* recent contribution, 'STREET NAMES OF OLD LONDON: THE CITY'; [fig. 241] the familiar map puns the name of streets which become Threadbare Street, Yenchurch Street, Grosschurch Street, and the tube stations: Monument to Greed and Bankrupt. Steve Bell's imaginative and caustic imagery can be seen in his view of London's Millennium Dome, *Remember – You Read it Here First* [fig. 240], published in *The Guardian* on 27 November, 1998. Within 400 days of the Dome's opening, secrets about the content were slowly being released when it was also found that the tube link would open eleven days before the opening. The image mocks the content in 'This is Arseworld', as it does the tube entrance labelled 'Down the Hole, Wildcat World'.

A universal characteristic of satire throughout its long history has been its popularity. Single prints, sold in large numbers, epitomised the medium and output in the Georgian period and periodicals in the Victorian period. Today, television reaches the majority of Britain's varied social makeup, and satire uses this medium, on occasion taking centre stage. In newspapers and journals, the audience is smaller, the cartoons most likely a wry aside. There are new possibilities for animated cartoons, where caricature and satire have a constant narrative. The Simpsons, for example, present a universally popular satire of life in the United States. In episode 317, 'The Regina Monologues', the dysfunctional American family visit London. The landscape is, of course, cliché ridden, and features the Tower of London, where Homer Simpson is imprisoned and creates the backdrop to the caricature and actual voice of Tony Blair.

Three-dimensional animation has also been used by satirists to great effect, a reminder perhaps that in London between 1767 and 1783, it was possible for Stevens to deliver his extraordinary lecture on heads. In the twentieth century animation was most famously created through the puppets of

239. Kipper Williams, *The Lady and the Wimp*, 1996. Ink drawing produced for *Time Out*.

240. Steve Bell, *'Remember – You Read It Here First'*, published in *The Guardian*, 27 November, 1998.

241. Martin Rowson, *Cocaine Lane,* 2001. Ink drawing for a cartoon that appeared in the *Independent on Sunday* on 22 April 2001.

242. Richard Burdett, *Street Names of Old London: The City,* published in *Private Eye,* reproduced by kind permission of Private Eye magazine/Richard Burdett.

243. Roger Law from Spitting Image, *Ken Livingstone,* Spitting Image Workshop.

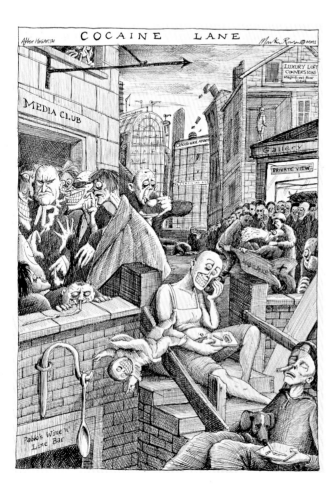

Hogarth, given a lowly place within the arts, it did enjoy an untold freedom and popularity that high art could not boast. Within the post-modern era, the boundaries between highand low art have in many senses been broken down, with satire embracing forms previously considered outside the bounds of fine art. Indeed, many works of art produced can be seen to be fundamentally satirical and ironic in their central aims. Interestingly, a universal admiration for Hogarth has been consistent throughout the years that followed his death, and he has continued to inspire artists and cartoonists alike. The

Fluck and Law. Peter Fluck and Roger Law initially produced caricature sculpture that was photographed and published in the *Sunday Times Magazine. Spitting Image*: these works and the first series were broadcast on 26 February, 1984. This first series was almost exclusively political in nature and as such limited its audience. The decision to widen its satirical scope to celebrities from all walks of life and to add an element of social satire ensured the programme's success, and it ran until November 1992.

With regards to popular art forms, satire continues to flourish. Within the realm of fine art, the influence and use of satire has also changed radically. If satire was, after

image of *The Rake's Progress,* for example, has been used by David Hockney in his series that traced his visit to New York. It has also been used by Ronald Searle and Ralph Steadman to satirically document the fall of *Punch. Gin Lane*; indeed, it is recurrently employed by cartoonists and if published together would fill several volumes.

It is difficult to predict which forms satire will adopt in the future. What is more certain is that the spirit of satirical image making will continue and its eclectic, brilliant and essentially dynamic nature, will allow it to use any new possibilities that arise, whatever they may be.

Notes

Chapter 1

1. Pierce Egan, *Life in London; or the Day and Night Scenes of Jerry Hawthorn, Esq. And his elegant friend Corinthian Tom, accompanied by Bob Logic, the Oxonian, in their Sprees through the Metropolis*, London, 1821, p. 14.

2. Francis Grose, *Rules for Drawing Caricaturas with an essay on Comic Painting*, London: A. Grant, 1788, p. 31.

3. Frederick Augustus Wendeborn, *A View of England towards the close of the eighteenth century*, translated by the author, William Sleater, Dublin 1791 in two volumes. Vol. II, p. 155.

4. Grose, *op. cit.* in note 2 above, p. 4.

5. *A True Born Englishman, A Ramble Through London – Containing Observations on Men and Things*, London, 1738, p. 38.

6. Grose, *op. cit.* in note 2 above, p. 3.

7. John Aubrey, *Aubrey's Brief Lives*, ed. Oliver Lawson Dick, London 1949, p. 325.

8. Louis Lippincott, *Selling art in Georgian London. The rise of Arthur Pond*, New Haven 1983, p. 134.

9. Mary Darly advertisement, quoted in Timothy Clayton, *The English Print, 1688–1802*, New Haven 1997, p. 215.

10. Grose, *op. cit.* in note 2 above, p. 15.

11. Mary Darly, quoted in Diana Donald, *The Age of Caricature, Satirical Prints in the Reign of George III*, New Haven 1996, p. 12.

12. John Caspar Lavater, *Essays on Physiognomy*, translated from the French by Henry Hunter, London 1789, Vol. III, p. 271.

13. Grose, *op. cit.* in note 2 above, p. 4.

14. Lavater, *op. cit.* in note 11 above, Vol. II, p. 108.

15. Grose, *op. cit.* in note 2 above, pp. 15–16.

16. Henry Fielding, *The history of the adventures of Joseph Andrews*, London 1742.

17. Donald, *op. cit.* in note 10 above, p. 2.

18. M. D'Archenholz, *A Picture of England: Containing a Description of the Laws, Customs and Manners of England*, translated from the French, London 1789, Vol. II, p. 171.

19. This is well written about, for a more recent discussion see Robert L. Patten, *George Cruikshank's Life, Times and Art, Volume 2: 1835–1878*, Cambridge 1996.

20. *William Blake*, Poetry & Prose, New York, 1965, p. 679.

21. Ned Ward, *The London Spy, The Vanities and Vices of the Town Exposed to View (1698–1703* in monthly supplements), edited with notes by Arthur L. Hayward, London 1927, p. 77.

22. Joseph Farington, diary entry, 27 August 1802.

23. John Gay, *Trivia: or, The art of walking the streets of London*, London 1716, (1922 reprinted edition), p. 28, Book II 'Of Walking the Streets by Day', lines 363–66.

24. Thomas Brown (1663–1704), *Amusements serious and comical, calculated for the meridian of London*, London: Printed for John Nutt 1700, p. 75 and p. 77.

25. James Boswell, *Boswell's London Journal*, 1762–63, Prepared for the Press, with an introduction and notes by Frederick A. Pottle, London, 1950, p. 299.

26. See David Alexander, *Richard Newton and English Caricature in the 1790s*, Manchester 1998.

27. *The Times*, 19 November 1788, p. 1.

28. *The Times*, 20 March 1790, p. 1.

29. Carrington Bowles, *New and enlarged Catalogue of Accurate and Useful Maps, Plans, Prints, At the propietor's Map and Print Warehouse, 69 St Paul's Church Yard*, London, 1790. Paul Mellon Centre for Studies in British Art.

30. William Holland, advertisement appended to Dorothy Jordan, *Jordan's Elixir of Life*, London, 1789.

31. Bowles, *op. cit.* in note 29 above.

32. Johann Christian Hüttner, 'Caricaturists in London Today', *London und Paris*, Vol. XVIII, 1806, pp. 7–10.

33. John Corry, *A Satirical View of London at the Commencement of the Nineteenth Century by an Observer*, London, 1801, pp. 149–51.

34. Richard Godfrey, *English Caricature, 1620 to the Present* (Victoria & Albert Museum exhibition catalogue) London, 1984, p. 10.

35. *Trial between Mr. Smith & Mr. Wood Before Lord Ellenborough in the Court of Kings Bench, on Wednesday Jan. 20, 1813; For a malicious & scandalous Libel contained in Caricature Print*, an unattributed cutting in Guildhall Library, London. The case was also reported at length in *The Times*, 21 January 1813, p. 3.

36. David Bindman, *Industry and Idleness, The Moral Geography of Hogarth's London*, University College London, Strang Room exhibition, 1997.

37. Brown, *op. cit.* in note 24 above, p. 22.

38. Corry, *op. cit.* in note 33 above, preface.

39. *A True Born Englishman*, *op. cit.* in note 5 above, pp. 8–9.

Chapter 2

1. Dorothy George, *Hogarth to Cruikshank: social change in graphic satire*, London, 1967, p. 47.

2. Samuel Pepys, 27 November 1662.

3. In particular: H. M. Atherton, *Political Prints in the Age of Hogarth*, Oxford, 1974; David Bindman, *Hogarth and his times: serious comedy*, London, 1997; Mark Hallett, *The Spectacle of Difference: graphic satire in the age of Hogarth*, New Haven & London, 1999.

4. Hallett, *op. cit.* in note 3 above, p. 28.

5. Samuel Pepys, 28 November 1663.

6. Bowles and Carver in around 1733 under the new title of *The Folly of Mankind Expos'd or the World Upside Down*. The British Museum has a slightly altered version [Catalogue number 1999].

7. Quoted in John Ireland, *Hogarth Illustrated*, 2nd edition, London, 1973–98, Vol. III, pp. 26–31.

8. *St. James's Chronicle* of 14–17 May 1768

9. *A True Born Englishman, A Ramble Through London – Containing Observations on Men and Things, viz. some account of the vast number of foreigners and their behaviour. Of the Scotch, Irish, and Welsh; Together with a small collection of the most refin'd jests* [Guildhall Library copy attributed in ink to Erasmus Jones] London, 1738, pp. 1–2.

10. Thomas Brown (1663–1704), *Amusements serious and comical, calculated for the meridian of London*, London: Printed for John Nutt 1700, p. 10.

11. John Strype, quoted in Hugh Phillips, *Mid-Georgian London*, London, 1964, pp. 11, 12. Pierre Jean Grossley, 1765, quoted in Hugh Phillips, *Mid-Georgian London*, London 1964, p. 179.

12. *A True Born Englishman*, *op. cit.* in note 9 above, p. 2.

14. See Celina Fox, *Specimens of Genius, truly English* (exhibition catalogue), Galdy Galleries, New York, 1984.

15. Quoted in Brandon Taylor, *Art for the Nation*, Manchester, 1999, p. 18.

16. David Bindman, *Industry and Idleness, The Moral Geography of Hogarth's London*, University College London, Strang Room exhibition, 1997.

17. See Sean Shesgreen, *Hogarth and the Time-of-the-Day Tradition*, Cornell University Press, Ithaca and London, 1983.

18. *London Daily Post*, 23 January 1738.

19. Hallett, *op. cit.* in note 3 above, pp. 9–10.

20. John Ireland, *Hogarth Illustrated*, London, 1791–98, Vol. I, p. 127.

21. The engraving was copied directly from the painting, as a result the image appears reversed when printed. The skill of copying in reverse was mastered by many engravers and became more common.

22. Ned Ward, *The London Spy, The Vanities and Vices of the Town Exposed to View* (1698–1703 in monthly supplements), edited with notes by Arthur L. Hayward, London, 1927, p. 164.

23. See Henry Fielding's *Tom Jones*, Book 1, Chapter II, Squire Allworthy's sister.

24. Sir John Fielding quoted in Hugh Phillips, *Mid-Georgian London*, London, 1964, Vol. I, p. 142.

25. *Weekly Miscellany*, 9 June 1739.

26. Ward, *op. cit.* in note 22 above, p. 165.

27. Ward, *op. cit.* in note 22 above, p. 41.

28. Francis Grose, *Rules for Drawing Caricaturas with an essay on Comic Painting*, London: A. Grant, 1788, p. 25.

29. *A True Born Englishman*, *op. cit.* in note 9 above, p. 4.

30. Ward, *op. cit.* in note 22 above, p. 130

31. A four-page quarto printed for R. Hine entitled, *A Walk to Smithfield, etc*, 1701.

32. Ward, *op. cit.* in note 22 above, pp. 176–77.

33. Ward, *op. cit.* in note 22 above, p. 178.

34. *Hob in the Well* was a popular variation of Colley Cibber's comedy *Hob; or the Country Wake* that featured Old Hob and his wife. Being Mr. D.'s farce of the Country Wake alter'd after the manner of the Beggar's Opera. By Mr. Hippisley. The seventh edition. London, 1728.

35. George, *op. cit.* in note 1 above, p. 45, n. 3.

36. *The Foreigner's Guide: or Companion both for the foreigner and native, in their tour through London and Westminster. Le guide des éstrangers*, first published in 1729, quoted in Hugh Phillips, *Mid-Georgian London*, London, 1964, p. 260.

37. Bailey's Dictionary, 1736, Billingsgate, quoted in Celina Fox, *Londoners*, 1987, p. 146.

38. Ward, *op. cit.* in note 22 above, p. 42.

39. *A True Born Englishman*, *op. cit.* in note 9 above, p. 3.

40. John Gay, *Trivia: or, The art of walking the streets of London*, London, 1716, (1922 reprinted edition) p. 43, Book III, 'Of Walking the Streets by Night,' lines 280–84.

41. Anonymous, *London A Satire*, printed by the Author, 3rd edition, London, 1782, p. 9.

42. Quoted in Ronald Paulson, *Hogarth's Graphic Works* (revised edition), New Haven & London, 1970, Vol. I, p. 141.

43. *A True Born Englishman*, *op. cit.* in note 9 above, p. 27.

44. From the Hackney Harlot in *A True Born Englishman*, *op. cit.* in note 9 above, p. 43.

45. Ward, *op. cit.* in note 22 above, p. 110.

46. See Mark Bills, 'The *Cries of London* by Paul Sandby and Thomas Rowlandson,' *Print Quarterly*, March 2003, Vol. XX, Number I.

47. Illustration of it later by 'J L' in J. Larwood and J. C. Hotten, *English Inn Signs*, London 1866. Retitled, 'A Man Loaded with Mischief, or Matrimony, A Monkey, a Magpie, and Wife; Is the true Emblem of Strife.' p. 456.

Chapter 3

1. Henry Angelo (1756–1835), *The reminiscences of Henry Angelo with an introduction by Lord Howard De Walden and notes and memoir by H. Lavers Smith. Illustrated with sixty-eight plates, reproduced from originals in the collection of Joseph Grego*, [two volumes], London, 1904.

2. Frith, *My Autobiography and Reminiscences*, London, 1887, Vol. II, p. 121.

3. J. P. Malcolm, *An Historical Sketch of the Art of Caricaturing*, London, 1813, p. iii.

4. Rev Dr Trusler, *The London Adviser and Guide: containing every instruction and information useful and necessary to persons living in London and coming to reside there.* London, 1790, p. 123.

5. Frederick Augustus Wendeborn, *A View of England towards the close of the eighteenth century*, translated by the author, William Sleater, Dublin, 1791, in two volumes. Vol. I, p. 280.

6. *Sophie in London 1786: being the Diary of Sophie v. la Roche*, translated from the German and edited by Clare Williams, London, Jonathon Cape, 1933, p. 262.

7. *The Times*, 16 December 1820, p. 2. For Thomas Tegg (1776–1846), see J. J. Barnes and P. Barnes, 'Reassessing the reputation of Thomas Tegg, London publisher, 1776–1846', *Book History*, 3 (2000), pp. 45–60.

8. *The Conjuror's Magazine or Magical and Physiognomical Mirror*, August 1791. The small periodical contains articles on a variety of topics relating to alchemy, magic and fortune telling.

9. *The Golden Cabinet, or, the Compleat fortune-teller*, London, c. 1790, p. 16.

10. John Clubbe, *Physiognomy, Being a Sketch only of a larger work upon the same plan*, London, 1763, p. 6.

11. Anna Jemima Provis, a little-known miniaturist, claimed to have a copy of an early Venetian manual of painting (She is represented on top of the rainbow), and set up subscriptions for the sale of its secrets. Several members of the Royal Academy were taken in by this fraud.

12. Oliver Goldsmith, *The Citizen of the World; or Letters from a Chinese philosopher residing in London*, London, 1762, Letter XXXIV.

13. Reynolds, *Discourse III* (1770), p. 51.

14. The fourteen small pictures of *The Cries of London* by Francis Wheatley were exhibited at the Royal Academy between 1792 and 1795. Thirteen were engraved in pairs between 1793 and 1796, the thirteenth appearing in 1797. They were issued in coloured and black and white under the generic title of *The Itinerant Traders of London in thirteen engravings, from the best artists, after Wheatley*. See Mark Bills, 'The *Cries* of London by Paul Sandby and Thomas Rowlandson,' *Print Quarterly*, March 2003, Volume XX, Number I.

15. Malcolm C. Salaman, 'Wheatley's "Cries of London"', *Apollo*, Vol. X, No. 59, November 1929, p. 252.

16. John Corry, *A Satirical View of London at the Commencement of the Nineteenth Century by an Observer*, London, 1801, p. 8.

17. Corry, *op. cit.* in note 16 above, p. 16.

18. Frederick Augustus Wendeborn, *A View of England towards the close of the eighteenth century*, translated by the author, William Sleater, Dublin, 1791, in two volumes. Vol. I, pp. 287–78.

19. Wendeborn, *op. cit.* in note 18 above, Vol. I, pp. 287–88.

20. Wendeborn, *op. cit.* in note 18 above, Vol. I, pp. 287–88.

21. Trusler, *op. cit.* in note 4 above, p. 124.

22. Wendeborn, *op. cit.* in note 18 above, Vol. I, pp. 293–94.

23. Richard King, *The Frauds of London detected; or, a new warning-piece against the iniquitous practices of that metropolis*, London, Alex Hogg, c. 1780, p. iii.

24. Corry, *op. cit.* in note 16 above, Vol. I, p. 232.

25. Angelo, *op. cit.* in note 1 above, p. 318, pp. 326–27.

26. John Feltham, *The picture of London, for 1802: being a correct guide to all the curiosities, amusements, exhibitions, public establishments, and remarkable objects in and near London*, London 1802.

27. George Alexander Stevens, *A lecture on heads/by G. A. Stevens; as delivered by that celebrated comedian Mr. Lewes, at the Theatres Royal of London, Dublin, and Edinburgh, and as performed by him with universal applause at different captial cities on the continent*, London, 1784, p. 62.

28. Corry, *op. cit.* in note 16 above, p. 144.

29. Corry, *op. cit.* in note 16 above, pp. 17–18.

30. Wendeborn, *op. cit.* in note 18 above, Vol. I, p. 314.

31. Edward Dayes, *The works of the late Edward Dayes: containing An excursion through the principal parts of Derbyshire and Yorkshire, with illustrative notes by E. W. Brayley; Essays on painting; Instructions for drawing and coloring landscapes; and Professional sketches of modern artists*, London, 1805, p. 224.

32. Wendeborn, *op. cit.* in note 18 above, Vol. I, p. 274.

33. The original watercolour is in the Victoria & Albert Museum. It makes an interesting point of comparison with James Gillray's *Very Slippy-Weather* etching, published by H. Humphrey, 1808 which shows his publisher, Humphrey's, shop with a comic scene being played out in the foreground.

34. Ned Ward, *The London-Spy Compleat*, London 1706, I, Part 2, pp. 293–98, quoted in Celina Fox, *Londoners*, London, 1987, p. 20.

35. *The Times*, 20 April 1802.

36. Guildhall Library, London have a less detailed wash drawing of the same scene.

37. 'Bartholomew Fair,' *The Microcosm of London; or, London in Miniature* (1808–10), Vol. I, p. 52.

38. Diana Donald, *The Age of Caricature, Satirical Prints in the Reign of George III*, New Haven and London, p. 129.

39. Donald, *op. cit.* in note 38 above p. 140. (The poll lasted 15 days and the final votes were Tooke: 2819, Gardner: 4814, Fox: 5160. The latter two were both elected. The board probably shows the state of the poll on the last day, Monday, 13 June. There is a caption identifying the main participants in the archive file. Two prints that were made after Dighton's watercolour are held within the British Museum collection: A hand-coloured engraving by M. N. Bate, (BM cat. 8815) and a mezzotint by H. S. Sadd published in 1839 (BM cat. 8815A).

40. Quoted in Henry M. Hake, 'Dighton caricatures', *The Print Collector's Quarterly*, vol. 13, 1926, p. 140 and Dennis Rose, *Life, times and recorded works of Robert Dighton (1752–1814) actor, artist and printseller and three of his artist sons :portrayers of Georgian pageantry and wit*, London, c. 1981, p. 18.

Chapter 4

1. Henry Angelo (1756–1835), *The reminiscences of Henry Angelo /with an introduction by Lord Howard De Walden and notes and memoir by H. Lavers Smith. Illustrated with sixty-eight plates, reproduced from originals in the collection of Joseph Grego* (two volumes), London 1904, Vol. I, p. 180.

2. John Hayes, *Rowlandson Watercolours and Drawings*, London, 1972, p. 11.

3. In 1777 he won the silver medal of the Royal Academy, voted for by 23 out of 24.

4. Angelo, *op. cit.* in note 1 above, p. 180.

5. Hayes, *op. cit.* in note 2 above, p. 21.

6. *The Gentleman's Magazine*, obituary June 1827, quoted in full in Bernard Falk, *Thomas Rowlandson His Life and Art, A Documentary Record*, London, 1949, pp. 24–27.

7. 'I have played the fool; but,' holding up his pencils, 'here is my resource'. Quoted in Hayes, *op. cit.* in note 2 above, p. 18.

8. Angelo, *op. cit.* in note 1 above, p. 185.

9. These include *A Bench of Artists*, 1776, pen over pencil and Thomas Rowlandson and Augustus Charles Pugin, *Drawing from Life at the Royal Academy*, published by Rudolph Ackermann as part of *The Microcosm of London; or, London in Miniature* (1808–10), hand-coloured aquatint.

10. Coutauld Institute of Art, Harvard University and the British Museum.

11. Written by Thomas Rowlandson in his *Comparative Anatomy*, c. 1820–21 (a book of original drawings and illustrations), British Museum, London.

12. Hayes, *op. cit.* in note 2 above, p. 107.

13. Angelo, *op. cit.* in note 1 above, pp. 180–81.

14. Angelo, *op. cit.* in note 1 above, p. 180.

15. Francis Grose, *Rules for Drawing Caricaturas with an essay on Comic Painting*, London: 1788, p. 31.

16. Ronald Paulson, *Rowlandson: A New Interpretation*, London and New York, 1972.

17. *The English Review*, exhibited at the Royal Academy 1786, pen and watercolour over pencil, Royal Collection and *The French Review*, exhibited at the Royal Academy 1786, pen and watercolour over pencil, Royal Collection.

18. John Corry, *A Satirical View of London at the Commencement of the Nineteenth Century by an Observer*, London, 1801.

19. George Alexander Stevens, *A lecture on heads/by G. A. Stevens; as delivered by that celebrated comedian Mr. Lewes, at the Theatres Royal of London, Dublin, and Edinburgh, and as performed by him with universal applause at different captial cities on the continent*, London, 1784, Stevens, pp. 37–38.

20. Produced as a print by Rudolph Ackermann in 1801 as *An Old Member on His Way to the House of Commons*.

21. Grose, *op. cit.* in note 15 above, p. 13.

22. There is a replica of this drawing in the Laing Art Gallery collection, Newcastle.

23. Stevens, *op. cit.* in note 19 above, p. 57.

24. Stevens, *op. cit.* in note 19 above, p. 9.

25. Hilaris Benevolus, *Mirth versus Misery, The Pleasures of Human Life: in a dozen dissertations on male, female & neuter pleasures, etc.*' London, 1807, pp. 170–71.

26. John Hayes, *A Catalogue of the Watercolour Drawings by Thomas Rowlandson in the London Museum*, London 1960, p. 7.

27. Advertisement for *The Microcosm of London*, undated, and unsourced MOL archive.

28. *Westminster Election, Covent Garden* (c. 1808), Art Institute of Chicago.

29. *The Microcosm of London; or, London in Miniature*, [text by William Combe and W. H. Pyne; illustrations by Thomas Rowlandson and Augustus Charles Pugin] London 1808–10, Vol. I, p. 52.

30. *Microcosm, op.cit.* in note 29 above, Vol. I, p. 52.

31. Robert Southey ['Don Manuel Alvarez Espriella'], *Letters from England*, London 1807, Letter XI, pp. 122–23.

32. *Microcosm, op. cit.* in note 29 above, Vol. I, p. 41.

33. Stevens, *op. cit.* in note 19 above, p. 52.

34. Southey, *op. cit.* in note 31 above.

35. *The Times*, February 26, 1793, p. 1.

36. Henry Angelo mentions Valle in Angelo, *op. cit.* in note 1 above Vol. II, p. 175.

37. Corry, *op. cit.* in note 18 above, p. 57.

38. *Cries of London*. A series of 8 plates, each plate marked, Cries of London. No. 1–8, Rowlandson Delin. Merke Sculp. London published 1799 at R. Ackermann's, 101 Strand; *Four London Cries* 1804 (Republished 1811); *Characteristic Sketches of the Lower Orders, intended as a companion to the New Picture of London: consisting of Fifty-four plates, neatly coloured (rule)* London: Printed for Samuel Leigh, 18 Strand, 1820 Price 7s. half bound 1820.

39. Southey, *op. cit.* in note 31 above, Letter VI, p. 67.

40. *The Times*, 10 March 1817, p. 2.

41. Southey, *op. cit.* in note 31 above, Letter IX, p. 106.

42. Angelo, *op. cit.* in note 1 above, pp. 246–47.

43. Corry, *op. cit.* in note 18 above, p. 51.

44. Paulson, *op. cit.* in note 16 above, p. 25.

45. See Angelo, *op. cit.* in note 1 above, Volume II, pp. 1–3; Falk, *op. cit.* in note 6 above p. 78; and Hayes, *op. cit.* in note 2 above, pp. 80–81; and Hayes, *op. cit.* in note 26 above, p. 85 (cat. no. 20).

46. *The Times*, 29 August 1811.

47. Doctor Syntax [anonymous], *The Tour of Doctor Syntax Through London*, London 1820, p. 207.

48. Sketches for the *The O.P. Riots at Covent Garden*, etched and published by T. Tegg, 27 September 1809. The disturbances lasted 61 nights after the opening of the new Covent Garden Theatre in 1809 with higher ticket prices.

Chapter 5

1. Pierce Egan, *Life in London; or the Day and Night Scenes of Jerry Hawthorn, Esq. And his elegant friend Corinthian Tom, accompanied by Bob Logic, the Oxonian, in their Sprees through the Metropolis*, London, 1821, p. 18.

2. Egan, *op. cit.* in note 1 above, p. 19.

3. Four for the City, two each for Westminster, Southwark and the County of Westminster.

4. Dorothy George, *Hogarth to Cruikshank: social change in graphic satire*, London 1967, p. 161.

5. Egan, *op. cit.* in note 1 above, p. 19.

6. See Jane Rendell, *The pursuit of pleasure :gender, space & architecture in Regency London*, London, 2002.

7. Egan, *op. cit.* in note 1 above, p. xi.

8. Egan, *op. cit.* in note 1 above, p. xi.

9. Egan, *op. cit.* in note 1 above, p. xi.

10. *The Times*, 18 May, 1815, p. 2.

11. In 1803 Thomas Tegg moved with his partner Castleman to 111 Cheapside, 1804 severed connection with Castleman.

12. *The Times*, 9 January 1806, p. 3.

13. *The Times*, 25 August 1825; p. 3.

14. Doctor Percy Jocelyn, Bishop of Clogher, was a famous homosexual who had been discovered in an intimate position with John Moverley in the back parlour of the White Lion pub. He was subsequently tried stripped of his position and jailed after been dragged through the streets and beaten. Clogher had been a member of the Society for the Suppression of Vice.

15. Thanks to Dr Andrew Norton for his information and expertise on prints published by Thomas Tegg.

16. Dorothy George, *Catalogue of Political and Personal Satires Preserved in the Department of Prints and Drawings at the British Museum*, London 1954, Vol. XI (1828–32), p. xvi.

17. A rare copy of this magazine can be found in the Guildhall Library, London.

18. A Book-Buyer, 'On the High Price of Modern Books' to the editor of *The Times*, 2 October, 1818, p. 3.

19. 'McLean's Monthly Sheet of Caricatures, Price 3s Plain, 6s Cold,' Vol. 2, 1 January 1831.

20. See Robert Upstone, *George Cruikshank's 'The Worship of Bacchus' – in focus*, London, 2001.

21. Quoted in Hackwood, *Frederick, William William Hone, His Life and Times*, London, 1912, p. 61.

22. Quoted in Robert L. Patten, *George Cruikshank's Life, Times and Art*, Vol. 1 (London 1992), p. 148.

23. Museum of London has two copies, one from the loyalist publishers and one published by Mrs Humphrey.

24. For Cruikshank's letter to Fuseli, see Patten, *op. cit.* in note 22 above, Vol. I, p. 48.

25. William Maginn, 'Gallery of Literary Characters. No. 39. George Cruikshank Esq,' *Fraser's Magazine*, No.4, August 1833, p. 190.

26. Egan, *op. cit.* in note 1 above, pp. 130–31.

27. R. H. Gronow, *Reminiscences*, London 1889, Vol. I, pp. 226–27.

28. George, *op. cit.* in note 4 above, concerning the changing of the dinner hour.

29. Egan, *op. cit.* in note 1 above, p. 227.

30. 'Death of the King of Beggars,' *The Times*, 5 April, 1826, p. 2.

31. J. P. Malcolm, *An Historical Sketch of the Art of Caricaturing with Graphic Illustrations*, London, 1813, p. 148.

32. Quoted in the *London Encyclopaedia* under the entry for 'Police.'

33. Egan, *op. cit.* in note 1 above, p. 2n.

34. A satire that alludes to the crash in value of railway stock 1845–46.

35. Museum of London collection, an inscription on the drawing notes it to be from the collection of Charles Dickens.

36. Charles Dickens, *Sketches by Boz*, London, pp. 158–63.

37. W. M. Thackeray, Article I, *Westminster Review*, Vol. 34, June 1840, pp. 6–7.

38. Henry Mayhew, *London Labour and the London Poor*, London, 1851, Vol. I, p. 27.

39. Graham Everritt, *English Caricaturists and Graphic Humourists of the 19th Century*, London, 1886, pp. 4–5.

Chapter 6

1. G. A. Sala, 'London as it Strikes a Stranger.' *Temple Bar*, Vol. 5, June 1862, p. 381.

2. Ernest Chesneau, *The English School of Painting*, translated by Lucy N. Etherington, 3rd edition, London 1887, p. 336.

3. William Makepeace Thackeray, John Leech's Pictures of Life and Character, *Quarterly Review*, No. 191, December 1854.

4. Celina Fox, 'Wood engravers and the City,' in Ira Bruce Nadel and F. S. Schwarzbach, *Victorian Artists and the City*, New York, Oxford, 1980, p. 1.

5. M. Wolff & C. Fox, 'Pictures from the Magazines,' H. J. Dyos & M. Wolff, *The Victorian City*, London, 1973, pp. 575–77.

6. Max Schlesinger, *Saunterings In and About London*, The English edition by Oscar Wenckstern, London, 1853, p. 210.

7. *Punch*, 1843, p. 22.

8. The Art-Union magazine attacked *Punch* for containing 'infinitely too much that degrades Art to the purpose of caricature, and renders personal the satire that should be only universal.' Quoted in Celina Fox, *Londoners*, London 1987, p. 192.

9. John Fisher Murray, *The World of London*, London, 1845, Vol. II, pp. 59–61.

10. Robert William Buss, *English Graphic Satire and its relation to different styles of Painting, Sculpture, and Engraving, A Contribution to the History of the English School of Art*, Printed for the Author by Virtue & Co., for private circulation only 1874.

11. See William Powell Frith, *John Leech, his Life and Work*, London, 1891 (two volumes).

12. The average attendance in the 1880s and 1890s was 355,000. It had long been popular, 'The opening of the Exhibition of the Royal Academy is one of our metropolitan galas, belonging to the same category as Christmas Day, Easter Monday, and the opening of Parliament.' *Pictorial Times*, Volume IX, 1847, p. 289.

13. See *Punch*, 1 June 1895.

14. *Vanity Fair* ran from 1868–1914. In 1869 an annual subscription cost £1. 6s and a single issue 6d. In 1895 an annual subscription cost £1. 8s.

15. Thomas Gibson Bowles on Carlo Pellegrini (1839–89) ['Ape'], *Vanity Fair*, 11 September 1869.

16. Charles Henry Bennett, *London People sketched from Life*, London 1863, p. 7.

17. John Ruskin, Letter to Franz Goedecker ('Goe' of *Vanity Fair*), Brantwood, March 28 1883, in *The Works of John Ruskin*, Edited by E. T. Cook and Alexander Wedderburn, London, 1903–12, Vol. 14, p. 490.

18. Graham Everritt, *English Caricaturists and Graphic Humourists of the 19th Century*, London, 1886, p. 368.

19. *Punch*, 8 August, 1863, p. 62.

20. Schlesinger, *op. cit.* in note 6 above, p. 82.

21. Schlesinger, *op. cit.* in note 6 above, Drury Lane, Saturday Night, p. 269.

22. See Julian Treuherz (ed.), *Hard Times: Social realism in Victorian art*, London 1987.

23. Murray, *op. cit.* in note 9 above, Vol. II, pp. 59–60.

24. John Ruskin, 'Modern Grotesque,' in *The Works of John Ruskin*, Edited by E. T. Cook and Alexander Wedderburn, London, 1903–12, Vol. 6, p. 471.

25. *Punch*, 'Song of the Shirt,' 1843 Christmas edition, p. 260.

26. Murray, *op. cit.* in note 9 above, Vol. I, p. 183.

27. Schlesinger, *op. cit.* in note 6 above, p.269. Illustrated by William McConnell on p. 266.

28. See Robert Upstone, *George Cruikshank's 'The Worship of Bacchus' – in focus*, London, 2001.

29. Blanchard Jerrold, *The Life of George Cruikshank*, London 1882, pp.266–7.

30. John Ruskin, 'John Leech's Outlines', (1872) in *The Works of John Ruskin*, *op. cit.* above, note 17, Vol. 14, p. 332.

31. John Ruskin, 'Fireside,' in *The Works of John Ruskin*, *op. cit.* above, note 17, Vol. 33, p. 359.

32. Bennett, *op. cit.* in note 16 above, p. 46.

33. Murray, *op. cit.* in note 9 above, Vol. I, pp. 111–12.

34. Miss Winter, The Family Governess, in (Joseph) Kenny Meadows, *Heads of the People; Portraits of the English*, London, 1840, p. 215.

35. Leigh Hunt, 'The Conductor', in (Joseph) Kenny Meadows, *Heads of the People; Portraits of the English*, London, 1840, p. 193.

36. Bennett, *op. cit.* in note 16 above, pp. 7–8.

37. Everritt, *op. cit.* in note 18 above.

38. G. A. Sala, *The Life and Adventures of George Augustus Sala Written by himself*, London, 1896.

39. Yveling Rambaud [Frédéric Gilbert], *Little Walks in London*, London, 1875, p. 5. John Leech drawings for 'Children of Mobility' were lithographs published by Richard Bentley, 1 February 1841.

40. *Fun*, 13 November 1869, p. 102.

41. *Town Talk*, 27 June 1859, p. 107.

42. Schlesinger, *op. cit.* in note 6 above, p. 231.

Chapter 7

1. E. H. Gombrich and Ernst Kris, *Caricature*, London, 1940.

2. The Centre for the Study of Cartoons and Caricature, University of Kent at Canterbury; The Cartoon Art Trust; and The Political Cartoon Society all make a significant contribution to the understanding of twentieth century cartoons.

3. V. Palmer, 'Will Dyson,' *Meanjin Quarterly*, 8/4, 1949, p. 214.

4. Celina Fox, *Londoners*, London 1987, p. 137.

5. Quoted in Langston Day, *The Life and Art of Heath Robinson*, London, 1947, p. 264.

Bibliography

Surveys of English Caricature

James Pellier Malcolm, *An Historical Sketch of the Art of Caricaturing*, London 1813.

Thomas Wright, *A History of Caricature and Grotesque in Literature and Art*, London 1865.

Robert William Buss, *English Graphic Satire and its relation to different styles of Painting, Sculpture, and Engraving, A Contribution to the History of the English School of Art*, Printed for the Author by Virtue & Co., for private circulation only 1874.

Graham Everritt, *English Caricaturists and Graphic Humourists of the 19th Century*, London 1886.

George Paston, *Social Caricature in the Eighteenth Century*, London 1905.

Frederick George Stephens and Mary Dorothy George, *Catalogue of Political and Personal Satires Preserved in the Department of Prints and Drawings at the British Museum*, London 1952 [11 volumes].

Dorothy George, *Hogarth to Cruikshank: social change in graphic satire*, London 1967.

H. M. Atherton, *Political Prints in the Age of Hogarth*, Oxford 1974.

Richard Godfrey, *English Caricature, 1620 to the Present*, [Victoria & Albert Museum exhibition catalogue] London 1984.

M. Bryant and S. Henage, *Dictionary of British Cartoonists and Caricaturists 1730–1980*, Aldershot 1994.

Diana Donald, *The Age of Caricature, Satirical Prints in the Reign of George III*, New Haven 1996.

Timothy Clayton, *The English Print, 1688–1802*, New Haven 1997.

Mark Hallett, *The Spectacle of Difference: graphic satire in the age of Hogarth*, New Haven & London 1999.

18th and 19th century Satire in London

Thomas Brown (1663–1704), *Amusements serious and comical, calculated for the meridian of London*, London: Printed for John Nutt 1700.

Ned Ward, *The London Spy, The Vanities and Vices of the Town Exposed to View* (1698–1703 in monthly supplements), edited with notes by Arthur L. Hayward, London 1927.

John Gay, *Trivia: or, The art of walking the streets of London*, London 1716.

A True Born Englishman, *A Ramble Through London – Containing Observations on Men and Things, viz. some account of the vast number of foreigners and their behaviour. Of the Scotch, Irish, and Welsh; Together with a small collection of the most refin'd jests* 1738.

George Alexander Stevens, *A lecture on heads by G. A. Stevens; as delivered by that celebrated comedian Mr. Lewes, at the Theatres Royal of London, Dublin, and Edinburgh, and as performed by him with universal applause at different captial cities on the continent*, London 1784.

Francis Grose, *Rules for Drawing Caricaturas with an essay on Comic Painting*, London 1788.

John Corry, *A Satirical View of London at the Commencement of the Nineteenth Century by an Observer*, London, 1801.

Robert Southey ['Don Manuel Alvarez Espriella'], *Letters from England*, London 1807.

Henry Angelo (1756–1835), *The reminiscences of Henry Angelo, with an introduction by Lord Howard De Walden and notes and memoir by H. Lavers Smith. Illustrated with sixty-eight plates, reproduced from originals in the collection of Joseph Grego*, [two volumes], London 1904.

The Microcosm of London; or, London in Miniature, [text by William Combe and W. H. Pyne; illustrations by Thomas Rowlandson and Augustus Charles Pugin] London 1808–1810.

Doctor Syntax [anonymous], *The Tour of Doctor Syntax through London*, London 1820.

Pierce Egan, *Life in London; or the Day and Night Scenes of Jerry Hawthorn, Esq. And his elegant friend Corinthian Tom, accompanied by Bob Logic, the Oxonian, in their Sprees through the Metropolis*, London 1821.

Max Schlesinger, *Saunterings In and About London*, the English edition by Oscar Wenckstern, London 1853.

George Augustus Sala, *Twice Round the Clock or the Hours of the Day and Night in London*, published in 1859.

Yveling Rambaud [Frédéric Gilbert], *Little Walks in London*, London 1875.

Individual Artists

Ronald Paulson, *Hogarth's Graphic Works*, [revised edition], New Haven & London, 1970.

David Bindman, *Hogarth and his times: serious comedy*, London 1997 .

David Alexander, *Richard Newton and English Caricature in the 1790s*, Manchester 1998.

John Hayes, *A Catalogue of the Watercolour Drawings by Thomas Rowlandson in the London Museum*, London 1960.

John Hayes, *Rowlandson Watercolours and Drawings*, London 1972.

Ronald Paulson, *Rowlandson: A New Interpretation*, London and New York 1972.

Richard Godfrey, *James Gillray: the art of caricature*, [Tate Gallery exhibition catalogue] London 2001.

Blanchard Jerrold, *The Life of George Cruikshank*, London 1882.

Robert L. Patten, *George Cruikshank's Life, Times and Art*, Cambridge [two volumes] 1992, 1996.

Major London Printsellers of Satire

Major satirical printsellers established before 1750

I. Baldwin & Craddock, Great Old Bailey.

II. George Bickham (c.1704–1771), engraver and printseller, Mays Building, Covent Garden.

III*a*. Thomas Bowles (1) (*d.* 1721) Paul's Alley, next to the chapter house in St Paul's Churchyard.

III*b*. Thomas Bowles (2) (1689/90?–1767), took over the running of the business from his father about 1714.

III*c*. Thomas Bowles (3) (1712?–1762) and John Bowles (1701?–1779).

IV*a*. Elizabeth Dicey (*fl.* 1713–1731) with husband John Cluer (*d.* 1728), the printing house at the Maiden-Head in Bow Churchyard.

IV*b*. Elizabeth Dicey with second husband Thomas Cobb (*fl.* 1728–1736), whom she married in 1731.

IV*c*. William Dicey (*d.* 1756), brother of John. Bow Printing Office, Bow Churchyard.

V. Charles Mosley (*d.* 1756), engraver and printseller, Old Round Court, Strand.

VI*a*. John Overton (1639/40–1713). Overton bought Peter Stent's shop at White Horse, near Pye Corner after he died in the plague of 1665. The building was destroyed in the Great Fire of London 1666.

VI*b*. White Horse on Snow Hill, opposite St Sepulchre's Church.

VI*c*. Henry Overton (1) (1675/6–1751) second son of John Overton, White Horse on Snow Hill, opposite St Sepulchre's Church.

VI*d*. Philip Overton (c.1681–1745) third son of John Overton, White Horse opposite St Dunstan's Church, Fleet Street, the name was changed the Golden Buck in 1710.

VI*e*. Mary Overton (*fl.* 1745–1748), widow of Philip Overton, Golden Buck in Fleet Street after her husband's death in 1745.

VII. Peter Stent (c.1613–1665), White Horse, near Pye Corner.

Major satirical printsellers between 1750 and 1830

1*a*. Rudolph Ackermann (1) (1764–1834), 101 Strand.

1*b*. Rudolph Ackerman (2) eldest son of Rudolph, opened in 1825, 191 Regent Street.

2. Allen & West, 15 Paternoster Row.

3*a*. William Austin (1721/1733–1820), drawing-master and engraver, with Gerard Vandergucht, Golden Head in George Street, Hanover Square.

3*b*. from 1763, Print Warehouse, Bond Street.

4. William Benbow, 269 Strand.

5. Berthoud & Son, 65 Quadrant.

6*a*. John Bowles, by February 1753 in partnership with his son, 13 Cornhill.

6*b*. Carington Bowles (1724–1793), son of John Bowles and later Henry Carington Bowles (1763–c.1830), 69 St Pauls Churchyard.

6*c*. Bowles and Carver, 69 St Pauls Churchyard.

7. Thomas Cornell (or Corneille), Bruton Street.

8. James Bretherton (c.1730–1806), engraver and printseller, 134 New Bond Street.

9. Elizabeth D'Archery, 11 St James's Street.

10*a*. Matthew Darly, (c.1720–1778?), designer and printseller, Duke's Court, St Martin's Lane, London, opposite Old Slaughter's Coffee House.

10*b*. Matthew Darly, in 1756 Golden Acorn opposite Hungerford market, Strand.

10c. Mary Darly (*fl.* 1760–1781), 'Fun Merchant', the Acorn in Ryder's Court, near Leicester Fields, from 1762.

10d. Matthew Darly and his wife Mary Darly, 39 Strand, from 1766.

10e. Mary Darly, 159 Fleet Street.

11. Cluer Dicey (1714/15–1775) The printing office, Bow Churchyard.

12a. Robert Dighton, (1751–1814), artist, 12 or 6 Charing Cross (1801–06).

12b. Robert Dighton, Charing Cross (1807–1810).

12c. Robert Dighton, 4 Spring Gardens, Charing Cross.

13a. Samuel William Fores (*bap.* 1761, *d.* 1838), publisher and printseller, 3 Piccadilly.

13b. Samuel William Fores, in 1795 he moved to larger premises at 50 Piccadilly, on the corner of Sackville Street. [The number was changed to 41 about 1820].

13c. Messrs Fores after Samuel William's death.

14a. William Holland, 66 Drury Lane, up to 1786.

14b. William Holland, 50 Oxford Street, from 1786.

15. William Hone (1780–1842), 55 Fleet Street.

16a. William Humphrey (*c.*1742–*c.*1814), from 1772, the Shell Warehouse, St Martin's Lane.

16b. William Humphrey from 1774, Gerrard Street, Soho.

16c. William Humphrey, by 1780, 227 Strand.

16d. Hannah Humphrey (*c.*1745–1818), printseller, sister of William Humphrey, from about 1778 St Martin's Lane.

16e. Hannah Humphrey, around 1779, 18 Old Bond Street.

16f. Hannah Humphrey, around 1783, 51 New Bond Street.

16g. Hannah Humphrey with the artist James Gillray in 1797, 27 St James's Street.

16h. G. Humphrey, 24 St James's Street.

17. J. Johnston, 98 and 101 Cheapside.

18. S. Knight, 3 Sweetings Alley, Cornhill.

19. Laurie & Whittle, 53 Fleet Street, [see Sayer and Bennett].

20. Thomas McLean, 26 Haymarket.

21. Charles Mosley (*d.* 1756), engraver and printseller, Maiden Lane, Covent Garden.

22. Samuel Okey, Samuel (*c.*1741–*c.*1780), mezzotint engraver, from about 1750, St Dunstan's Church, Fleet Street.

23. Henry Overton (2) (*fl.* 1751–1764), nephew and successor of Henry Overton (1), White Horse on Snow Hill, opposite St Sepulchre's Church.

24a. W. Richardson, 68 High Holborn (1778–82),.

24b. W. Richardson, 174 near Surrey Street Strand (1782–).

25. Percy Roberts, 28 Middle Row, Holborn.

26a. Robert Sayer, Robert (1724/5–1794), 53 Fleet Street.

26b. Sayer and Bennett, 53 Fleet Street [became Laurie & Whittle].

27a. J. Sidebethem or Sidebotham, 287 Strand.

27b. J. Sidebethem or Sidebotham, 96 Strand.

28. John Smith, Cheapside.

29a. Thomas Tegg, (1776–1846), between 1801 and 1804 partnership with Castleman, the Eccentric Book Warehouse, 122 St John's Street, West Smithfield.

29b. Thomas Tegg, from 1804 into business by himself at 111 Cheapside.

29c. Thomas Tegg, from 1824, Old Mansion House, 73 Cheapside.

30. Robert Wilkinson, 58 Cornhill (bought John Bowles's stock).

MAP 223

Anonymous, *Under Hoop & Bell, The World or
Fashionable Advertiser*, 1787.

Index

Accum, Friedrich Christian, 133–4
Ackermann, Rudolph, 32–3, 80, 108, 109, 113, 134
 Microcosm of London, 33, 76, 111, 112, 113–14, 118
 illustrations for, *77, 78, 120, 121, 124*
 Street Cries of London, 113
Adelphi, 108
Alken, Henry Thomas
 A Touch of the Fine Arts, 159
Alma Tadema, Sir Lawrence, *217*, 199
Almack, William, 85
Almack's Assembly rooms, 85, 89, 156
Almack's Club, 85, 86
Angelo, Henry, 56, 71, 72, 73, 86, 106, 108, 109, 126–7
Anonymous Works
 The Beauties of Bagnigge Wells, 85, *92*
 Blood Money: How it is Made; How it is Spent, 204, 189
 Casualties of London Street Walking: A Strong Impression, 24
 The celebrated Lecture on Heads, 16
 A Chancery Lane Noodle, 157
 The Civilised Home… And this is the father lying there, 196, 186
 Craniological Physiognomy, 158
 The Curds and Whey Seller, Cheapside, 50, 47
 Dick Swift, Thieftaker of the City of London, 35
 Dirty Father Thames, 201
 The Education Question: "Move on!" Where? To the Prison or To The School, 202, 188
 An Englishman's Delight or News of all Sorts, 20
 The Farmer's Daughter's return from London, 86, *97*
 Father Thames introducing his offspring, 200
 Female Terror, or Flogging Tom, 29, *33*
 The Fog, January 21st, 1865, 199
 The Folly of Man or The World turn'd upside-down, 43, *38*
 A Good Excuse, 179, *191*
 A High Wind in St Paul's Churchyard, 25, *19*
 Honi Soit Qui Mal Y Pense, 18
 The Hopes of a Family, 87, *83*
 The Humours and Diversions of Bartholomew Fair, 55–6, *52*
 The Last Few Days of St Paul's, 184, *198*
 The Lawyer's Coat of Arms, 67
 A London Conveyance, 26, *33*
 A Macaroni Liveryman, 87, *94*
 A Man loaded with Mischief, or Matrimony Drawn by Experience – Engraved by Sorrow, 68, *70*
 The Midnight Hour, 167, 158–9
 The Modern Moloch! A View of Society For 1870, 195, 183–4
 New System of Physiognomy (Wells), illustrations for, *194*

Princess Alexandra and Sally Muggins, *214*
A Print Seller Stood Outside his Shop, 148
A Prophecy – The Coach overturned or the fall of Mortimer, *10*
Specimens of Partial Genius, *79*, 78
Spectators at a print shop in St Paul's Church Yard, *1*
Thy face begrimed and black as soot, 184, 172
Under Hoop and Bell, 88, *98*
View of all the principal masquerade figures at the Rotunda May 12th 1789, 91, *100*
'Ape' (Carlo Pellegrini), 196
Apollo Library, 33, 141
Art-Union magazine, 175–6
Arundel, Earl of, 17
Asmodeus in London, 144
Atkinson, John Augustus
 The Berners Street Hoax, 156, *156*, 158

Bagnigge Wells, 75, 85
Baker, James, 141–2
Bank of England, 116, 118, 210
Barker, Robert and Henry Aston:
 Panorama of London, 81
 acquatint by Berne (after the Barkers), *80*
Barlow, Francis, 42
Barry, James, 35, 76, 78
Bartholomew Fair, 22, 38, 55–6, 99–100
Beckett, Gilbert à, 144
Belcher, George, 210
 Assistant: "I'm afraid we don't have anything in your size Madam", 210, *235*
Belgrave Square, 199
Bell, Steve, 209
 Remember – You Read it Here First, 212, *240*
'Benevolus Hilaris'
 Mirth versus Misery, The Pleasures of Human Life, 112
Bennett, 45
Bennett, Charles
 London People: Sketched from Life, 181, 194, 196
 The Cheap Swell, 210
Bentley's Miscellany, 178, 194
Bernie, Frederick
 London from the Roof of the Albion Mills (after Robert and Henry Aston Barker), *84*
Bethlehem Hospital, 47
Billingsgate, 38, 60–1, 199
Bindman, David, 38, 51
Bird, Cyril Kenneth ('Fougasse')
 Oh, so this is a flyover, 212
 Remarkable occurrence in the Heart of the Metropolis, The newcomers to No. 21 use their balcony as a balcony, *237*, 212
Black Dwarf, The, 144, 151
Blair, Tony, 212
Blake, William, 26

Bluck, J., 33
Boitard, Louis-Philippe
 The Imports of Great Britain from France, 61, *56*
 The Sailor's Revenge, 65, *62, 63* (detail)
 Taste à la Mode 1735, 62, *58*
 Taste à la Mode 1745, 62, *60*
Bond Street, 32, 82, 83
Borough Street, 56
Boswell, James
 London Journal, 31
Bow Churchyard, 31, 43
Bow Street, 199
Bowles, Carington, 20, 33, 34, 45, 93
 Polite Recreation in Drawing, 19
Bowles, John, 28, 61
Bowles, Thomas Gibson, 181, 196
Bowles family, 31
Boyne and Walker, 88
Bradford, Thomas, 45
Brandoin, Charles
 The inside of the pantheon in Oxford Street, 90, 85
Bretherton, James, 32, 87
Bridewell Prison, 65
Brooks's Club, 111
Brown, J. R.
 The Engraving Studio, 172, *183*
Brown, Tom (Thomas)
 Amusements serious and comical, calculated for the meridian of London, 37
 quoted, 31, 38, 49
Bunbury, Henry William, 32, 87
 The Houndsditch Macaroni, 87, *95*
Bunyan, John
 Pilgrim's Progress, 88
Bute, John Stuart, Third Earl of, 46, 47
Buss, Robert William 179
 The Crowd, 179, *190*

Calais, 28
Canaletto, 49, 109
Carlisle House, 85
Caroline, Queen, 148
Carracci, Annibale, 17, 21, 109
Cartoon Art Trust, 208
Cartoon Centre, University of Kent, 208
Cato Street Conspiracy, 139
Cats, Jacob, 68
Cavendish, Margaret, Dowager Duchess of Portland, 129
Chancery Lane, 201, 204
Charing Cross, 51, 55
Charles I, King, 42, 54
Charles II, King, 54
Charteris, Colonel Francis, 64
Cheapside, 33, 50, 64, 88, 141, 144
Chesneau, Ernest
 The English School of Painting, 170
Christie, Mr, 102–3, *113*
Cibber, Colley, 65
Cibber, Theophilus, 64
City of London, 51, 87, 116
City Philosophical Society
 Three Familiar Lectures on Craniological

Physiognomy, 78
Clark, Sir Kenneth, 210
Clogher, Bishop of, 142
Clubbe, John
 Physiognomy, 78
Cluer, John, 31
Cocker's English Dictionary, 18
Collet, John, 34, 44–6, 179
 The Female Bruisers, 59, 64–5
 La Françoise à Londres, 82, *88*
 May Morning, 59–60
 The Pretty Bar Maid, 45, *40*
Conjuror's Magazine or Magical and Physiognomical Mirror, The, 77–8
Cornelys, Mrs (Theresa Imer), 85
Cornhill, 61
Corry, John, 15
 Satirical View of London, 81, 110
 quoted, 34–5, 38, 81–2, 123, 129
Cosway, Richard
 Il Milanese, 56
Court and City Magazine, The, 144
Covent Garden, 38, 39, 51, 52, 54, 87, 92, 100, 101, 159
Covent Garden Theatre, 134
Craftsman, 31
Crocker, George, 142
Crockford's Club, 111
'Crowquill, Alfred' *see* Forrester, Alfred Henry
Cruikshank, George, 25, 26, 33, 72, 139, 140, 141, 144, 146–51, 153, 166, 180, 189, 191
 Anticipated effects of the Tailor's "Strike", *9*
 The Art of Walking the Streets of London, 37, 161, *178*
 Automaton Police Officers and Real Offenders, 158, *159*
 Bank Restriction Note, 147–8
 The Bottle, 146, 180, 191
 Comic Almanack, 141, 146
 The Drunkard's Children, 180, 191
 Fashionables of 1817, 153, *161*
 Gambols on the River Thames February 1814, 155, *148*
 The Inside of a Newly Reformed Workhouse With all Abuses Removed, 31, 37
 Life in London (illustrated with Robert Cruikshank), 25, 37, 140, 146, 147, 153–6, 161, 162
 Frontispiece, *147*, 140
 Jerry in Training to be a Swell, *162*
 Lowest "Life in London" – Tom, Jerry and Logic among the unsophisticated Sons and Daughters of Nature at "All Max" in the East, *165*
 A Shilling well laid out. Tom and Jerry at the Exhibition of Pictures at the Royal Academy, 156
 Tom getting the best of a Charley, *157*
 London Characters, 147
 London going out of Town – or – The March of Bricks and Mortar, 34
 March, 141, *150*

March of the Bricks, 160
Metropolitan Grievances; or, a Serio-comic Glance at Minor Mischiefs in London and its vicinity, 147
Monstrosities, 153
Monstrosities of 1822, 160, *152*, *153*
Mornings at Bow Street, 147
The Mother Red Cap Public House in opposition to the King's Head, *154*, 148
Oliver Twist, 26, 146, 147
Oliver Claimed by his affectionate Friends, *153*
Phrenological Illustrations, 150, *159*
Queen Victoria Enthroned, 166, *181*
The Railway Dragon, 159–60, *174*
Sketches by Boz, 141, 146, 161–2
The Gin Shop, 162, *175*
A Pickpocket in Custody, 141, *149*
Taking the Census, *209*
Tower of London, 146, 147
The Triumph of Bacchus, 146, 149–50
The Worship of Bacchus, 206, *191*
Cruikshank, Isaac, 146
Cruikshank, Robert (Isaac Robert), 141, 144, 146
Dandy pickpockets, diving – Scene near St James's Palace, *23*
Life in London (illustrated with George Cruikshank), 25, *37*, 140, 146, 147, 153–6, 161, *162*
Frontispiece, 147, *140*
Jerry in Training to be a Swell, *162*
Lowest "Life in London" – Tom, Jerry and Logic among the unsophisticated Sons and Daughters of Nature at "All Max" in the East, *165*
A Shilling well laid out. Tom and Jerry at the Exhibition of Pictures at the Royal Academy, *156*
Tom getting the best of a Charley, *168*

D'Archenholz, M, 24
Daily Herald, 209
Daily News, The, 181
Daly, 75
Darly, Mary, 19, 20, 26, 32, 75
Darly, Matthew, 19, 26, 32, 73, 75, 87
Dayes, Edward, 95
The Promenade in St James's Park, *91*, *99*
de Veil, Sir Thomas, 54–5
De Ville, J., 151
Della Porta, Giovanni
De Humana Physiognominia, *20*, *14*, 21, 109
Derby Day, 177, 178
Devil in London, The, 144
Devonshire, Georgiana, Duchess of, 100
Dicey, William, 31, 43, 55, 67, 99
Dickens, Charles, 26, 166, 191, 199
Oliver Twist, 26, 146, 147
illustration for, *153*
Sketches by Boz, 141, 146, 147, 161–3, 191
illustrations for, *149*, *175*
Dighton, Richard, 102

A Firm Banker, *111*
A Pillar of the Exchange, *110*
Dighton, Robert, 92–4, 100, 102–3
George III aged 72, 1810, *73*
A Jewish Clothes Trader and a Butcher, 94, *96*
Lady being carried throught the streets of London in a Sedan chair, *93*, *102*
Pea Cart, 94, *103*
A Real Scene in St Paul's Churchyard on a Windy Day, *22*, 93
The Return from a Masquerade – A Morning Scene, 92–3, *101*
The Specious Orator, 102–3, *113*
Westminster Election 1788, *108*, 100–1
Westminster Election 1796, *109*, 101–2
Dilettanti Society, 35
Disney, 208
Disraeli, Benjamin, 196
Dixon, John
The Old Beau in Ecstasy, *8* (detail), *91*, 88
Donald, Diana, 22, 100, 102
Douglas, William, Fourth Duke of Queensbury *see* Queensbury, William Douglas, Fourth Duke of
Doyle, James, 201
Doyle, John (H.B.), 166
An Eclipse as seen over London, *180*
Doyle, Henry, 201
Doyle, Richard ('Dick Kitcat'), 175, 201
Manners and Customs of Ye Englishe in 1849, 201
A Prospect of Greenwich Fair, 201, *227*
A View of Epsom Downs on ye Derbye Daye, *178*
Drury Lane, 62
Du Maurier, George, 175, 192, *186*, 199
A Jubilee Private View, *175*, 178
Duncannon, Lady, 100
Dyson, Will, 209–10
The New Advocate, *223*, 209

Eamer, Sir John, 95, 96
Egan, Pierce
Boxiana, or, Sketches of Ancient and Modern Pugilism, 140–1
Life in London, 25, *37*, 140, 146, 153–6, 161, 162
quoted, 11, 139, 156, 159
illustrations, *147*, *156*, *162*, *165*, *168*
Ellenborough, Lord, 37
Elmes, William
Prime Bang up at Hackney, *32*
Espriella, Don Manuel Alvarez *see* Southey, Robert
Everett, Edward, 141–2
Everitt, Graham, 166, 196
Every Body's Album and Caricature Magazine, 144, *151*

Fairburn's print shop, 166
Farington, Joseph, 28, 35, 78
Feltham, John, 87
Fielding, Henry, 21

Fielding, Sir John, 52
Figaro in London, 144
Files, Luke, 186
Fish Street, 87
Fitzherbert, Mrs, 101
Fluck, Peter, 214
Foreigner's Guide, The, 59
Fores, Samuel William, 28, 32, 33, 109, 141, 142–3
Forrester, Alfred Henry ('Alfred Crowquill')
Stanley Thorn at Epsom, 178, *189*
'Fougasse' *see* Bird, Cyril Kenneth
Fox, Celina, 172
Fox, Charles James, 100, 101, 210
Free Society, 51
French, the, 81–3, 88
French Revolution, 81, 82
Frith, William Powell, 72, 73, 176–7
Derby Day, *187*, 177, 178
Morning, Noon and Night, 180
The Race for Wealth, 180
The Road to Ruin, 72, 180
Fun, 196
British Working Man anthology, 196
'Types of Thoroughfare', 201
Furniss, Harry, 199
George du Maurier, 186, 199
Mr George Grossmith, *218*, 199
Interiors and Exteriors, No. 22, Charing Cross Station, 230
Interiors and Exteriors, No. 24, The Central Criminal Court, 228
Sir Alma Tadema and Sir Henry Irving, *217*, 199
Fuseli, 149

Gainsborough, Thomas, 109
Gall, Francis Joseph, 151
Gardner, Admiral Sir Alan, 101
Gay, John
Beggar's Opera, 52
Trivia: or the art of walking the streets of London, 161
quoted, 31, 62
Gentleman's Magazine, 107
George III, King, 72, 74, 139
George IV, King, 148–9
George, Dorothy, 41, 139, 142, 144
Géricault, Théodore, 141
Combat de Boxe series, 141
Ghezzi, Pier Leone, 21, 109
Gillray, James, 25, 32, 72, 73, 75, 78, 82, 106, 149, 170, 172, 209
Connoisseurs examining a collection of George Morland's, *71*, 78
Following the Fashion, St James's & Cheapside, 88, *71*, *96* (detail)
Freedom and Slavery, 188
The Graces in High Wind – a scene Taken from Nature, in Kensington Gardens, 75, *76*
High Change in Bond Street – ou – La Politesse du Grande Monde, 82–3, *85*

A New Administration, or the State Quacks Administering, 75, *75*
Notorious Characters No. 1, 35
Sad Sloppy Weather, 84, *86*
Sandwich-Carrots! Dainty Sandwich-Carrots, 80, *83*
Titanus Redivius or The Seven Wise-Men consulting the new Venetian Oracle, 78, *80*
Very Slippy-Weather, *25*, 32
Gilpin, William, 109
Goddard, 144
Godfrey, Richard, 35
Goedecker, Franz ('Goe'), 181
Golden Cabinet, The, 77–8
Goldsmith, Oliver, 78
Graphic, The, 173, 186
Gravesend, 201
Great Fire (1666), 42
Gronow, Captain, 152
Grose, Francis
Rules for Drawing Caricatures, 19–20, 20–1, 76, 110
quoted, 11, 13, 17, 21, 54, 110
Figure 5 in, 20, *13*
Grossmith, George, 199, *218*
Guardian, The, 212

H.B. *see* Doyle, John
Haddock, Richard, 54
Hallett, Mark, 52
Harper, Jack, 56
Harraden, 33
Hayes, John, 106–7, 112–13, 118
Haymarket, 121, 141
Heath, William
Cigars, 161, *177*
Contrasts, Ancient and Modern Gentlemen, 152, *163*
The March of Intellect, 159, *171*
Monster Soup commonly called Thames Water, 160–1, *172*
Strand in Fog, 161, *176*
Herkomer, Hubert, 186
Hewitt, 96
Hicks, George Elgar, 72, 176–7
Hill, J., 33
Hockney, David, 214
Hog Lane, 51, 54
Hogarth, William, 12, 20, 21, 22, 25, 33, 39, 42, 43–4, 46, 51–5, 68, 71, 72, 79, 92, 155, 170, 176, 208, 209, 214
The Analysis of Beauty, 46
Before and After, 188
Characters and Caricaturas, *17*, 21
The Cockpit, 39
The Four Times of the Day, 51–5
Morning, 52, *53*, 54
Noon, 50, 54
Evening, 50, 54
Night, 51, 54–5
Gin Lane, 45, 49, 68, 214
Harlot's Progress, 64
Plate 1, 64, *61*
Plate 4, 65, *65*

Plate 6, 66
Industry and Idleness, 2
 The Idle 'Prentice executed at Tyburn,
 54, 59,
 *The Industrious 'Prentice Lord Mayor of
 London*, 2
March to Finchley, 33
Marriage à la Mode, 180
Paul Before Felix Burlesqued, 46, 47
The Rake's Progress, 180, 214
 Plate 4, *33*, *36* (detail)
Southwark Fair, 56, *53*
The Times Plate 1, 46
Holl, Frank, 186
Holland, William, 32, 33
Hollar, Wenceslaus, 17–18, 30, 42
 Five Grotesque Old Men, 5
 The world is ruled by opinion, 7, 17–18
 *A Young Man with a Hideous Old
 Woman*, 6, 17
Hone, William, 141, 147–8, 166
Hood, Admiral Lord, 100
Hood, Thomas
 'The Song of the Shirt', 188–9
Hoppner, John, 78
Houndsditch, 87
Huguenots, 54
Hulton, Robert, 31
Humprey, Mrs, 86, 149, 151, 153
Humphrys, Mrs, 32, 35
Hunt, G.
 *A Thoroughbred November & London
 Particular*, 161, *173*
Hunt, Leigh, 195
Hüttner, Johan Christian, 34
Hyde Park, 153, 188

Illustrated London News, The, 173, 186
Ireland, John, Dean of Westminster, 52
Ireland, Samuel, 35
Irving, Sir Henry, *217*
Islington, 51, 52, 54
Italy, 12, 17

James Street, Adelphi, 108
Jerrold, Douglas, 195
Johnston, 144
Joli, 49
Jones, Ersasmus, 49 *see also* True Born
 Englishman, A
Jones, William Naunton, 144
June, John
 The Lady's Disaster, 62, 64
 A View of the Mall (L'Agneau, engraved
 by June), *57*

Keene, Charles Samuel, 175
 Difference of Opinion, 204
King, Moll, 54
King, Richard
 *The Frauds of London detected, or, a new
 warning-piece against the iniquitous
 practices of that metropolis*, 84
King, Tom, 52, 54
King Street, St James's, 85, 156

Kings Cross, 75
'Kitcat, Dick' *see* Doyle, Richard
Knight's print shop, 166

L'Agneau
 A View of the Mall, 57, 61–2
Ladies Coterie, 86
Lane, Theodore
 Covent Garden, 159, *170*
Lavater, John Caspar, 77, 151
 Essays on Physiognomy, 20, 21
Law, Roger, 214
Lee, Hannah, 56
Lee, Joseph
 London Laughs series, 212
 Giant Clock Embankment, 212, *238*
Lee, Nathaniel, 65
Leech, John, 72, 170, 175, 179, 192
 Children of Mobility drawings, 199
 Miss Adelina Harpagon, 199, *231*
 Harmonious Owls, 194, *207*
 Hercules returning from a Fancy Ball, 208
 Here and There, 188, *203*
 Pin Money, Needle Money, 189, *205*
 Substance and Shadow, Cartoon No. 1,
 175–6, 178, *185*
 What Wide Reverses of Fate are There,
 188
Leicester Square, 81, 144
Leigh, Percival, 201
Leighton, Frederick, 199, *221*
Lemon, Mark, 175
Leonardo da Vinci, 17, 21, 30, 109
Lewis and Johnston, 33
Lisle Street, Soho, 110
London in Paris, 144
London und Paris, 34
London Bridge, 149
London Daily Post, 52
Looking Glass, The, 144, *152*
Loutherbourg, Philip James de
 From the Haymarket, 86, *93*
Low, David, 209, 210
 The Lord Chief Justice, 210, *234*
Loyalist Association, 148, 149
Loyalist's Magazine, 148
Ludgate Hill, 166
Lunardi, Vincenzo, 47

Macaroni Club, 86
Macaroni Print Shop, 13
Macaronis, the, 86–7
McConnell, William, 199, 201
 *Covent Garden Market: Early Breakfast
 Stall*, 223
 Five O'Clock P.M.: The Prisoners' Van,
 226
 Gin Shop, 225
 *Types of Thoroughfares, No.4 – Chancery
 Lane*, 201, 229
 Windmill Hill, Gravesend, 201
McLean, Thomas, 141, 144, 152, 161
Maitland, William, 49
Malcolm, J P, 73, 156
Mall, the, 39, 62, 132

Mark
 *Brutes Humaniz'd in Alderman Turtle &
 Singe his wife*, 15
May, Phil *see* William, Philip May
Mayhew, Henry, 155, 166, 175, 194–5,
 199
 London Labour and the London Poor, 195
Meadows, Kenny, 144, 175
 Heads of the People, 192
 The Conductor, 211
 The Family Governess, 213
 The Stock-Broker, 212
Merke, H., 33
Merry, Tom
 On the Hill at Epsom, 178–9, *188*
Methodism, 88
Meteor or Monthly Censure, The, 144
Metropolitan Police, 159
Michelangelo, 51
Middle Temple, 87
Millais, John Everett
 drawing of soldiers, 179–80, *192*
 It is the chapeau blanc, the white witness
 (illustration for *Mokeanna*), 180, *193*
Millennium Dome, 212
Mitchell (banker), 78
Moorfield, 47
Morland, George, 78
 A Tea Garden, 78, *81*
Morning Chronicle, 102, 195
Mortimer, John Hamilton, 109
Mother Red Cap inn, 148
Motte, C., 144
Murray, John Fisher
 The World of London, quoted, 176,
 187–8, 191
Mylne, Robert, 85

Nalson, J.
 *An Impartial Collection of the Great
 Affairs of State*, prints for, *36*, 42
Needham, Mother (Elizabeth), 64
New Bagnio, 54
New Statesman, The, 210
Newgate Prison, 56, 124
Newton, Richard, 32
Nixon, John
 Bartholomew Fair, 99–100, *107*
 A City Pageant, 95, 96, *105*
 Entrance to St James's Palace, 91–2
 *A peep behind the scenes: Covent Garden
 Theatre*, 103, *112*
Norfolk, Duke of, 100

Opie, John, 78
O'Rilley, Bernard, 144
Overton, John, 30, 31
Oxford Street, 32, 85

Pall Mall, 85, 86, 144, 179
Palmer, V., 209
Pantheon, The, 85, 89
Paris Charivari, 175
Park Place, 64
Patch, Thomas

 Caricature, 19
 Tommaso Patch Autore, 8, 19
Paulson, Ronald, 110, 130
Pellegrini, Carlo ('Ape'), 196
Penny Trumpet, 144
Pepys, Samuel, 41, 43
Piccadilly, 123, 142
'Pindar, Peter' (John Wolcot), 108
Pitt, William, the Younger, 118
Pitts, J.
 A Smock Race at Tottenham Court Fair,
 96, 99, *106*
Poland Street, 107, 126
Political Cartoon Society, 208
Political Register, 144
Pond, Arthur, 19
Portland, Margaret Cavendish, Dowager
 Duchess of, 129
Pre-Raphaelites, 179
Private Eye, 37, 212
 Street Names of Old London: The City,
 212, *241*
Privy Garden, 129
Provis, Ann Jemima, 78
Pry, Paul *see* Heath, William
Pugin, Augustus Charles
 Microcosm of London (illustrated with
 Rowlandson), 33, 113, 114, 118
 Bartholomew Fair, 99, 114, *121*
 *Drawing from Life at the Royal
 Academy, Somerset House*, 76, 78
 Exhibition Room, Somerset House, 77
 The Great Hall, Bank of England, 116,
 124
 Westminster Election, *120*
Punch, 12, 37, 139, 170, 172, 175–6, 178,
 179, 180, 184 188, 194, 201, 204, 214
 Frontispiece, *182*
Punch and Judy, 25
Punchinello, 144

Queensbury, William Douglas, Fourth
 Duke of ('Old Q'), 39, 122–3

Ranelagh pleasure garden, 85
Raphael, 21
Reform Bill, 139
Rembrandt, 46
Repository of Arts (shop), 32–3
Repository of Arts (magazine), 33
Reynolds, Sir Joshua, 88
 Discourses, 79
Richmond Bridge, 118
Rigaud, J. F., 78
Rimbaud, Yveling
 Little Walks in London, 199
Robert Street, Adelphi, 108
Robinson, Heath, 210
 The Bank of England, 210, *236*
Roche, Sophie von la, 74–5
Rock, Dr, 54
Rowlandson, Thomas, 17, 25, 33, 72, 73,
 75, 78, 80, 103, 104–35, 149, 172, 209
 *Barto Valle's Italian Warehouse,
 Haymarket*, 122, *131*

Calling for a Christmas Box, 129, *137*
Careening a Coaster at Rotherhithe, 118, *128*
The Caricature Port Folio, 30, 33
Comparative Anatomy. Resemblances Between the Countenances of Men and Beasts, 115
A City Chop House, 118, 122, *130*
Delilah payeth Sampson a visit while in prison, 109
A Drawing Room at St James's Palace, 129, *145*
The Elephant and Castle Inn, 118, *126*
An Execution, 124, *135*
An Execution Outside Newgate Prison, 124, *136*
Gaming at Brooks's Club, 111, *118*
A Gin Shop, 129, *146*
Hackney Coachman, 132
An Irish Member on His Way to the House of Commons, 110, *117*
Kicking up a Breeze at Nell Hamilton's Hop, 114
Last Dying Speech and Confession, 124, *134*
Loan Contractors, 118, *125*
Microcosm of London (illustrations with Pugin), 33, 113, 114, 118
 Bartholomew Fair, 99, 114, *121*
 Drawing from Life at the Royal Academy, Somerset House, 76, 78
 Exhibition Room, Somerset House, 77
 The Great Hall, Bank of England, 116, *124*
 Westminster Election, 120
Miseries of London – or – a Surly Saucy Hackney Coachman, 109, *116*
Mr Accum Lecturing at the Surrey Institution, 133–4, *140*
The Old Price Riots, 134, *142, 143*
The Piccadilly Farce, 123, *129*
Richmond Bridge, 118, *127*
A Rout at the Dowager Duchess of Portland's, 129, *144*
Skaters on the Serpentine, 130, *140*
Stock-Jobbers, 116, *122*
Street Cries of London series, 33, 113, 123–4
Taking Tea at the White Conduit House, *141*
Touch for Touch or a Female Physician in Full Practice, 111, *123*
Vauxhall Gardens, *130*, 130, 132, 134
Watching the Comet, 133, *138*
A Watchman Making his Rounds, *133*
Westminster Election, Covent Garden, 114, *119*
Rowlandson, William, 107
Rowson, Martin
 Cocaine Lane, 240
Royal Academy, 25, 72, 76, 78, 79, 106, 107, 108–9, 129–30, 149–50, 177, 178
Royal Exchange, 28
Rummer Court, 54
Ruskin, John, 181, 183, 188–9, 192

Sadler's Wells, Islington, 54
St George's Church, 56
St Giles, 39, 49, 51, 61
St Giles's-in-the-Fields church, 54
St James's, 31–2, 61, 74, 85, 87, 88, 91, 111, 121, 149, 156
St James's Palace, 46
St James's Park, 61, 62
St James's Street, 46
St Martin in the Fields, 133
St Paul's, 30
St Paul's Cathedral, 184
St Paul's Church, 38, 52
 old, 42
St Paul's Churchyard, 31, 93
St Sepulchre's church, 56
St Stephen's, 42
Saint Stephen's Review, 178
Sala, George Augustus
 Twice Round the Clock, 170, 199, 201
 illustrations for, *199, 200, 201*
Salaman, Malcolm, 80
Sambourne, Linley, 175
Sandby, Paul, 46–7, 67–8
 The Butifyer. A Touch upon The Time Plate 1, 46, 46–7
 An English Balloon, 47, *47*
 A hot pudding, 68
 The Magic Lantern, 45, 46
 Rare Mackerel Three a Grout or Four for Sixpence (Twelve London Cries No. 8), 67–8, *68*
Sandwich, Lord, 80
Satirist, or Monthly Meteor, The, 144
Sayer, Robert, 28, 45, 85
Scarfe, Gerald, 212
Schlesinger, Max
 Saunterings In and About London, quoted, 175, 184, 204
Schnebbelie, Robert B.
 Richardson's ancient & modern Print Warehouse, 31
Schoolmaster at Home, The, 144
Scourge, or Monthly Expositor of Literary, Dramatic, Medical, Political, Mercantile and Religious Imposture and Folly, 144
Searle, Ronald, 212, 214
Serpentine, 130
Seymour, Robert, 144
Sheppard, Jack, 49
Sidebothem, J.
 Perambulators in Hyde Park!, *159, 163*
Simpsons, The, 212
Smirke, Robert, 78
Smith, John, 35, 37
Smith, John Raphael
 The Bread and Butter Manufactory, or the Humors of Bagnigge Wells, 73, 75
 Miss Macaroni and her gallant at a print shop, 14
Smithfield, 55, 99
Society of Artists of Great Britain, 51
Soho Square, 85, 107, 127
Southey, Robert (using name Don Manuel Alvarez Espriella)

Letters from England, 114, 116, 121, 124, 126
Southwark Fair, 22, 39, 56
Spitting Image, 25, 214, *215*
Spurzheim, Johann Christian, 151
'Spy' *see* Ward, Leslie Matthew
Stadler, J. C., 33
Steadman, Ralph, 212, 214
Stent, Peter, 30
Stevens, George Alexander
 'A Lecture on Heads', 22, 24, 78, 88, 110, 111, 118, 212
Stothard, Thomas, 78
Strand, the, 19, 32, 33, 49, 50, 62, 65, 108
Strype, John, 49
Stuart, John, Third Earl of Bute *see* Bute, John Stuart, Third Earl of
Sullivan, James Frank
 On the Power of the Human Eye, 195
 The Triumph of Row, 195
Sunday Times Magazine, 214
Sutherland, T., 33
Sweeting's Alley, 166

Tegg, Thomas, 33, 109, 141, 144, 149
Temple, 49, 87
Tenniel, John, 175
 Sooner or Later, or what it must come to, 19
Thackeray, William, 166, 170, 195
Thames, River, 149, 184
Thistlewood, Arthur, 139
Thomas, William Luson, 173
Tilt, Charles, 141
Time Out, 212
Times, The, 95–6, 121, 124, 133, 141, 144, 156
Tissot, James Jacques Joseph, 196
 Portrait of Frederick Leighton, *197*, 198
Tom King's Coffee House, 52, 54
Tomahawk, 175, 183, 189
Toms, William Henry
 Bow Church, 49, *50*
Topham, Colonel, 132
Topham, Edward
 The Macaroni Print Shop, 19, 26, 32, 87
 Moderate Interest, *72*, 73
Tooke, John Horne, 101
Tottenham Court Road, 96, 99, 148, 162
Town Talk, 176, 184, 188, 201
 Frontispiece, *184*
Townshend, Lord John, 100
True Born Englishman, A, 15, 39, 47, 49, 50, 55, 62, 65, 194
Trusler, Rev Dr
 The London Advisor and Guide, 73–4, 83–4
Truth, 186
Turk's Head Bagnio, 54
Tyburn, 59, 61, 124
Tyburn Fair, 56, 59
Tyers, Jonathan, 52

United States, 212

University of Kent: Cartoon Centre, 208

Valle, Barto, 121, 122
Vanhaeken, Arnold, 60, *60*
Vanity Fair, 37, 102, 181, 196, 199
Vauxhall Gardens, 52, 85, 130, 133
Venne, Adrien van de, 68
Vertue, George, 64

Wag, The, 144
Wales, Prince of, 74–5, 95, 96, 100–1, 132, 139
Ward, Leslie Matthew ('Spy'), 196
 Joseph Edgar Boehm with a bust of John Ruskin, *181*
 North East Bethnal Green, Sir Mancherjee Bhownaggree KCIE MP, *220*
Ward, Ned, 170
 The London Spy, 37
 quoted, 26, 52, 54, 55, 60–1, 65, 94
Weichsel, Mrs, 132
Welcome Guest, 201
Wells, S. R.
 New System of Physiognomy, 193
 illustration for, *194*
Wendeborn, Frederick Augustus, 74, 81, 82, 84, 89
Wesley, Charles, 88
West End, 32, 51, 62, 116
Westall, Richard, 78
Westmacott, Sir Richard, 153
Westminster, 39, 42, 65
 elections, 100–02
Westminster Abbey, 49
Westminster Hall, 28, 175
Weston, Andrew, 156
Wheatley, Francis, 79–80
 Turnips & Carrots Oh!, 79
Whig Dresser, The, 144
White, Robert, 42
 Britania, 42, *36*
 Thus black look't Heav'n, 42, *43*
Wigstead, Henry, 108
Wild, C.
 A Lesson in Colouring – sixteen caricatures of musicians, 222
Wilkes, John, 39, 100
William, Philip May ('Phil May')
 Gutter-Snipes, 201
 A Swell, *204*
Williams, C.
 The Balance of Justice, 32
 The Haberdasher Dandy, 153, *155*
Williams, Kipper
 The Lady and the Wimp, 212, *213*
Wilson, James
 Light your Honour?, 83, *84*
Wolcot, John ('Peter Pindar'), 108
Wood, William, 35, 37
Woodward, George, 33, 171, 178